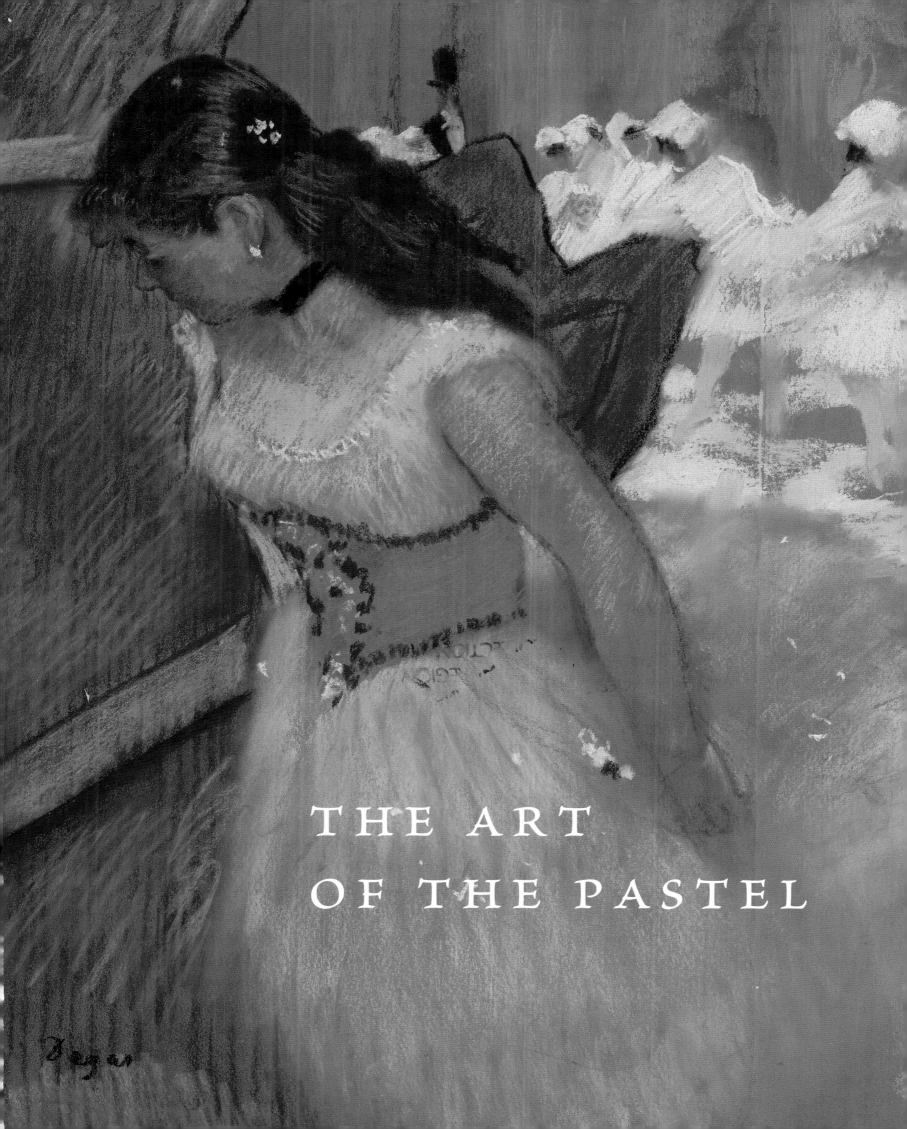

THE ART
OF THE PASTEL

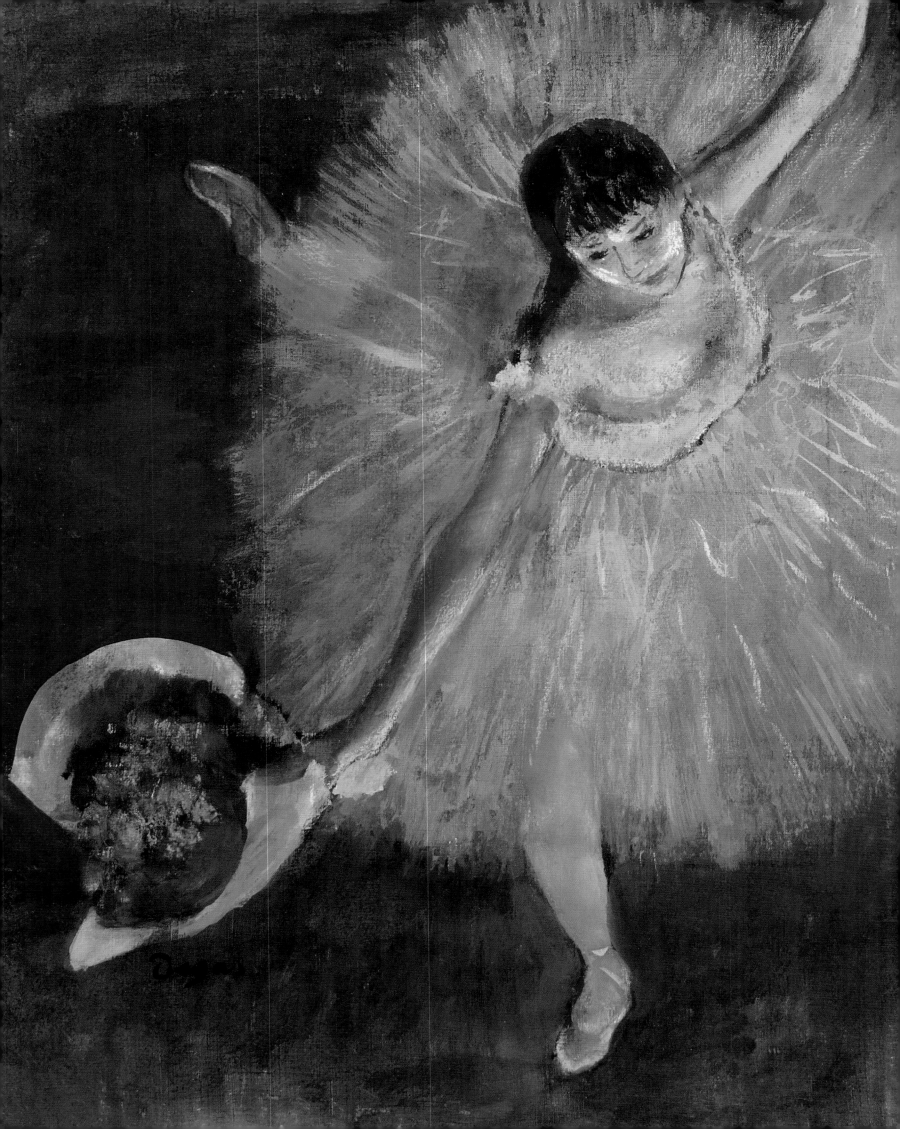

THE ART OF THE PASTEL

Thea Burns

Philippe Saunier

Abbeville Press Publishers
New York · London

Philippe Saunier's text translated
from the French by Elizabeth Heard

FOR THE ORIGINAL EDITION:
Editor: Emmanuelle Gaillard
Graphic design: Marc Walter/Studio Chine
Copy editors: Philippe Rollet, Olivier Valentin
Translator: Pascal Tilche
Pre-press: Planète Couleurs

FOR THE ENGLISH-LANGUAGE EDITION:
Editor: Nicole Lanctot
Copy editor: Miranda Ottewell
Proofreader: Patricia Bayer
Production manager: Louise Kurtz
Jacket design and typographic layout: Misha Beletsky
Composition: Kat Ran Press

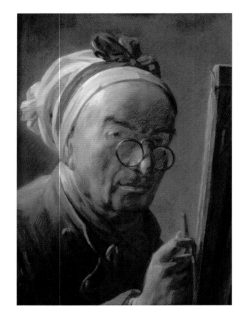

First published in the United States of America in 2015 by Abbeville Press,
116 West 23rd Street, New York, NY 10011

First published in France in 2014 by Editio-Éditions Citadelles & Mazenod,
8, rue Gaston de Saint-Paul, 75116 Paris

First edition
10 9 8 7 6 5 4 3 2 1

Library of Congress Cataloging-in-Publication Data

Burns, Thea, author.
 [Art du pastel. English]
 The art of the pastel / by Thea Burns and Philippe Saunier.—First edition.
 pages cm
 Summary: "An illustrated, comprehensive survey of the fine art of pastel"—Provided by
publisher.
 ISBN 978-0-7892-1240-5 (hardback)
 I. Saunier, Philippe, author. II. Title.
 NC880.B8613 2015
 741.2"35—dc23

 2015014020

For bulk and premium sales and for text adoption procedures, write to
Customer Service Manager, Abbeville Press, 116 West 23rd Street, New York, NY 10011,
or call 1-800-ARTBOOK.

Visit Abbeville Press online at www.abbeville.com.

FRONT COVER
Mary Cassatt
At the Theater, c. 1879
Pastel on paper, 21⅝ × 18⅛ in. (55.4 × 46 cm)
The Nelson-Atkins Museum of Art,
Kansas City, Missouri

BACK COVER
Edgar Degas
Blue Dancers (detail), c. 1899
Pastel on paper, 25¼ × 25⅝ in. (64 × 65 cm)
Pushkin Museum, Moscow

PAGE 1
Edgar Degas
Entrance of the Masked Dancers (detail), c. 1884
Pastel on paper, 19¼ × 25½ in. (49 × 64.7 cm)
Sterling and Francine Clark Art Institute,
Williamstown, Massachusetts

PAGE 2
Edgar Degas
End of the Arabesque (detail), 1876–77
Peinture à l'essence
(oil thinned with turpentine) on canvas,
26⅜ × 15 in. (67 × 38 cm)
Musée d'Orsay, Paris

ABOVE
Jean Siméon Chardin
Self-Portrait of Chardin at His Easel (detail),
c. 1779
Pastel on blue paper, 16 × 12¾ in.
(40.5 × 32.5 cm)
Musée du Louvre, Paris

BELOW
Maurice Quentin de La Tour
Self-Portrait (detail), c. 1742
Pastel on paper, 15 × 11¾ in. (38 × 30 cm)
Musée Antoine Lécuyer, Saint-Quentin,
France

OPPOSITE
Jean-Etienne Liotard
Self-Portrait (detail), 1744
Pastel on paper, 24 × 19¼ in. (61 × 49 cm)
Galleria degli Uffizi, Florence

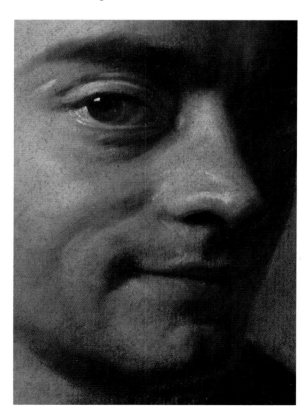

Contents

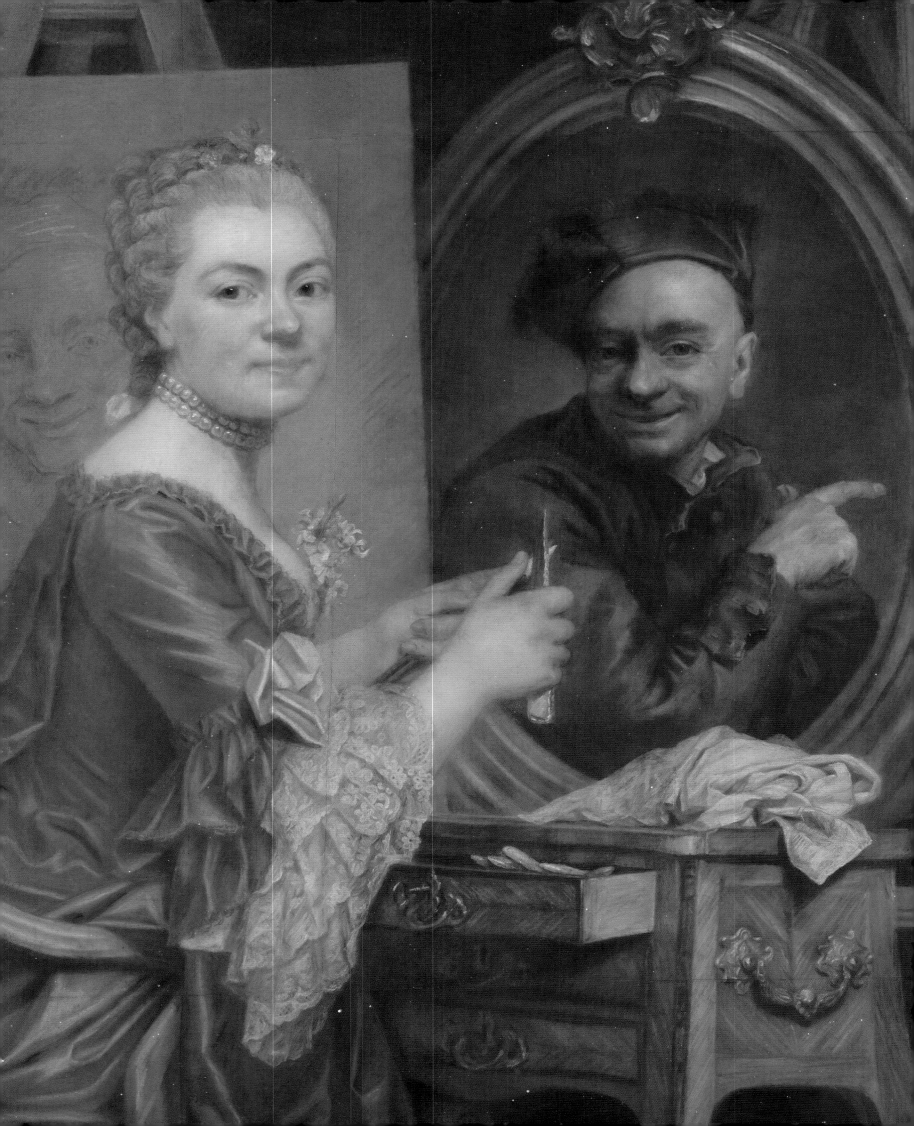

Introduction

Jean-Etienne Liotard
Portrait of Marie Fargues in Turkish Costume (detail),
1756–58
Pastel on parchment,
40½ × 31⅜ in. (103 × 79.8 cm)
Rijksmuseum, Amsterdam

Marie-Suzanne
Giroust-Roslin
Self-Portrait in Pastel of the Artist Copying a Portrait of Quentin de La Tour (detail),
1771–72
Pastel on blue paper,
36¼ × 43¾ in. (92 × 111 cm)
Private collection

*I*t seems remarkable that pastel, a uniquely appealing art form, has not been the topic of earlier comprehensive studies. It is fascinating to learn how artists took up these vivid sticks of color and embraced their potential for a distinctive form of artistic expression. The eighteenth century produced some of the most brilliant pastelists, among them Rosalba Carriera, one of the first female painters to achieve European renown; Maurice Quentin de La Tour, a genial autodidact who did portraits of the leading figures of his era; and Jean-Etienne Liotard, a Swiss artist who traveled throughout Europe disguised as a Turkish painter after spending several years in Constantinople. At the end of the century, a handful of women— Marie-Suzanne Giroust-Roslin, Adélaïde Labille-Guiard, and Elisabeth Louise Vigée Le Brun—boldly stormed the gates of the Académie Royale de Peinture et de Sculpture. To this list of luminaries we should add many other talented artists who played decisive roles in their own countries, including George Knapton, Arthur Pond, Francis Cotes, and John Russell in England, and Anton Raphael Mengs and Johann Heinrich Schröder in Germany. Pastel fell into neglect in the late eighteenth and early nineteenth centuries but returned to assume a prominent role in the 1830s. Its popularity has continued to this day. Jean-François Millet, Edgar Degas, and Giuseppe De Nittis adopted the medium, as did James Abbott McNeill Whistler, Edouard Manet, Odilon Redon, and innumerable others. These undisputed masters created a renaissance of pastel following its golden age in the eighteenth century. Pastel clearly earned this place of distinction. At the conclusion of a long history, there could be no doubt that pastel rivaled—or equaled—oil painting, and indeed sometimes surpassed it with the striking richness of its colors.

This recognition was not a foregone conclusion. Pastel was initially perceived as an ancillary medium. It was used to execute sketches and add appealing highlights to portrait drawings. In the late seventeenth century, pastel came to be viewed as a distinctive art form in the skilled hands of artists such as Robert Nanteuil and Joseph Vivien. This newly won respect was affirmed when Vivien was accepted as a "pastel painter" in 1701 by the Académie Royale de Peinture et de Sculpture in Paris. In the 1720s, pastel portraits by Rosalba Carriera evoked unprecedented enthusiasm. Her fame extended across Europe, attracting admiration in cities including London, Vienna, and Paris. The king of Poland commissioned a hundred of her pastels. Within a few years' time, Maurice Quentin de La Tour's work was also highly esteemed. Pastel presented a welcome alternative to traditional oil painting and was frequently less expensive. The uncontested masters of the genre were able to turn the implicit hierarchy of techniques to their advantage, although the medium was still generally regarded as inferior to oils. The remarkable success of pastel beginning in the 1740s had its negative aspects, however. This now-fashionable technique attracted many less gifted artists who harmed the image of pastel, giving it an undeserved reputation for facileness. Once she managed to breach the walls of the Académie Royale with her pastel works, Adélaïde Labille-Guiard, the queen of techniques, increasingly devoted herself to oil painting to distinguish herself from the ranks of mediocre pastelists. The notion of a hierarchy of techniques was revived with the rise of neoclassicism and continued throughout the nineteenth century. The demand for recognition led to the establishment of several pastelist societies between 1880 and 1900 in New York, Paris, London, and Brussels. The efforts of these associations had a significant impact, and the endorsement of modern artists, including Degas, Whistler, and Manet, assured continuing respect for the medium of pastel.

Studying these pages, the reader will certainly be intrigued by "this volatile medium that lends itself to happy discoveries, a palette of a thousand shades holding the secret of unanticipated possibilities and the delight of unexpected tonalities" (Charles Yriarte, 1892). There is a gulf between the muted, subdued, even bland colors called to mind by the word *pastel* in common speech and the vivid, dazzling, saturated tones of the works reproduced here. There are no insipid colors in works signed by Mary Cassatt, Albert Besnard, and Jules Chéret. Instead, we see vigorous hatching and forceful application that heighten the colors and express the artists' inspired energy. The impact and power of these works—including the traditional genre of portraits—belie the widespread perception that pastel is an overly refined, outdated art form with blurry effects and dull colors. Edvard Munch was wise in his selection of pastel for his second version of *The Scream* in 1895. He could not have chosen a technique better suited to expressing his anguish. This volume will surely do full justice to a demanding medium that has inspired some of the greatest masters in the history of art.

OPPOSITE
Lucien Lévy-Dhurmer
Clouds over the Sea, c. 1925
Pastel on beige paper,
28¾ × 20½ in. (73 × 52 cm)
Musée d'Orsay, Paris

SPREAD OVERLEAF
Maurice Quentin
de La Tour
Head of a Young Girl (detail)
Pastel on paper, 9½ × 12⅝ in.
(24 × 32 cm)
Musée Antoine Lécuyer,
Saint-Quentin, France

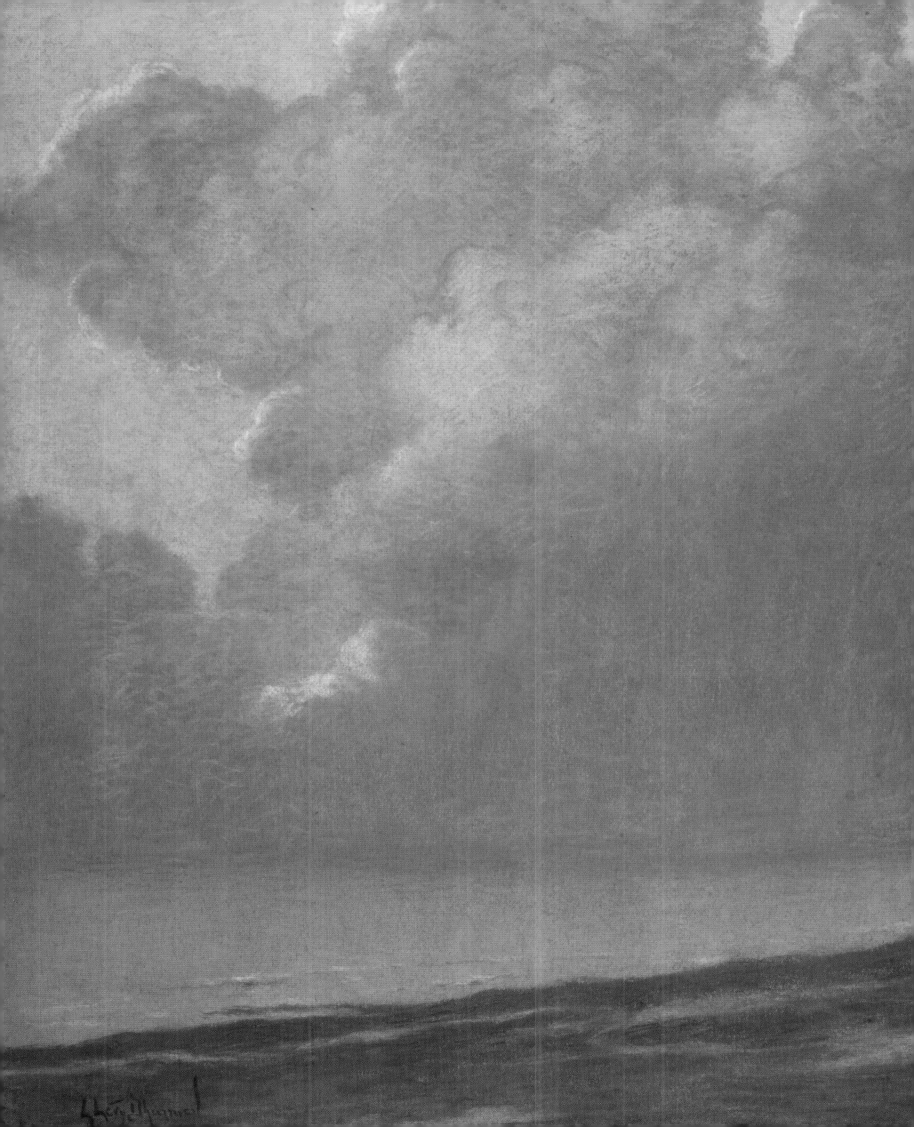

ORIGINS OF THE GOLDEN AGE

*The Invention of an Art,
Sixteenth to Eighteenth Centuries*

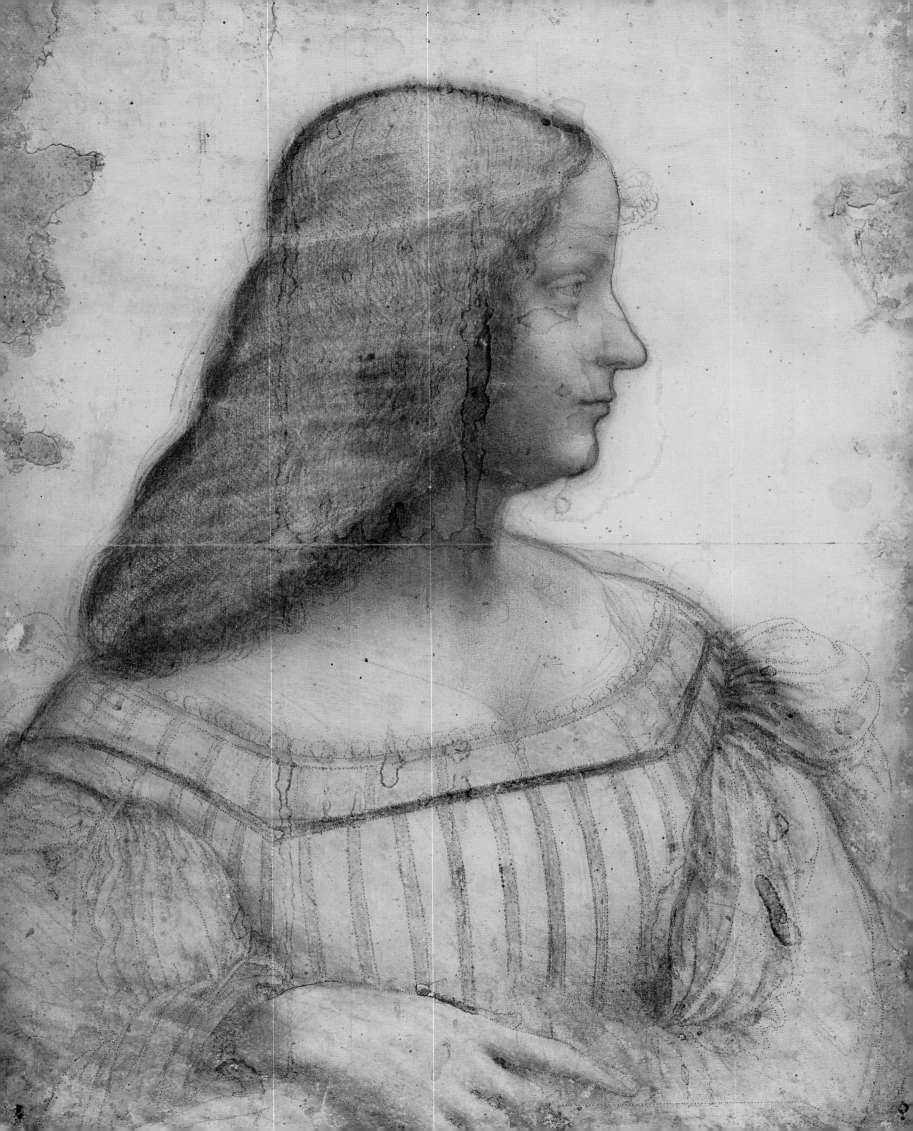

1.

A Fashion for Independent Chalk Drawing in Italy and France

Simon Vouet
Jeanne-Angélique Vouet, c. 1635
Colored chalk on beige paper,
10⅞ × 8⅜ in. (27.6 × 21.2 cm)
Musée du Louvre, Paris

OPPOSITE
Leonardo da Vinci
Portrait of Isabella d'Este,
1499–1500
Colored chalk on white
paper, 24⅞ × 18⅛ in.
(63 × 46 cm)
Musée du Louvre, Paris

ITALY, SIXTEENTH CENTURY

*L*eonardo da Vinci (1452–1519) was among the first early modern European artists to select friable drawing materials—charcoal and black and red chalks— to work out color and graded effects of light and atmosphere in images made preparatory to paintings.[1] Although Giovanni Paolo Lomazzo's treatise *Trattato dell'arte della pittura scultura et architettura* (1584) and Leonardo's own notes refer to "pastelli," the only extant drawing incorporating red, black, and yellow chalks traditionally attributed to him is the presentation drawing *Portrait of Isabella d'Este* (1499).[2] Masterful lifelike large-scale heads in colored chalks by Leonardo's Milanese pupil Giovanni Antonio Boltraffio (1467–1516) and Lombard followers Bernardino Luini and Andrea Solario demonstrate their interest in the painterly potential of Leonardo's innovation; some heads are fully finished and were perhaps conceived as independent works as well as preliminary designs.[3]

The friable colors in these drawings were likely natural chalks, clay-based minerals mined from the earth in cohesive lumps and used for drawing after minor shaping. The historical availability and use of black, white, red, yellow, brown, and blue natural chalks have been well documented in the art technical literature.[4] For colors not found in nature, it was relatively easy for artists or their assistants to fabricate individual pigment sticks from studio materials. Without undertaking scientific analysis to identify the presence of added fillers and binders and thus a fabricated stick, it is impossible to distinguish with certainty between natural or fabricated chalk in drawings of this period.

The practice of drawing with natural and fabricated dry pigment sticks appeared in other centers beyond Lombardy. Jacopo Bassano (c. 1510–1592), a successful painter from the Venetian provinces, was praised by the art biographer and painter

13

Jacopo Bassano
*Christ Driving the Money
Changers from the Temple,*
c. 1570
Colored chalk on blue paper,
16½ × 20⅞ in. (41.8 × 53.1 cm)
The J. Paul Getty Museum,
Los Angeles

OPPOSITE
Giovanni Antonio Boltraffio
Study for Saint Barbara,
c. 1502
Colored chalk on paper,
21 × 16 in. (53.3 × 40.5 cm)
Biblioteca Ambrosiana,
Milan

Carlo Ridolfi for his original and powerful newly naturalistic style in a 1648 biography.[5] Bassano's extant drawings evince a broad coloristic approach. Figure and head studies in a restricted range of colored chalks on blue paper, both materials used earlier in Venice, survive, as well as a group of six large compositional sketches made circa 1568–69 in strongly colored chalks on blue-green paper; whether they are experimental drawings, preparatory *modelli,* or *ricordi* (mementos) is unknown.[6] Bassano composed his subject in a welter of energetic black chalk lines, forcefully blocking in salient parts of the image with unmodulated colored chalks (most often blue, mauve, red, yellow, and peach); line and color together imply movement and clarify structural space and illumination.

A huge drawing oeuvre survives for Federico Barocci (c. 1535–1612) of Urbino.[7] Remarkably inventive yet meticulous in his approach to design, this painter incorporated more color in drawings than had earlier Italian artists. Beginning in the 1560s, after a sojourn in Rome, he experimented extensively with natural and fabricated colored chalks—black, red, white, peach, ocher, yellow, and rose.[8] Though

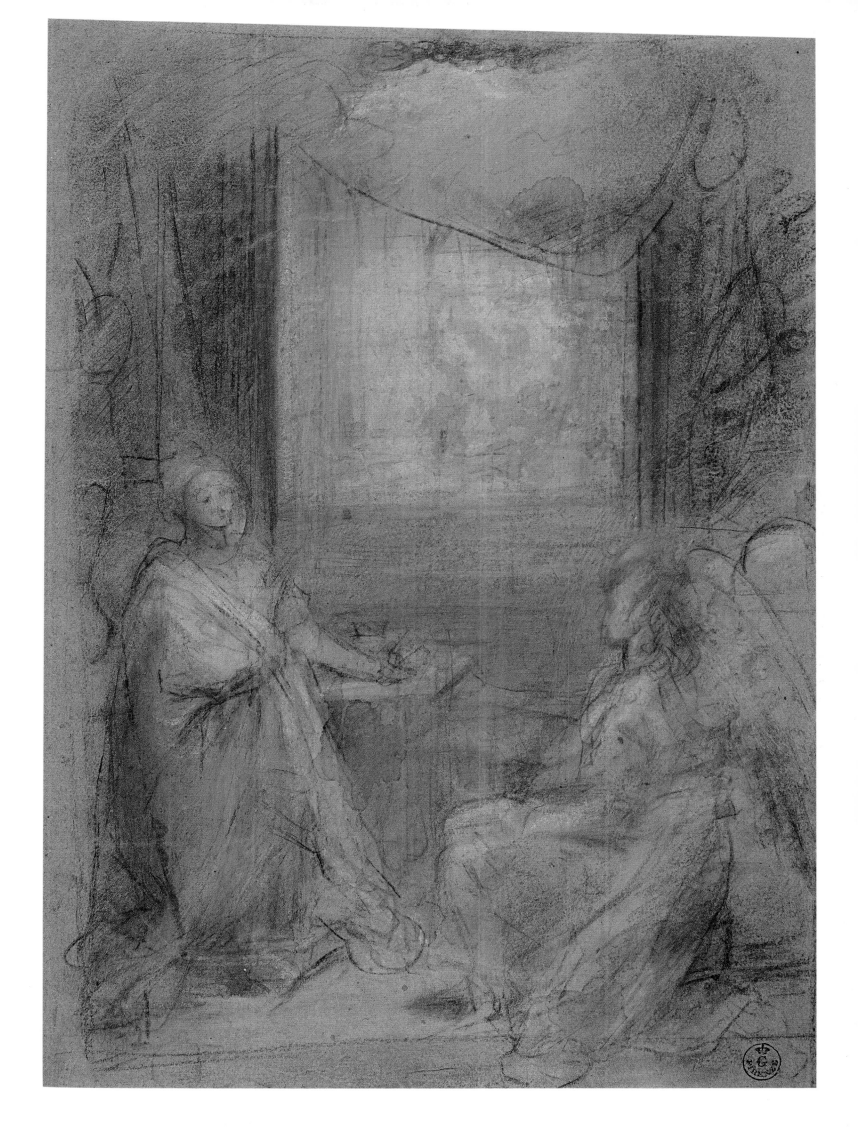

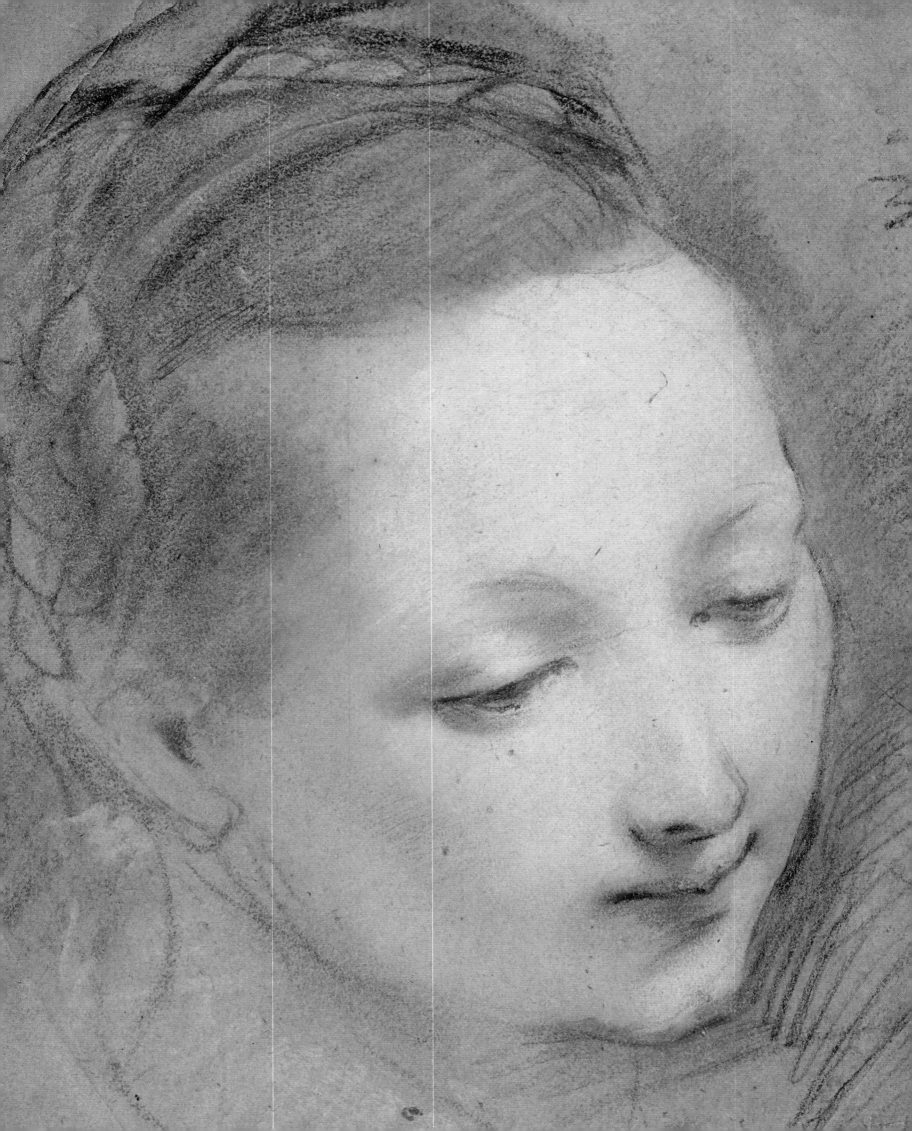

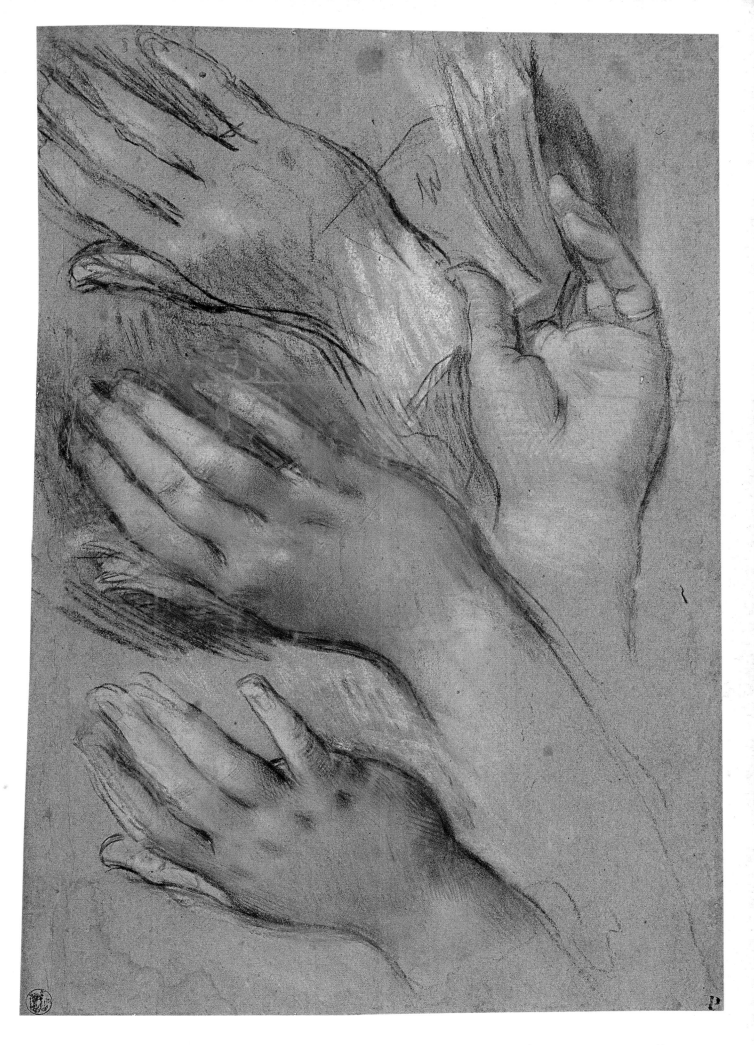

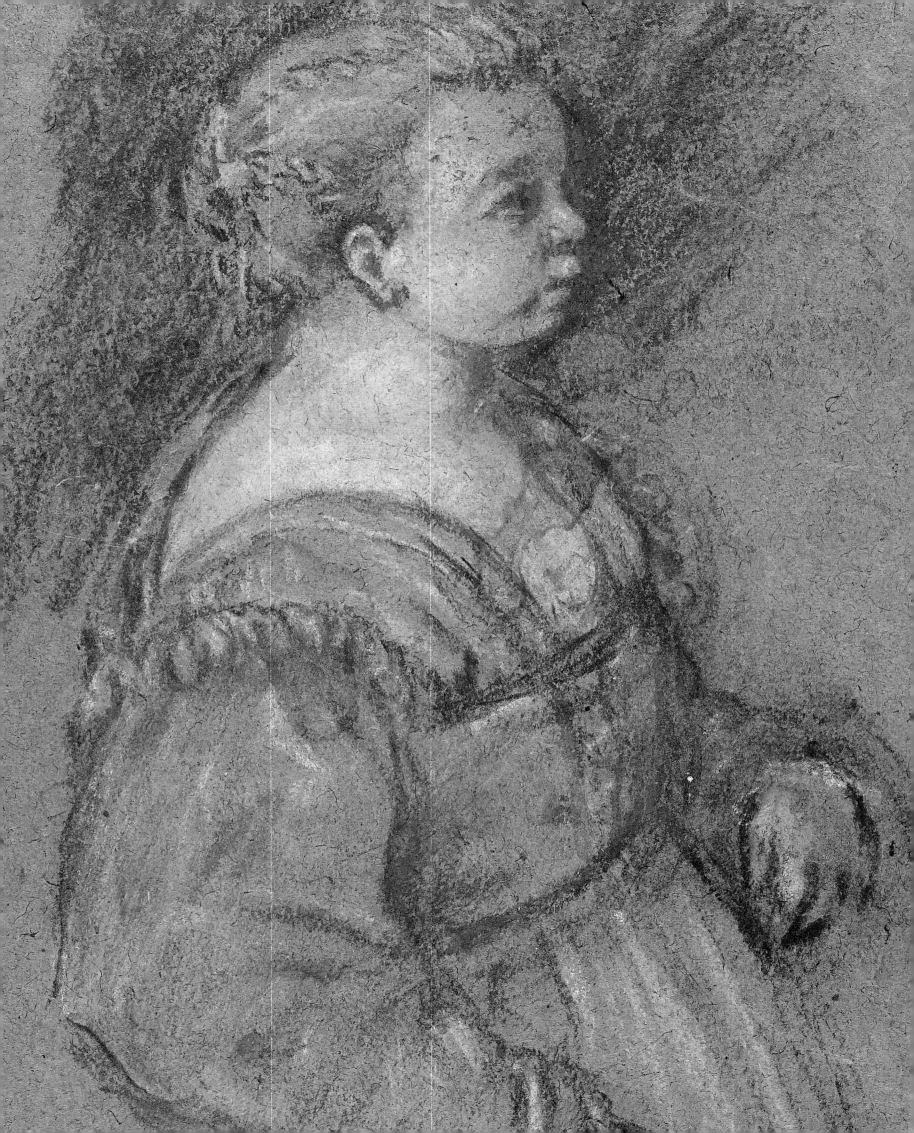

the two artists were active over the same years, no extant evidence connects Barocci's and Bassano's drawing practice. Barocci may have seen chalks in works by Leonardo's followers, by Raphael (1483–1520) or by Timoteo Viti (1469/70–1523), a painter from the Marches.[9] An early biographer, Giovanni Pietro Bellori, claimed on reliable authority that Barocci learned the technique from seeing *pastelli* by Correggio (1489/94–1534), none of which are known today.[10] Pastel was ideal for capturing the *sfumato* of Correggio's frescos in Parma, and Barocci may have seen such copies.[11]

A freely worked colored chalk study in Florence, the only one known to show a full composition entirely in friable materials, was perhaps intended to give Barocci's patron a preliminary view of his design—the distribution of color, light, and shadow and the dynamism of the poses.[12] There was no obvious precedent for his choice of colored chalks on paper, often blue, to explore harmonic color relations in nature, particularly the rendering of flesh tones.[13] The exquisite finished study *Head of the Virgin Mary* corresponds precisely in color, illumination, and expression to Mary's painted head in Barocci's oil painting of the Annunciation. Outlines are drawn in black and red chalk, the face smoothly modeled. Additional colors, softly fused, convey her freshness and modesty, in contrast to swift, strong strokes in the hair and background.[14] Barocci's palette was vibrant and hauntingly beautiful: "The blue . . . of the paper [imitated] the venous colors of flesh over bone or in shadow, turning to pink and yellow where the light strikes the flesh directly."[15]

Barocci's sensitivity to the interactions of color and light and his long drawing and redrawing process resulted in stylistically, expressively, and iconographically unified and spatially resolved paintings that engaged worshipers directly in the emotion of a scene.[16] His works responded to the need of the sixteenth-century Catholic Church, in a period of profound changes, to adapt to new spiritual and material forces by providing the faithful with relevant and accessible Christian imagery.[17]

Colored chalks are found in works by later Italian artists, including Bassano's son, Leandro dal Ponte (1570–1661), Lodovico Cigoli (1559–1613) and his pupils, and Annibale Carracci (1560–1609), who also studied the naturalistic effects of light and color.[18] Colored chalks became an accepted workshop resource for drafting figure and head studies preparatory to paintings.

FRANCE, SIXTEENTH CENTURY

A fashion for drawn portraiture—keenly observed likenesses in colored chalks— appeared in France early in the reign of François I (1515–47). The court artist Jean Clouet (1475/85–1540), a Fleming, established an intimate, collectively somewhat monotonous three-quarter-view format and a way of structuring the face that persisted in the refined and elegant works of his son François (c. 1510–72).[19] The origins of this portrait type, with its delicately toned color and oblique parallel hatching that captured volumes with remarkable plasticity, may point to the impact of the practices of Leonardo, who arrived in France in 1516.[20] Some Clouet drawings were rough studies for paintings, but *Portrait of Léonore de Sapata* and many others were highly finished and functioned independently—not framed, but kept in boxes or albums of historical interest, featuring the court of the sovereign.[21] A drawn portrait was cheap, quickly executed, easily copied and collected, and, importantly for the still peripatetic Valois court, readily portable.

After François's death other artists, including generations of the Quesnel and Dumonstier families, continued this chalk portrait tradition. None were as gifted as the Clouets, with whom some had studied, or imposed as strong a personality on their works. Yet all were successful, patronized by kings and the elite.[22]

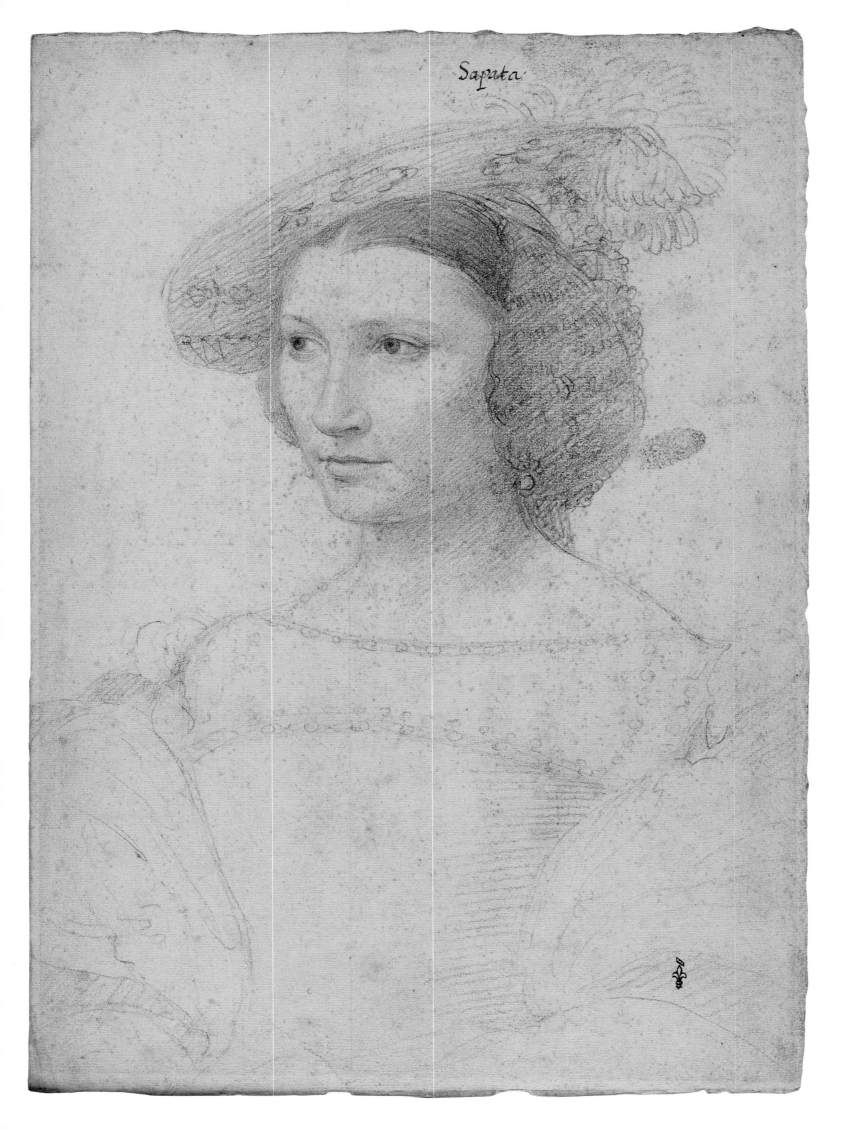
Sapata

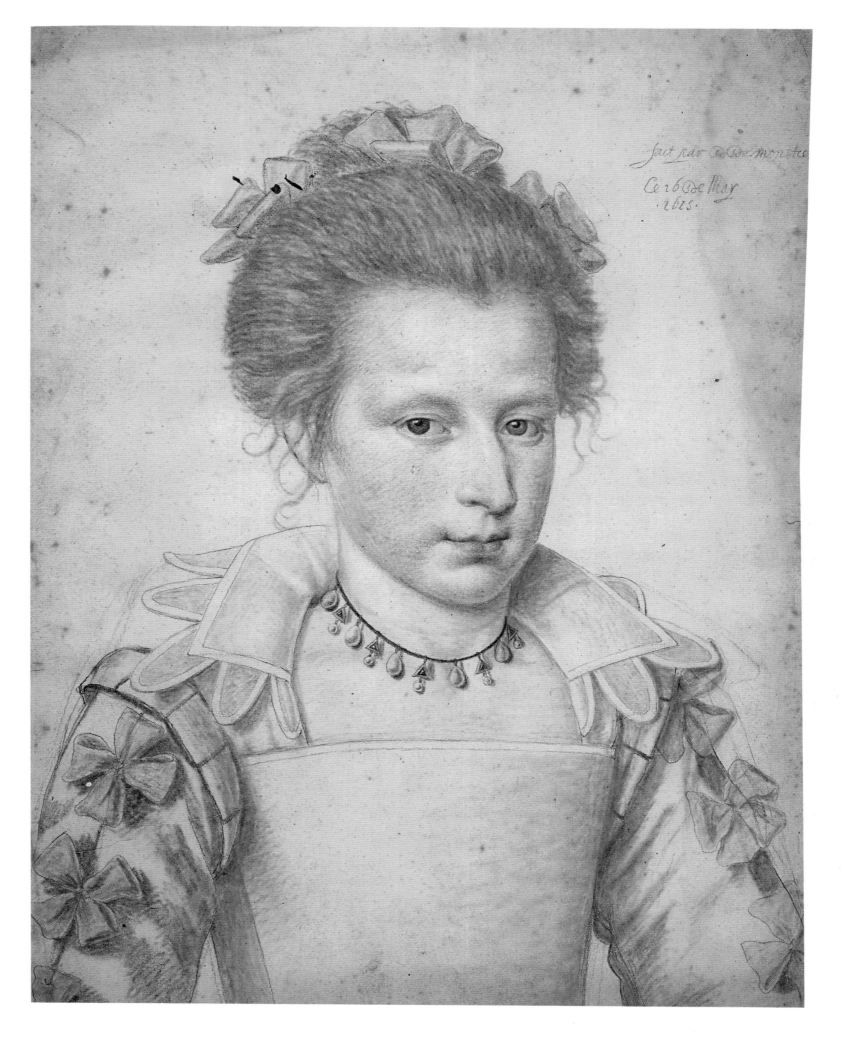

fait par De Monstier
Ce 16 De May
1615.

23

For centuries portraiture served the cult practices of the church, and the state exploited it "to make great men immortal by leaving their image to posterity."[23] The phenomenon of the portrait series continued a long tradition of portraying great men that, since Greco-Roman antiquity, responded to an innate need to represent historical personages who belonged to the European cultural heritage.

As the sixteenth century progressed, this focus waned, and the aristocratic clientele of the third-generation Dumonstier portraitist Daniel (1574–1645) adopted the format to affirm its superior social status.[24] In three-quarter-face portrait busts Daniel sought to associate reality and representation while satisfying court taste. He enlarged and elaborated the portrait and broadened the use of color.[25] Whereas Jean Clouet noted costumes summarily, Daniel's were often detailed and decorative, conveying his sitters' status. Unfinished portraits reveal that he traced contour and features first, giving life to the face, then added the hair and tinted the cheeks with sanguine; he added further color, stumping, and finishing touches later in the absence of the model.[26]

ITALY AND FRANCE, EARLY SEVENTEENTH CENTURY

Economic pressures tied to a rising urban population reshaped the practice of art by 1600, when Ottavio Leoni (1578–1630) became the leading portraitist in Rome. Artists were numerous, their labor often cheap, opportunities erratic, and competition intense. Art production was characterized by speed of execution; earlier, more painstaking methods were no longer profitable.[27] Ottavio was trained by his father, Ludovico Leoni (1531–1606), and adopted the latter's practice of drawing portraits *alla macchia*; that is, rapidly and directly from life in one sitting, so as to capture a lively and psychologically penetrating likeness.[28] The painter and art historian Giovanni Baglione (1566–1643) praised Ottavio Leoni's portraits more for their extreme fidelity (*similissimi*) than for idealizing and enhancing beauty.[29] Their immediacy and naturalism corresponded with the new naturalism favored in Caravaggio's Rome.[30] Leoni, a favorite of the aristocracy, was sought after and well paid; he also portrayed artists, men of letters, and ordinary citizens.[31]

Leoni left a vast repertory of drawings, called *pastelli* in contemporary inventories but properly referred to today as chalk drawings. Since many of his paintings are lost, it is unknown to what extent they were preparatory to paintings.[32] A few were autograph *ricordi*; others were the basis of prints.[33] Often they were executed in black chalk heightened with white on rather coarse blue paper.[34] At other times they were drawn *à trois crayons*, in natural black, white, and red chalks. For his *Portrait of a Lady* he may have used a fabricated stick to capture the sitter's stunning red-orange hair. Leoni's drawn oeuvre has been dismissed by commentators as formulaic in conception. But his material choices evolved over time: first he worked with black chalk on whitish paper, then added white chalk heightening on a whitish paper washed with blue on the image side, then used a paper made from blue rags. This and his adoption of natural red and other colored (probably fabricated) chalks suggest that the artist continued to experiment with color, volume, and light effects to achieve likeness and animation in his portrait heads, which were often accorded the same dignity as paintings and valued as finished works.[35] Contemporary inventories record that Leoni's chalk portraits were framed, glazed, and hung on the wall.

Naturalistic portraiture in red and black chalks was popularized earlier in Florence by Ottavio Leoni's friend, the superb draftsman Federico Zuccaro (c. 1541–1609).[36] Zuccaro too applied black and white chalks to paper to define soft volumes and capture the lighting of the face, and red chalk to approximate flesh tones and

OPPOSITE
Ottavio Leoni
Portrait of a Lady, 1623
Colored chalk on blue paper,
9 × 6¼ in. (22.8 × 16 cm)
National Gallery of Art,
Washington, DC

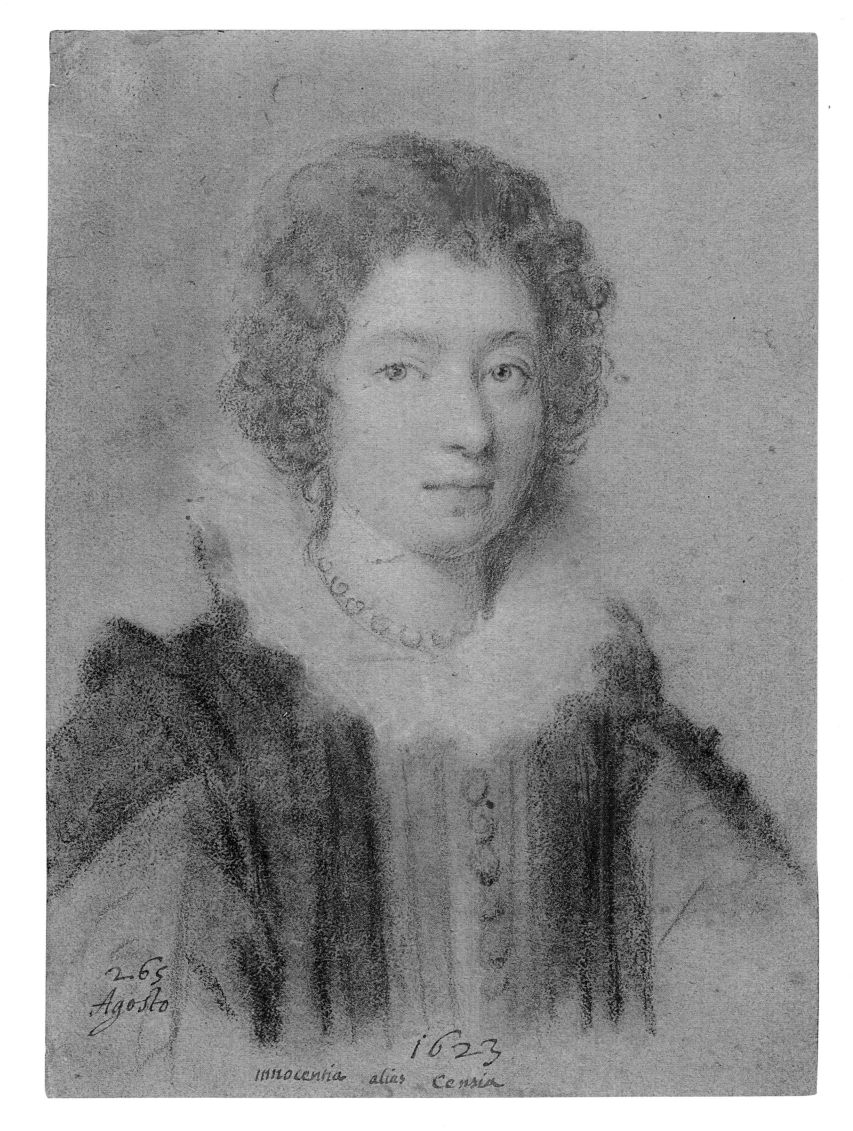

innocentia alias Censia

265
Agosto

1623

enhance lifelikeness, concentrating attention on the face and sketching costumes cursorily. Like Leoni's, Zuccaro's drawings are difficult to link to his paintings.

By the late sixteenth century, many foreign painters established themselves in Rome, where no corporation controlled painting. Leoni's renewal of the drawn colored chalk portrait influenced Simon Vouet (1590–1649) and his student Claude Mellan (1598–1688), French painters resident there.[37] In 1627 Vouet returned to Paris, where he continued to make colored chalk portraits affected by Leoni's heightened psychological realism.[38] Daniel Dumonstier never traveled to Italy but his son Nicolas visited Rome about 1630 and, while continuing the family tradition, began to incorporate into his portraits the new fashion for quick execution, freer drawing, and animated poses with gesturing hands.[39] Such seventeenth-century drawings represented an alternative to fully colored images and were made by many painters, including Velázquez.

2.

The Early Market for Painting in Pastel and Its Place in the Académie Royale

Joseph Vivien
Self-Portrait, 1730
Pastel on paper,
31½ × 25¼ in. (80 × 64.2 cm)
Alte Pinakothek, Bayerische
Staatsgemäldesammlungen,
Munich

Pastel painting, as opposed to drawing in natural and fabricated colored chalks, emerged as a new artistic practice by the mid-seventeenth century. This did not occur by chance but because economic, social, and aesthetic expectations of artists and public in an increasingly competitive market led to changes in practice, a growth in the demand for sets of colored sticks, and shifts in manufacturing and marketing practices. The rise of an amateur market for artists' materials and the growing enthusiasm of elite and, increasingly, middle-class society for portrait paintings provided the context for the increasing production of fabricated chalks in purpose-made sets. The seemingly innumerable formulae, the juggling of fillers and binders, and the knowledge and skill required, plus an element of unpredictability, must have encouraged their production by professional colormen.[1]

These sets of fabricated sticks are called pastels; pastels differ in function and use, though not necessarily in composition, from fabricated chalks. Their attraction to artists, professional and amateur, was that each pastel stick was carefully formulated to achieve a predictable consistency, so that all the sticks in a set could be handled confidently to create a visually unified, fully colored, and, if desired, highly finished image. Perhaps it was the availability of better materials that led the Fleming Wallerant Vaillant (1623–1677) and the Frenchman Robert Nanteuil to begin to use this medium in Paris at the same time.[2] Pastel portraiture became popular in part because it could compete visually with oil painting but was easier to master and cheaper, cleaner, and quicker to produce.[3]

ROBERT NANTEUIL (c. 1623–1678)

The art of Robert Nanteuil centered on the production of engraved portraits after his own drawings. He made these preparatory drawings ad vivum in *mine de plomb* (lead pencil), metalpoint, and pen and ink. The earliest works to survive are on parchment, and date from 1647–50.[4] In them he achieved subtle light effects and precise detail, ideal for the engraver to transcribe and reminiscent of contemporary Flemish and Dutch art.

Nanteuil's pastels date from the 1660s. These were not mere drawings in black chalk selectively touched with colored chalks; rather, the artist reduced black chalk outlines to an underdrawing or omitted them altogether and painted his portrait in full color. Typical of the period and the status of his sitters, the color range was restrained and poses and compositional formats formulaic, reminiscent of earlier French and Italian chalk portraits. Nevertheless his works differed from earlier work technically, materially, functionally, and conceptually. They were effectively paintings, in style and execution as broadly worked and highly finished as oil paintings. Like his colleagues Charles Le Brun and Pierre Simon, Nanteuil achieved fully realistic pastel portrayals based on precise observation and captured the fabrics, textures, and lights associated with oil portraiture.

Nanteuil's pastels were made preparatory to large engraved portraits of the

OPPOSITE
Robert Nanteuil
Self-Portrait, c. 1669
Pastel on paper,
20½ × 16¹/₁₈ in. (52 × 41 cm)
Galleria degli Uffizi,
Florence

Robert Nanteuil
Portrait of Madame de Sévigné, c. 1670
Pastel on paper,
20½ × 16⅞ in. (52 × 42.8 cm)
Musée Carnavalet, Paris

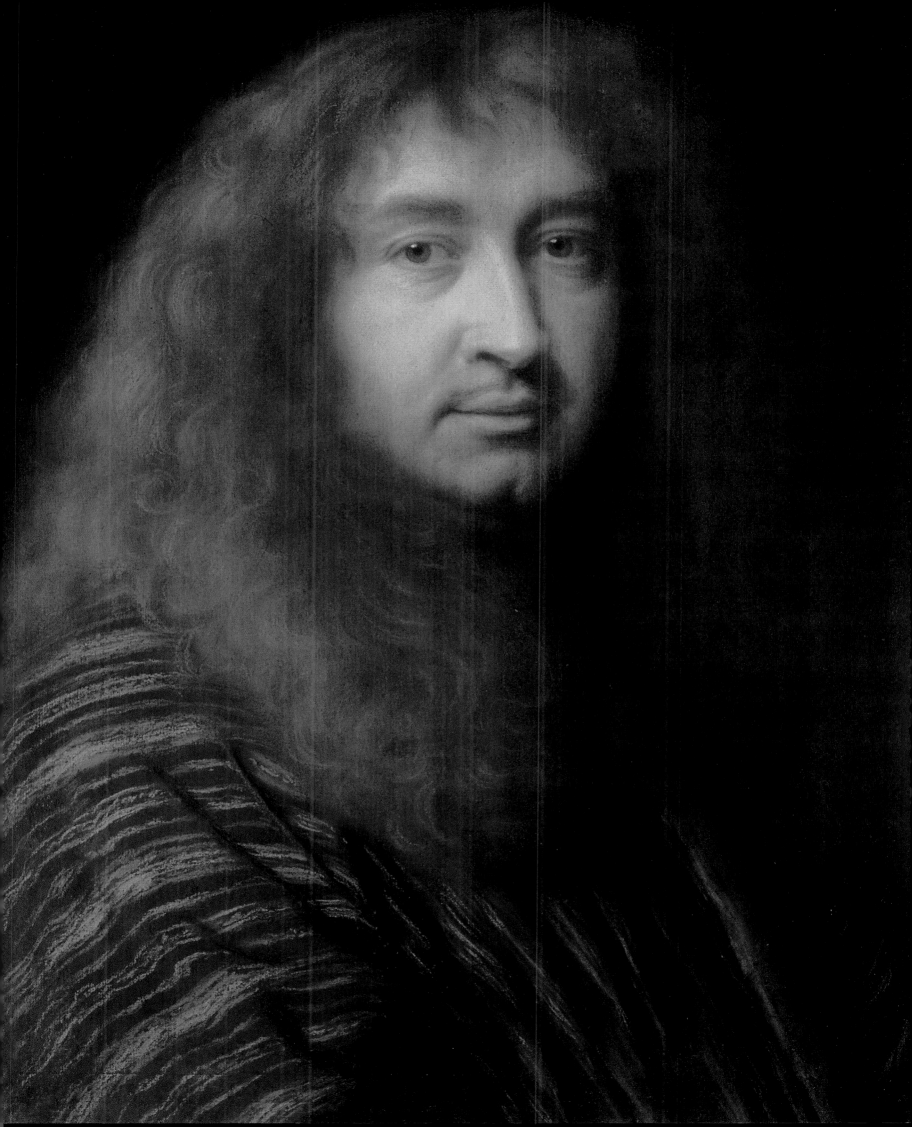

dedicatees of academic theses publically defended by candidates for degrees at French universities; printed beneath the portraits were Latin summaries of the theses' headings and conclusions. A less finished monochrome drawing would have provided a satisfactory model for an engraved portrait, but the fully painted pastel portraits were also displayed prominently during the ceremonial defense.[5]

The Florentine painter Domenico Tempesti (c. 1652–1737) left an eyewitness account of his master's methods and materials. Tempesti's detailed description circa 1678 of Nanteuil's pastel fabrication and the attempts recorded in the 1663 correspondence of Constantijn Huygens (1596–1687) and Christiaan, his son, to discover his practice suggest that fabricating sets of pastels was still a new venture.[6] Nanteuil's *Portrait of Philibert-Emmanuel de Beaumanoir de Lavardin* shows the state of a portrait after one sitting, with the head sketched in black chalk and touched with color.[7] His *Portrait of Dominique de Ligny* (1661) is finished. It is characterized by the utmost simplicity: a neutral unified ground, a neutral pose, a costume reduced to essentials, and a limited range of colors. The sitter's face is keenly observed—the gaze is sharp, the modeling firm. Pastel's painterly qualities have been exploited in the sitter's face; elsewhere the underlying linear structure is clear.

For a time pastel, as a genre, oscillated conceptually between drawing and painting: Nanteuil wrote "pinxit" (he painted it) on engravings made after his portrait pastels, but his official title was *dessinateur et graveur du roi*.[8] In 1681 Filippo Baldinucci compared the colors of *pastelli* with tempera and fresco rather than oil painting.[9] In 1684 Roger de Piles classified pastel as a type of painting that lacked the strength and energy of oil painting.[10] In 1699 Philippe de La Hire called pastels a type of drawing, and André Félibien wrote in 1725, "Very beautiful figures are made with pastels or sticks of different colors that give almost the same effect as painting, but it is not called painting."[11] For Jacques Lacombe in 1753 it was "a painting where the sticks do the work of the brushes."[12] Some confusion has reigned ever since; in the end it is the intentions of pastelists that determine the genre—drawing or painting.

BENEDETTO LUTI (1666–1724)

Luti was a native of Florence, where he studied painting under Anton Domenico Gabbiani.[13] He left in 1690 for Rome. There he was elected to the Accademia di San Luca in 1694, worked for the leading Roman families and the church, and quickly rose to prominence. Luti was a fine colorist, painting oils of religious subjects in the Italian post–Counter-Reformation tradition and in a classicizing style based on his study of works by Raphael, Annibale Carracci, and Domenichino.[14] He was also a dealer, collector, and teacher.

Luti may be best known today for his work in pastel: fresh, graceful single heads and bust-length images of apostles, saints, angels, and children. He fused color and tone, creating even, luminous pictorial surfaces strengthened with discrete black, brown, and white strokes.[15] His pastels recall the sweet, light-filled art of Correggio, which was much in vogue by the eighteenth century. Whether or not they served Luti in a preparatory capacity, he apparently intended both his pastels and his related chalk drawings as independent works of art for elite collectors and for sale in the trade. He made them over an extended period, repeating, with his pupils, stock types with little variation.

Luti's use of pastels originated in Florence, where at the time they were much appreciated. The influence of the French tradition of pastel portraiture had been felt there since 1670, when Cosimo III, the grand duke of Tuscany, visited the Paris studio of Robert Nanteuil and returned with several pastel heads for his personal collection. Cosimo sought to cultivate "modern" artists in Florence and in 1676

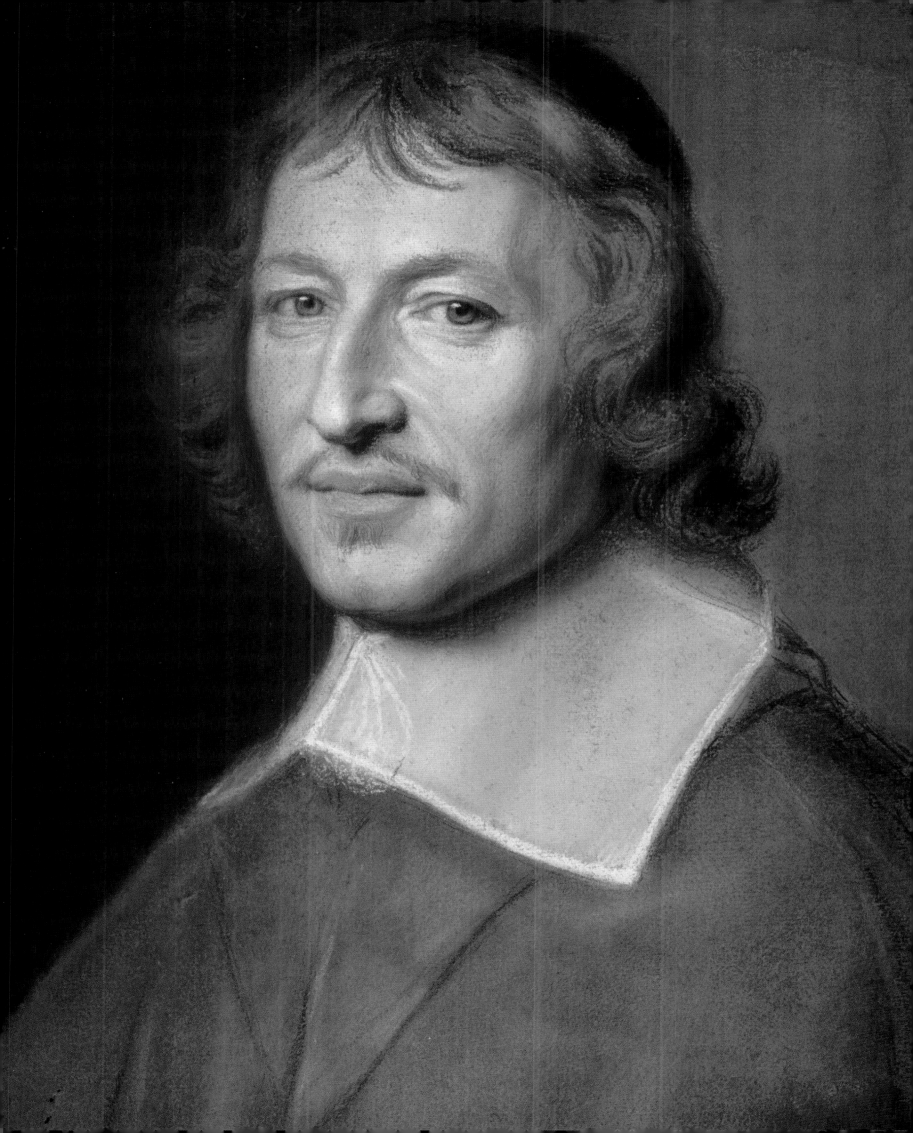

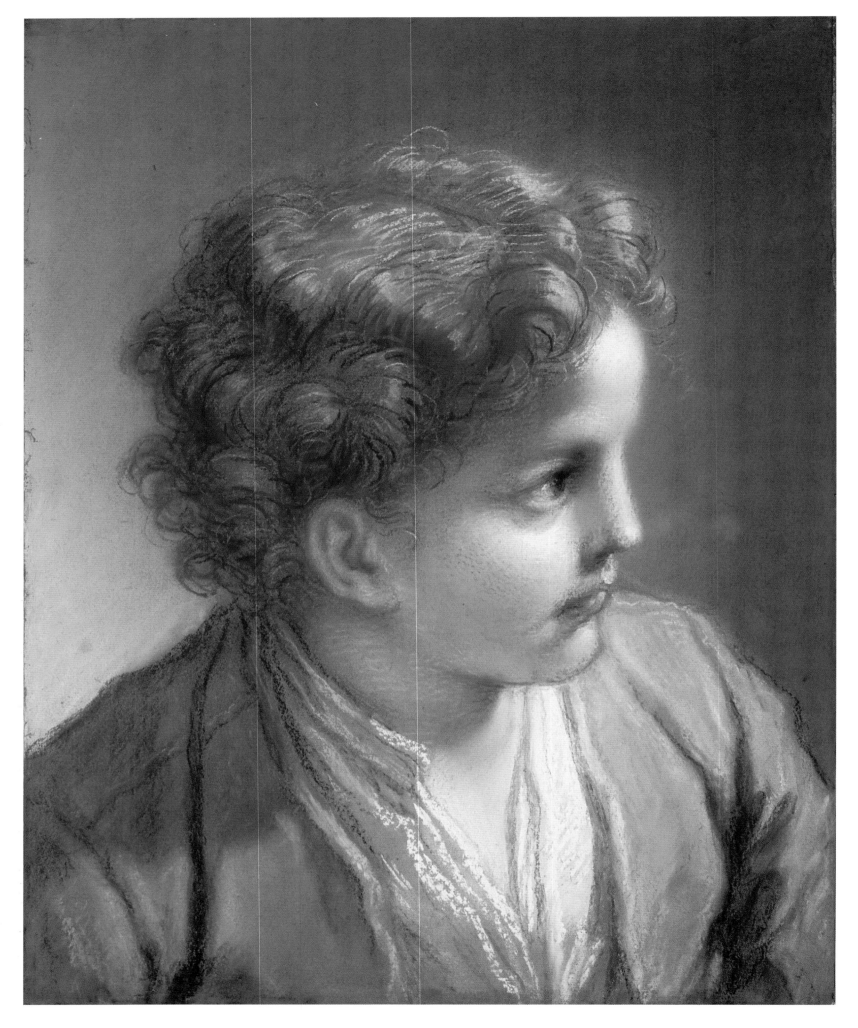

34

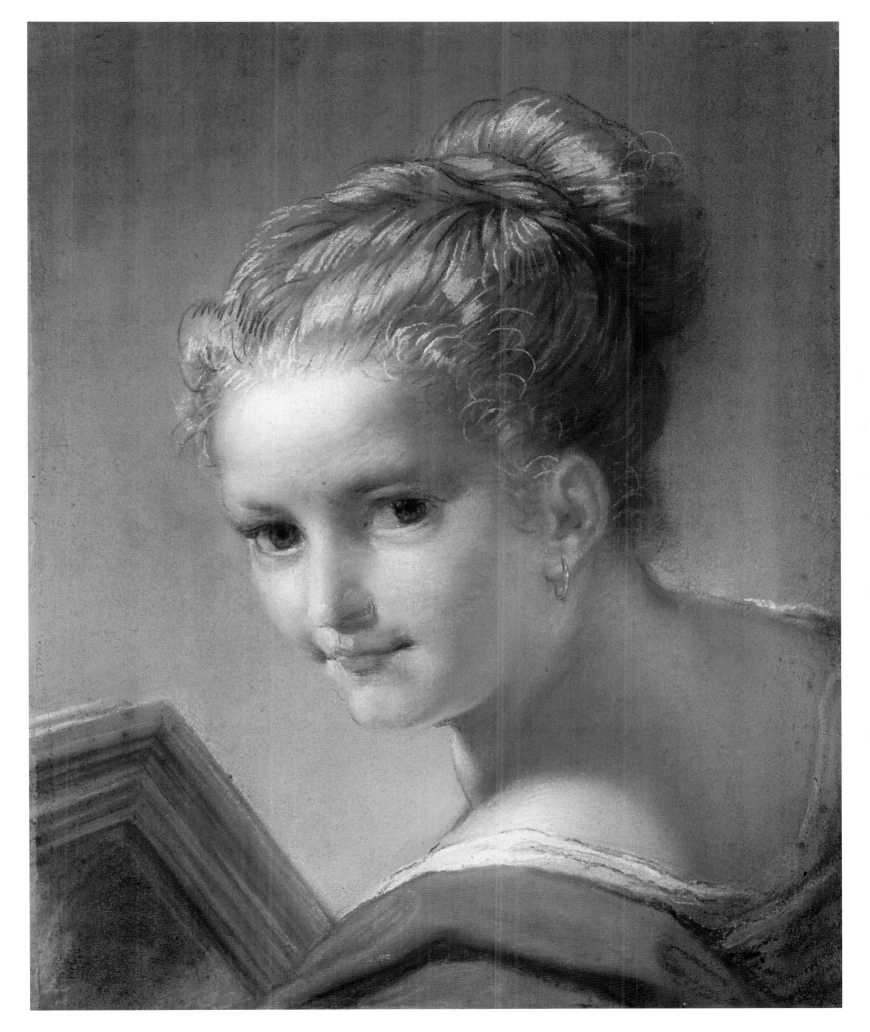

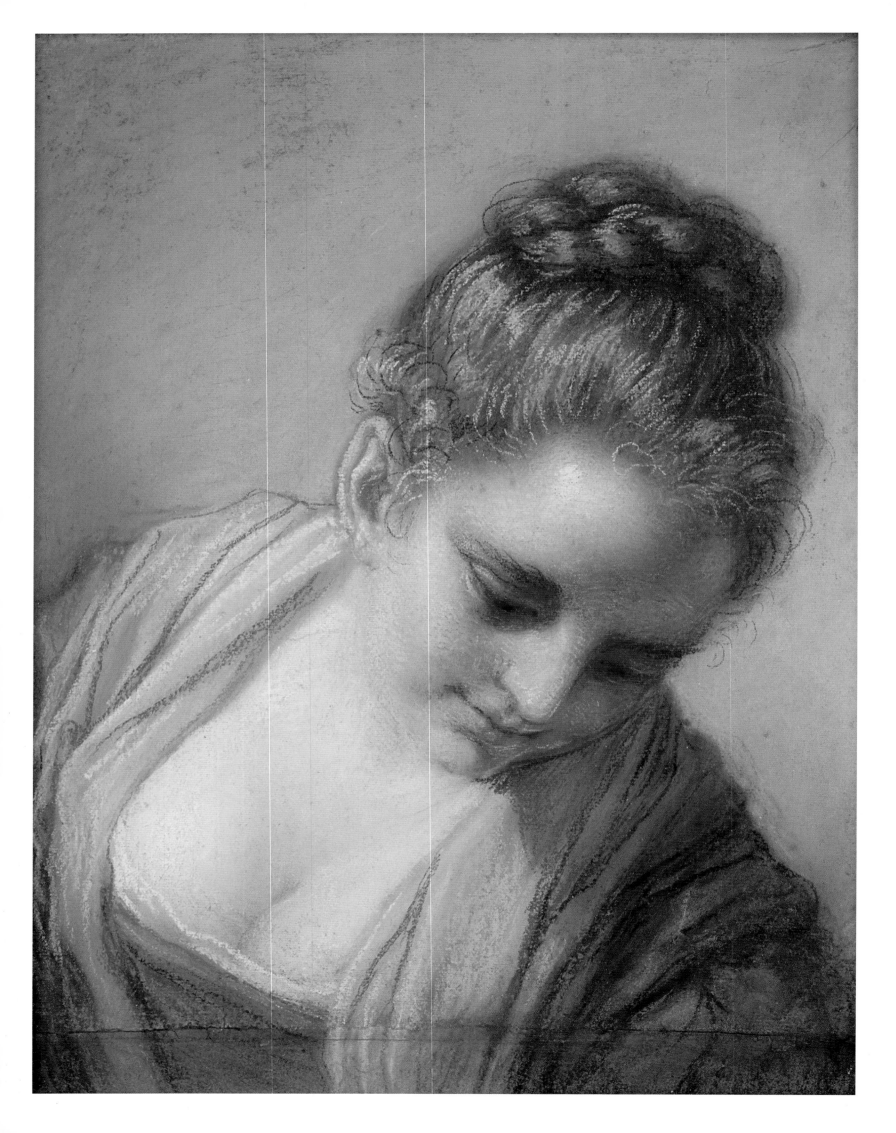

OPPOSITE
Benedetto Luti
Head of a Woman, 1719
Pastel on paper,
16⅛ × 12⅜ in. (41 × 31.5 cm)
Musée Bonnat, Bayonne,
France

sent Domenico Tempesti to Paris to study engraving and pastel under Nanteuil. Tempesti returned in 1679 to Florence, where he resided in the ducal palace, supplying Cosimo with "the most beautiful portraits after nature with pastels" of members of the Medici court and Florentine nobility.[16] He taught the use of pastel to younger artists such as Giovanna Fratellini (1666–1731), a pupil with Luti in Gabbiani's studio in the 1680s. From 1690 to 1702 Tempesti paid a long visit to Rome, where for a time he entered the workshop of Carlo Maratti.[17] Following this, he traveled through Europe, working at numerous courts. He returned to Florence in 1715.

Giovanna Fratellini
Self-Portrait, c. 1720
Pastel on paper,
28⅜ × 22½ in. (72 × 57 cm)
Galleria degli Uffizi,
Florence

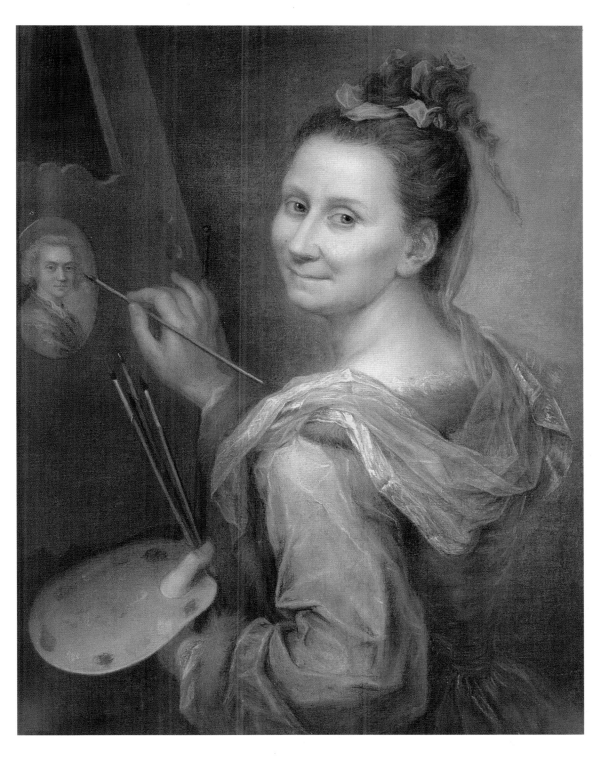

JOSEPH VIVIEN (1657–1734)

The French painter Joseph Vivien was the first to show, at the 1704 Paris Salon, portraits that imitated in pastel the structure, size, format, and stylistic effects of oil paintings. Trained as an oil painter, he was first referred to as a "painter of portraits in pastel" in his application for provisional admission to the Académie Royale (1698), the year of his first extant pastel.[18] He was received as *peintre en pastel* in 1701. (At the academy, the provisional admission preceded the reception.)

Vivien's portraits were executed on large sheets of paper, often pieced; enlarging by piecing was a practical way to increase the size of the paper support beyond the maximum dimensions of a single sheet of contemporary handmade paper. Prior to painting, canvas was tacked to the sides of a rigid wood strainer, a contemporary oil painting practice; then the paper's primary support was pasted out and adhered to the tensioned canvas. This structure offered pastel portraitists several advantages: it provided the strong, taut working surface that artists trained as oil painters were accustomed to and facilitated the handling and subsequent framing of large pastels with powdery unfixed surfaces. Vivien worked directly on this primary support, first sketching preparatory outlines and color blocks, as seen in the image supported on the easel in his *Self-Portrait at the Easel* now in Schleissheim.[19] Next Vivien applied pastel to the sketch, blending it with his fingers or a paper or leather stump to create velvety expanses and seamless transitions. His smooth, polished surfaces obliterated strokes and presented a highly finished surface, free of physical distraction, typical of contemporary oil paintings.

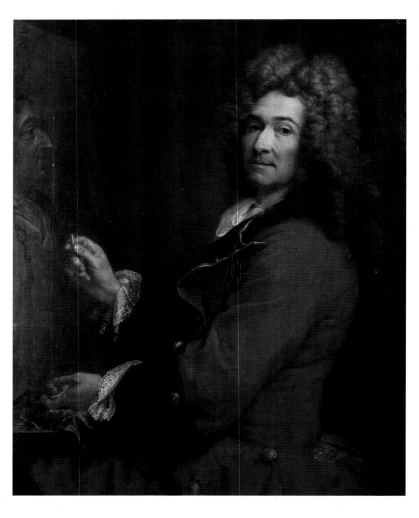

Joseph Vivien
Self-Portrait at the Easel
Oil on canvas, 46¼ × 37⅛ in.
(117.5 × 94.3 cm)
Staatsgalerie Schleissheim,
Bayerische
Staatsgemäldesammlungen,
Schleissheim, Germany

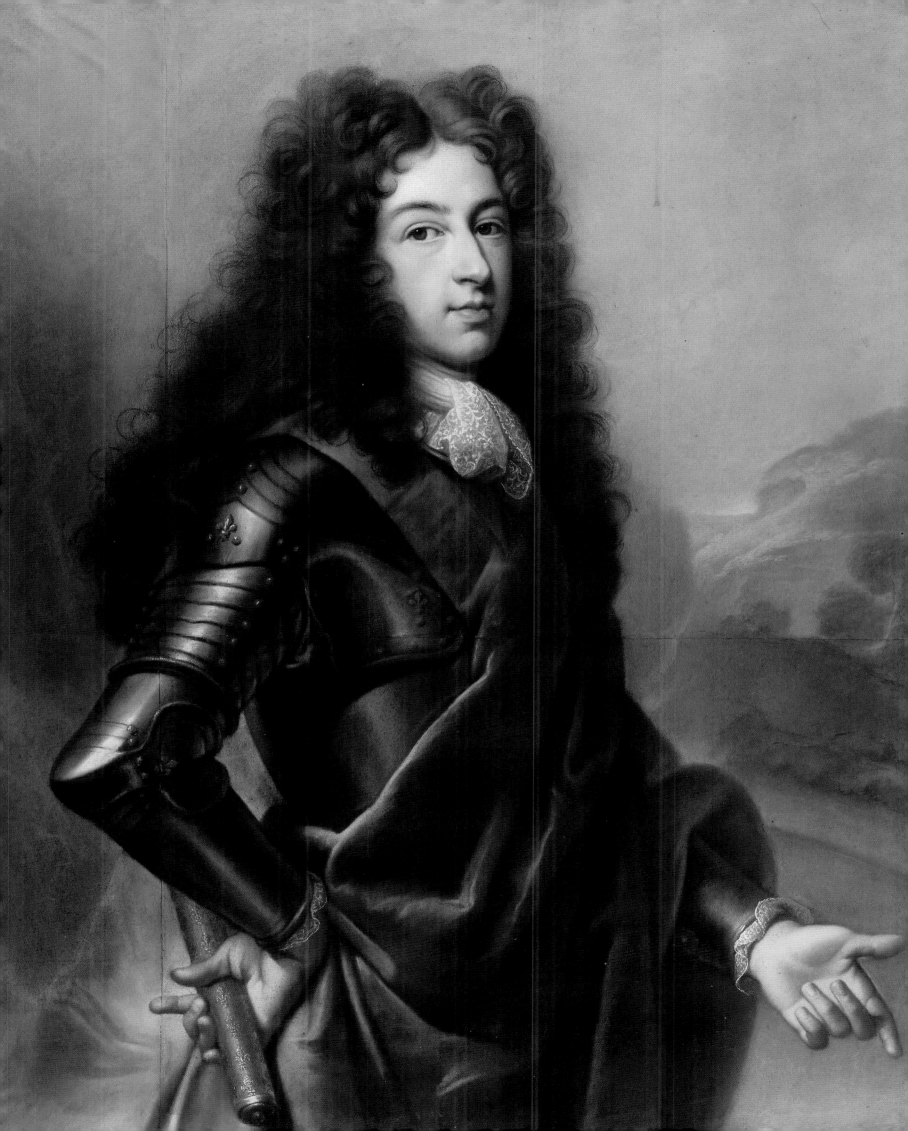

That there is no surviving documentation for Vivien's fabrication or purchase of pastel sets suggests that obtaining a set may have presented no special problems late in the century. By the years 1670–80, changes in the paintings market led to the appearance of a small group of specialized merchant-painters in Paris and elsewhere. Earlier, painters had obtained their supplies directly "from grocers for colors [and] from drapers or linen sellers for canvases."[20] Paper was obtained from stationers until specialized artists' papers were developed in the nineteenth century.

Oil painting was the focus of Vivien's early training and production. He turned for a time to pastel as a way to make a name for himself in the novel but increasingly popular technique in a highly competitive market already dominated by Nicolas de Largillière, Hyacinthe Rigaud, and other talented oil portraitists. Contemporaries found distinctive Vivien's use of pastel for works normally painted in oil: "His talent . . . is for portraiture; . . . in order to set himself apart, he paints in pastel; a style of painting that has more brilliance than painting in oil."[21] By 1710 Vivien had established a solid reputation and returned increasingly to oil painting. From the late seventeenth century, portraiture at the German courts was increasingly influenced by France, and for much of his life Vivien served as court painter to the Bavarian elector, Maximilien II Emmanuel, and the Wittelsbach court.[22]

OPPOSITE
Joseph Vivien
Portrait of a Woman
Pastel on paper, glued to canvas, 31⅞ × 25⅜ in. (80.9 × 64.5 cm),
Musée des Beaux-Arts, Lyon

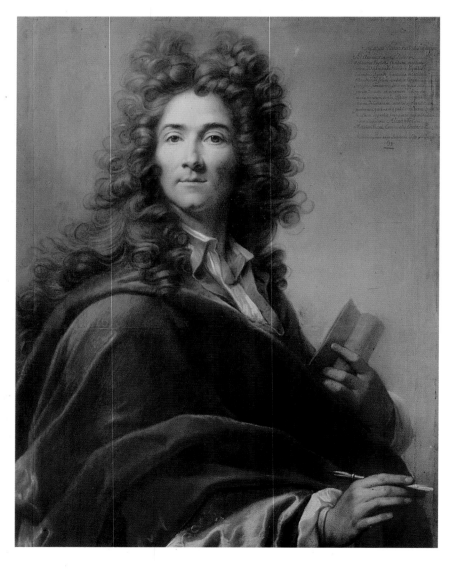

Joseph Vivien
Self-Portrait, 1699
Pastel on paper, 38⅞ × 29⅛ in. (98.8 × 74 cm)
Galleria degli Uffizi, Florence

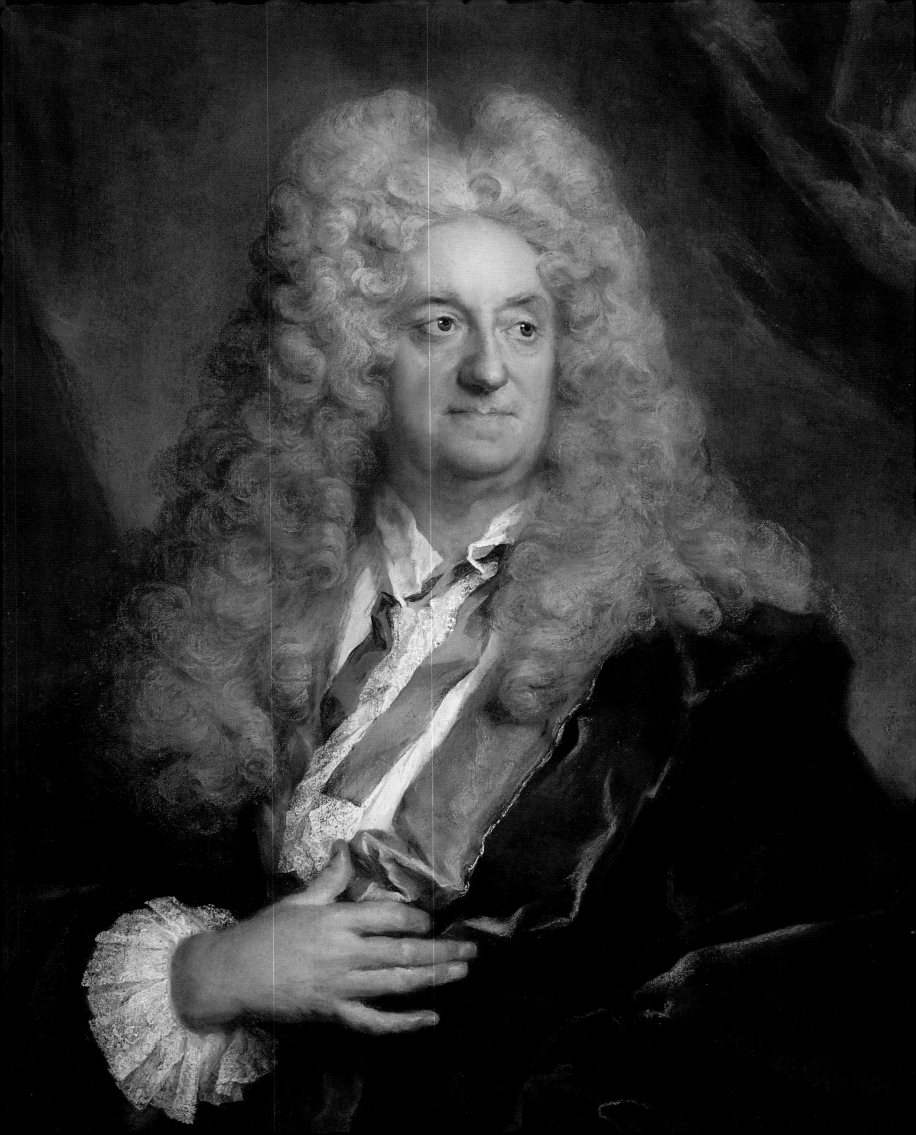

THE INITIAL STATUS OF PASTEL PAINTING IN THE ACADÉMIE ROYALE

The Académie Royale de Peinture et de Sculpture was a professional association founded in 1648 as a challenge to the hegemony of the painters' guild, the *maîtrise*. By the 1660s it had claimed for its members on the basis of antique precedents an intellectual mastery reserved hitherto for the liberal arts. At the same time it devalued execution and technique, the "mechanical" aspects of painting, though not entirely.[23] It is often said that pastel was officially recognized in 1665 when the painter Nicolas Dumonstier (1612–1667) was received by the Académie Royale as *peintre en pastel*. His reception piece, in fact, was identified in academy records only as "en pastelz," not as a portrait, and he was charged to make, in addition, a portrait of the painter Charles Errard in an unspecified technique.[24]

The earliest statutes of the Académie Royale did not distinguish between different modes and genres of painting; all painters had equal access to academic honors.[25] By 1654–55 the academy was well supported by the monarch and assumed a central place in French artistic life until its abolition in 1793.[26] In 1664 new statutes were drafted under Jean-Baptiste Colbert, Louis XIV's minister of finance, aimed at consolidating the academy's theoretical canons. They confirmed the superiority of oil painting and the hierarchy of genres; history painting, with its heroic text-based subjects featuring the human figure, particularly the nude male, was prized most highly, followed by portraiture, animal images, and lastly, lowly landscapes and still lifes.[27] The perceived nobility and difficulty of the subject determined market value.[28] The academy's highest positions—professor, director, rector—were now reserved for history painters. In 1666 the French Academy in Rome was created to expose outstanding students of history painting to the achievements of antiquity and the Renaissance.

Over its first decades the academy moved from promoting teachable scientific rules of art (such as perspective) to espousing the concept of an unteachable poetic genius comprising taste and judgment to consolidate the elite status of academic artists.[29] The less prestigious position of portraiture in the academic hierarchy contrasted with its place in the real life of painting; great numbers of portraits, increasingly in pastel, were exhibited at the Salon.[30]

3.

Rosalba Carriera and
"The Game of Appearances"

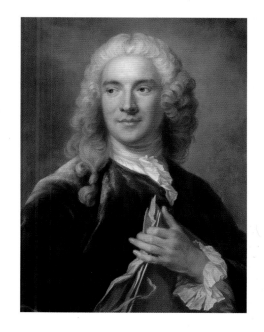

Gustaf Lundberg
Portrait of Charles Natoire, half-length, 1741
Pastel on paper, 25⅝ × 19⅝ in. (65 × 50 cm)
Musée du Louvre, Paris

ROSALBA CARRIERA (1673–1757)

SPREAD OVERLEAF

Rosalba Carriera
*Gustavus Hamilton (1710–1746),
Second Viscount Boyne, in
Masquerade Costume,* 1730–31
Pastel and paint on paper,
glued to canvas, 22¼ × 16⅞ in.
(56.5 × 42.9 cm)
The Metropolitan Museum
of Art, New York

LEFT
Rosalba Carriera
*Portrait of the Dancer Barbara
Campanini,* 1739
Pastel on blue paper, glued to
canvas, 22¼ × 18¼ in.
(56.5 × 46.5 cm)
Gemäldegalerie Alte Meister,
Staatliche Kunstsammlungen,
Dresden, Germany

RIGHT
Rosalba Carriera
Young Woman with a Parrot, c. 1730
Pastel on blue paper, 23⅝ × 19⅝ in.
(60 × 50 cm)
The Art Institute of Chicago

*L*ittle is known of Carriera's early life, training, and work. Various artists have been suggested as her teachers, but conclusive visual and textual documentation is lacking. Ursula Mehler has recently constructed a convincing though hypothetical outline of her early years.[1] In 1700 the painter began to preserve her writings. These show that although dedicated to portraiture, she was familiar with the art of the past and possessed a broad pictorial culture through her friendships with the Venetian connoisseur Anton Maria Zanetti and the French collectors Pierre Crozat and Pierre-Jean Mariette, as well as through visiting collections and studying masterpieces.[2]

Bernardina Sani has described how Carriera collected ideas from other painters, not merely copying their works but adapting their compositions for her purposes. Sani is constructing a framework of Carriera's interest in Italian Renaissance masters such as Correggio and Titian, as well as Emilian artists like Guido Reni, Guido Cagnacci, Guercino, and Giuseppe Maria Crespi, whose works she saw in Venetian and Parisian collections or through Zanetti.[3] Paintings she made while studying and adapting other painters' works have proved difficult to attribute, as they may appear uncharacteristic of Carriera's work as understood at present.

Educated Venetian women like Carriera, socially well placed though not patrician, could either marry, enter a convent, or remain at home; bearing children, running the home, and doing handwork—tapestry and lace making, for the upper classes—were typical pursuits.[4] Carriera, from the *cittadini,* an elite class of merchants and bureaucrats, chose to remain at home but did not remain invis-

45

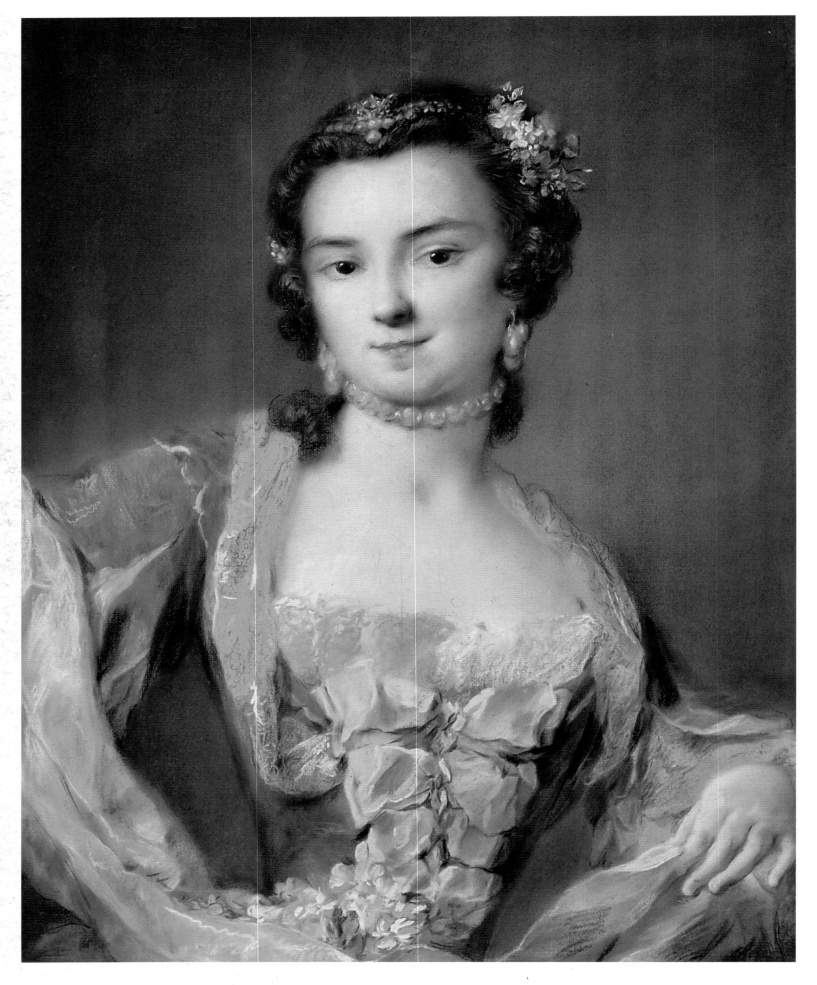

46

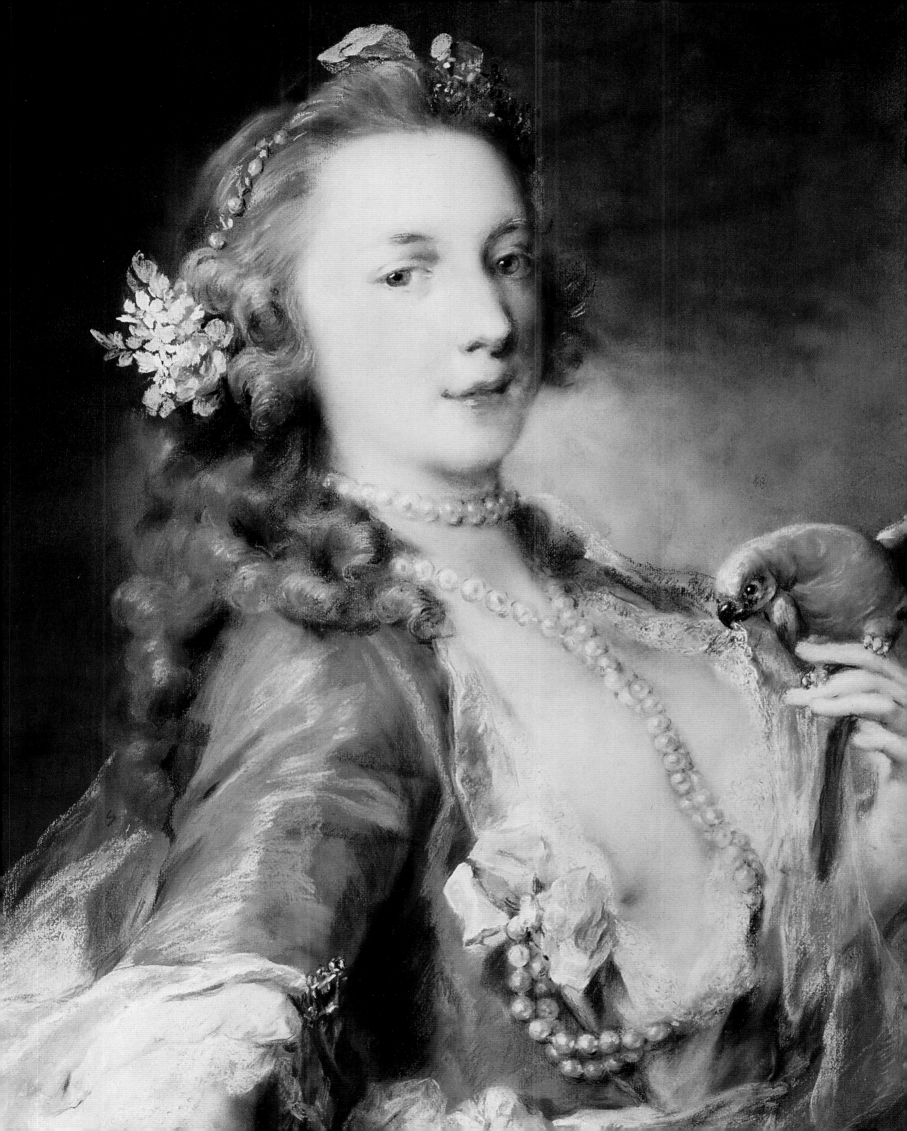

ible. Her pastel portraits won her an exceptional international reputation among royalty, aristocrats, connoisseurs, amateurs, and artists. Initially Carriera painted in miniature, an activity often recommended for gentlefolk, in part because of its cleanliness; her works were widely admired, especially by the French.[5] Increasingly her production of portraits and mythological figures in pastel gained favor. Although Titian and the Bassanos had drawn in colored chalks on blue papers, pastel painting was not a Venetian mode, nor were Carriera's pastels solicited primarily by Venetians; this aspect of her art played out on a European stage.[6]

The doctrinaire elitism, erudition, and theoretical leanings of the French Académie Royale contrasted with the social aspirations of its members, who shunned pedantry; the *honnête homme* ("upright man") of the French court and the beau monde of early eighteenth-century Paris preferred art that produced easily perceived, immediate, and striking effects. The art critic Roger de Piles (1635–1709) set out an aesthetic of pleasurable illusion that measured the value of art by the gratifying sensory experience it offered the viewer, provided the brush was guided by the painter's rational mind.[7] "Painterly" styles, with their bold brushwork and sketchy effects, found an appreciative audience in Paris and, since Paris dictated fashion, the rest of Europe. The expressive range and force of the marks made by

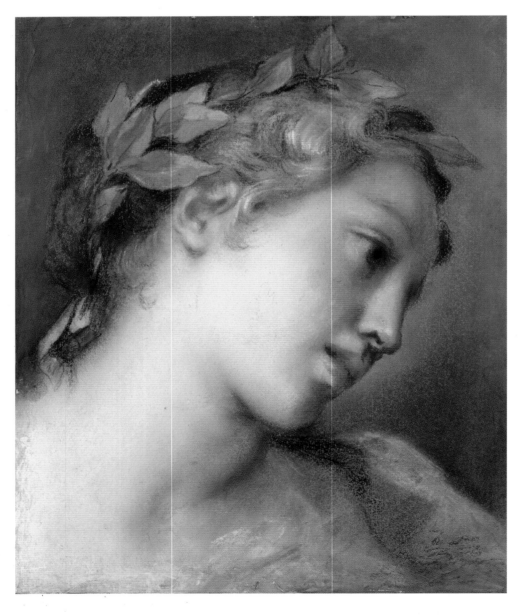

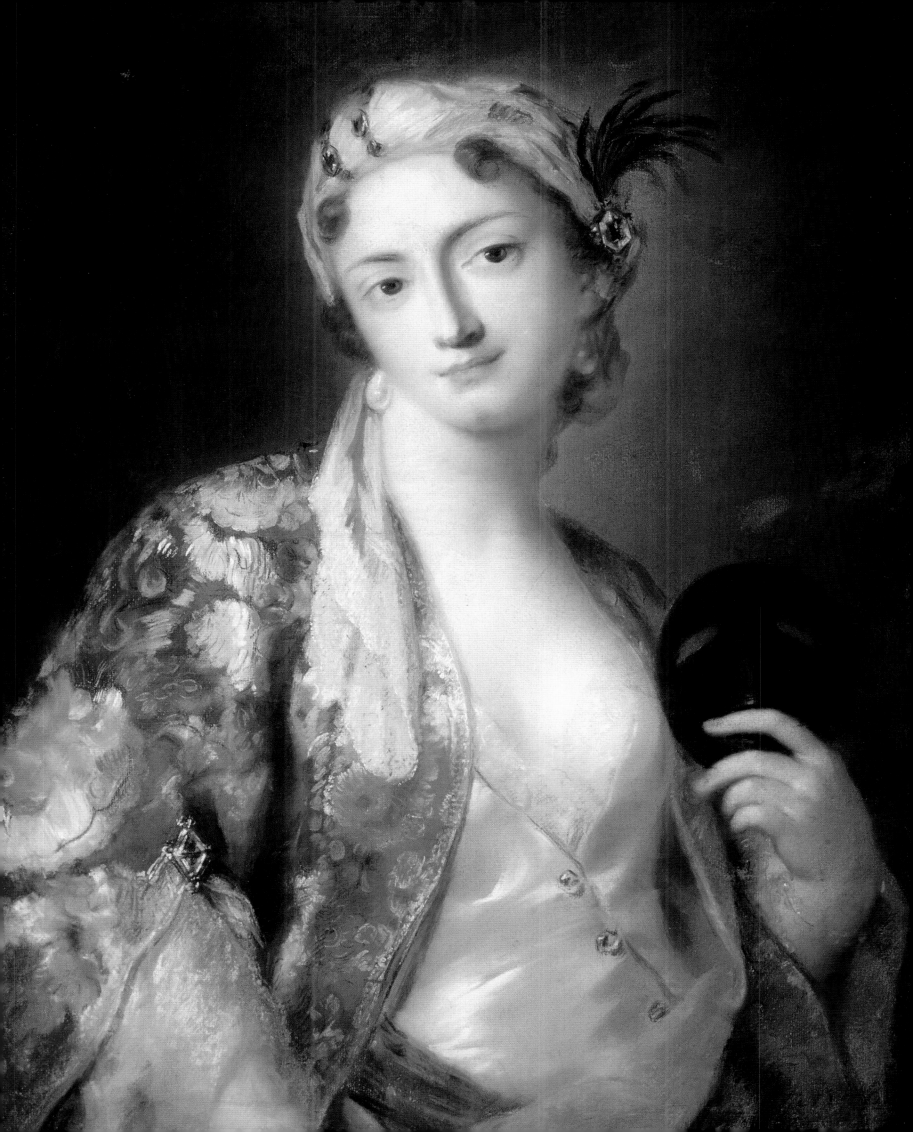

the painter's hand at work appealed to viewers' aesthetic sensibilities.[8] Carriera's success in Paris resulted from the visual qualities of her pastel paintings.

Carriera's likenesses appeared forceful and convincing to her contemporaries precisely because they were executed in pastel.[9] A painted image supplied absent things, not just their idea, to please and to deceive the eye: a painting must address the spectator, and the surprised spectator must be drawn to it.[10] Viewers were aware of the illusion, not duped, and after initial resistance were won over by its effectiveness; the mind oscillated indefinitely between surprise and satisfaction, between the depiction of the object and the object depicted.[11] The constantly interrupted illusion privileged material aspects of the painting, never allowing viewers to be completely absorbed in the content of the image.[12] This seductive play with illusion was intensified for viewers of Carriera's pastels because the same materials and techniques were used to paint portraits and to make up faces.

Carriera visited Paris in 1720–21. The Académie Royale accepted her as a full member in 1721, one of a handful of exceptions to its 1706 policy against admitting women.[13] This was a triumph, since an artist's success in France was contingent on membership. (When founded, the academy had fairly liberal intentions toward women until it changed its policy in 1706. It had admitted seven by 1682, although many benefits of membership were inaccessible to them because they were excluded from drawing the nude male model, a study essential for history painting.)

After her return to Venice, Carriera maintained links with French connoisseurs, artists, and Enlightenment culture. Many Venetian painters were leaving Venice at this time because of a lack of local patronage,[14] but Carriera remained active and productive there for the rest of her long life, with rare trips to European courts. In her studio her students and collaborators, including her sister Giovanna, Felicità Sartori, and Marianna Carlevaris, helped her to meet the demand for her works. Carriera's fame, which gave rise to the production of copies and forgeries that can be difficult to attribute, has obscured the achievements of these pupils and followers and still distorts our picture of them.[15]

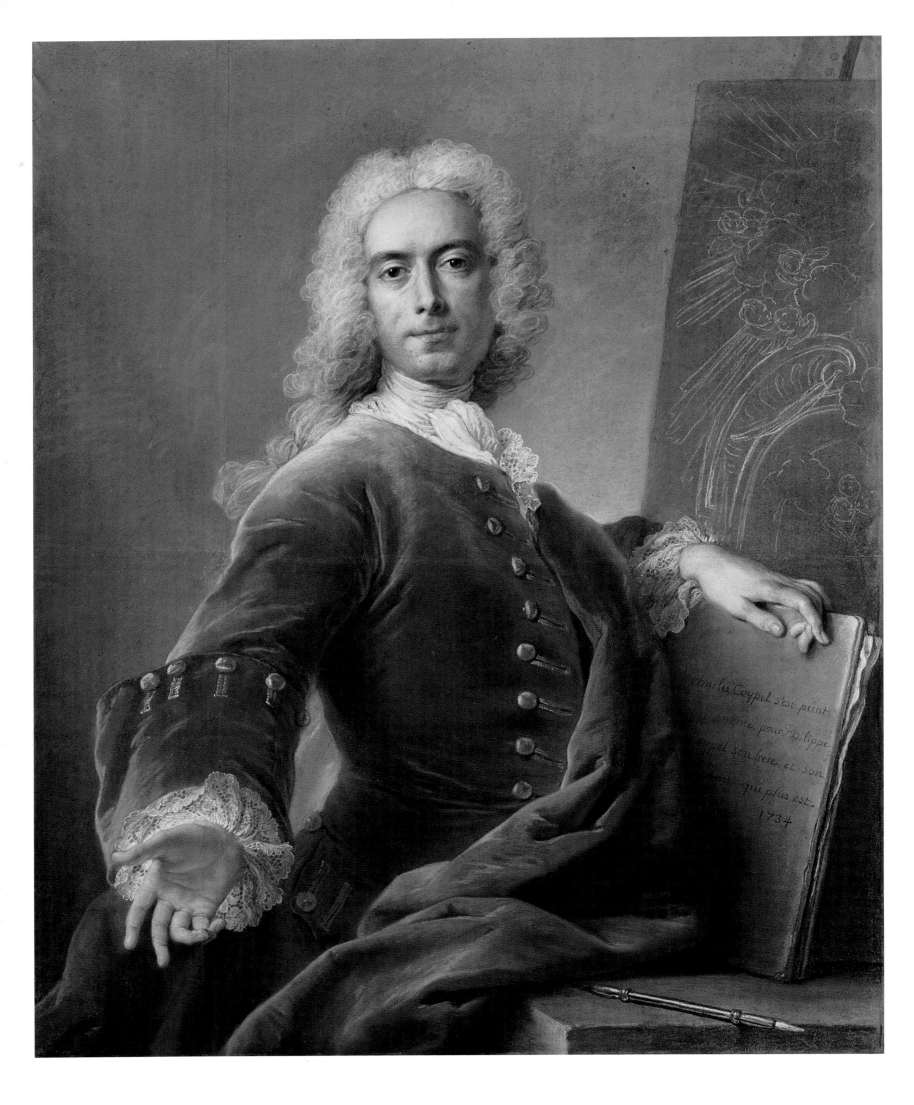

Charles Coypel s'est peint
... pour Philippe
... son frere, et son
... qui plus est
1734

OPPOSITE
Charles-Antoine Coypel
Self-Portrait, 1734
Pastel on paper,
38⅝ × 31½ in. (98.1 × 80 cm)
The J. Paul Getty Museum,
Los Angeles

CHARLES-ANTOINE COYPEL (1694–1752)

The history painter and academician Charles-Antoine Coypel was a friend of Carriera.[16] The son and grandson of prominent painters and appointed *premier peintre du roi* on the death of his father in 1722, he lived comfortably on his inheritance and appointments and had no financial need to turn to portraiture. Carriera's work stimulated his interest in pastel, and he used it for both preparatory studies for oils and finished portraits. His confident self-portrait of 1734, on a large paper support pieced together from four sheets, demonstrates his skillful and beautiful rendering of materials—heavy velvet, delicate lace, metal buttons.

GUSTAF LUNDBERG (1695–1786)

In 1717 the Swedish painter Gustav Lundberg settled in Paris, where he pursued further training, becoming successful as a pastel portraitist despite keen competition. In a manuscript biography he described how in 1720, under the influence of Carriera's painting, he decided to "abandon [his] paint brush for crayons"; he was not Carriera's pupil but rather "an attentive visitor to her studio, quick to learn from what he saw."[17] His clients included royalty and visiting Swedes. In 1725 he became *peintre du roi*, and in 1741 he was elected to the Académie Royale upon presentation of two pastels, one a portrait of Charles Natoire. There are traces of Carriera's format and soft style and color in this beautifully painted pastel, but the sharply delineated, slightly smiling face and the sitter's intense gaze, more animated and immediately present than in Carriera's portraits, recall the work of Vivien and Maurice Quentin de La Tour.

Gustaf Lundberg
*Portrait of Charles Natoire,
Half-Length* (detail), 1741
Pastel on paper,
25⅝ × 19⅝ in. (65 × 50 cm)
Musée du Louvre, Paris

In 1745 Lundberg returned to Sweden as court painter, perhaps because in Paris he saw his work eclipsed by that of La Tour and Jean-Baptiste Perronneau. There he worked for a further forty years portraying the royal family, nobility, and wealthy educated middle class, though more often he oversaw the production of royal portraits by assistants and a network of independent artists working under him.[18] His later pastels are uneven in quality, sometimes harder in style, intensely and thickly colored, and repetitive in format. It is not always certain which works are autograph replicas, since he did not sign his works and was so often assisted by others.

LOUIS VIGEE (1715–1767)

Vigée, best known as the father of the painter Elisabeth Louise Vigée Le Brun, is only secondarily identified in the literature as "a skilled portraitist, particularly in pastel."[19] Sources in the eighteenth century and later tell us little about his life and art; few documents have been published.[20] Highly praised by his daughter in her autobiography, he was essentially a pastel portraitist, painting the fashionable subjects attractive to amateurs—charlatans, little beggars, young draftsmen, fashionable theatrical personalities, pastoral themes, and literary illustrations.[21] In 1743 he submitted his masterpiece to the Académie de Saint-Luc, where he participated regularly in salons and attained the rank of counselor.

Vigée is an example of a *maître-peintre* (master painter), a member of the painter's guild. The founding of the Académie Royale precipitated the guild's decline,[22] and in 1705 it was converted into the Académie de Saint-Luc. Vigée and his work provide interesting insights into the role of the *maîtres-peintres*, painters of Paris who observed the city's daily and cultural life, especially that of the theater. Though they could be gifted, socially connected, involved, and ambitious, the *maîtres-peintres* were nevertheless held in contempt by members of the Académie Royale, who never treated their counterparts in the Académie de Saint-Luc as equals, artistically or socially. Nonetheless, by 1764 Vigée had important patrons for whom he executed portraits and fashionable subjects.[23] David Beaurain has suggested that the positive reputation of Louis Vigée and his links with other eminent painters may have helped, after Vigée's death, to promote the success of his gifted daughter.[24]

OPPOSITE
Louis Vigée
Young Woman with a Marmot, date unknown
Pastel on paper, applied to canvas, 25¼ × 21¼ in. (64 × 54 cm)
Musée Antoine Lécuyer, Saint-Quentin, France

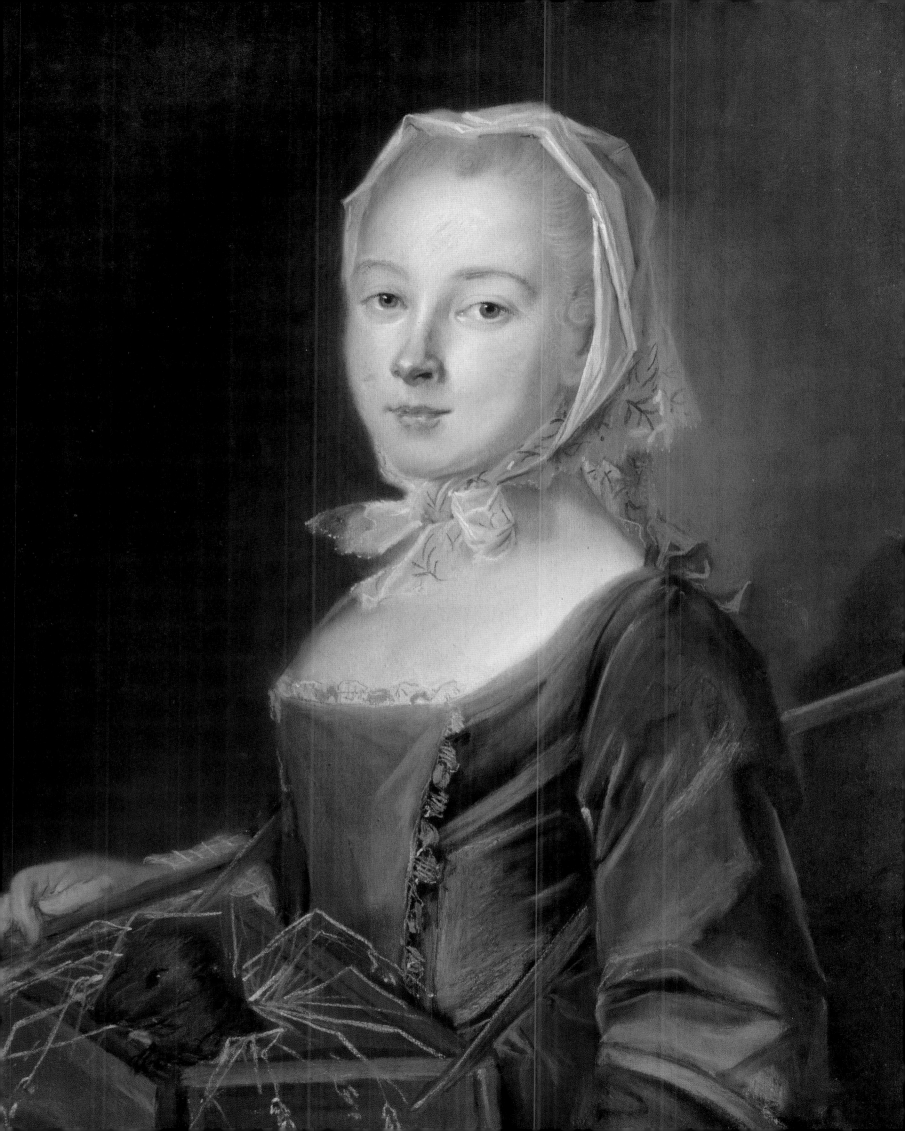

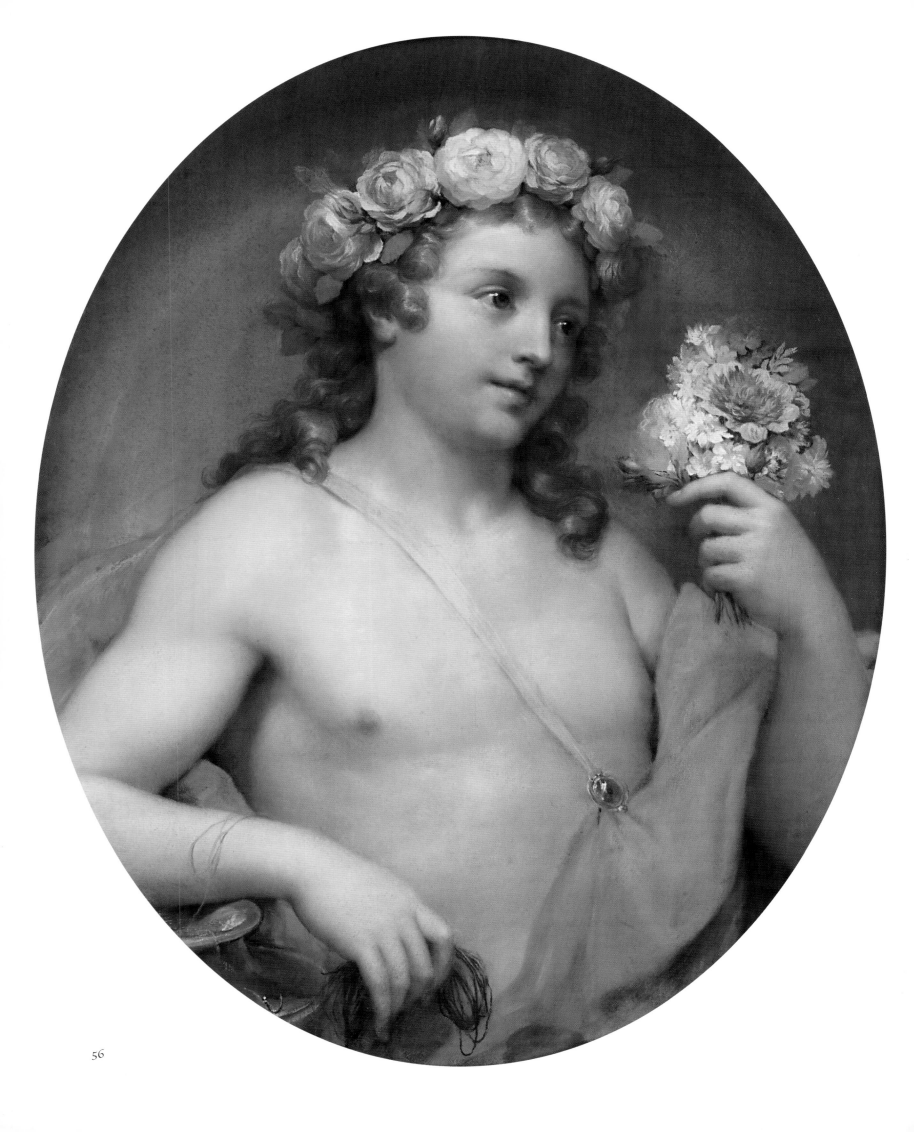

56

Born in Bohemia, Anton Raphael Mengs was first trained by his father, Ishmael, a portraitist in oil and miniature appointed to the Dresden court and director of the academy there.[25] Mengs spent four years in Rome training as a painter and studying works from antiquity, the Renaissance, and the Baroque, returning to Dresden in 1744. Encouraged by the admiration of the king of Poland and elector of Saxony, Augustus III, for Rosalba Carriera's work and inspired by the king's superb collection of her pastels, he set up a successful practice in pastel portraiture and was soon appointed *premier peintre du roi*. During a second trip to Rome (1746–49), he began painting in oil. He returned again to Dresden in 1749 and left definitively in 1751.

Mengs spent 1751–61 in Italy, mostly in Rome, where he painted Grand Tour portraits of English aristocrats, frescoes, and altarpieces.[26] His *Portrait of William Burton Conyngham*, dated around 1754–55, was likely commissioned by the sitter as a souvenir. It features a conventional composition, strong, saturated colors, and highlights typical of oil paintings. Mengs's modeling is smooth, and individual strokes are blended together as in finished oil paintings. His allegorical figure *Pleasure*, a pastel of around 1754, though not a portrait, may have been closely studied from the model and "improved" in accord with Mengs's interpretation of classical standards. Technically stunning, the modeling is delicate and softly blended; the figure is pretty and androgynous, the forms soft and pleasing, and the anatomy perfect, echoing Raphael and the antique.[27]

Mengs later went to Madrid, where in 1767 he was appointed court painter to King Carlos III. He died in Rome in 1779. Although his production of pastels is small compared to Jean-Etienne Liotard's, for example, and is overshadowed by his work in oil, he was an important pastelist who worked totally outside France.

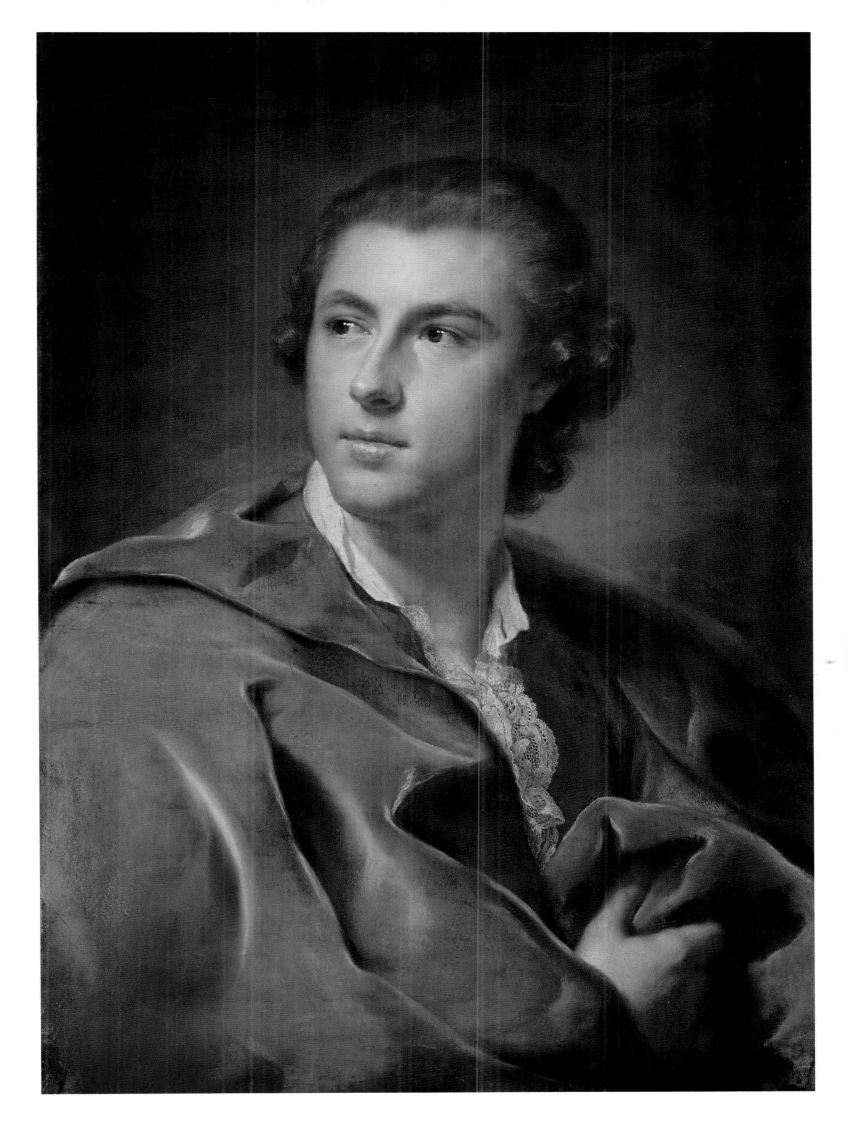

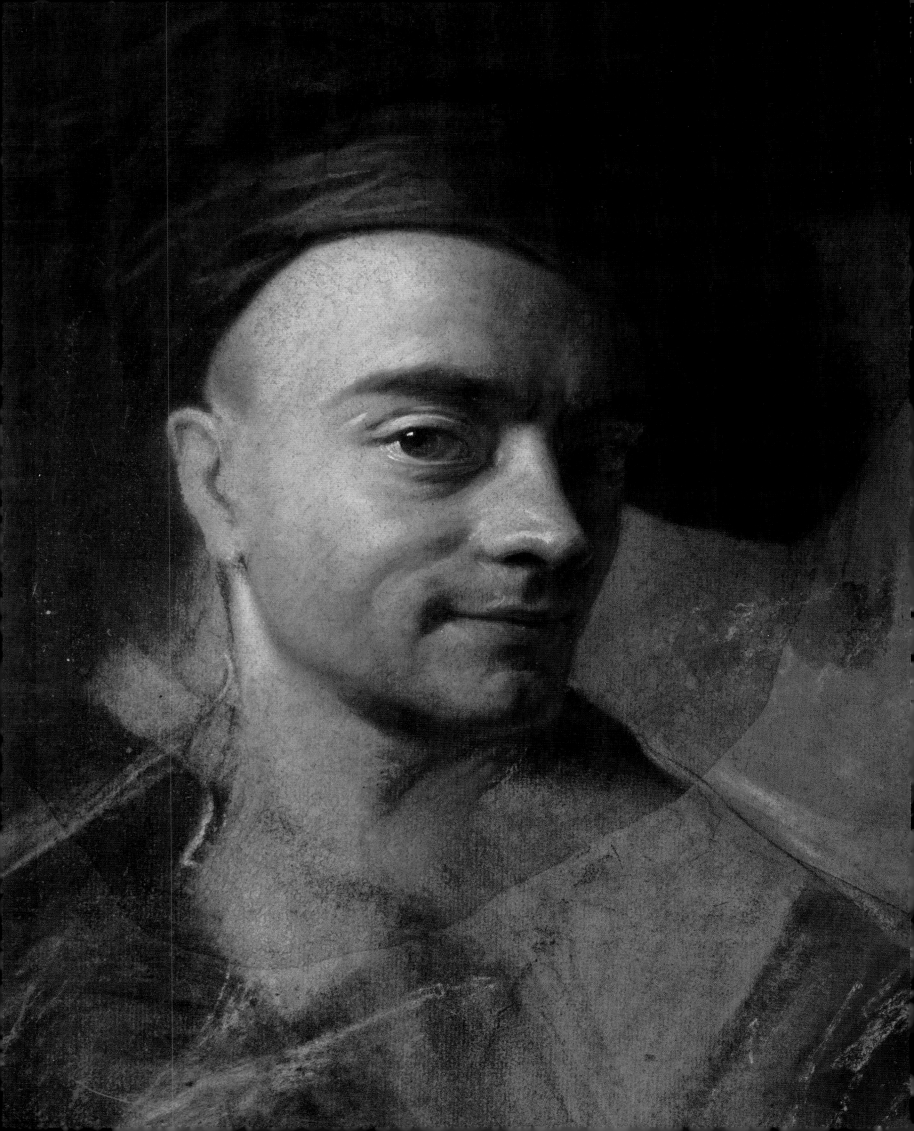

4.

Maurice Quentin de La Tour and
the Triumph of Pastel Painting

Maurice Quentin de La Tour
Jean-Nicolas Vernezobre,
date unknown
Pastel on paper, 23 × 18½ in.
(58.5 × 47 cm)
Musée Antoine Lécuyer,
Saint-Quentin, France

OPPOSITE
Maurice Quentin
de La Tour
Self-Portrait, c. 1742
Pastel on paper, 15 × 11⅞ in.
(38 × 30 cm)
Musée Antoine Lécuyer,
Saint-Quentin, France

SPREAD OVERLEAF
LEFT
Maurice Quentin
de La Tour
*Preparatory Study for the
Portrait of Voltaire,* 1735
Pastel on brown paper with
the addition of gray-blue
paper in the lower section,
14⅜ × 11¼ in. (36 × 28.5 cm)
Musée Antoine Lécuyer,
Saint-Quentin, France

RIGHT
Maurice Quentin
de La Tour
*Preparatory Study for the
Portrait of Mademoiselle de
Chastagner de Lagrange,*
date unknown
Pastel on paper, 15 × 11⅞ in.
(38 × 30 cm)
Musée Antoine Lécuyer,
Saint-Quentin, France

*L*ittle is known about the first thirty years of the life of Maurice Quentin de La Tour (1704–1788); few documents, early biographies, or artworks survive.[1] His origins in Saint-Quentin in Picardy were modest and provincial. Ambitious, he served a traditional French apprenticeship and by the late 1730s was a sought-after Parisian pastel portraitist and a provisional member of the Académie Royale. Perhaps he was drawn to the lucrative market for portraiture for financial reasons while apprenticing in Paris from 1719 under the painter Claude Dupouch (d. 1747). Though probably not influenced directly by Carriera's pastels early in his career, he may have been in Paris during her sojourn there in 1720–21, and realized the potential for capitalizing on the interest in pastel and demand for portraiture.[2]

After a period of travel in northern France and to London, La Tour moved definitively to Paris by 1727 and dominated its portrait market from the mid-1730s to the 1760s. In early 1735, the philosopher Voltaire sat for him—a prestigious commission.[3] To prepare his portraits, the artist executed head studies on loose paper sheets. Called *études* by the artist and *préparations* by the Goncourt brothers, who, in the nineteenth century, first explored the relevant primary sources, these studies reveal the initial stages of the artist's creative process.[4] Valued by La Tour as working drawings, they were unusual for portraitists, who typically worked directly on the primary support; more than eighty survive.[5] In black and white chalks La Tour explored the plasticity and structure of the sitter's face; with pastel he determined the color values of flesh and complementary background tones and captured momentary expressions.[6] This process suited La Tour, a slow worker and a perfectionist, because it allowed him to work up the final portrait without irritating clients with lengthy sittings.[7] Often, as in this study for Voltaire's portrait, his sitters' faces are stained by haloes of fixative applied by the artist in an attempt to preserve the fragile image.

La Tour's association with Voltaire brought him admiration and new clients.

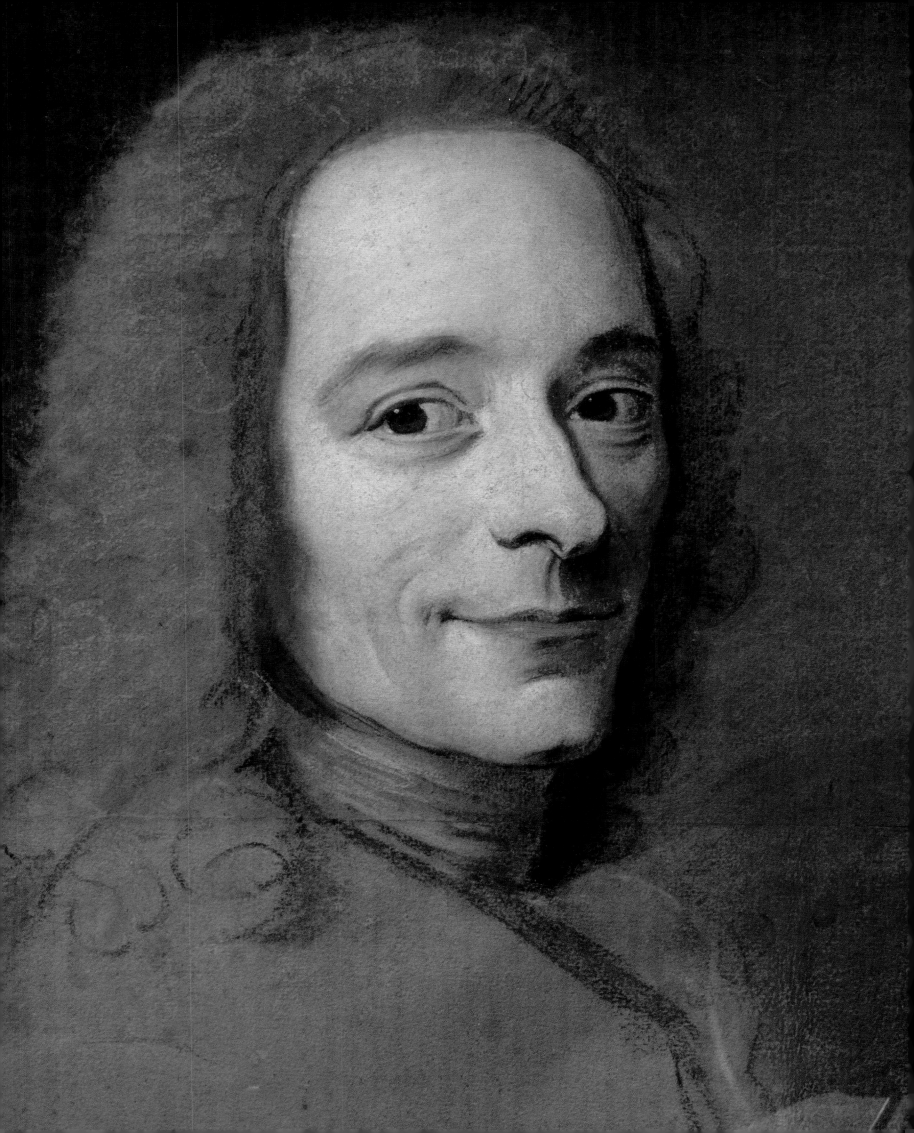

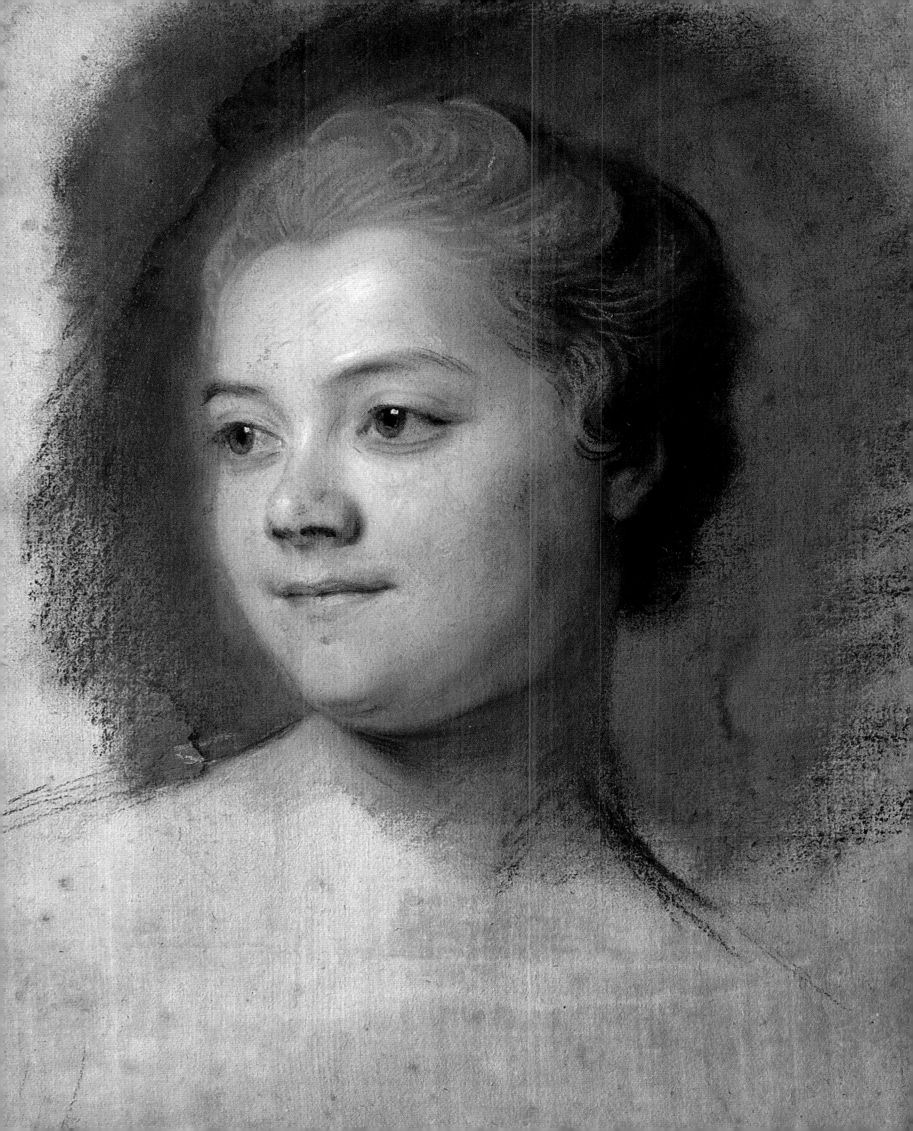

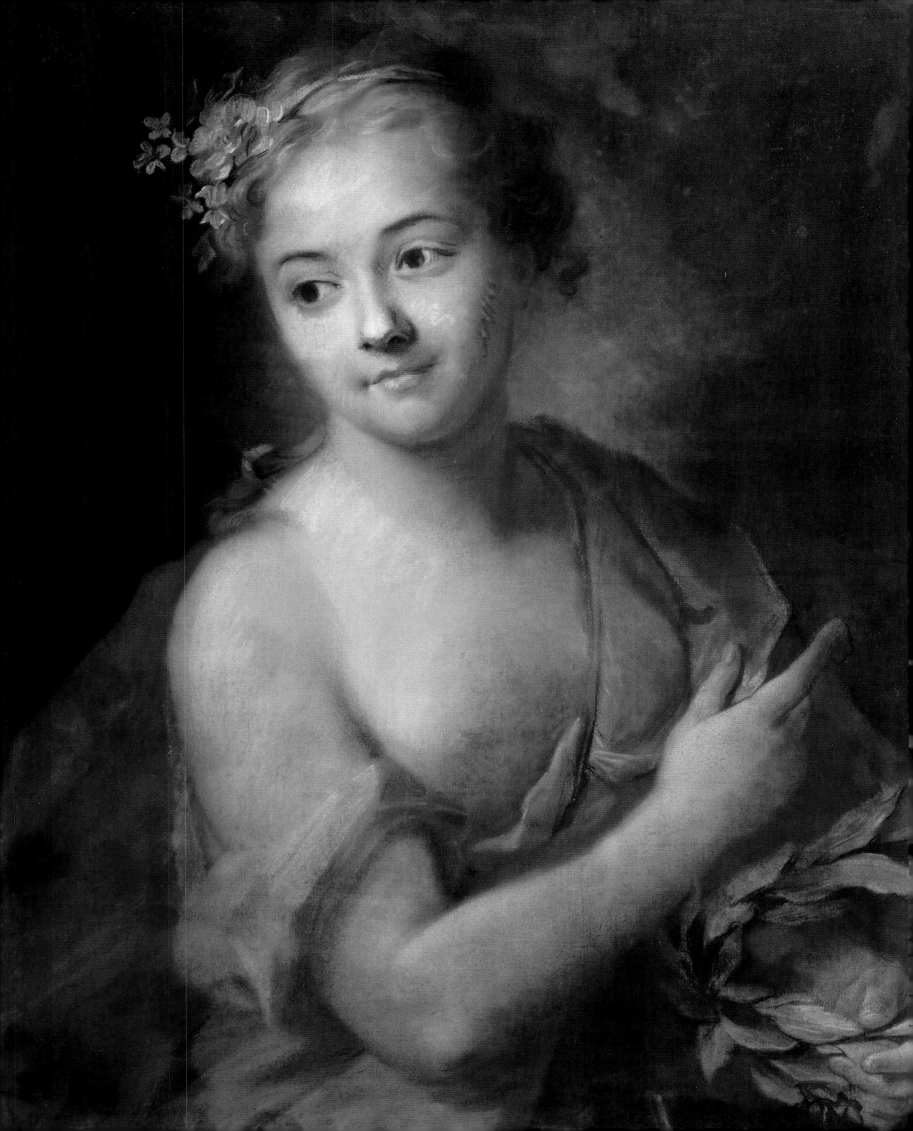

In 1737 he successfully presented selected works to the Académie Royale on a designated day—the standard route to provisional membership for practitioners of minor genres, such as portraiture.[8] While studying the academy's collection of artists' reception pieces, La Tour copied Carriera's *Nymph from Apollo's Retinue,* possibly to show that he was capable of replicating her achievement in pastel. He individualized the pretty nymph's features, giving her a penetrating gaze and a firm structure and plasticity, rendering Carriera's graceful idealizing figure as a solid presence.[9] The generation of Louis XV sought generally to replace traditional iconic formality with a more intimate presentation, a "devotion to the idea of inner truth through instantaneity and fleeting expression [that] found its best advocate in . . . La Tour."[10] Pastel, happily, was well suited to the depiction of these momentary expressions.

La Tour made his debut at the Salon du Louvre of 1737 when regular exhibitions resumed after a hiatus. He hung works that showcased his talents to attract clients, displaying his genius for self-promotion. Lacking influential sitters, he used readily available models—Madame Boucher, a beauty and wife of a successful academician—and himself in a clever, informal image in which he adopted the persona of the ancient philosopher Democritus to suggest his own culture, learning, and wit and to assert his superiority.[11] These were the only pastels shown that year.[12]

It is difficult to trace La Tour's artistic journey—no early work survives, and

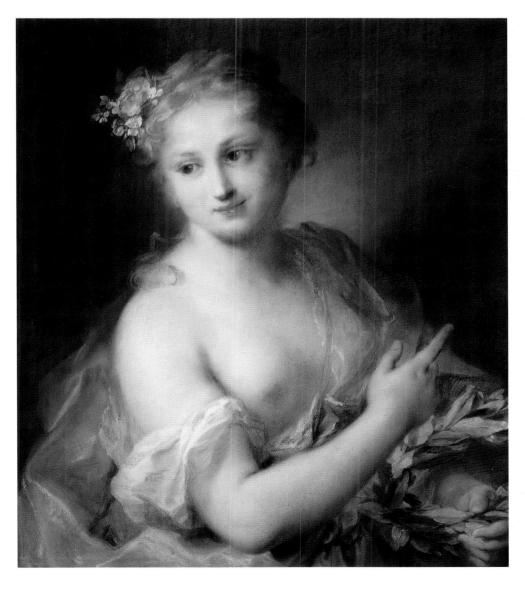

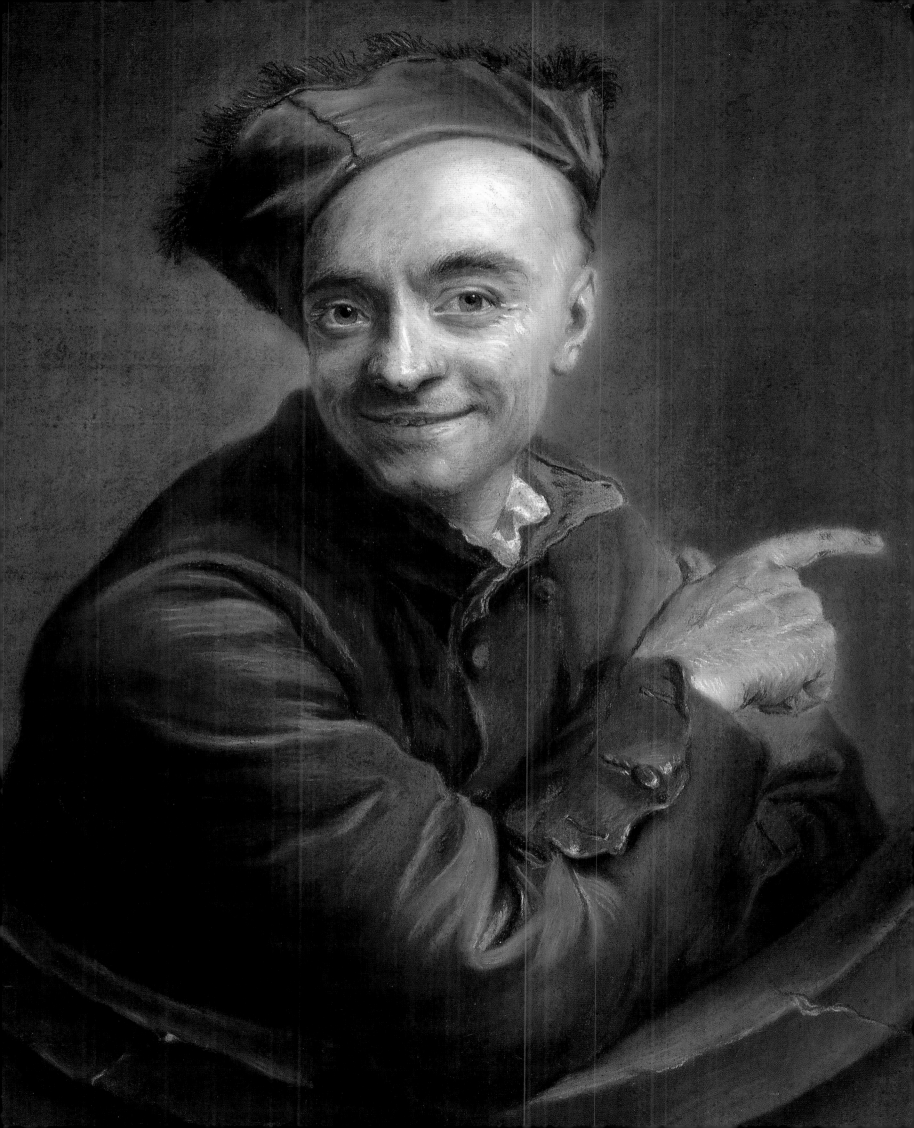

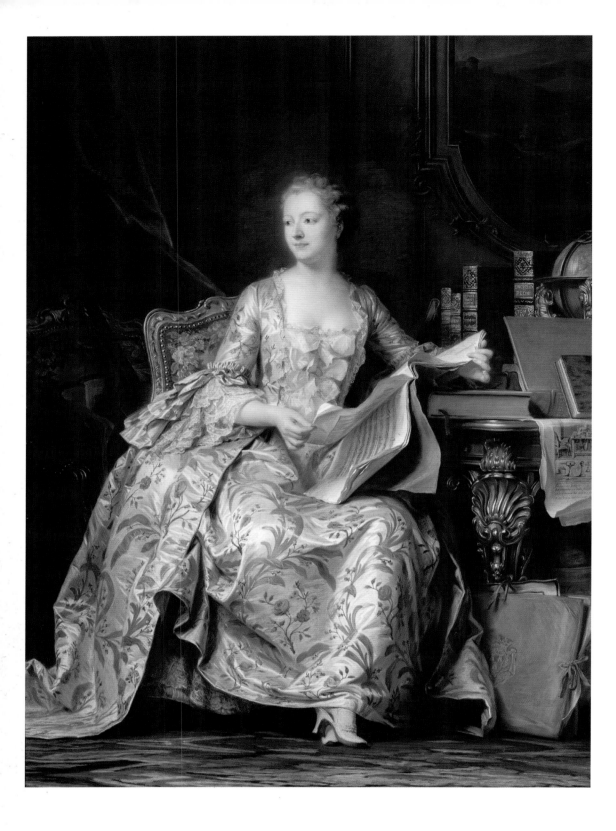

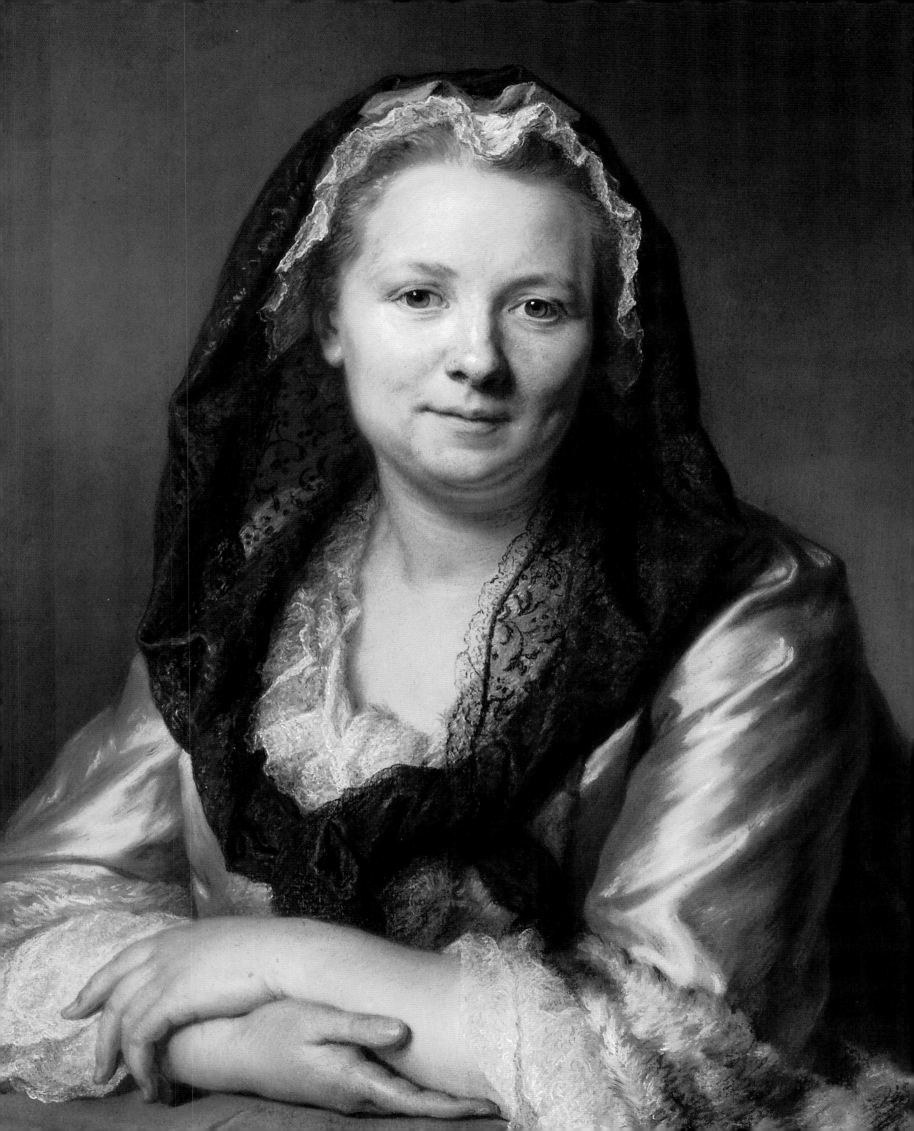

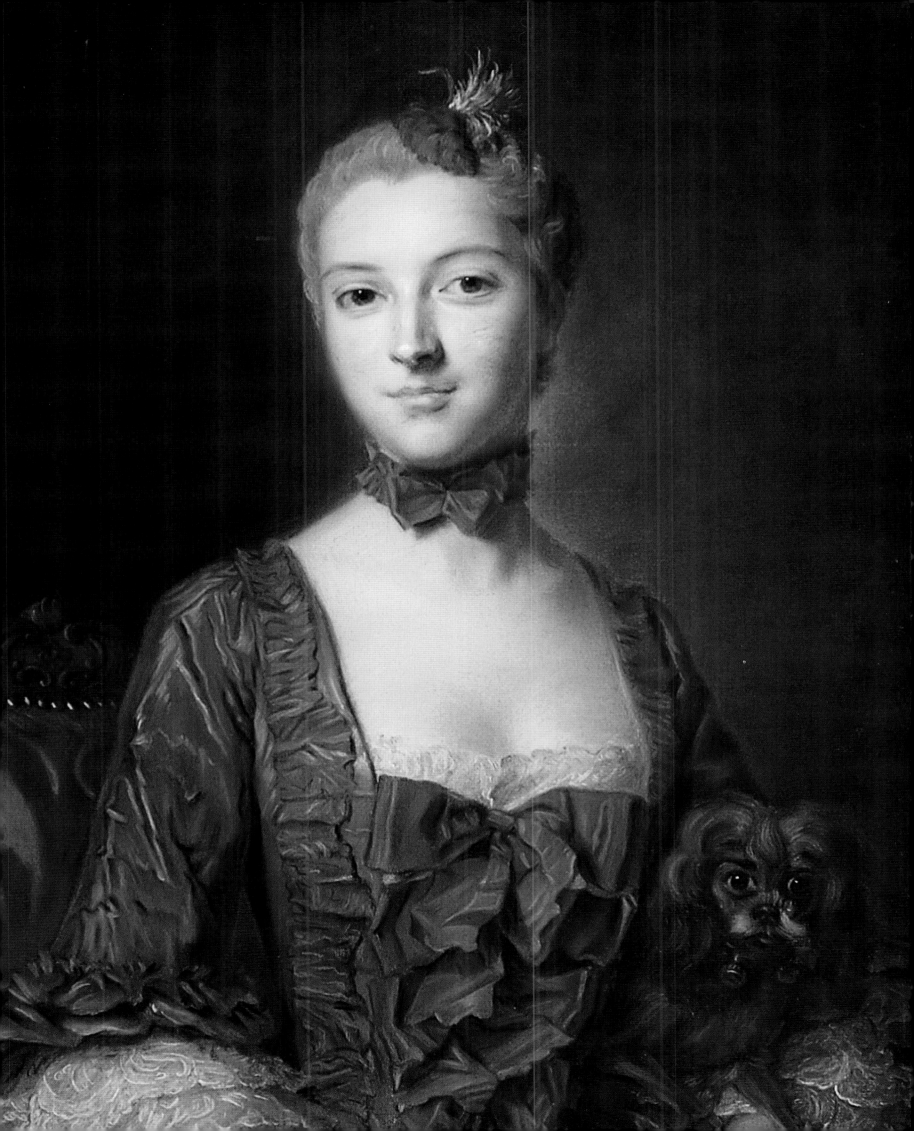

none of his portraits are dated and signed, although surviving documentation is revealing. Neither are any landscapes, still lifes, mythological works, or oil paintings by La Tour known; such specialization was rare. However, several of La Tour's large portraits include extraordinary still life details of books and objects.

The most important aesthetic criterion for eighteenth-century French portraiture was *ressemblance* (likeness), the naturalistic and detailed rendering of the sitter's distinctive facial features, with more limited recourse to accessories symbolizing the sitter's personal, professional, and social position.[13] Sitters were set against plain backgrounds, in a specific moment that evoked a living, breathing presence, with fleeting expressions and casual gestures. La Tour captured the distinctive physical appearance of each sitter as it changed in response to thoughts and emotions as well as to the light of various times of day. His paintings suggested "an interaction between the viewer and sitter, quite often direct eye contact and a smile," intimating that the sitter was reacting to the viewer's presence.[14]

Pastel enhanced the tactile qualities of this naturalism for La Tour's contemporaries. A critic wrote of "the truth of likeness" of his portraits at the 1738 Salon: "Nothing is lighter and more graceful than his touch. One sees, one feels, one believes one is about to touch everything he paints. . . . it is not possible that it is only a deception of colors."[15] La Tour's ability to achieve a successful likeness, the most prized aspect of his work, may be compared with the elaborate "mythological

Jean-Marc Nattier
Portrait of Manon Baletti,
1757
Oil on canvas, 21¼ × 18¾ in.
(54 × 47.5 cm)
National Gallery, London

OPPOSITE
Maurice Quentin
de La Tour
Portrait of Gabriel Bernard de Rieux, 1741
Pastel with gouache
highlights on an assemblage
of sheets of gray-blue paper,
glued to canvas,
82⅝ × 59½ in. (210 × 151 cm)
The J. Paul Getty Museum,
Los Angeles

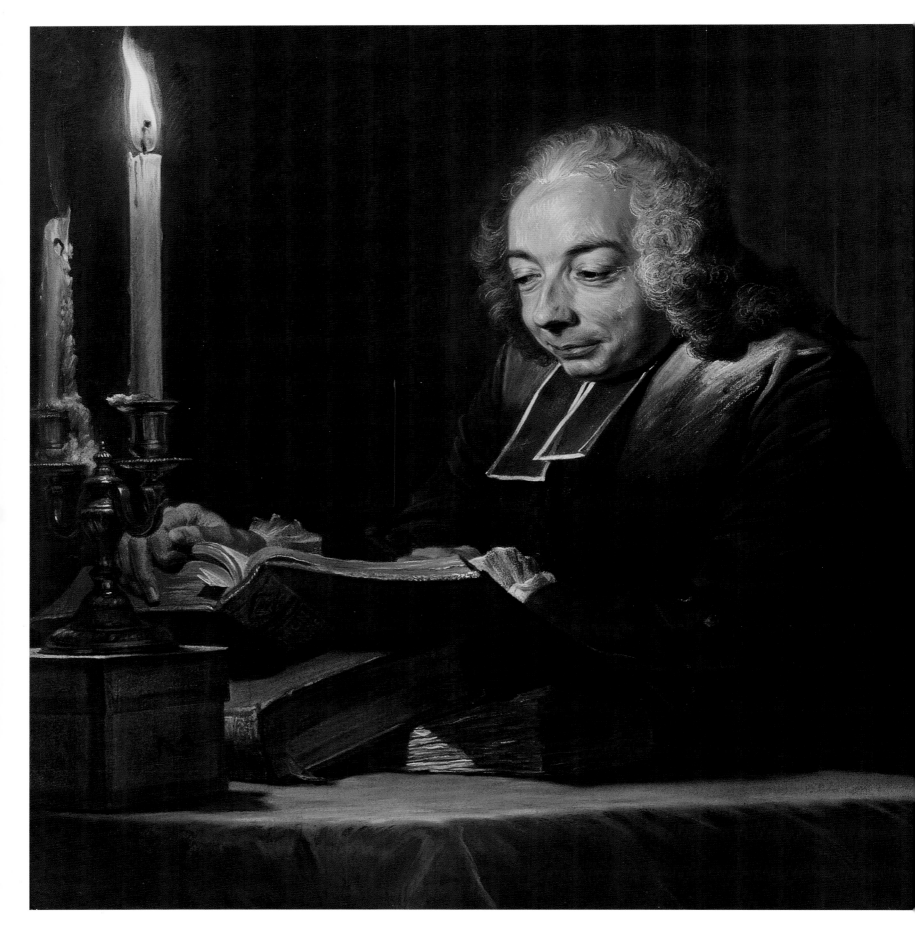

74

Maurice Quentin de La Tour
Abbé Jean-Jacques Huber Reading, 1742
Pastel on gray-blue paper, 31⅞ × 40⅛ in. (81 × 102 cm)
Musée d'Art et d'Histoire, Geneva

portraits of radiant young women dressed as fanciful goddesses" by his contemporary Jean-Marc Nattier.[16]

To overcome a bias against pastels implicit in criticism of the 1737 Salon and to stress that his work rivaled oil paintings, La Tour exhibited increasingly larger pastels. In the 1741 Salon he hung his largest work, a full-length life-size official portrait of Gabriel Bernard de Rieux, accompanied by elaborate accessories and seated in the intimacy of his study, its space cut off by a leather screen. The sitter pauses to acknowledge the spectator's presence. The pastel is composed of twelve sheets of now-faded blue laid paper, edges overlapped and glued to the underlying canvas. To this, La Tour glued the tablecloth, head, and each hand on separate, individually cut sheets of irregular shapes and sizes whose edges corresponded to the major lines of the composition. Attempts were made to conceal the joins with diluted gouache and layers of fixative.[17] The unusually large and thus exceedingly expensive sheet of glass needed to protect the pastel was bought under Rieux's initiative and with his financial support.[18] With this portrait La Tour established that pastels could compete with oils in scale and presence; the increase in size also marked a shift in the artist's clientele from the bourgeoisie to the new and, later, old nobility.[19]

In 1744 La Tour was asked to paint a portrait of Louis XV, the symbolic height of official recognition, and in 1745 he executed a portrait of the queen. His remarkable mastery led the Bâtiments du Roi, the section of the king's household responsible for royal residences, to select La Tour's works as models to be copied by other painters.[20] The royals recognized themselves vividly in La Tour's portrayals, and using these as a pattern spared them the fatigue of further sittings.[21]

In 1745 La Tour, still a provisional member of the Académie Royale, was awarded a prestigious apartment in the Louvre, and in 1746 he was received as *peintre de portraits en pastel*. From this date he tended to exhibit bust- to half-length portraits in a limited repertoire of poses, appealing to viewers with the range and importance of his sitters rather than displays of virtuosity and versatility.[22] In 1751 La Tour was made *conseilleur* (counselor), the highest position for a portraitist within the Académie Royale. Still an excellent self-promoter, he asserted his importance as an artist through his Salon displays and eccentric behavior, which attracted attention and enhanced his reputation by underlining his privileged position.[23]

La Tour's prominence in the Salon and the increasing fame of his sitters attracted a growing body of art criticism focused on him.[24] In *Réflexions sur quelques causes de l'état présent de la peinture en France* (1747), the critic Etienne La Font de Saint-Yenne supported the hierarchy of genres, arguing that minor genres, including portraiture, were less intellectually challenging than history painting. Portraiture appealed to artists for base reasons, for "its ready market, popularity, and purported lack of difficulty. . . . Since works in pastel were almost exclusively portraits, it is not surprising that the medium itself was attacked."[25]

La Tour was obsessed by the fragility of the pastel surface, and even spoiled works in his ill-conceived attempts to secure the vulnerable surface with a fixative. Some writers criticized him for making false claims about preserving his work for posterity while, they insisted, wanting only to make money; others, however, assured the public that he "had the good fortune to discover a varnish that, without altering at all the freshness and 'flower' of his pastel, fixes it so that the most violent shock does not disturb it, thus assuring his portraits a life span of which they are so worthy because of their beauty."[26]

Doubt cast upon the longevity of pastels, in fact, provided an excuse to effectively dismiss the material for those who feared that, because of its popularity, pastel would replace oil painting, which as a genre was claimed to be more complex in procedure and more intellectually challenging.[27] In his *Lettre sur l'exposition des*

ouvrages, Abbé Le Blanc championed La Tour's talent for portraiture and insisted that his works would last, the result of his discovery of "a secret [a varnish] that guarantees their durability."[28]

By midcentury pastel portraits were immensely popular, and increasing numbers were shown in the Salons. Many were by artists only provisionally admitted to the academy, who specialized in pastel—Jean-Baptiste Perronneau, Alexis Loir, and Jean Valade.[29] Although La Tour encouraged young portraitists, neither they nor his older competitors, Nattier and Jacques-André-Joseph Aved, nor the internationally famous Jean-Etienne Liotard, who spent 1746–53 in Paris, seriously challenged his preeminence, and by the mid-1750s he dominated portraiture in France.[30] La Tour's exhibition of his *Portrait of the Marquise de Pompadour* at the 1755 Salon was the last time his work generated extensive discussion in the critical literature.[31] He continued to paint royal portraits in the early 1760s and to charge high prices, and he exhibited at the salons until 1773, but his works were often hung less prominently on the salon walls and critics engaged less and less with his work.[32] La Tour returned to Saint-Quentin in 1784, and died there in 1788.

OPPOSITE
Maurice Quentin
de La Tour
Louis de Silvestre, 1753
Pastel on paper,
24⅞ × 20⅛ in. (63 × 51 cm)
Musée Antoine Lécuyer,
Saint-Quentin, France

Maurice Quentin
de La Tour
*Marc René, Marquis de Voyer
de Paulmy d'Argenson*, 1753
Pastel on paper,
25¼ × 20½ in. (64 × 52 cm)
Musée Antoine Lécuyer,
Saint-Quentin, France

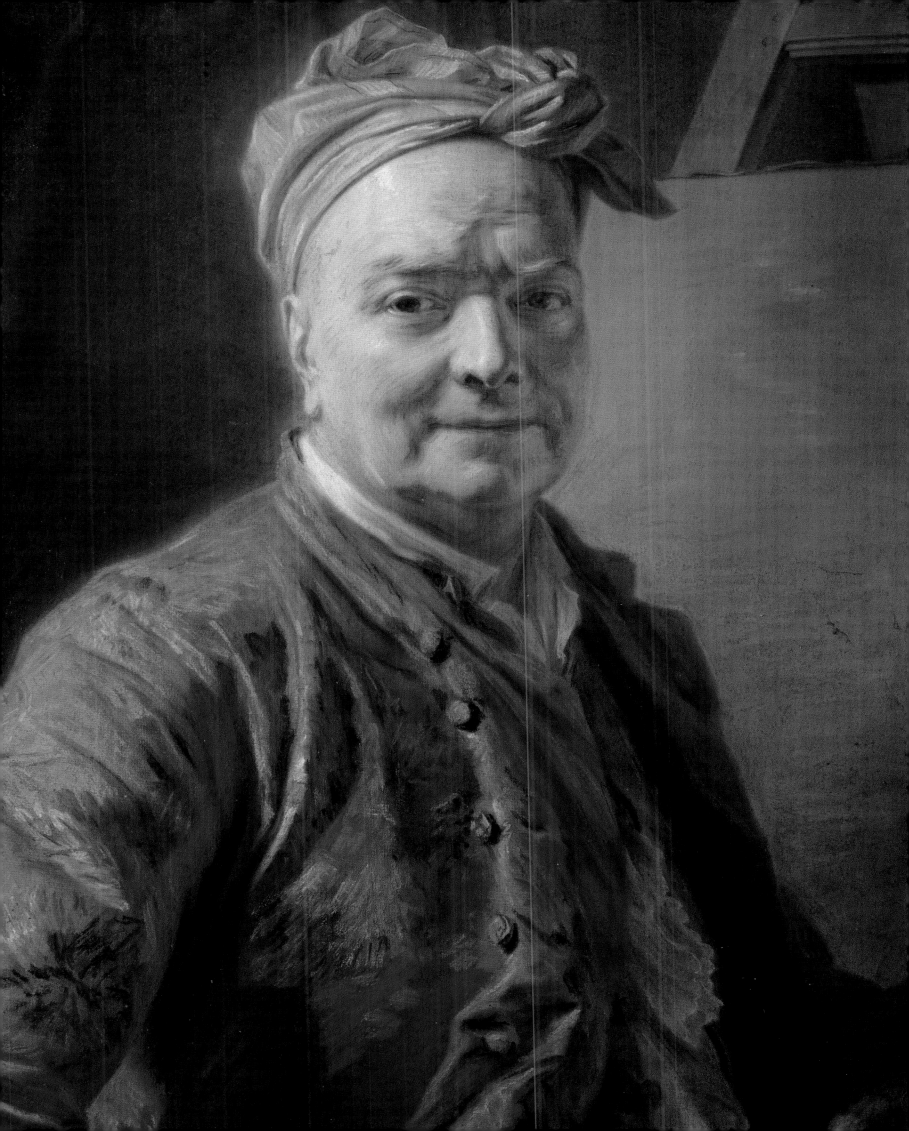

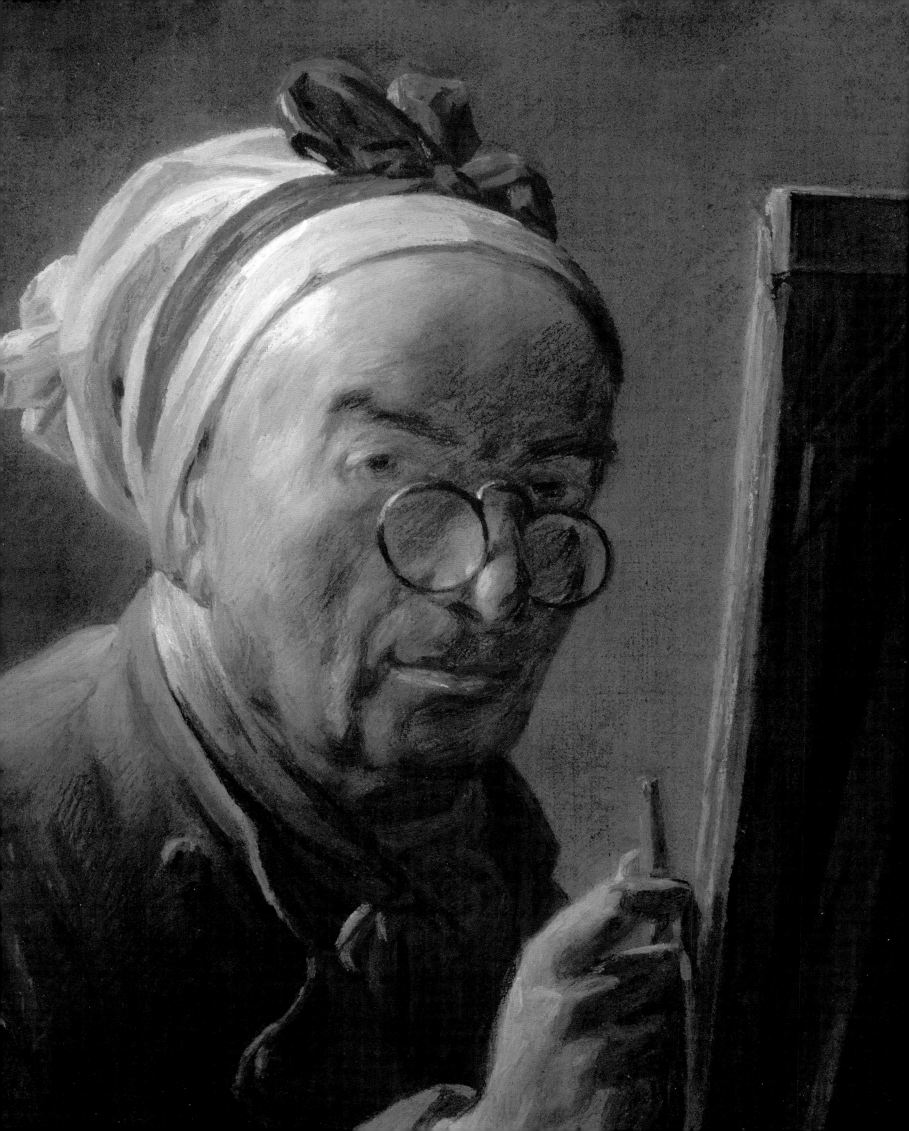

5.

The Golden Age of
Pastel Painting:
France at Midcentury

Jean-Baptiste Perronneau
Portrait of Maurice Quentin de La Tour
(detail), 1750
Pastel on paper, 22 × 18⅞ in. (56 × 48 cm)
Musée Antoine Lécuyer, Saint-Quentin,
France

JEAN SIMÉON CHARDIN (1699–1779)

OPPOSITE
Jean-Siméon Chardin
Self-Portrait at the Easel,
c. 1779
Pastel on blue paper,
16 × 12¾ in. (40.5 × 32.5 cm)
Musée du Louvre, Paris

*U*nder the enlightened direction of the marquis de Marigny, superintendent of the king's buildings, and François Boucher, *premier peintre du roi* and director of the Académie Royale, an artist's talent was important. This may account for remarkable academic and popular success of Jean Siméon Chardin, who was admitted provisionally and received fully by the Académie Royale in 1728 as painter of still lifes in oil, the lowest genre in the academic hierarchy.[1] By the 1770s, when new directors favored an increasingly conservative approach, Chardin's authority declined, and his work was even viewed with contempt. In old age, with his health and eyes failing, Chardin turned to pastel, executing head studies and self-portraits shown at salons in the 1770s.[2]

In *Self-Portrait at the Easel* (about 1779), Chardin, positioned before an easel supporting a wood strainer wrapped with blue paper, holds up a red pastel stick. With its penetrating gaze and substantial forms, this portrait was, like Chardin's still lifes, rooted in a habit of rigorous observation that had led critics to describe the artist as a "sober naturalist."[3] Yet the vivid colored strokes, freely juxtaposed and unblended, form a vibrant textured painted surface that, when viewed more closely, dissociate from the facial features.[4] Chardin's contemporary, the writer Abbé Raynal, observed, "His manner of painting is unique: he places the colors one after another, barely blending them, so that his work somewhat resembles mosaic."[5] Chardin made himself the object of study, perhaps in part as psychological reflection, but importantly as a link in the act of painting.[6] The painter, omitting details, allowed the viewer to imagine what remained underdetermined, visually and psychologically, challenging and enriching the viewing experience, "an interplay of the viewer and the work."[7]

Chardin's move to portraiture has been interpreted simply as an attempt "to climb a rung on the ladder . . . of the hierarchy of genres" in a time of political transformation.[8] Apparently finished, such works were exhibited as "head studies in pastel," the title suggesting that Chardin and his audience considered them as preparatory studies.[9] They stand apart from the official tradition of self-portraits in eighteenth-century France as defined by Roger de Piles and practiced by artists like Hyacinthe Rigaud and Louis-Michel van Loo, which, with their courtly attributes, sumptuous clothes, and proud attitudes, were more symbolic than functional.[10] Chardin's bust-length self-portrait, intimate and modest in format, presents the artist close to the picture plane as a man of the studio, dressed for work, rather than as the privileged *peintre du roi* that, with a royal pension and free lodging in the Louvre, he in fact was.[11]

Chardin used drawings to prepare only for his earliest paintings, and he drew very little for an academician: artists trained at the Académie Royale were taught drawing before painting, but Chardin never attended classes there.[12] According to his first biographer, Charles-Nicolas Cochin, Chardin came to realize that he needed nature to achieve "with the greatest truth the general masses, the tones of color, the fullness, the effects of light and shadow."[13] According to Pierre Rosenberg, he thus dispensed with drawing, returning to it only late in life with his "marvelous pastels."[14] This raises the broader question—are his pastels drawings or paintings? As pictures, Chardin's oils and pastels, whatever the subject, are intimately linked conceptually—discursively elusive and concentrating on pictoriality rather than the imitation of nature as understood in the classical tradition. To debate their genre is unproductive. Chardin, undoubtedly conscious of his exceptional talent, must have seen his genius as based on his talent, intellect, and professional activity rather than the academic status of his oeuvre, a viewpoint that privileged technical aspects of the artist's creation.[15] Recently several scholars have suggested that, influenced by eighteenth-century scientific literature about the nature and effects of light and its visual perception, Chardin sought through technically achieved effects to imitate not nature but "the nature of our perception of nature."[16]

OPPOSITE
Jean Siméon Chardin
Self-Portrait of the Artist with Eyeshade and Spectacles, 1775
Pastel on gray paper,
18⅛ × 15 in. (46 × 38 cm)
Musée du Louvre, Paris

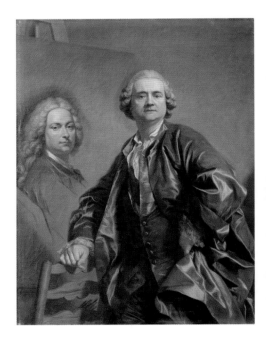

Louis-Michel van Loo
Self-Portrait of the Artist Painting from Memory the Portrait of the Painter Jean-Baptiste van Loo, 1762
Oil on canvas, 60 × 38⅝ in. (129.5 × 98 cm)
Musée National des Châteaux de Versailles et de Trianon, Versailles

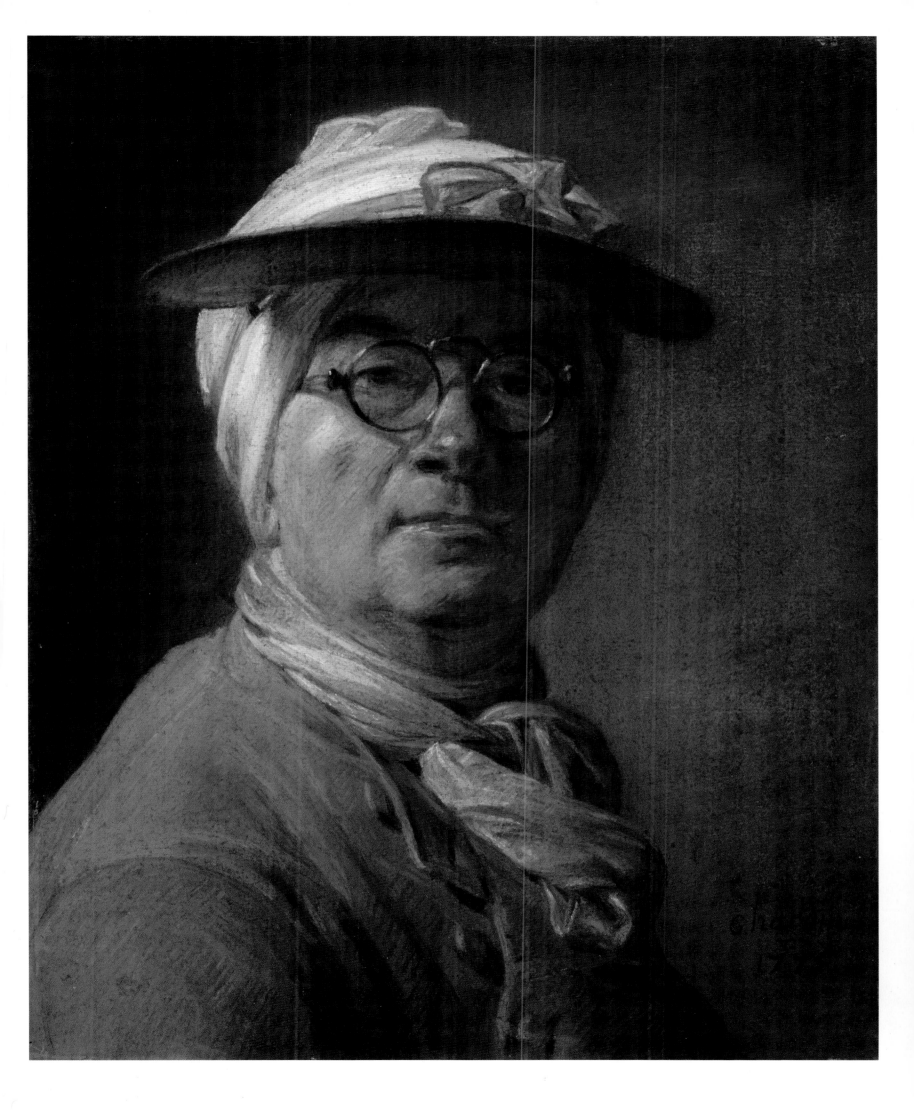

JEAN VALADE (1710–1787)

"Jean Valade, painter," son of a "master of the art of painting of Poitiers," is recorded from 1742 in Paris, where he studied under Charles-Antoine Coypel and Louis Tocqué.[17] In the early 1750s he copied works in Coypel's studio.[18] He was received as a full member of the Académie Royale as *peintre de portraits* in 1754, and he presented as his reception pieces two portraits in oil on canvas. From a modest provincial milieu, he ascended in capital society, making a good living painting portraits in oil and pastel, serving as *"peintre ordinaire du Roy et de Son Academie Roialle de Peinture et Sculpture"* and active in the art market.[19] Diderot alluded to this conflict when he wrote of Valade as "not a poor [impoverished] painter but a very poor [weak] painter, because we cannot do two occupations at the same time."[20] In theory, academicians were fully employed in the royal service, but in reality most still needed to pursue commissions from more reliable patrons. Thus, though the Académie Royale disparaged trade as demeaning, it turned a blind eye to dealing by academicians.[21]

Although Valade did paint some illustrious persons, they did not sit for him directly; rather he copied their portraits as executed by other artists.[22] Perhaps his rather pedestrian talents lost him access to officials and the elite, or maybe he did not seek their support or protection. His clients were instead from the provincial and professional bourgeoisie. In his 1774 *Portrait of Monsieur Théodore Lacroix* and its pendant of his wife and child, the artist concentrated on the faces while capturing their social aspirations through his loving attention to detail—carefully depicting lace around wrists, cascading neck frills, and taffeta bows—instead of seeking to penetrate their characters.

Valade's technique possesses a dry clarity: he applied the pastel thickly, his technical skill evident in the detail of his painted accessories. His portrait format is repetitive; figures sit conventionally before an interior decor or a neutral, graded ground. He rarely varied poses or assembled several figures in a group.[23]

For thirty years, from 1747, academy and critics were engaged in a campaign to revalorize history painting, despite the obvious popularity of portraiture.[24] To this end Charles-Antoine Coypel, *premier peintre du roi* and new director of the academy, renewed and enriched the academic training of history painters. Although Etienne La Font de Saint-Yenne attacked portraits shown at the Salon of 1746, the best portraitists were still well respected, and portrait production remained strong.

Because Valade faced competition from "exceptional geniuses of all sorts . . . the history of art has not remembered his name after his death."[25] Our knowledge of his life is still full of gaps, and his work presents attribution problems in part because many portraits are in private collections or unknown locations. Eventually Valade stopped painting; instead, by selling art and buying property, a not-uncommon practice for artists, he assembled a decent fortune.[26]

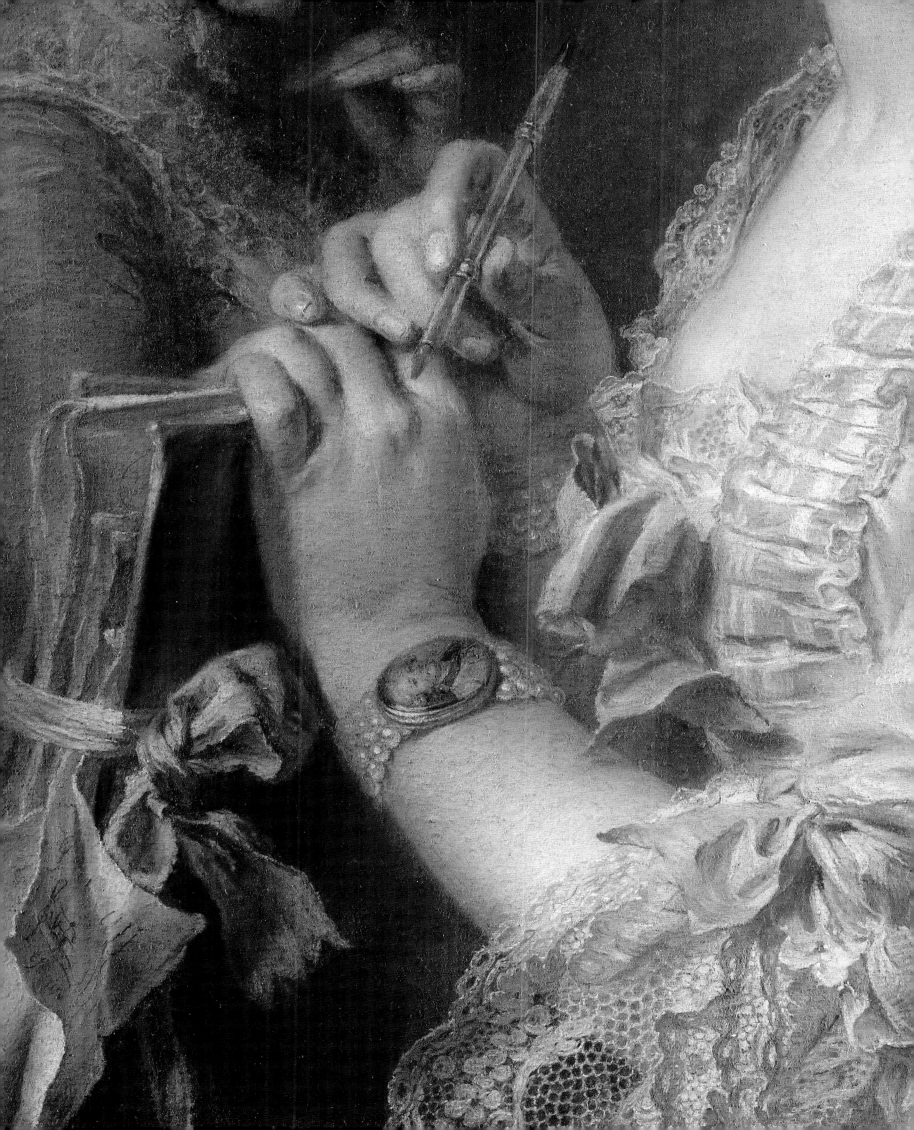

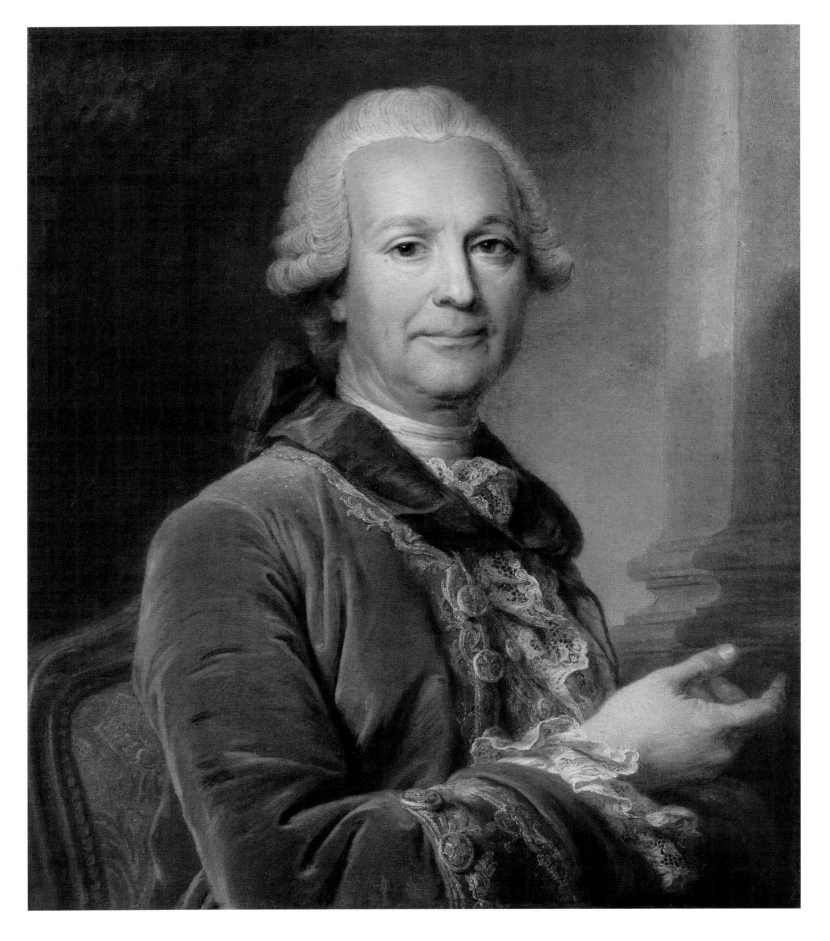

Jean Valade
Portrait of Monsieur Théodore Lacroix, 1774
Pastel on paper, 25¼ × 21¼ in. (64 × 54 cm)
Musée du Louvre, Paris

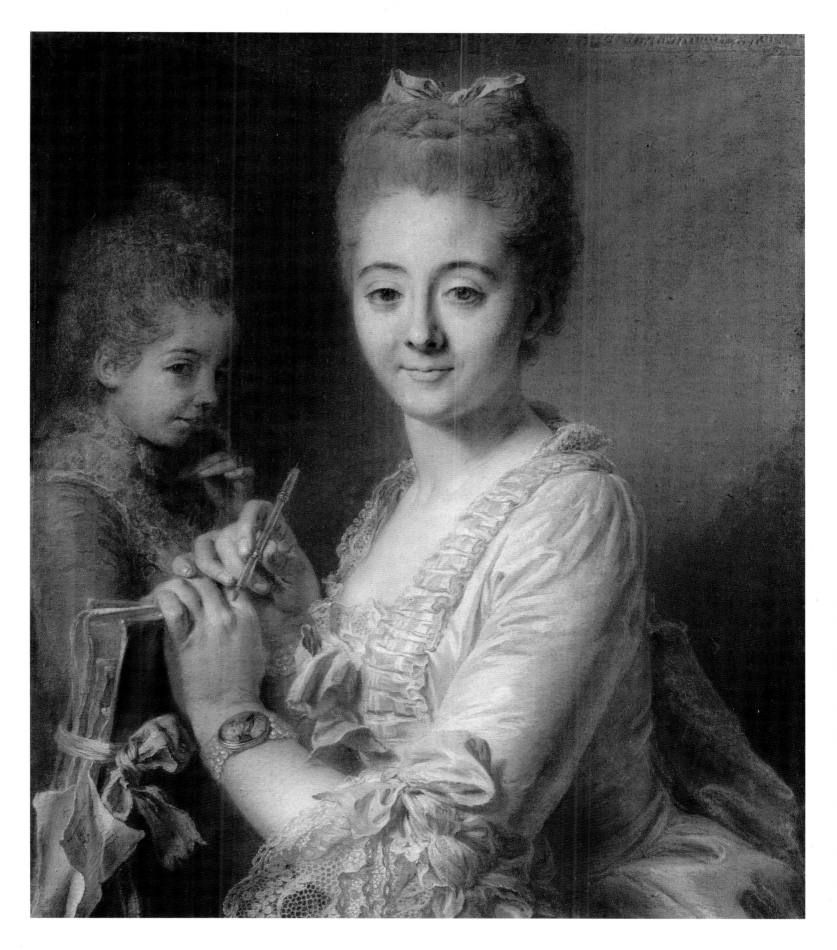

Jean Valade
*Portrait of Madame Théodore Lacroix
and Suzanne-Félicité*, 1775
Pastel on paper, 25¼ × 21¼ in.
(64 × 54 cm)
Musée du Louvre, Paris

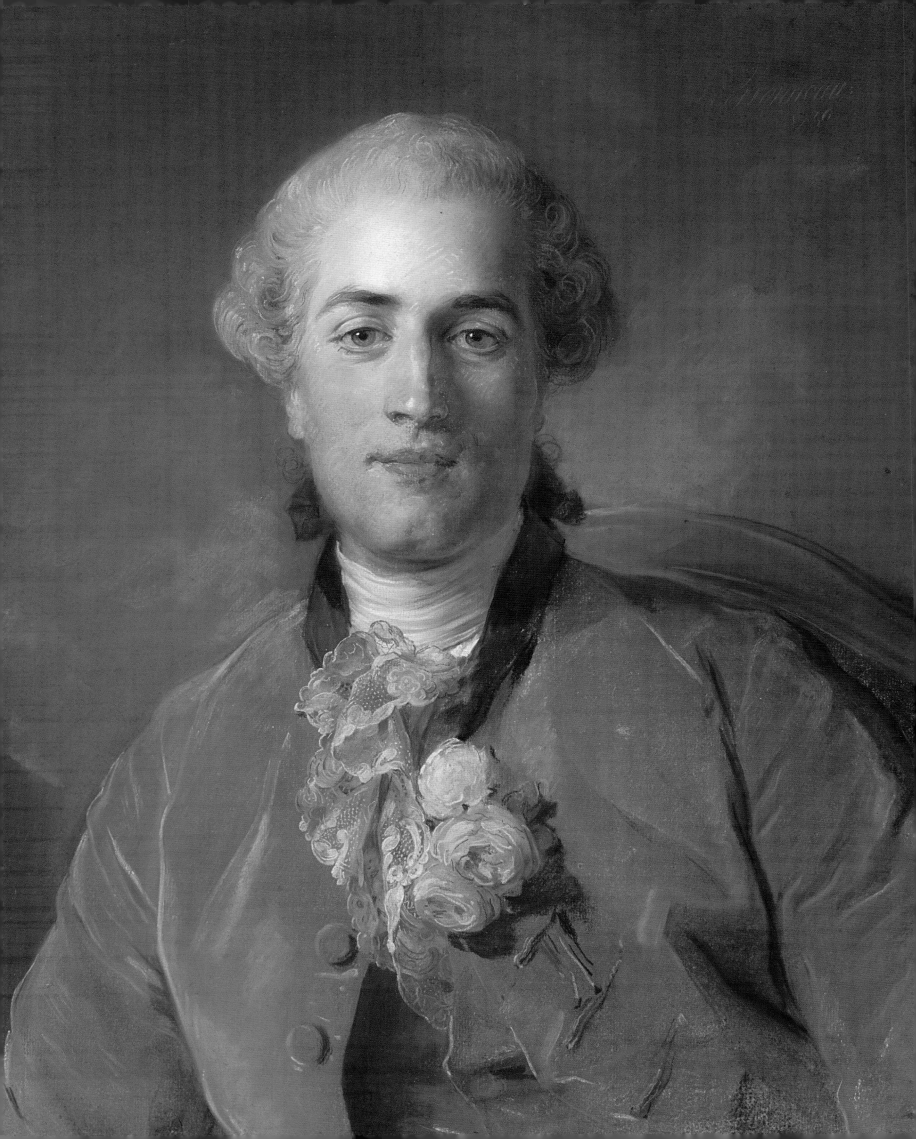

Perronneau studied drawing with Charles Joseph Natoire (1700–1777), court painter and professor at the Académie Royale, and possibly Hubert Drouais (1699–1767), and engraving with Laurent Cars (1699–1771). Realizing that "it was not in him to excel in an art which requires much constancy and patience," by 1743 he had given up engraving and embraced painting "with equal mastery" in oil and pastel.[27] In 1746 he became a provisional member of the Académie Royale, and in 1753 he was received upon the presentation of two oil portraits. He exhibited regularly at the Salon du Louvre. Throughout his life Perronneau experienced financial problems, in part because he failed to build the right connections in the art world. Eventually he died in poverty in Amsterdam.

Contemporary critics admired Perronneau's work. In 1748 Baillet de Saint-Julien wrote, "I believe that one may speak of M. Perronneau after M. La Tour. He follows very closely in his footsteps, and probably should take from his hands one day the scepter of pastel."[28] His facility with both oil and pastel made him sought after as a portraitist. Surviving accounts clarify that pastel original and oil copy could be valued differently by Perronneau and by his patron and serve different functions, intimate and official, depending on context.[29]

Diderot claimed that Maurice Quentin de La Tour's dominance in court and fashionable Parisian circles caused Perronneau to leave Paris in the 1750s and seek portrait commissions in the French provinces and abroad.[30] In Orléans he painted the collector Aignan-Thomas Desfriches, once a fellow student in Natoire's atelier; Desfriches introduced him to the local upwardly mobile bourgeoisie whom he portrayed, including, for example, the codirector of the Manufacture Royale

Jean-Baptiste Perronneau
Portrait of Elisabeth-Victoire de Grilleau, née Seurat, c. 1751
Pastel on parchment,
22 × 15¾ in. (56 × 40 cm)
Musée des Beaux-Arts,
Orléans, France

des Bonnets, façon de Tunis and the founder of the royal sugar refinery and their wives.[31]

Perronneau's portrait of Olivier Journu, the son of a wealthy Bordeaux merchant, is one of several pastels he made of the Journu family. The sitter is shown half-length, directly facing the viewer, a disarming pose frequently adopted by Perronneau. The artist sought verisimilitude in his sitters and concentrated attention on the face. He infused the image with forceful hatching and created crisp details with discrete hard lines. His color harmonies are striking: their infinite variety ranges from soft white and pale yellow highlights of the face through various shades of rosy pink to broken blue and gray shadows and to the rose velvet coat shot with strokes of blue and salmon. Perronneau's contemporaries often admired "the ease and attractiveness of the color."[32] Others, however, were critical: "His color is negligent, his heads . . . seem too sketchy, and I wish that we could not pick out the colors separately."[33] A sitter, Robbé de Beauveset, recorded that Perronneau required lengthy sittings, returning many times to perfect details that troubled him; this contrasts

Jean-Baptiste Perronneau
Portrait of Maurice Quentin de La Tour, 1750
Pastel on paper, 22 × 18⅞ in.
(56 × 48 cm)
Musée Antoine Lécuyer,
Saint-Quentin, France

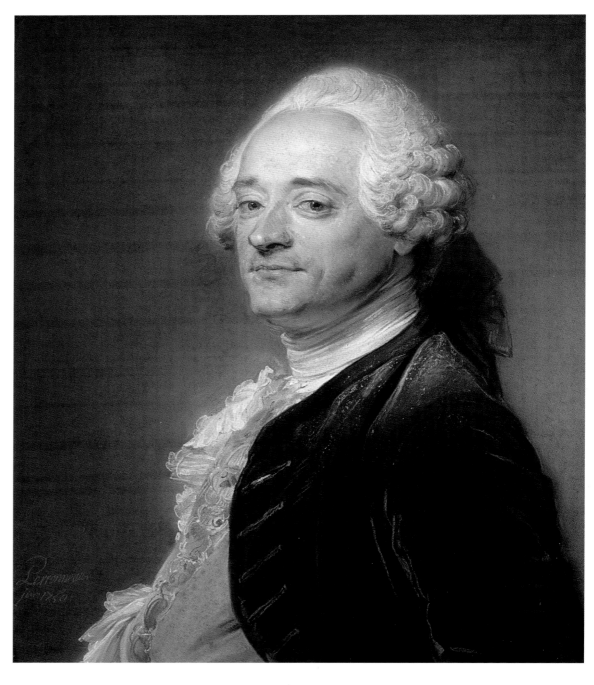

THE GOLDEN AGE OF PASTEL PAINTING

with the impression of spontaneity often given by the play of opposing color strokes and perceived lack of finish in his pastels.[34]

This impression of spontaneity characterizes, for example, his *Young Lady in a Yellow Gown with Blue Ribbons*, painted in pastel on a rough pebble-surfaced blue paper.[35] The unidentified sitter is placed at a slight angle to the picture plane and turns her head to gaze directly, dreamily at the viewer. Pastel was broadly and freely applied in the costume and background, where it is overlaid with bold linear slashes, and particles sit only on the high points of the paper surface. It was applied more thickly over the radiant face and blended with a stump or fingers so that it fills the crevices in the surface, which thus appears smoother than in areas of looser application. Additional unblended pastel strokes define the sitter's hair, cheeks, nose, ears, and eye areas and create a mobile surface effect. The bright blue, yellow, and white strokes of the garment are as broadly and loosely applied as are those in the background. The variations in the artist's touch focus attention on the higher finish of the sitter's face. This is vividly yet delicately colored, "bathed in the luminous

Jean-Baptiste Perronneau
Young Lady in a Yellow Gown with Blue Ribbons, c. 1767
Pastel on blue paper, glued to canvas, 24⅛ × 19⅞ in.
(61.4 × 50.5 cm)
National Gallery of Art, Washington, DC

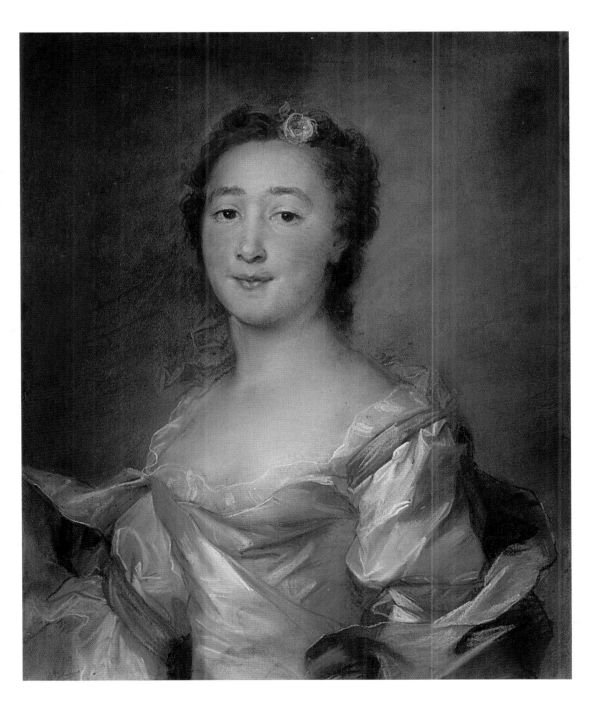

interplay of light and reflections," capturing the mobility of nature with its variety and movement.[36]

ALEXANDER ROSLIN (1718–1793)

Alexander Roslin was born in Malmö, Sweden, in 1718, during a somber period of plague and war that was followed by Russian domination of northern Europe and a peace accord of 1719–21. Subsequent years were characterized by economic development in Sweden and the rest of Europe, although the international political arena remained unstable.[37] Regular artistic contact between remote Sweden and Paris began in the seventeenth century, and France served as the primary model through the eighteenth century for fashionable Europe, including Sweden. The French Rococo painter Guillaume Taraval (1701–1750), a student of Claude Audran III, arrived in Stockholm in 1732 and in 1735 became founding director of the state-sponsored Royal Swedish Drawing Academy, where instruction was based on the hierarchical principles of the Paris Ecole des Beaux-Arts.[38] Its mandate was to train artists to high standards of artistic practice and to produce luxury goods.

Roslin first studied drawing as an apprentice in naval draftsmanship.[39] From 1736 to 1741 he studied portraiture with Swedish court painter Georg Engelhard Schröder (1684–1750), who had studied with Rosalba Carriera. Roslin may have learned from Schroeder to use pastel, though no very early examples survive to confirm this.

Roslin set out to continue his studies in Italy, intending to go eventually to France, as Schroeder did; this was a typical pattern for Swedish painters of the time.[40] First, from 1745 to 1747, Roslin served as court painter at Bayreuth, where his first known pastel was a heavy-handed portrait of Frederick, margrave of Brandenburg-Kulmbach. The choice of pastel may have been deliberate; in 1745 Jean-Etienne Liotard had painted the margrave's wife in pastel. It proved impossible to keep the experienced and costly Liotard at Bayreuth, and luckily Roslin offered the same service, perhaps at a more attractive price.[41] In 1747 Roslin left Bayreuth for Italy, where he stayed four years.[42] Little is known of his activities there. He spent 1750 in Parma, where a newly established Académie des Beaux-Arts benefited from his increasing skill as a portraitist, mostly in oils.

Roslin took up his pastels again in Paris in 1752 and was admitted provisionally to and then fully received as a member of the Académie Royale in 1753 as *peintre de portraits*, despite being a foreigner and a Protestant. It was stipulated that his reception pieces be painted in oils, and once received fully, he showed only three pastels at the Salon.[43] Through the Swedish embassy Roslin was quickly introduced and integrated into powerful circles, gaining access to important art-world figures—Joseph-Marie Vien, the comte de Caylus, François Boucher, and Louis Tocqué among them—and enjoying great success, illustrated by the social standing of his sitters.[44]

In the years following his reception, Roslin painted many portraits of his fellow artists, possibly to cultivate links with them. He also painted foreigners in Paris, visiting Swedes, members of the court, society figures, and *salonnières*. He became very skilled in the illusionist rendering of jewels and fabrics—silks, velvets, satins, and laces—which, along with his color sense, was praised by contemporaries. Diderot observed, "This painter's color is good; he knows how to paint flesh"; however, his poses lacked variety, and he showed little interest in allegorical portraiture.[45] He painted mostly in oil but never abandoned pastel completely. In 1753 he was asked by Swedish collector Count Tessin to copy two French pastels in oil "because pastel suffers on the sea," that is, in travel.[46] In 1765 the Bâtiments du Roi ordered from him a pastel "portrait of the Dauphin, son of Louis XV, 'drawn from

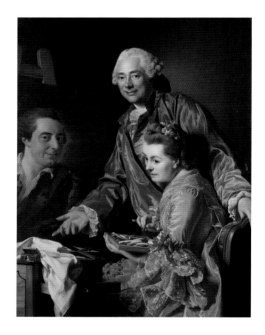

Alexander Roslin
Self-Portrait with His Wife Marie-Suzanne Giroust-Roslin Painting a Portrait of Henrik Wilhelm Peill, 1767
Oil on canvas, 51⅝ × 38⅝ in. (131 × 98 cm)
Nationalmuseum, Stockholm

Alexander Roslin
*The Dauphin of France, Louis
(1729–1765), Son of Louis XV,*
1765
Pastel on parchment,
22⅜ × 18½ in. (57 × 46.9 cm)
Musée National des
Châteaux de Versailles et de
Trianon, Versailles

life,' " and a pastel copy of an original oil portrait of Madame Victoire. In 1766 he painted a pastel portrait of Béatrix de Choiseul-Stainville, duchesse de Gramont, directly from the sitter.[47]

Given his extensive oeuvre, the number of pastels that Roslin executed was limited. However, he never neglected the technique, and in fact he showed an interest in exploring new procedures of fixation, making colors, and preparing supports.[48] After the death of his wife, the pastel painter Marie-Suzanne Giroust-Roslin, Roslin traveled internationally and achieved brilliant successes as a technically accomplished, fashionable, and elegant though reserved portrait painter at the courts of Stockholm, St. Petersburg, Warsaw, Vienna, and Brussels.

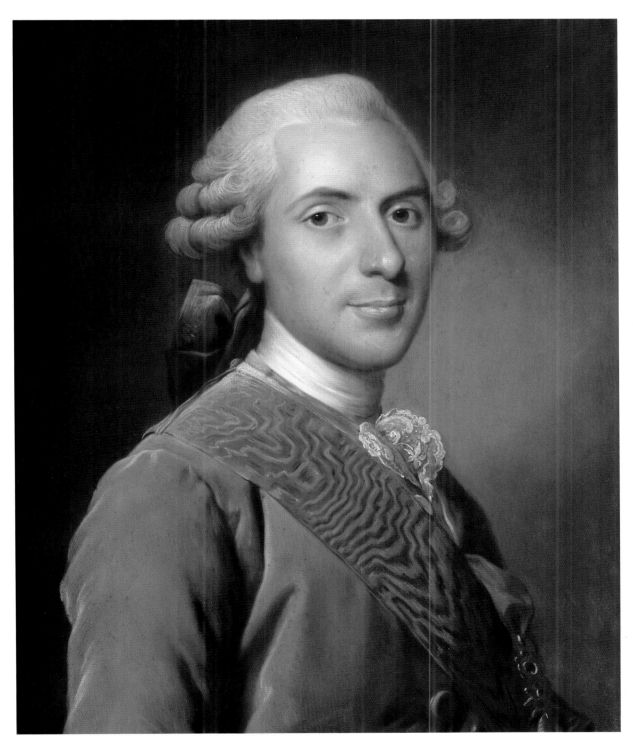

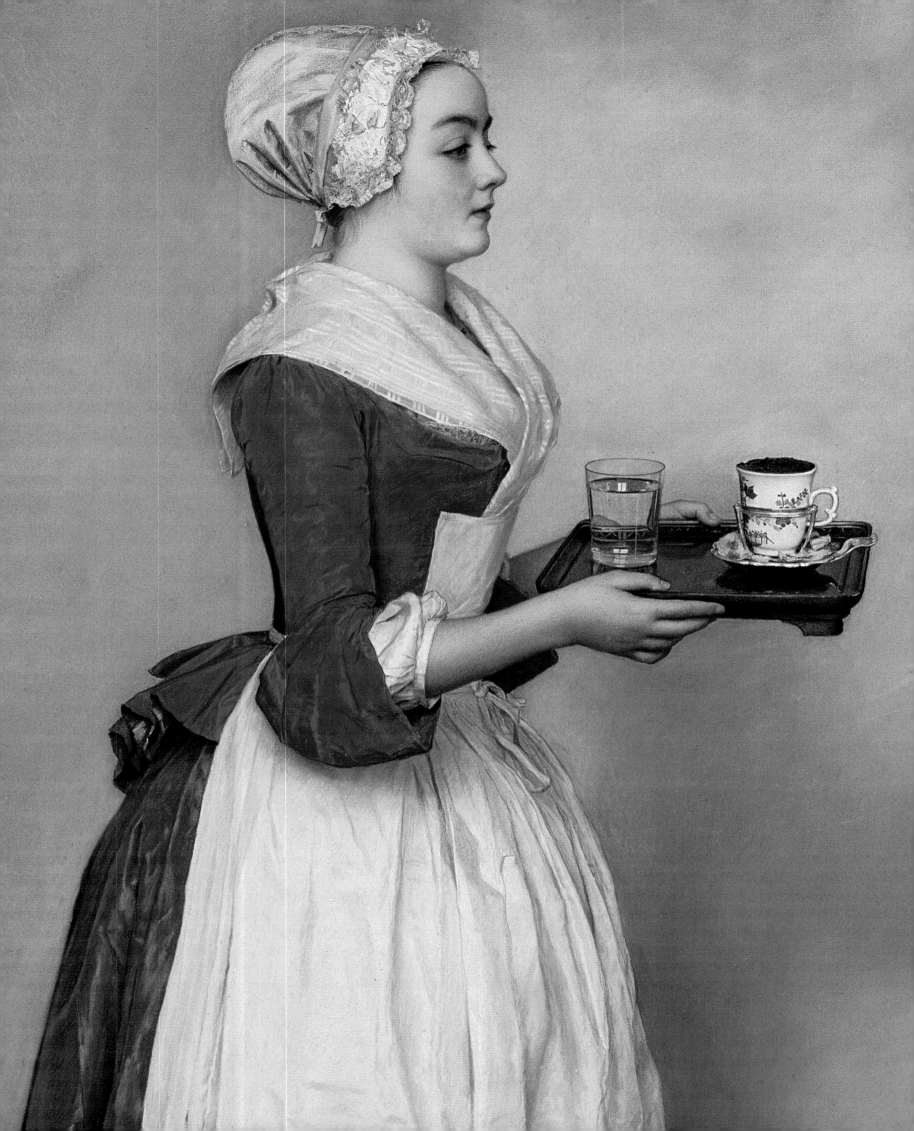

6.

The Turkish Painter: Jean-Etienne Liotard of Geneva (1702–1789)

Jean-Etienne Liotard
The Reader (Marianne Lavergne), 1746
Pastel on parchment,
21½ × 16⅞ in. (54.5 × 43 cm)
Rijksmuseum, Amsterdam

OPPOSITE
Jean-Etienne Liotard
The Chocolate Girl (detail),
1744
Pastel on parchment,
32½ × 20⅝ in. (82.5 × 52.5 cm)
Gemäldegalerie Alte
Meister, Staatliche
Kunstsammlungen, Dresden

*I*n 1745 Francesco Algarotti, acting as agent for Augustus III, purchased the pastel painting *The Chocolate Girl*, executed on a large pieced parchment support, in Venice from the painter Jean-Etienne Liotard (1702–1789). This work depicts a Viennese serving girl, full figure, in profile and carefully dressed; silhouetted against a neutral background, she carries a cup of chocolate and a glass of water across a floor oddly tilted in relation to the picture plane. This, Liotard's best-known work and of a stunning compositional simplicity, was admired by and intrigued contemporary audiences. In the first known description by a connoisseur of a work by Liotard, a 1751 letter to Pierre-Jean Mariette in Paris, Algarotti noted its peculiar qualities: "This painting is almost without shadows on a bright field . . . wholly worked in half-tints and imperceptible gradations of light and is in an admirable relief. . . . And while being a European painting, it would please the Chinese immensely . . . sworn enemies . . . of shading. As for the high finish of the work . . . it is a Holbein in pastel."[1] Algarotti's stress on the minimal shading, graduated light, finish, relief achieved without strong chiaroscuro, and his allusions to shadowless Chinese painting and to Hans Holbein highlight stylistic features that engage viewers today. Liotard achieved great success with an international picture-buying public during his long career; his high prices were often commented on. At the same time he was criticized, sometimes vehemently, by academic detractors who judged his work to be "painstakingly craftsmanlike" and "flat," lacking in perspectival space and mass.[2]

Liotard was a native of Geneva, the son of Huguenot refugees who fled Montélimar, France, after the revocation of the Edict of Nantes (1685). He trained as a miniaturist, enameler, and portraitist, studying briefly (1715/20) with a mediocre painter, Daniel Gardelle (1679–1753).[3] The Protestant republic produced

useful or instructive art objects—watches, clocks, jewelry, and goldsmith's work. Through the eighteenth century the city positioned itself at the high end of this market, and products were decorated, increasingly, with refined portrait enamels and miniatures.[4] Sober portraits provided important records for the local oligarchy and bourgeoisie, as well as souvenirs for foreign visitors. Repressive sumptuary laws and the lack of a princely court discouraged pure artistic display.

Liotard's four-month apprenticeship with Gardelle typified the traditional route for miniaturists seeking a career in city workshops.[5] Liotard's earliest known enamel, *Séléne et Endymion*, signed and dated 1722, is masterful, suggesting that he gained additional instruction in Geneva.[6] Its strong colors, unified surfaces, and detailed observation are traits acquired during his training that persisted throughout his career.

Liotard left Geneva to train further in Paris with the miniaturist, engraver, and academician Jean Baptiste Massé (1687–1767), a Protestant.[7] He stayed three years, from 1723 to 1726; Liotard's son and namesake, his primary biographer, reported only that "he spent them making copies"; he left "in despair at seeing that he had learned nothing," apparently because Massé was a poor teacher. He set up on his own in Paris's vibrant art world to work as a portraitist in miniature, enamel, and pastel "with great success."[8] This suggests he may have actually benefited from his apprenticeship with Massé, an increasingly important figure in the Paris art world.[9] Possibly Liotard mastered pastel while in Paris, but most of his early work is lost.

In 1735 Liotard submitted a history painting to a competition at the Académie de Saint-Luc, but he was unsuccessful.[10] His decision to leave Massé had probably lost him the latter's support, preventing his admission to the Académie Royale; the pastelists Louis Tocqué and Jacques-André-Joseph Aved were admitted in 1734.[11] His failure to penetrate the highest ranks of the French art establishment made the chance to visit Italy attractive, and he accepted an invitation to accompany an embassy to Naples.[12] He spent November 1736 to April 1738 mostly in Rome. His was not the traditional study trip made by young northern European artists; rather, he continued to work professionally as a portraitist and made noncommissioned pastels intended for sale. *Apollo and Daphne*, an interpretation in pastel after Bernini's marble sculpture in the Casino Borghese, reveals no influence from Italian painting but echoes Jean-Antoine Watteau in the diaphanous landscape and warm tonality and François Boucher in the figure of the river god.[13] In Rome he met two English lords, the Earl of Sandwich and the future Earl of Bessborough, who hired him to accompany them to the Levant and record popular dress, prospects, and "noble remains of antiquity" there; no scenes or ruins, and only a few detailed costume studies, survive from the trip.[14]

From 1738 to 1742 Liotard lived in Constantinople. Established as a portraitist and genre painter to the local and expatriate communities, he portrayed ambassadors, envoys, merchants, and Western travelers, often in Turkish robes.[15] Lady Tyrell, wife of the English consul, was depicted in half figure with two hands—the latter a rare feature of Liotard's portraits—and wearing a magnificent dress, its textures captured with detail and clarity. Exceptionally, her hair is unpowdered.[16] Liotard kept one version, now in Amsterdam; he made for the sitter an almost identical—though, it is said, better—version, now in Geneva.[17]

Islam proscribed human images, and the private world of the Turks was inaccessible to Europeans. Thus few works depicting Turks survive; those that do were costumed figures, sometimes part of genre scenes, probably inspired in part by eighteenth-century illustrated travel plates.[18] In his pastel genre scene of a Levantine woman at her bath, dressed *à la turque* and accompanied by a young servant, Liotard rendered the details of the costumes, attributes, and accessories realistically, with miniaturist precision. The picture space is shallow and incompletely described.

OPPOSITE
Jean-Etienne Liotard
Apollo and Daphne, 1736
Pastel on paper, 26 × 20⅛ in.
(66.2 × 51.2 cm)
Rijksmuseum, Amsterdam

OPPOSITE
Jean-Etienne Liotard
Jeanne-Elisabeth de Sellon,
Wife of Sir Charles Tyrell,
British Consul in
Constantinople, 1746
Pastel on parchment,
24⅝ × 19⅛ in.
(62.5 × 48.5 cm)
Rijksmuseum, Amsterdam

Five versions of this composition exist—in pastel on paper, parchment, and in oil on canvas. All have only minimal variations and are the same size; undoubtedly a single, now-lost tracing was used to transfer the design.[19]

In Constantinople, Liotard adopted Turkish garb; ostensibly more comfortable, it also allowed him to circulate more freely.[20] He retained this dress and a long beard, the latter acquired in 1743 during a stay as court painter in Moldavia, on his return to Europe. His eccentric image as the *peintre turc* must have intrigued Westerners and proved an astute form of marketing, but at times it was condemned as a publicity-seeking affectation. His 1744 self-portrait, with its large, ostentatious signature, was an important commission. "Among the vast collection of self-portraits [of artists at Florence], . . . the one of the Genevan establishes itself as one of the most striking . . . by its Turkish allure . . . its incisive appearance . . . and its chromatic unity."[21]

Back in Europe, Liotard served a rich international clientele, staying for extended periods at the courts of Vienna (1743–45), Venice (1745), Paris (1748–52; here he faced stiff competition from Maurice Quentin de La Tour, Jean-Baptiste Perronneau, and Jean Valade), London (1753–55), and Amsterdam (1755–57), moving on when local demand for his work declined.[22] In 1757 he settled in Geneva,

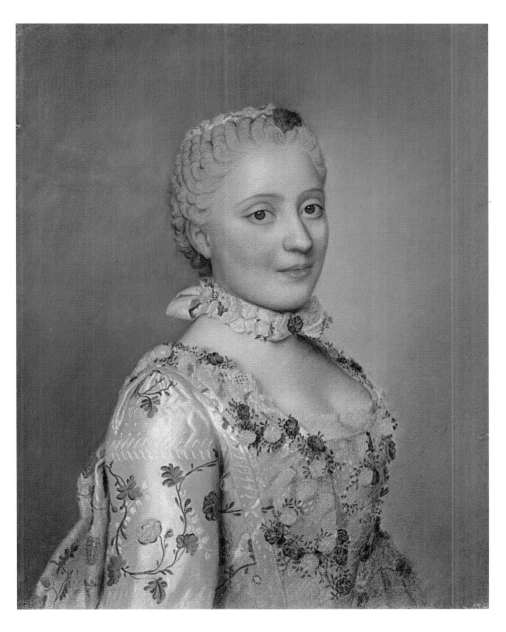

Jean-Etienne Liotard
Marie-Josèphe of Saxony,
Dauphine of France, 1749–50
Pastel on parchment,
16 × 12⅜ in. (40.5 × 31.5 cm)
Rijksmuseum, Amsterdam

where he portrayed the local oligarchy and visiting foreigners, mostly in pastel, and traveled intermittently to seek work and to sell master paintings from his personal collection.[23] Liotard was famous and his work praised during his lifetime, but later it was ignored. Scholarly publications began to appear only after commemorative exhibitions of his work were held in Amsterdam and Geneva in 1885 and 1886. For the French, Liotard remained a second-order provincial painter; only in the late twentieth century did art historians begin to appreciate his oeuvre more fully.[24]

In 1940 Louis Hautecoeur and Arnold Neuweiler proposed that the lightened palette and meticulous execution of Liotard's Ottoman works resulted from his seeing Persian miniatures in Constantinople.[25] Marcel Roethlisberger and Renée Loche denied any such influence, and Anne de Herdt expressed skepticism; recently, however, Kristel Smentek has argued convincingly that an encounter with Turkish, Persian, and Chinese art in the Levant led Liotard to forge a vaguely Turkish style

OPPOSITE
Jean-Etienne Liotard
Lady and Her Servant at the Bath, 1738–42
Pastel on parchment,
28 × 20⅞ in. (71 × 53 cm)
Musée d'Art et d'Histoire, Geneva

Jean-Etienne Liotard
Self-Portrait, 1744
Pastel on paper, 24 × 19¼ in. (61 × 49 cm)
Galleria degli Uffizi, Florence

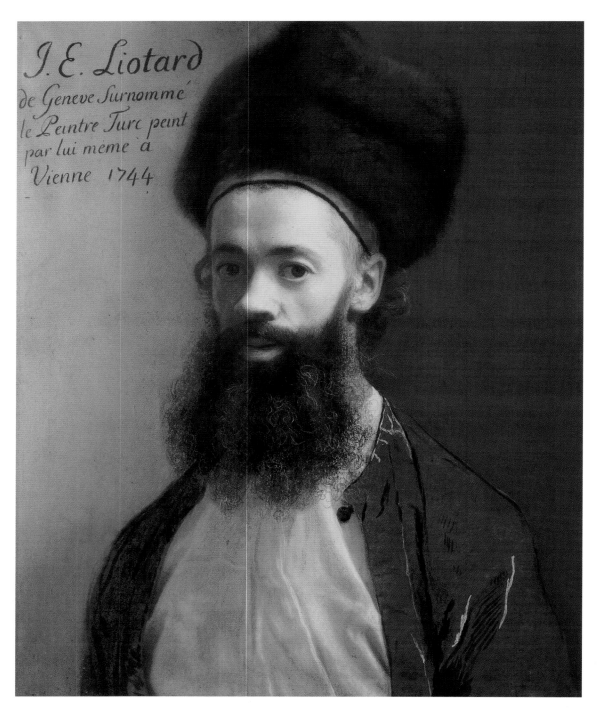

J. E. Liotard
de Geneve Surnommé
le Peintre Turc peint
par lui même à
Vienne 1744

JEAN-ETIENNE LIOTARD OF GENEVA

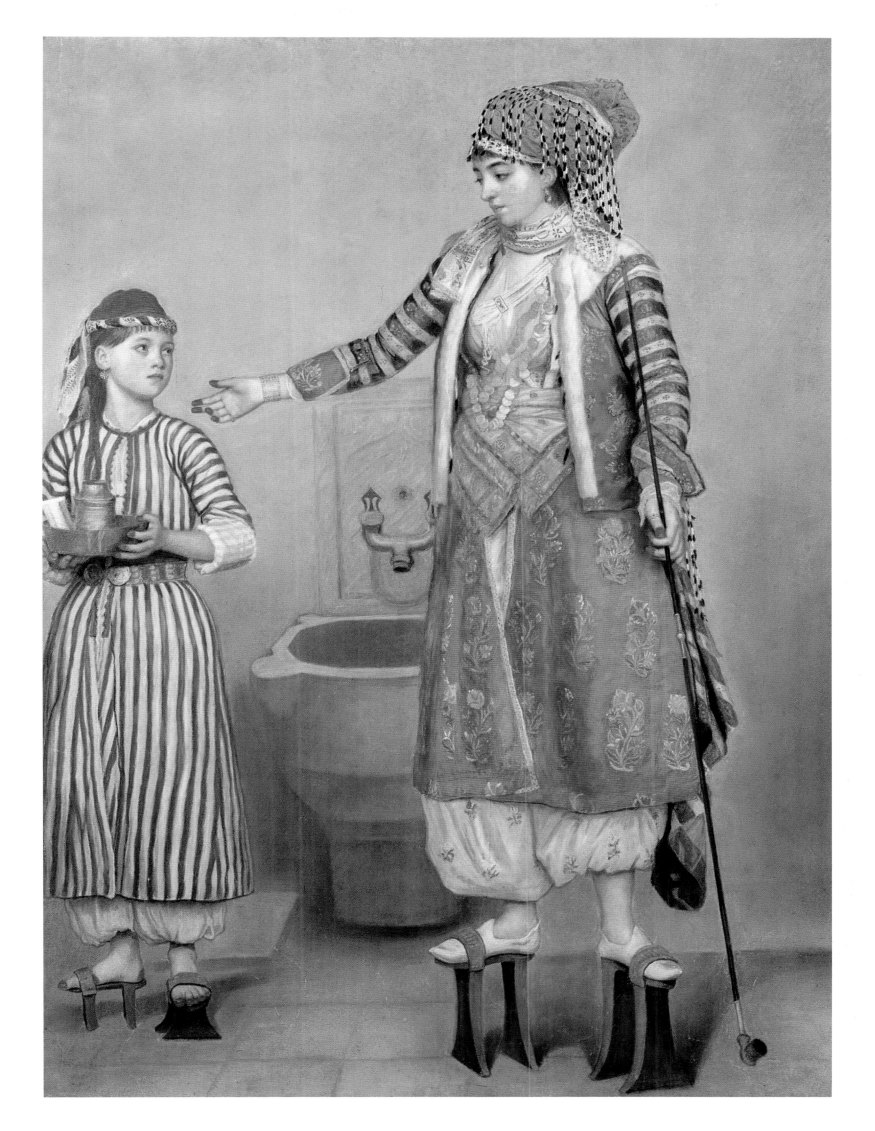

that subtly countered prevailing Western European artistic conventions.[26] Like Algarotti, she singles out the even lighting, lack of strong contrasts, vibrant and saturated colors, and flattening of space in his post-Ottoman painting—all of these being unusual in European art at the time.[27] Smentek suggests that Liotard's exposure to different artistic values may have reinforced the precise line and clear translucent colors he acquired during his early training, so leading him to question European, and particularly French, artistic conventions.[28] She argues that *The Chocolate Girl*, painted in Vienna in 1744 just after Liotard's return from the East, demonstrates his fastidious pastel technique and powers of observation and exemplifies his "Turkish" art.[29]

Between 1738 and the early 1770s, Liotard included dazzling still life elements in a few portraits, and trompe l'oeil and genre scenes—fruit, flowers, and, in *The Chocolate Girl*, porcelain and glass.[30] Still life engaged him as the sole subject of pastels only late in life. Was this choice the result of weakened sight or a decrease in portrait commissions caused by a change in taste or his rightist political stance?[31] In a letter to his son, Liotard characterized still lifes executed in 1782: "These four paintings are fresher and livelier, and the objects are more detached and stand out more.... [They] are truer than those of Vanhuysume [Jan van Huysum, a seventeenth-century Dutch artist whose highly finished still lifes Liotard admired], but they are less finished."[32] One, his *Still Life with Fruit*, is typical—small, sober, modest, uncommissioned, personal, and highly original.[33] It is simply composed with fruit, knife, bread, and napkin ranged across a tabletop. Liotard explored the shallow, indeterminate space by choosing an irregular perspective and a high viewpoint, and laterally constricting the table. The brightly toned table with its short, sharp cast shadows is hemmed in by the unified dark background. Hatching and visible strokes, condemned in Liotard's writings but not in his practice, are more apparent in the late still lifes than in his earlier works, their luminosity, fluidity, and suppleness contrasting with the brittle, factual precision of earlier still life elements. Roethlisberger compared Liotard's still lifes with Chardin's, which, equally simply structured, featured humbler subjects and were executed in Chardin's livelier painterly manner.[34]

Jean-Etienne Liotard
Still Life with Lotto Game,
1760–71
Pastel on paper,
14½ × 17½ in. (36.8 × 44.5 cm)
Musée d'Art et d'Histoire,
Geneva

JEAN-ETIENNE LIOTARD OF GENEVA

Jean-Etienne Liotard
Still Life with Fruit, 1782
Pastel and gouache on
canvas, 13 × 15 in. (33 × 38 cm)
Musée d'Art et d'Histoire,
Geneva

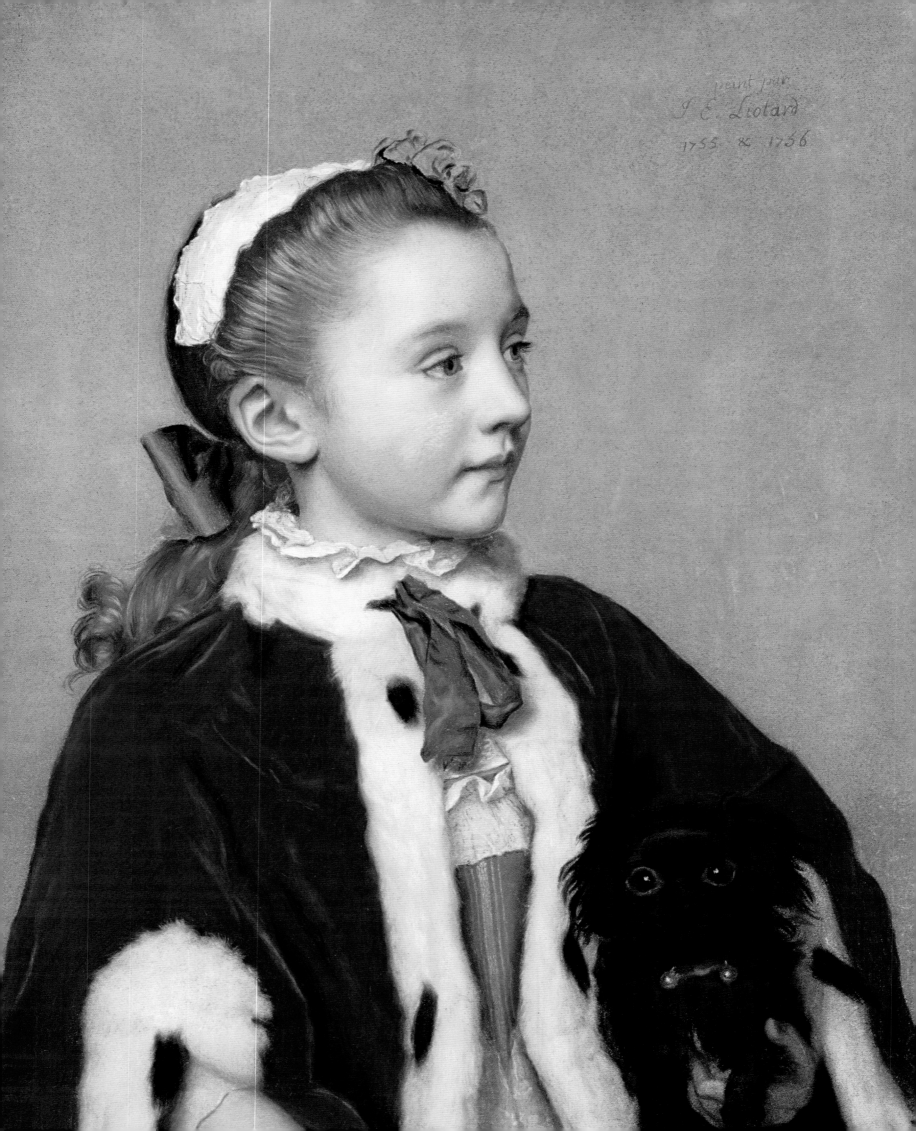

peint par
J E Liotard
1755 & 1756

Opposite
Jean-Etienne Liotard
*Maria Frederike van Reede-
Athlone at Seven Years of Age*,
1755–56
Pastel on parchment,
22½ × 18½ in. (57.1 × 47 cm)
The J. Paul Getty Museum,
Los Angeles

In 1781, at the age of eighty, Liotard published in his *Traité des principles et des règles de la peinture* (Treatise on the principles and rules of painting) his thoughts on the proper functions and processes of painting, a topic he first broached in an essay of 1762 in the *Mercure de France*. Holbein's pictorial realism and smooth finish, noted by Algarotti, provided an antidote to the extravagances and artificiality Liotard perceived in French painting. He declared unnatural the *touche*, or visible stroke, a visual flourish characteristic of much eighteenth-century art, writing, "There are no strokes in nature."[35] This was not how humans actually saw. Yet close looking reveals his frequent use of fine discrete unblended pastel strokes. Also contrary to nature, he wrote, were strong contrasts of light and dark, lack of finish, and excessive use of halftones.[36] Paintings must be judged by their truth to nature and vision rather than by the rules of art, and therefore the untrained viewer was a better judge than the painter.[37] Painting demanded a painstakingly descriptive approach to nature, best exemplified for Liotard by the works of the seventeenth-century Dutch painters—"they resemble nature more—which is even, blended, clear, and without *touches*."[38]

7.

Women Pastel Painters of Late Eighteenth-Century France

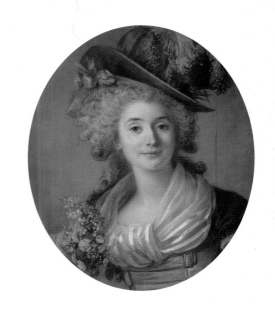

Women at the Académie Royale

Adélaïde Labille-Guiard
Portrait of a Fashionable Noblewoman Wearing a Feathered Hat, c. 1789
Pastel on blue paper,
21⅝ × 18⅛ in. (55 × 46 cm)
National Gallery of Art, Washington, DC

Few women entered the Académie Royale in eighteenth-century France, and many privileges enjoyed by male artists—teaching, voting, holding office, and competing for the Prix de Rome—were closed to those who did.[1] But membership entitled woman academicians to show their art in the prestigious state-sponsored exhibitions held in the Salon Carré of the Louvre until 1791, when entry was opened to all. Membership and exhibition gave women artists visibility, attracting the attention of patrons and critics.[2] Yet at a time when French society placed increasing value on familial ideology, this high visibility made successful women painters "morally suspect and put them at odds with Enlightenment ideals of feminine propriety as did the ambition it took to vie for recognition and patrons."[3] In 1770 the Académie Royale's 1706 policy of no longer admitting women was reversed, and they were again authorized to be received as academy members, but only to a maximum of four at a time.[4]

It would be wrong to assume that few women participated in the visual arts; few, however, attained real eminence without the advantage of academy membership. Many women took part in the later eighteenth-century artistic scene—as practitioners in the king's service and in regional academies, as painters in oil, pastel, and miniature, engravers, students, anonymous workers in family studios, copyists, restorers, teachers, collectors, and patrons. Nonacademic women artists stayed on the margins of art production, often working in the "lower genres" favored by the dictates of fashion and the art market—portraiture, genre painting, still life, pastel portraiture, engravings and luxury objects, like miniatures, and in enamel and glass painting.[5] Women exhibited at all the occasional venues open to extra-academic

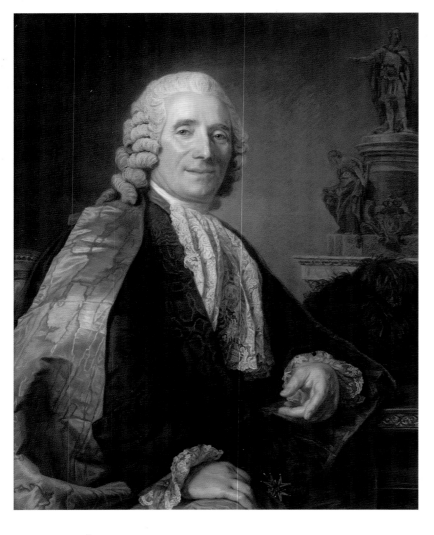

LEFT
Marie-Suzanne
Giroust-Roslin
*Portrait of the Sculptor Pigalle
Wearing the Costume of a
Knight of the Order of Saint
Michael*, 1771
Pastel on gray paper,
35⅞ × 28¾ in. (91 × 73 cm)
Musée du Louvre, Paris

RIGHT
Marie-Suzanne
Giroust-Roslin
*Self-Portrait in Pastel of the
Artist Copying a Portrait of
Quentin de La Tour*, 1771–72
Pastel on blue paper,
36¼ × 43¾ in. (92 × 111 cm)
Private collection

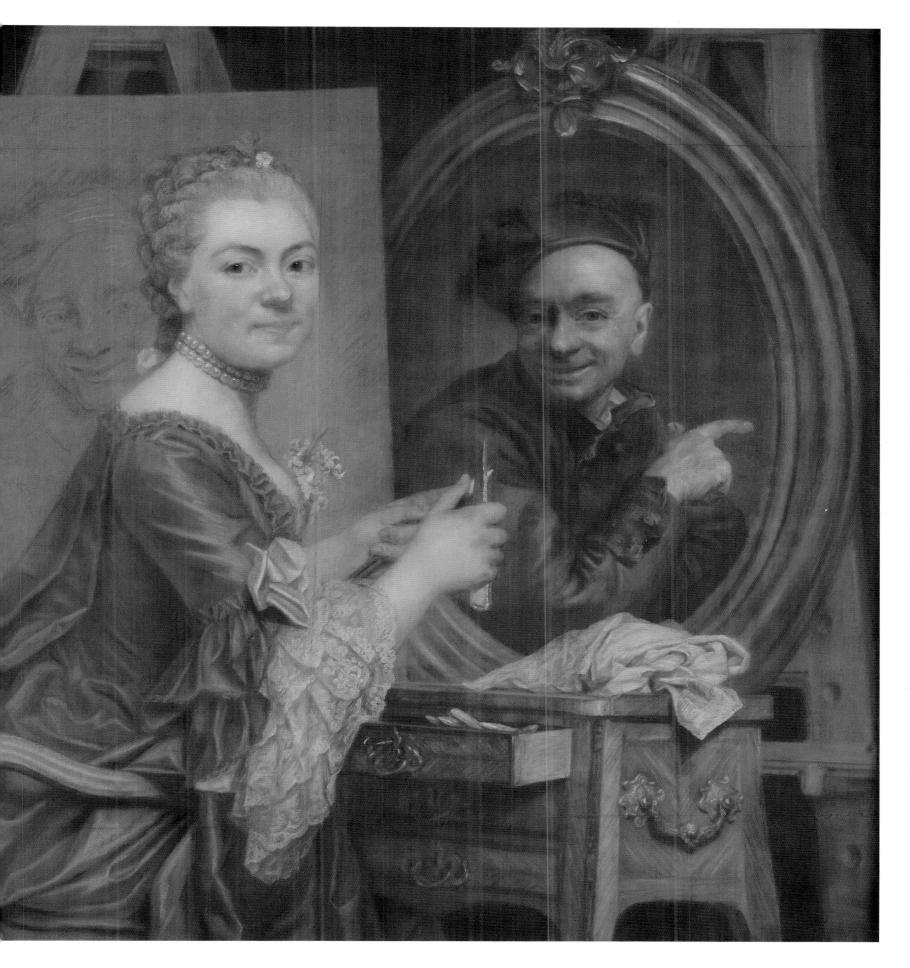

painters throughout the century. Hard evidence about these aspects of the art world is scarce.

MARIE-SUZANNE GIROUST-ROSLIN (1734–1772)

The few women elected to academy membership after 1770 painted in oil and/ or pastel. All were Parisian. The parents of Marie-Suzanne Giroust died when she was a child, leaving her money. She became a painter and studied pastel with Maurice Quentin de La Tour, later entering Joseph-Marie Vien's studio. Around 1751 Giroust met Alexander Roslin there, marrying him in 1759. She was received by the Académie Royale in 1770, as a provisional and a full member simultaneously, in "le genre du Portrait au Pastel." Her reception piece, a pastel portrait of the sculptor Jean-Baptiste Pigalle was shown with great success in the 1771 Salon and praised by Diderot: "It is a good portrait, well composed . . . ; the color is beautiful and strong."[6] Other critics agreed that Giroust-Roslin painted true to nature, making perfect likenesses.

Despite her acknowledged talent, Giroust-Roslin was known primarily as the wife of Roslin and mother of their six children. Nevertheless her *Self-Portrait in Pastel of the Artist Copying a Portrait of Quentin de La Tour* of 1771–72, a veritable manifesto that presents the artist to her audience on her terms, shows her constructing a professional identity for herself, providing insight into how viewers might proceed in their apprehension of the image.[7] She depicts herself as an artist, shaping her pastel stick "as one sharpens a weapon before engaging in combat," while copying a version of La Tour's self-portrait as "the man who laughs."[8] The position of her right arm and its echo in La Tour's self-portrait tentatively identifies Giroust-Roslin with the master of pastel.[9] La Tour's oval portrait, in fact, is placed to function as the mirror that relays the gaze of the artist portraying herself, a reflection that allows her to constitute herself as subject while at the same time banalizing the image of the male artist through its repetition and giving other women direct access to their own image mirrored in the glass.[10]

In the last quarter of the century female artists portrayed themselves practicing painting—as opposed to creating allegories of painting—thus posing publicly the question of their professional status, given the still-discriminatory policies of the Académie Royale.[11] Such images represent an important break with the masculine cultural tradition that made woman the object of man's gaze and not the subject of her own, and which kept women mostly in the margins of the art world as artisans or amateurs practicing decorative art or minor pictorial genres.[12] Roslin's pastel *Self-Portrait* was never exhibited in her lifetime; she died in 1772 of breast cancer.

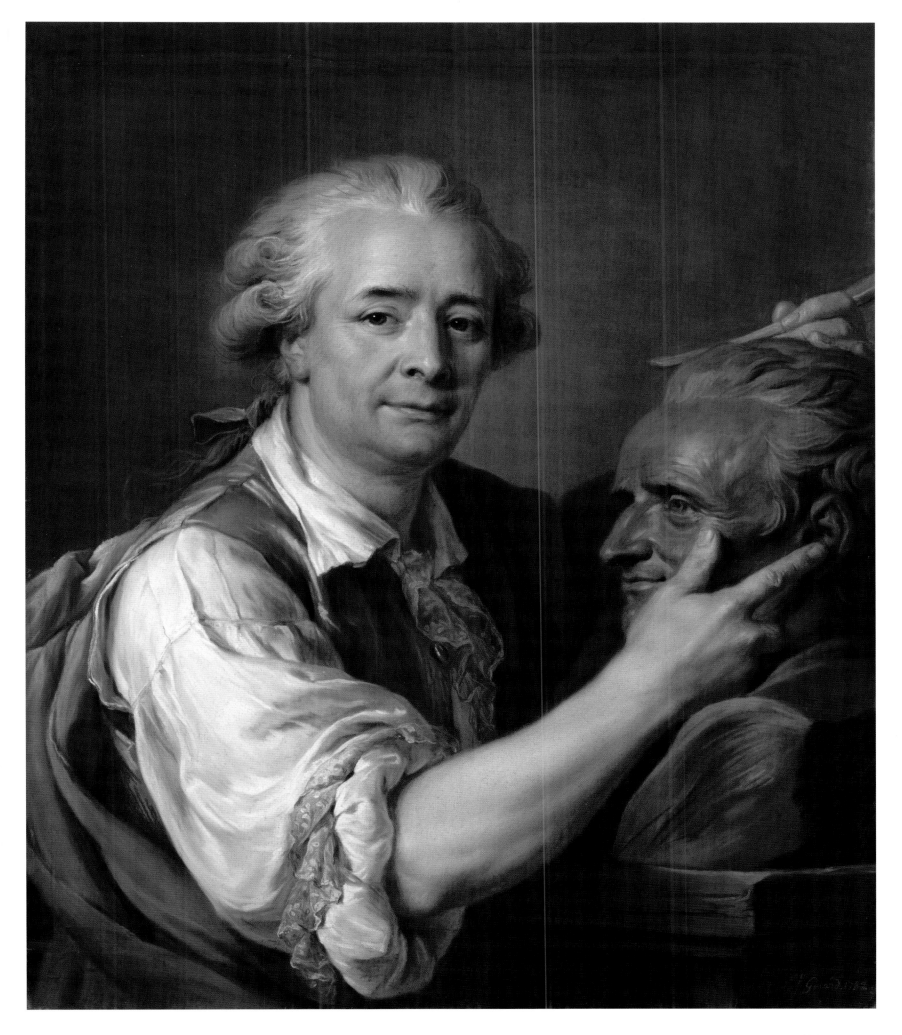

ADÉLAÏDE LABILLE-GUIARD (1749–1803)

Adélaïde Labille-Guiard, the daughter of a haberdasher, was instructed in miniature painting, then considered a suitable accomplishment for women, by François-Elie Vincent, a Paris neighbor; in pastel, also recommended for women, by La Tour (it is said); and in oil by Vincent's son, François-André, who would become her second husband.[13] She was accepted into the Académie de Saint-Luc by the time of her first marriage in 1769.[14] She exhibited a pastel self-portrait on blue paper, along with several other pastels, at the Salon de la Correspondance in 1782.[15] Though known at the time primarily as a pastelist, she portrayed herself holding palette and brushes and fixed her determined gaze, that of an ambitious and hard-working woman, on the spectator.[16] An enterprising businessman, Pahin de La Blancherie, who established this salon as a shop, meeting, and exhibition space after the dismantling of the guilds in 1776, described the artist's handling of pastel to be "*mâle* [a firm self-assured stroke, strong and colorful[17]] and firm, quite rare in this type of painting."[18]

To attract patrons among the Paris elite and support for her bid for election to the Académie Royale, Labille-Guiard, who had left her husband and needed to support herself, established a link with a group of well-placed male academicians by painting them in pastels (1782–83) that she exhibited.[19] She also exhibited pastel portraits of influential members of the Comédie-Française.[20] Presented to the Académie Royale by Roslin in 1783, she was elected according to the ordinary procedure for accepting women:[21] "She wished to be judged and not protected."[22] One reception piece, a pastel portrait of the sculptor Augustin Pajou, was chosen from among the portraits she brought to an academy meeting. She was to present an oil portrait later (from 1749 the regulations required the presentation of at least one portrait in oil), and from this time on she increasingly painted in oil.[23]

Around 1780 Labille-Guiard had opened an atelier where young women studied pastel and miniature painting; they exhibited their work publicly, playing a role in the Paris art scene that increasingly could not be ignored.[24] Her enormous *Self-Portrait with Two Pupils, Mademoiselle Marie Gabrielle Capet and Mademoiselle Carreaux de Rosemond*, painted in oil and shown at the Salon du Louvre in 1785, is a manifesto in favor of artistic training for women; to be sure that the viewer got this message she showed the back of the painting and arranged the gazes of her female pupils to suggest that the spectator is actually present at, and the model for, this painting lesson.[25]

After the success of this portrait, Labille-Guiard was protected by the king's aunts, becoming *premier peintre des mesdames* in 1787. Her half-length pastel *Madame Elisabeth de France*, exhibited at the 1787 Salon, was a study for a full-length oil, ambitious and monumental in style and her first important commission.[26] She would have traveled to the royal residence to work on the life study and then taken it to her studio with the garments and accessories needed to paint the oil. Although the study is informal, it is complete and differs from La Tour's more linear preparatory studies, which focused on the sitter's face.[27]

Labille-Guiard drew closer to the seat of royal power and received important commissions for oil paintings just as the French Revolution unfolded. In the altered political and economic circumstances, she turned her attention from painting to politics and, with the collapse of the elite portrait market and destruction of many of her royal portraits, to survival, reinvention, and retrenchment.[28] She survived by making clear her support for the revolutionary cause, and she died in Paris in 1803.

Adélaïde Labille-Guiard
Madame Elisabeth de France
(detail, left; complete
picture, above), c. 1787
Pastel on blue paper,
31 × 25¾ in. (78.7 × 65.4 cm)
The Metropolitan Museum
of Art, New York

ELISABETH LOUISE VIGÉE LE BRUN (1755–1842)

An enormously successful and versatile painter, Elisabeth Louise Vigée Le Brun was taught by her father, the guild painter Louis Vigée (1715–1767), until his death. Although she also studied with friends of her father, Gabriel Doyen and Joseph Vernet, and copied works in private collections, she was, according to her much later autobiography, *Souvenirs*, in part self-taught.[29] By 1770 she set up her own portrait studio. According to the statutes of the Académie de Saint-Luc, it was illegal for a member to engage independently in trade, and in 1774 she was forced to seek the protection of the guild. In 1776 she married the successful and savvy art dealer Jean-Baptiste Le Brun.

Her career blossomed, and in 1778 she gained the king's protection. This led to her reception in the academy in 1783 by order of the king rather than by vote of the academicians.[30] Marriage to a dealer disqualified her under the academy's rules.[31] The powerful *premier peintre du roi*, Jean-Baptiste Marie Pierre, objected to her election, and her contemporaries, offended by Marie-Antoinette's conspicuous patronage, thought Vigée Le Brun too ambitious for seeking to be admitted as a history, not portrait, painter; history paintings usually featured subjects depicting the male body in heroic action, which women's modesty excluded them from painting.[32] The reception piece she presented was *Peace Bringing Back Abundance* (1780), an allegorical history painting in oil, albeit without male bodies, but nevertheless a confrontational choice that de facto forced the academicians to rank her as a history painter.[33] She chose pastel for an allegorical painting, *Innocence Taking Refuge in the Arms of Justice* (1783), a pendant to her reception piece and painted for Marie-Antoinette. Soon thereafter the number of women academicians was limited to four. Vigée Le Brun continued to exhibit at the academy salons, where her works attracted attention and where enlightened critics acknowledged her talent for history painting. Her financial situation, however, forced her to paint more lucrative portraits.[34]

An ardent royalist with aristocratic connections, Vigée Le Brun left France in 1789 and traveled for years, settling for a time in Italy, Austria, and Russia, creating a new clientele at each locale "through the sheer dynamism and charm of her talents" and earning a considerable fortune.[35] She returned to Paris in 1802 but, failing to receive commissions in the post–revolutionary city, went for a time to London.[36] She finally settled in Paris in 1805.

Simone de Beauvoir regarded Vigée Le Brun's flattering self-portraits as indicative of her narcissism.[37] However, they must be understood in the context of motherhood as a late eighteenth-century trope and increasing hostility to women in the public sphere.[38] In them the artist sought to undermine prevailing assumptions about women. At a time when female virtue was increasingly defined by women's confinement to the domestic arena and female dignity lay in "being ignored," the competitive display by women of self-portraits in public exhibitions was construed as an unnatural, even suspect activity.[39] Like other female academicians, Vigée Le Brun had to negotiate a careful path between maintaining her public visibility and her reputation. She appropriated conventional tropes of masculine genius to place herself in the tradition of the great masters.[40] Her skillful pairing of pendant portraits, the self-portrait with her daughter known as *Maternal Tenderness* (Salon of 1787), its composition echoing Raphael's *Madonna della Seggiola*, and her forceful

Elisabeth Louise Vigée Le Brun
Innocence Taking Refuge in the Arms of Justice, 1783
Pastel on paper, 41 × 51⅛ in. (104 × 130 cm)
Musée des Beaux-Arts, Angers, France

portrait of Hubert Robert (Salon of 1789), a friend and fellow artist, two chromatically harmonious images in oil on identical panels, produced meanings on various levels. It showed Vigée Le Brun's ability to paint in male and female modes and stressed the subjects' equality as artists—"Here are two artists: one of them also happens to be a mother."[41] The quintessential maternal imagery of 1787 is undercut and reformulated in the pairing to define what it meant to be an artist in the 1780s by pointing to variables relating to gender.[42]

Vigée Le Brun's imposing and ambitious portraits of powerful men and prominent women were executed in oil. She used pastel through her long career, particularly when she traveled, as she often did later in life, since it was more portable, required less space and fewer materials, and was more straightforward to work with. Her heads are animated compared to those of her contemporaries, informed by her interest in the popular genre of *têtes d'expression*, heads or busts in poses of heightened emotion.[43] She focused on resemblance and explored moods rather than permanent character traits. Sometimes she transfigured reality by idealizing or mythologizing sitters, a portrait type in vogue in the late eighteenth century that served to ennoble female sitters or convey their social status.[44]

Undoubtedly Vigée Le Brun selected pastel for landscapes made during visits to Switzerland (1807–8, 1809) because of its portability. She executed these works to preserve for herself her impressions of the mountains that she described in letters to a friend as splendid, raising feelings of terror.[45] The landscapes were dispersed after her death, and only a few survive. A large pastel, freely composed and executed and representing Mont Blanc, was made during a visit to Chamonix in 1807.[46] The image is romantic in feeling and reflects her description of the rugged landscape:

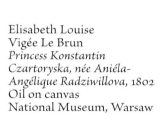

Elisabeth Louise
Vigée Le Brun
Princess Konstantin
Czartoryska, née Aniéla-
Angélique Radziwillova, 1802
Oil on canvas
National Museum, Warsaw

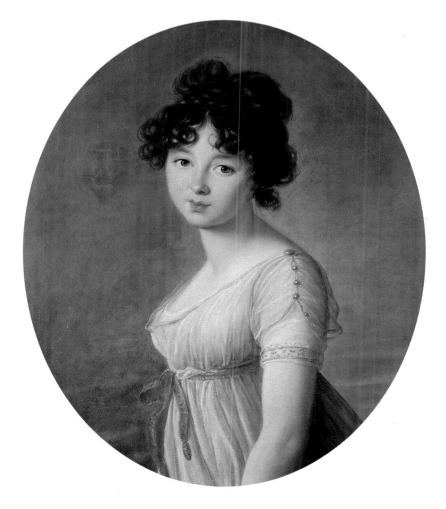

"This sad Chamouni . . . its lofty mountains of black pine trees . . . interrupted by huge glaciers. . . . All in all, this wild place astonishes, but it does not charm."[47]

The emancipatory spirit of the 1770s and 1780s was broken by the misogyny of the French Revolution and the increasing exclusion of women from art institutions.[48] In her *Souvenirs*, Vigée Le Brun summed up the change: "Women reigned then, the revolution ousted them."[49] Published at age eighty, her *Souvenirs* are part art memoir and part autobiography, a personal account of the last years of the ancien régime and its art establishment and a chronicle of her travels in exile as remembered in old age, documenting her "astute recognition of the strategic importance for a woman to forge personal myths of her own."[50]

Elisabeth Louise
Vigée Le Brun
Aglaé de Barbentane, Countess of Hunolstein (1756–98), 1777
Pastel on paper,
28¼ × 22⅞ in. (73 × 58 cm)
Private collection

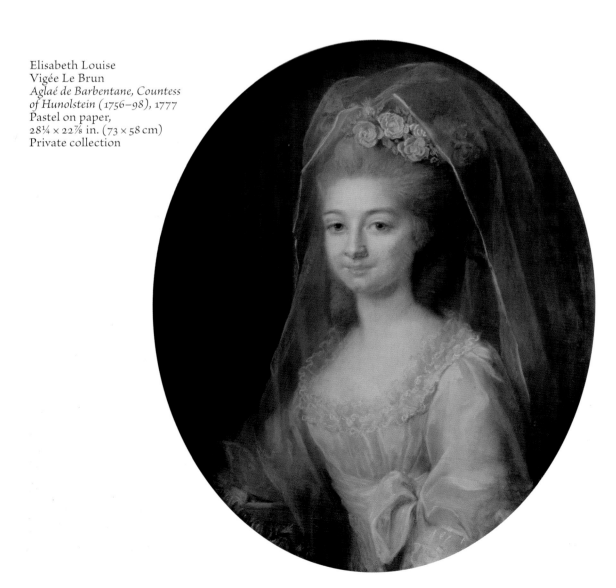

WOMEN PASTEL PAINTERS

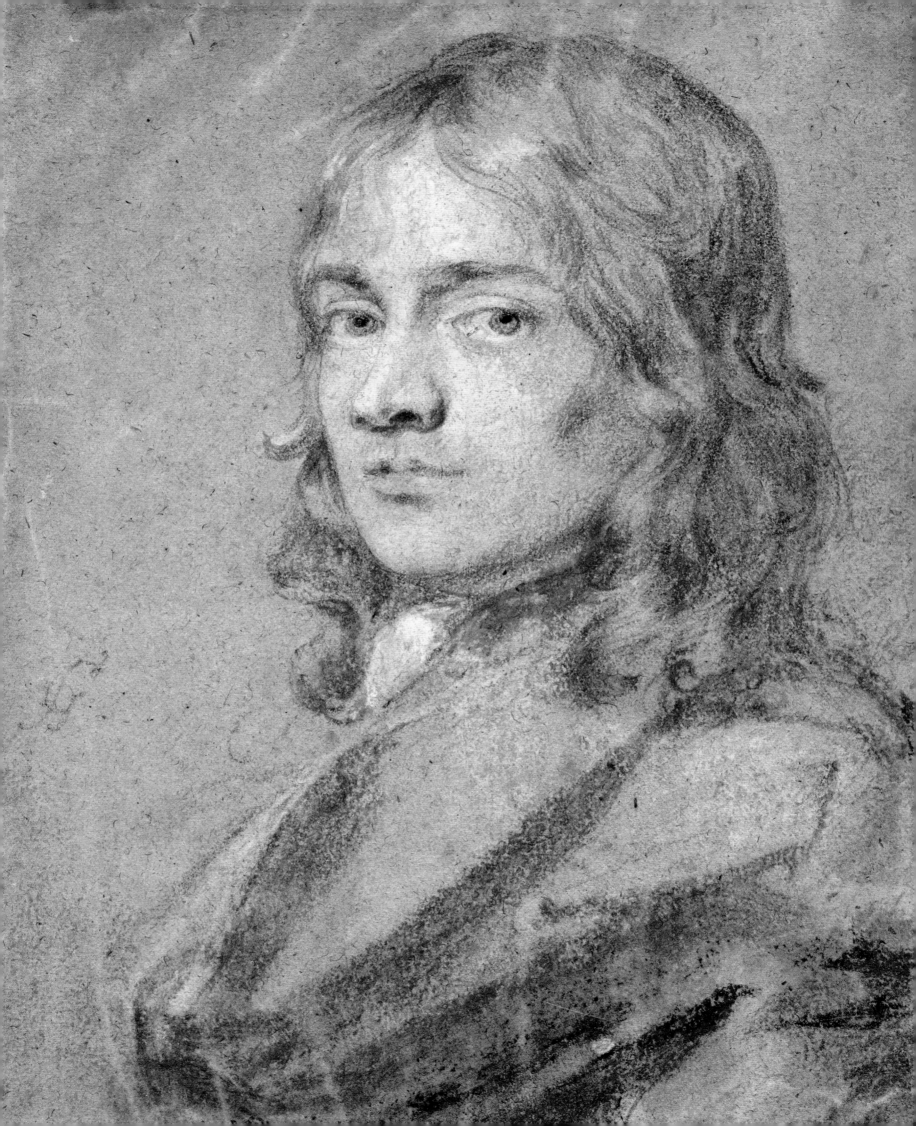

8.

British Pastel Artists
in the Seventeenth
and Eighteenth Centuries

Sir Peter Lely
*Portrait of Sir Charles
Cotterell*, c. 1660
Colored chalk on gray-
brown paper, 10⅞ × 7⅝ in.
(27.7 × 19.4 cm)
British Museum, London

Early Days in England—

Sir Peter Lely, John Greenhill,

Edmund Ashfield, Edward

Lutterell

*A*public for portraiture emerged about 1640—a public who commissioned, purchased, collected, viewed, and talked and wrote about portraits, and included individuals who made them as a leisure activity. In later seventeenth-century England, Sir Peter Lely (1618–1680), Charles II's principal painter, made small portrait heads of beauties and aristocrats of the Restoration court in dry friable colored drawing sticks on paper. Signed and sometimes dated, they were unrelated to his oil portraits and conceived as independent works of art. Called *craions*, they were executed in black, white, and colored chalks—the color usually restricted to the face—on brown, buff, or gray paper. A number were found in his studio at his death, framed in ebony and glazed.

John Krill summarized historical English terminology for dry friable drawing sticks: "During the seventeenth, eighteenth and early nineteenth centuries 'chalk' referred to sticks cut from naturally occurring stone; they were white, black or red. 'Crayon' and 'pastel' most often referred to pigments which were mixed . . . and rolled into sticks; they came in many colors. Occasionally 'crayon' [*craion*] was used as a general name for all colored earths, whether chalk or pastel."[1] Today the English term *crayon* refers to a wax-based colored drawing stick.

Detailed instructions for fabricating drawing sticks, referred to as "pastels" and obtained from Lely's assistant, survive in the correspondence of Constantijn (1596–1687) and Christiaan (1629–1695) Huygens.[2] Despite the limited color range of Lely's sticks, they were not natural or fabricated chalks but mixtures of pigments—pastels—made as a set calibrated to perform homogeneously in painting to convey a subtle range of flesh tones. Henry Peacham, author of *The Gentleman's Exercise* (1612), indicated that amateur artists were not expected to grind their pigments or

prepare colors, which may or may not indicate the existence at that time of professional artists' colormen. However, from an advertisement in Alexander Browne's *Ars Pictoria* (1675), it is clear that Browne has established himself as a colorman, prepared to "grind colors himself" and to supply "all other materials useful for limning."[3]

The portrait painter John Greenhill (1644–1676), active in Lely's studio from 1662, produced *craion* portraits similar to Lely's. Some were larger and more fully colored than Lely's, closer to the highly finished mixed media portrait studies of Edmund Ashfield (1640–1679) and his pupil Edward Lutterell (c. 1650–before 1737).[4]

In the later seventeenth and early eighteenth centuries, English artistic production was dominated by foreign artists with large, efficiently run studios, including

the Dutch Lely and the German-born Sir Godfrey Kneller, and the market by fashionable imported master paintings. Portraiture, the genre most in demand, was "a manifestation and a symbol of power . . . a [selective] reflection . . . clouded by the desire to impress, to embody the superior . . . qualities of the subject, and to project a sense of confidence about the longevity of the subject's family."[5] A realistic likeness that gave off fewer power signals might at times be preferred to an idealized or improved likeness, but mostly clients liked to be flattered.[6]

GEORGE KNAPTON AND ARTHUR POND: A NEW FASHION—PASTEL PORTRAITS

Native painters faced obstacles in their struggle for respectability because English, like continental, society traditionally placed greater value on intellectual than on manual labor. Increasingly, however, painters claimed a liberal status for their art while, of necessity, continuing, incompatibly, to work with their hands for money.[7] George Knapton (1698–1778) is sometimes held responsible for developing a British tradition of pastel portraiture.[8] From 1715 to 1722 he apprenticed with Jonathan Richardson Senior (1667–1745), a late Baroque portraitist and influential connoisseur. Richardson's ideas "on the elevated roles of art and the artist, on the socially beneficial effects of training in art and connoisseurship, and on the importance of [visiting] . . . Italy" influenced Knapton.[9] There were no organized art academies in England nor was great art readily accessible in churches or palaces, as it was on the Continent, so Knapton traveled abroad to supplement his training, studying painting in Italy (1725–32). He worked in several genres and moved in Grand Tour circles, coming to the attention of British aristocrats in Rome. He returned to London where, assisted by contacts made in Italy, he established a reputation and clientele as a portraitist.[10] In 1743 George Vertue, the antiquary, listed Knapton as one of "the best available painters."[11]

Arthur Pond (1701–1758), like Knapton a member of a prosperous City of London family, studied under John Vanderbank (1694–1739), who painted in a "dry, late baroque style" and, possibly, Richardson.[12] Pond traveled to Italy with Knapton.[13] On his return to London in 1727 he set up as a painter, eventually working also as a print seller and art dealer. Surviving documents relating to Pond's activities from 1734 to 1750 provide a rich picture of the art world in this transitional period of economic growth and burgeoning wealth (particularly among affluent middle-class professionals), increasing interest in the work of continental artists, and changing forces in the London art market.[14] The range of Pond's entrepreneurial activities suggests that specialization, though increasingly pursued, was still impractical for an ambitious painter; commercial practices, structures, and audiences, though evolving, were unreliable.[15] Until the founding of the Royal Academy in 1768, an artist's success depended on the direct commissioning of works of art; Pond found clients through his membership in private clubs, which, until about 1760, provided stimulating environments for creative developments and determined the internal organization of the art world.[16]

Continental artists had established the suitability of pastel for portraiture. Young English "milords" on the Grand Tour commissioned elegant pastels in soft intimate rococo styles in Italy and Paris and sent them home. Such portraits became popular in England by the 1730s and 1740s, just as Knapton and Pond sought to break into the lucrative London art market; pastel gave them a competitive edge over established portraitists in oil. Pastel was particularly appropriate for a young painter with limited means—it required no assistants, and was worked on a small scale (fixed by the dimensions of glass) and speedily executed. It required fewer sittings and simple cheap materials; thus finished works were competitively priced rela-

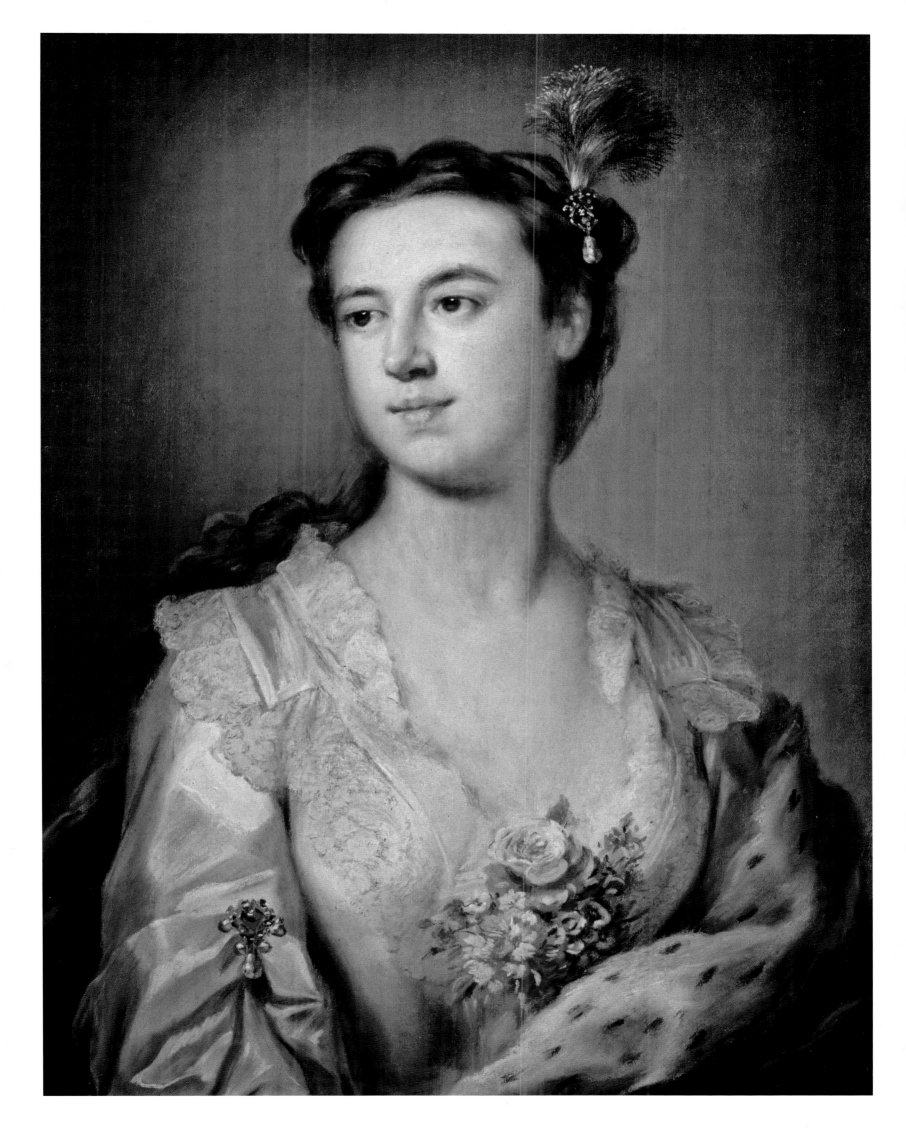

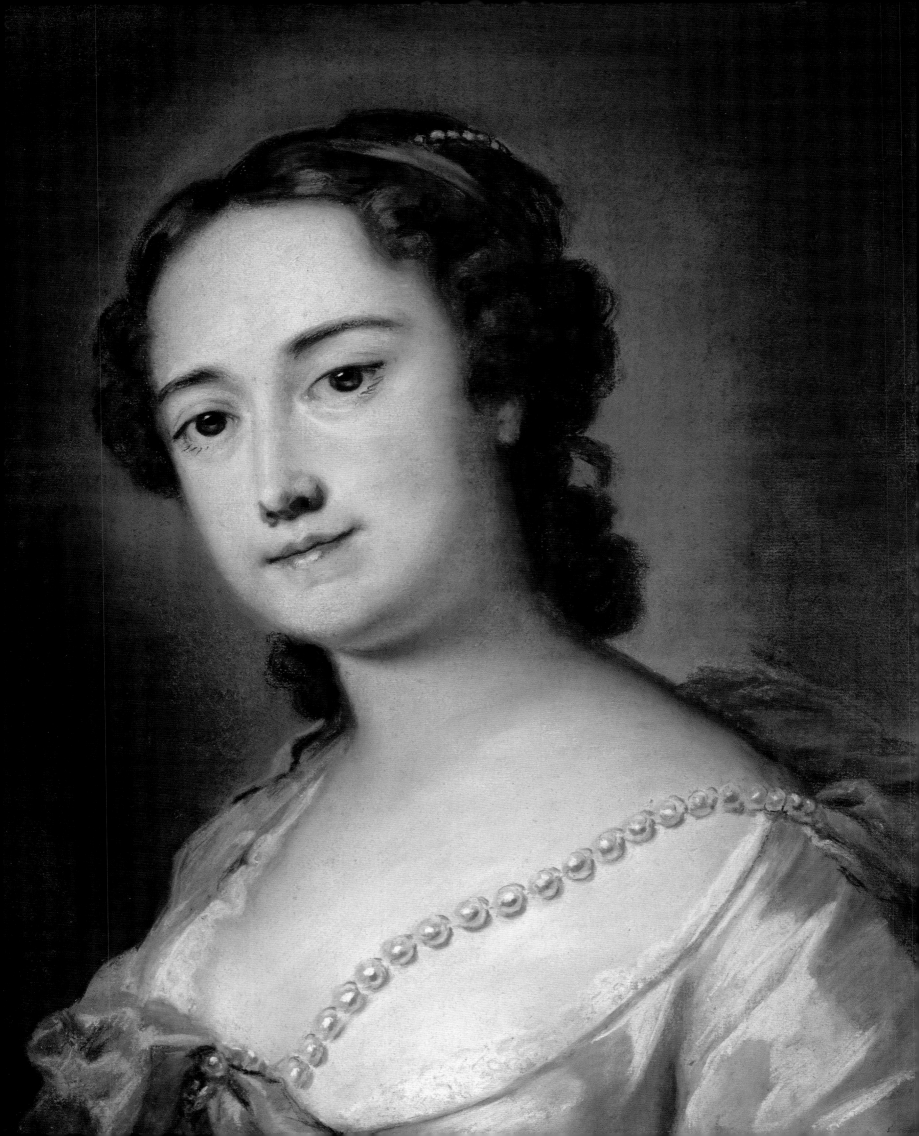

tive to oils.[17] Knapton and Pond gained a reputation for expertise in this specialty and found an enthusiastic market for their pastel portraits, which attempted to emulate the soft, gentle qualities, delicacy, characteristic palette, and attention to textures of skin and fabric of Rosalba Carriera's pastels.[18] They may have seen her pastels on the Continent and certainly knew works brought to England.[19] The close relationship of their work to hers has confused attribution; a portrait of Margaret Nicol, Marchioness of Carnarvon (1753), long attributed to Carriera, may be by Pond.[20] Neil Jeffares has noted many insecure attributions to English early eighteenth-century pastelists in his online *Dictionary of Pastellists.* Copying Carriera's works was, in fact, a profitable activity.[21]

In the late 1740s Frederick, Prince of Wales, commissioned pastels of his children from Knapton; they were emblematically portrayed according to the prince's directions.[22] Pond too painted small intimate portraits of women and children and only rarely made male or full-length portraits.[23] His production was high, and his prosperity grew: Lippincott estimated that in his busiest years (1738–1740) Pond averaged over a portrait a week during the London social season. The conventions of portraiture broadened to accommodate the emerging middle class based in trade and commerce, while the rare lower-class sitter was shown free of pretensions.[24] In the 1740s Pond switched to oil painting; Lippincott has described the challenges he experienced.[25] Increasingly Knapton gave up painting to concentrate on connoisseurship. In 1765 he became "Surveyor and Keeper of the King's Pictures," a post he held to his death.[26] Like Hugh Howard and others, he "abandoned his [painting] career . . . once he had obtained a . . . government post . . . , preferring the more dignified activity."[27]

Pastel portrait painting remained a fashionable and profitable practice through the rest of the century. Importantly, it offered artists social mobility. Artists lived and appeared like gentlemen to attract a fashionable clientele; they conducted their business in their homes—carefully located, stylish, and well maintained—which served as studio, workshop, exhibition space, and retail outlet.[28] Pond and Knapton's successes were always facilitated by social connections. They trained apprentices and hired English artists, thereby helping to break the continental dominance.[29]

FRANCIS COTES AND
THE SOCIETY PASTEL PORTRAIT

At fifteen, the usual age for starting an apprenticeship, Francis Cotes (1726–1770) probably entered Knapton's London studio to study painting in oil and pastel. Alastair Smart traced the circumstances of Cotes's career and rise to fame from 1748, when the artist was relatively unknown and perhaps abroad; he may have visited the Continent and viewed pastels in the Dresden collection.[30] Hogarth had demonstrated to British painters that prints after their own paintings provided an excellent form of publicity and a good financial return, and by 1752, in the absence of public venues, Cotes was selling prints after his pastels of fashionable sitters from a gallery in his Cork Street home.[31] Prints established his reputation in London, and he continued to produce them throughout his career. By 1754 Cotes stood out as an eminent London artist, and from 1766 to his death he was employed at court. He was among the artists who, in 1768, petitioned King George III for his patronage of an Academy of Arts (Royal Academy).[32] Established the same year, this institution helped painters to define themselves professionally as intellectuals, justifying their acceptance by high society, and stimulated patronage for landscape, genre, and to some extent history painting.[33]

Cotes was a gifted practitioner and fine colorist. His *Gentleman in a Three-Cornered Hat* of 1747, an early pastel, was exhibited in 1911 and sold in 1913 as Knapton's.[34] The sitter's alert expression and the work's stylistic elegance and consummate finish contrast with the pallid faces, heavier style, and "rather uninspiring world of Knapton's conservative mentality"; possibly Cotes picked up his general technical facility from his master.[35] His work is further distinguished by firm, confident drawing and his masterful exploitation of the full range of pale pinks, ochers, and blues through gold embroidery to deep rich blue velvet, its sheen suggested by veils of white pastel. He was called "the Rosalba of England."[36] In a 1772 essay on pastel painting, Cotes's pupil John Russell wrote, "If the *Crayon* pictures left by Mr Cotes are not held in equal estimation [to Carriera's], posterity will not do justice to his merit."[37] Smart, too, suggested that Cotes's *Gentleman in a Three-Cornered Hat* "would seem to derive directly" from Carriera's portrait of Gustavus Hamilton in masquerade costume (1730–31), which was by then in England.[38] Cotes was directly familiar with Carriera's pastels, having "removed a fine *Crayon Picture of Rosalba's*, and placed it on another strained cloth, without the least injury."[39]

The small doll-like head and face, large moist wide-set almond-shaped eyes, full lower lips, and enameled finish of the portrait of Elizabeth Gunning, celebrated for her great beauty, are characteristics of Cotes's female portraits of the 1750s. The smooth alabaster face, lightly tinged with pink and blue, and the stiff figure recall Knapton's work, while the broad strokes of sumptuous fabric, the delight in color, sparkling highlights, and intricate construction of the sitter's fashionable clothes are distinct from Knapton's pale simple draperies and Carriera's soft melting modeling and color.[40] Cotes's society portraits, though admitted by contemporaries to be good likenesses, are sometimes condemned today for their lack of realistic description and psychological penetration. What were Cotes's clients seeking in a portrait?

In that time of social mobility, traditional hierarchies were in flux.[41] New patterns of consumption led to a leveling of social classes. Increasingly fashion was acquired through wealth, not traditional breeding, and it acted to confound rather than to signify status, rank, and condition. To avoid the social confusion caused by the increase in wealth more broadly, one did not present one's true self in real life or a portrait; one acted out one's presentation of one's role in life—"keeping up appearances, looking the part, following good form were of the essence."[42] In 1745 Lord Chesterfield advised his son to be "absolute master . . . of your temper and

OPPOSITE
Francis Cotes
*Gentleman in a
Three-Cornered Hat*, 1747
Pastel on paper, glued to
canvas, 23⅝ × 16⅞ in.
(60 × 43 cm)
Leicester Museum and Art
Gallery, Leicester, England

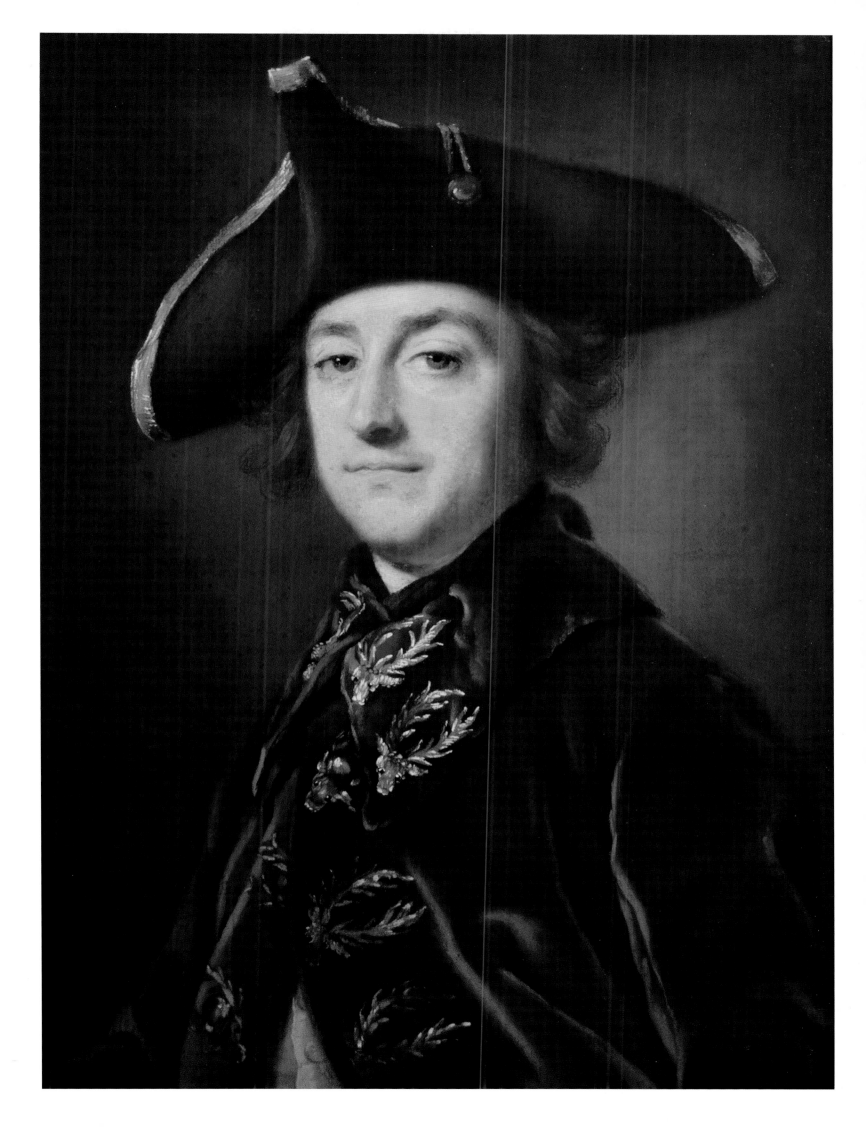

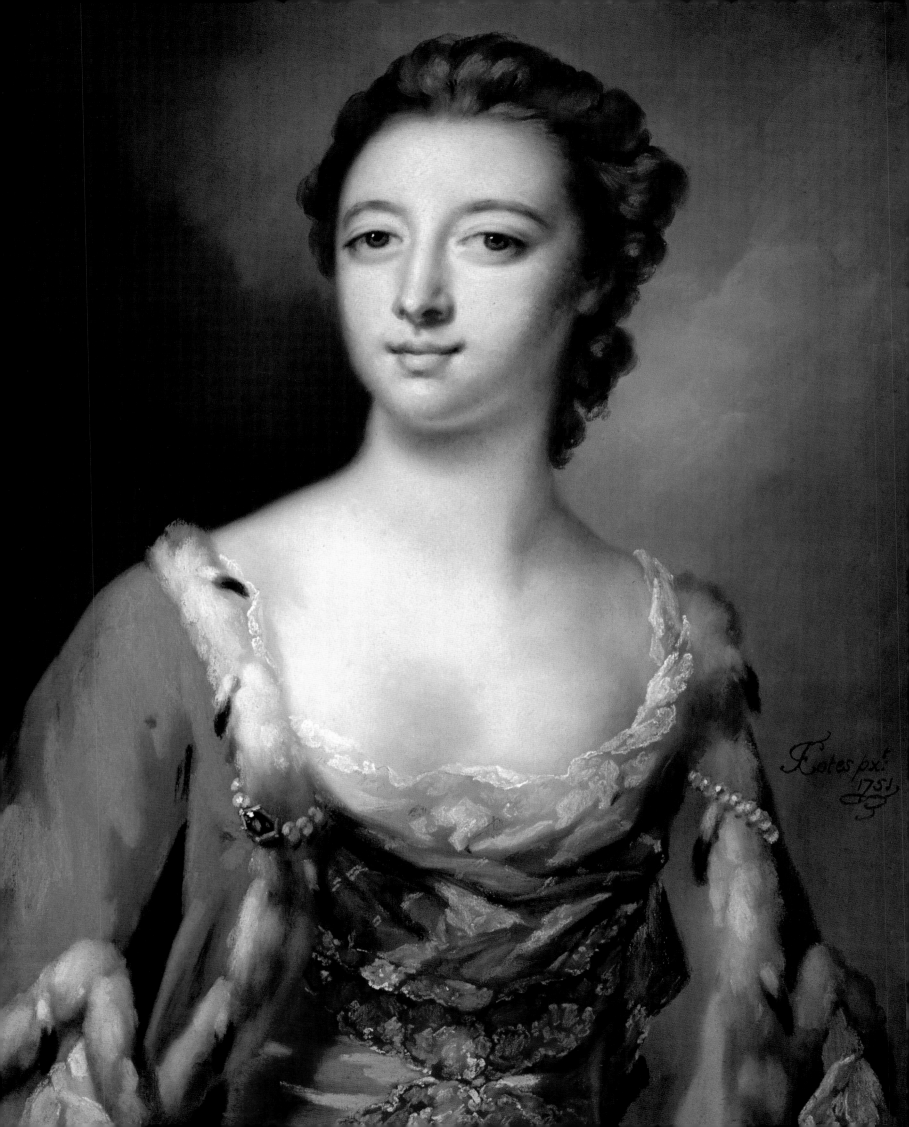

your countenance so that no visible changes appear in either, whatever you may feel inwardly."[43] To hide one's true appearance ("age, wrinkles, pock-marks") and feelings ("the secrets of your heart"), the natural face, especially of women (who were assumed to lack self-mastery), was hidden behind "powder, paint, patches and puffs."[44] A lady's mouth in a portrait should be "graceful, without a smile, but rather of a pouting turn, which gives it at once both grace and dignity."[45] Large eyes suggested spiritual qualities, like grace, and avoided too much emphasis on the body.[46]

Cosmetics, "by their color, quality and style of application" helped to render group identity visible on the face by "encoding sumptuary distinctions of social rank, gender, occupation and sexual availability" and by smoothing over individual traits. Apparently English women wore less makeup than the French. The English face was often described as "unadorned," yet recipes for homemade products abounded and customs records reveal that numerous products were imported.[47]

In the late 1750s, although his reputation still rested primarily on his skill as a pastelist, Cotes turned increasingly to oil portraits, which fetched higher prices.[47] Pricing depended on the size of pictures; English pastels were usually small, limited by the sizes of paper and glazing readily available.[49] Between 1760 and 1768 Cotes exhibited annually at the Society of Artists, which was dominated by Sir Joshua Reynolds and his evolving grand manner. Although Cotes was challenged to compete with Reynolds and at times adopted his formats, his portraits remained more conservative—elegant, decorative, and intimate—even as he explored movement and vividness in more relaxed and natural poses.[50] Cotes executed several half-length pastels of Queen Charlotte with the infant Charlotte, Princess of Wales. The composition was first exhibited in 1767 and was greatly admired; a full-length version in oils was based on it. Horace Walpole likened the sleeping infant to a figure by Guido Reni—a great compliment—and the queen's gesture was considered unusually informal for a royal portrait: "Who . . . can look on that gently lifted hand that prays a silence where a word would command it, and not be fixed with awe and admiration at so new an approach to real action?"[51] Cotes's "beguiling naturalism" may result from new cultural currents that sought to put society "back in touch with Nature, with true feelings, spontaneity, with the heart" and from the freer social context in which Cotes worked.[52]

This spontaneity is skillfully conveyed in the alert penetrating expression and sparkling engaged eyes in Cotes's portrait of his father, Robert Cotes, and is reinforced in its pastel technique. Against a blended background, neutral in hue but graded in intensity, the face comes alive in the play of unsweetened strokes of blue, pink, ocher, and sanguine. The ponderous faded purplish cloak is only broadly and roughly suggested, yet its weight and warmth are palpable. The pastels of Jean-Etienne Liotard, who visited England from 1753 to 1755/6, may have been known to Cotes, and his realistic style would have impressed the latter. Liotard's work amazed the English; according to Horace Walpole, "His likenesses were as exact as possible. . . . He could render nothing but what he saw before him. . . . Truth prevailed."[53] Cotes's increasingly naturalistic style has also been attributed to his knowledge of Mengs's and La Tour's pastels.

Landscapes are quite rare in Cotes's pastels. A notable example appears in his double portrait of Joseph Gulston and his brother John (1754). There line and color of the background are interpreted in decorative terms—fine, soft, and smooth.[54] At this time he made a specialty of portraying children in pastel, often holding a favorite plaything or pet. His charming *Portrait of Selina Chambers* (1764) is straightforwardly conceived, decorative, intimate yet technically masterful, harmonizing the colors and communicating the softness and tonal delicacy of the skin, the hardness of the pearls, and the stiffness of the lace trim.[55]

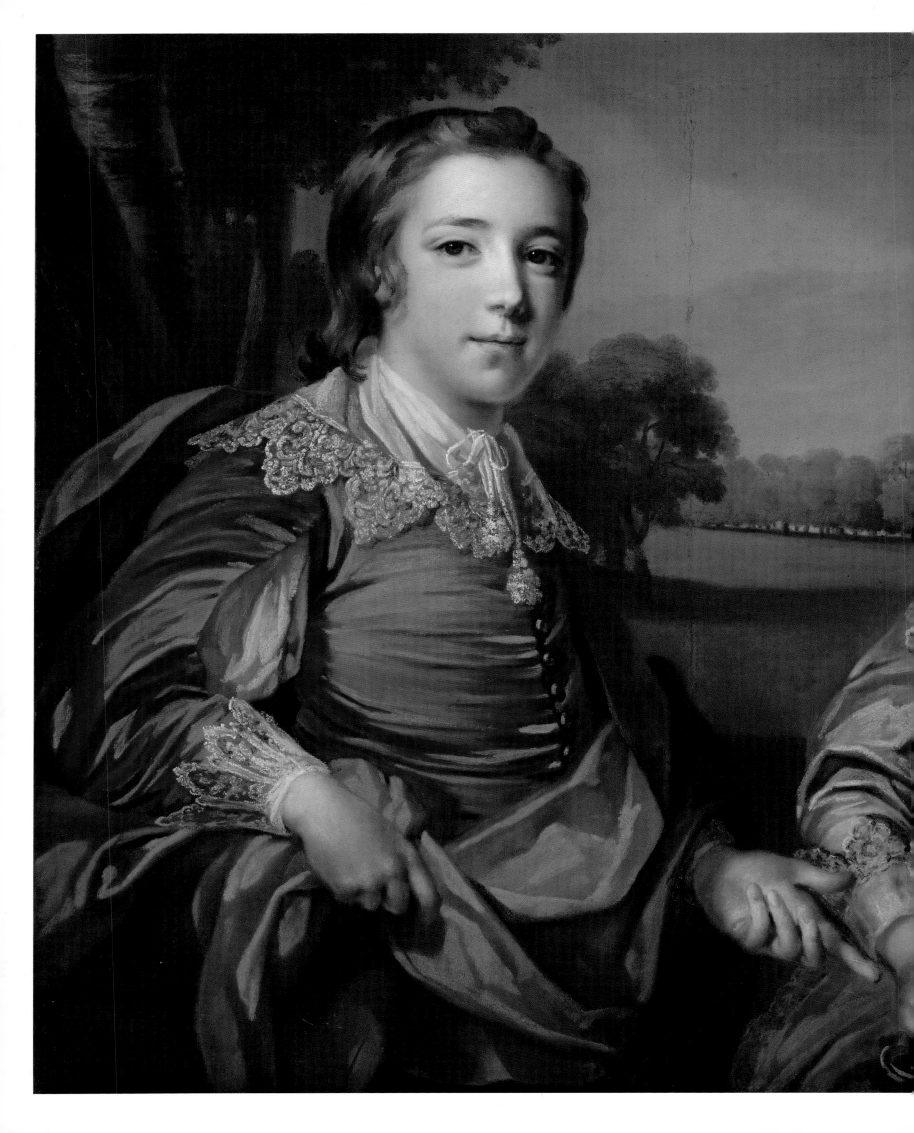

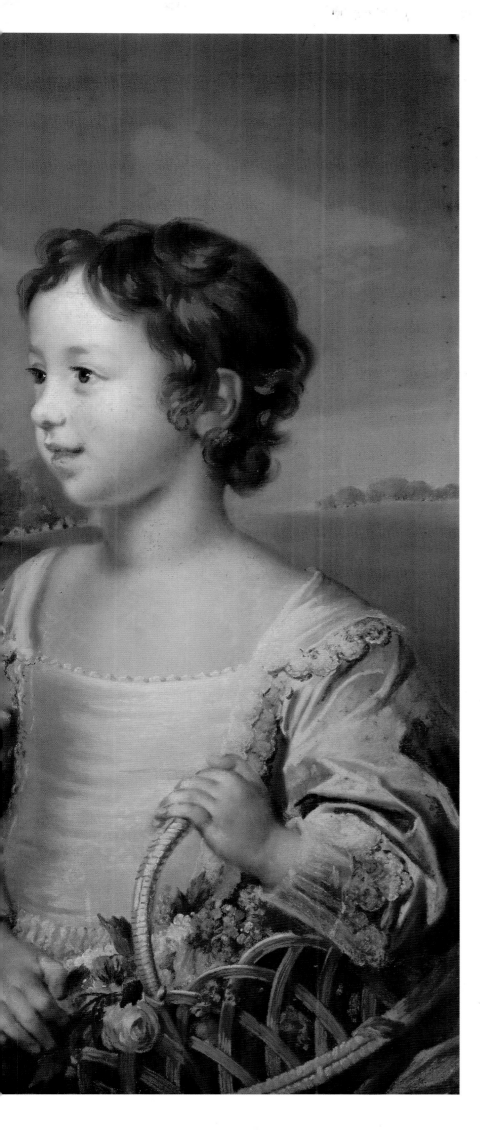

Francis Cotes
*Portrait of Joseph Gulston and
His Brother John Gulston,*
1754
Pastel on blue paper,
26½ × 32½ in. (67.3 × 82.6 cm)
The J. Paul Getty Museum,
Los Angeles

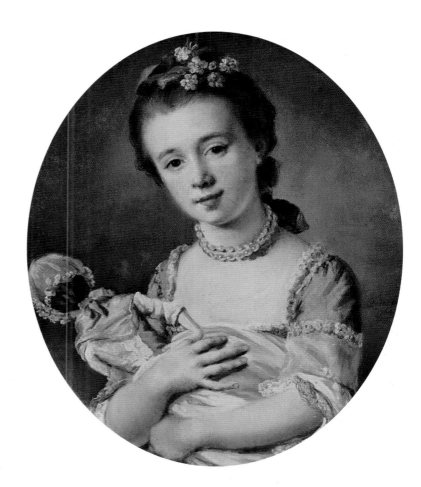

Francis Cotes
Portrait of Selina Chambers,
1764
Pastel on paper,
20⅝ × 18⅛ in. (52.5 × 46 cm)
Victoria and Albert
Museum, London

131

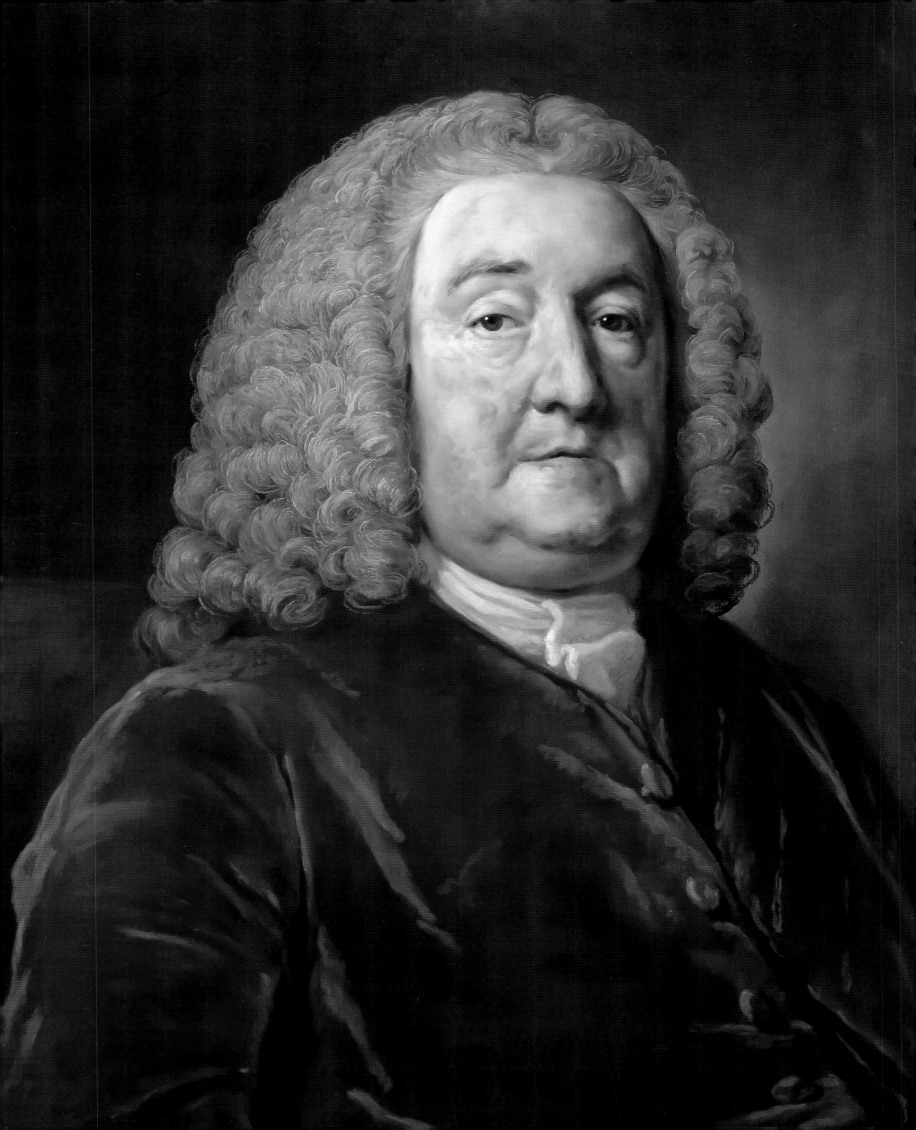

Cotes was an ambitious professional who flattered his sitters in a socially appropriate style. His work was successful because it was flattering yet realistic enough to satisfy his clients' needs for portraits that were "nature to advantage dressed," embracing socially mandated signifiers of status and class.[56] Cotes taught students— notably John Russell. He died young, in 1770, at the height of his artistic powers. After his death his paintings were no longer exhibited publicly. They "settled into the depths of country houses or lay hidden in secluded London drawing rooms," and Cotes's fame "slowly faded into oblivion."[57] Demand for his work only grew again in the early twentieth century.

In 1797 the *European Magazine* published Cotes's notes on crayon painting, found among his papers after his death.[58] There he briefly described the materials of pastel painting, their preparation, vulnerability, and care, and listed the "finest" pastels— Carriera's, Liotard's, Knapton's, and his own. Cotes's father, an apothecary, could have provided Cotes with specialized knowledge of chemistry useful in his fabrication of pastels.

Francis Cotes
Queen Charlotte with the
Princess Royal as a Child, 1767
Pastel on parchment,
36⅝ × 30⅞ in. (93 × 78.5 cm)
Windsor Castle, England,
Royal Collection Trust

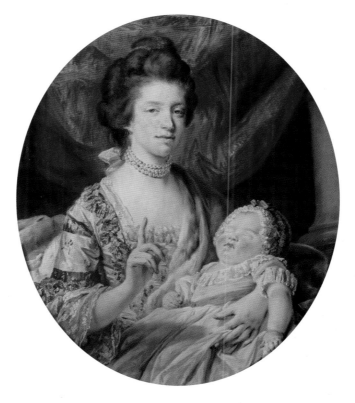

9.

John Russell, "Prince of Pastelists"

John Russell
Portrait of Mary Wood
(detail), 1794
Pastel on blue paper, glued
to canvas, 23⅞ × 17¾ in.
(60.5 × 45 cm)
National Gallery of Art,
Washington, DC

*T*he dazzling pastel *Portrait of Mary Wood*, dated 1794, is by John Russell (1745–1806), the most brilliant and prolific English pastelist of his generation. Executed on blue paper adhered overall to canvas and nailed to a strainer, it was executed on Russell's ideal support, described in his pamphlet *Elements of Painting with Crayons*.[1] Russell advised the "Student" to select a smooth, thick, fine-grained blue paper and paste it to a linen cloth that had already been nailed to a deal frame. First, however, he suggested that the image be dead-colored on the paper; the advantage of this sequence was that the "Crayons" used in blocking out the image would adhere more firmly to the paper once it was moistened, on the verso, with the aqueous paste.

Except at the lower edge, where a strip of blue paper is visible, the pastel application extends over the edges of the paper, onto the canvas, and around the edges of the strainer, evidence that the image was prepared before the mount structure was assembled. At normal viewing distance, the sitter's complexion appears to have been "sweetened" to give soft, smooth, melting gradations; under low-power stereo-binocular (x8) magnification and a slightly raking light, however, the individual chalk strokes remain clearly discrete and are distinguished by directional ridged striations. This directionality enlivens and enriches the depiction of the skin without distracting the viewer at normal viewing distance from its alabaster perfection. The eyes are highly worked with lines and patches of color to capture the sitter's dreamy, limpid gaze; Russell incises with a harder chalk in the face—eyebrows, eyelids, and chin—to add semi-highlights that further define the features.

The dress and its pink sash are also textured with directional striations; the blunt endings of the strokes suggest that dry powder may have been applied by a broader pastel stick (examples remain in Russell's extant pastel box) or by brush. Creases in

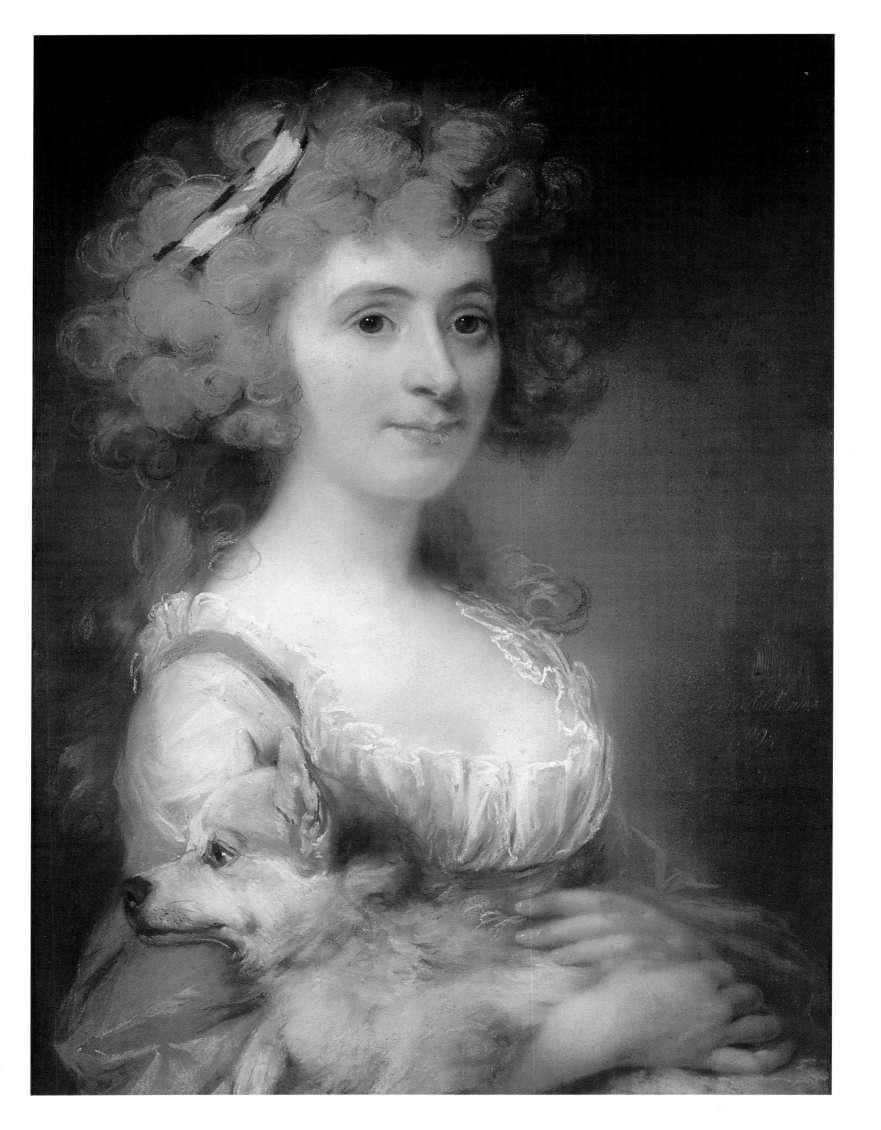

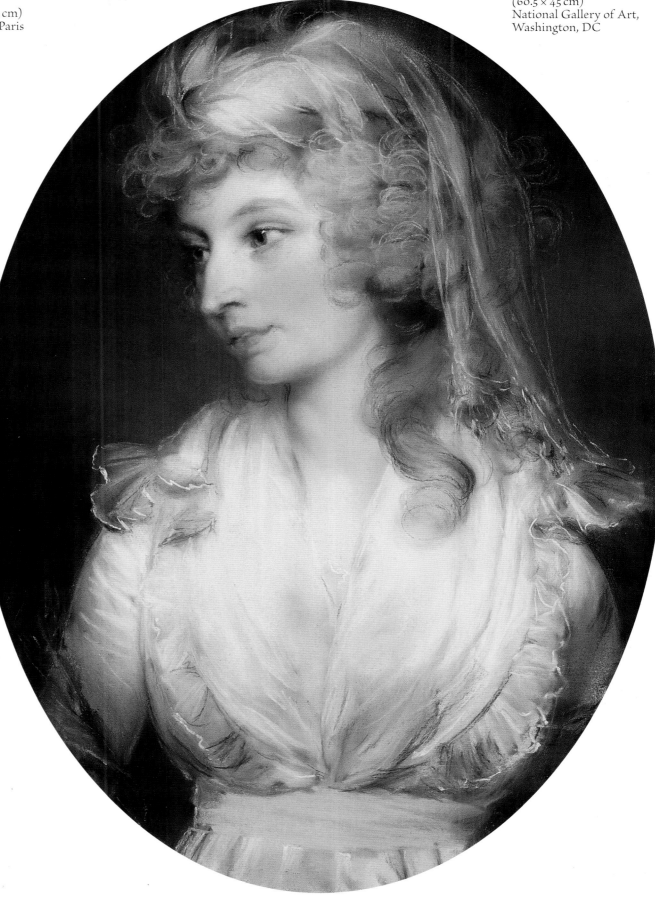

John Russell
*Portrait of Miss Power, later
Mrs. Shea,* 1789
Pastel on paper,
23⅞ × 17¾ in. (60 × 45 cm)
Musée Cognacq-Jay, Paris

John Russell
Portrait of Mary Wood, 1794
Pastel on blue paper, glued
to canvas, 23⅞ × 17¾ in.
(60.5 × 45 cm)
National Gallery of Art,
Washington, DC

the pink fabric are hinted at by the black lines of the previously fixed sketch that lie under the pink pastel. Russell has scraped back, perhaps with a brush handle, through the pink skin to an underlying white layer to suggest a fluff of lace at the base of the dress collar. The sitter's virtually transparent head covering is suggested by the faintest lightening of the underlying areas of the hair, dress, and dark background, its edges by strokes of white and yellow chalk.

Russell studied with Cotes until 1767, perhaps serving a seven-year apprenticeship before setting up on his own.[2] Pastel was his chief activity, and his work quickly became known and admired. From 1769 until his death he exhibited annually at the Royal Academy, becoming an associate in 1772 and a full academician in 1788.[3] His association with the Royal Academy was professional, for he didn't enjoy the company there: "Spent part of the evening with the Royal Academicians, was obliged to fly away as they were full of filthy blaspheming the scriptures."[4]

Russell emerged as the leading pastel portraitist in Britain after Cotes's death and was painter to the Prince of Wales from 1785, King George III (1790), and the Duke of York (1792). He specialized in portraits and so-called fancy pictures, which combined genre scenes and disguised portraits.[5] His polished, technically exquisite, and flattering likenesses were extremely popular with the wealthy middle classes, aristocracy, intellectual elite, and royal family.

In 1764 Russell converted from Anglicanism to Methodism and thereafter belonged to the Evangelical revival.[6] He promoted their religious values and imposed his strenuous opinions and his faith on his sitters, causing them "to become nauseous . . . by reason of [this] very awkward habit."[7] "Had an argument with Mr. Haydon on religion today, as he came to see me paint the portrait of his son."[8] Although some see Russell's superficial artistic brilliance as sitting "oddly" with his deeply held religious convictions, for the artist painting was the most effective way of spreading Evangelical values, and it remained his vocation.[9] "He portrayed children learning Christian values from their animal companions . . . and under the tender authority of their parents," and depicted the deserving poor with benevolence and compassion.[10] His anatomical studies and landscapes reveal his fascination with nature, which he observed for clues of the Divine Creator.

Russell's pastels of the waxing and waning moon, painted in the 1790s, do not fit into the established eighteenth-century genre of nocturnal pastoral landscape and have been called eccentric.[11] Russell, a passionate amateur natural philosopher and astronomer, spent years studying the moon and could have produced scientifically accurate maps of the lunar surface—fully illuminated and giving longitudinal and latitudinal grids and legends.[12] Instead he created strongly accurate yet stunningly beautiful portrayals of the moon in different phases in the emptiness of space; in the same way, he sacrificed the comprehensiveness of his portraits by improving the less advantageous features of his sitters.[13] He perceived a strong connection between the sight of the night sky and a feeling of religious fulfillment, and associated the moon with the renewal of faith.[14]

Russell's pamphlet *Elements of Painting with Crayons* was first published in London in 1772. It received widespread notice, and Russell is still considered an authority on pastel materials and techniques.[15] He explained Cotes's methods and materials "principally for the use of those who are just entering into the World of Imitation . . . should inclination lead them to the study of Painting with *Crayons*. . . . Those who are Masters . . . may be tempted to improve."[16] He reminded the young painter that the basis of good portraiture was a sound understanding of anatomy, but that the art itself involved the improvement of the observed particularities through generalization; beautification would excite the viewers' interest and admiration. "This portrayed the blueprint of Creation which underlay every faulty particular."[17]

OPPOSITE
John Russell
Portrait of George de Ligne Gregory, 1793
Pastel on paper,
29⅞ × 24⅞ in.
(75.9 × 63.2 cm)
The J. Paul Getty Museum,
Los Angeles

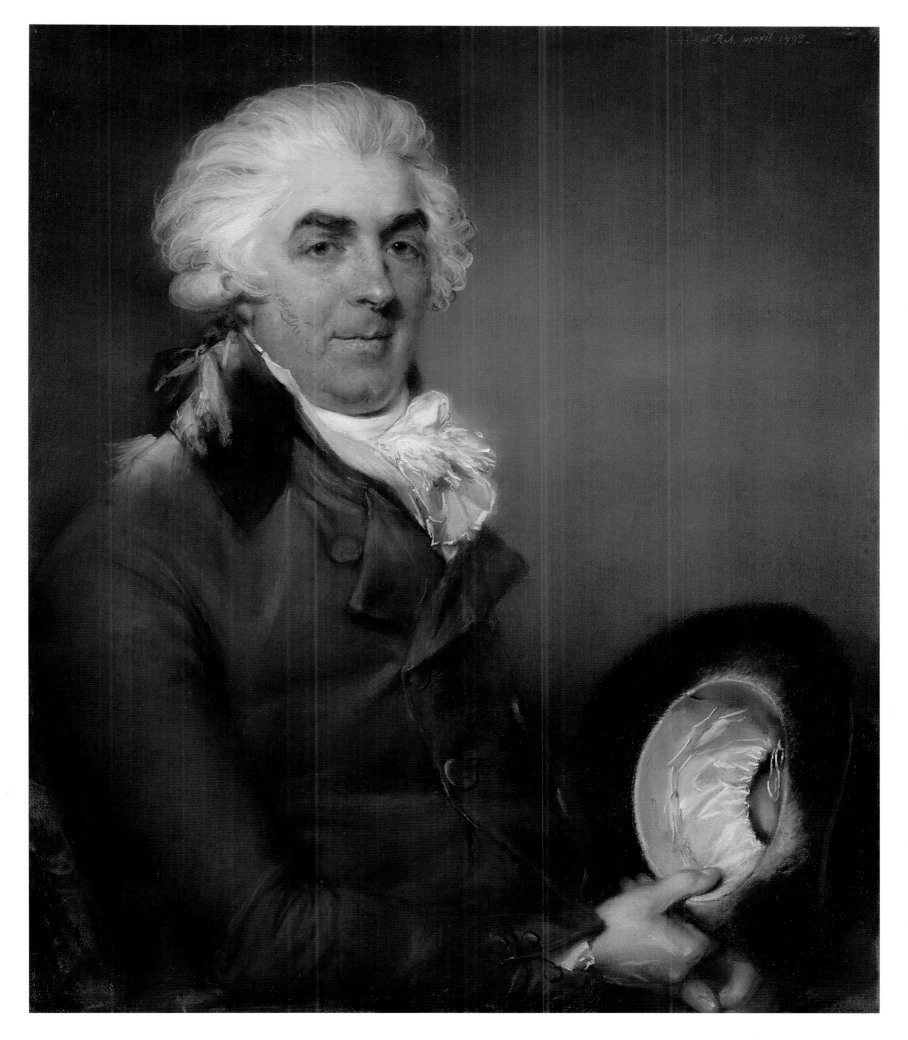

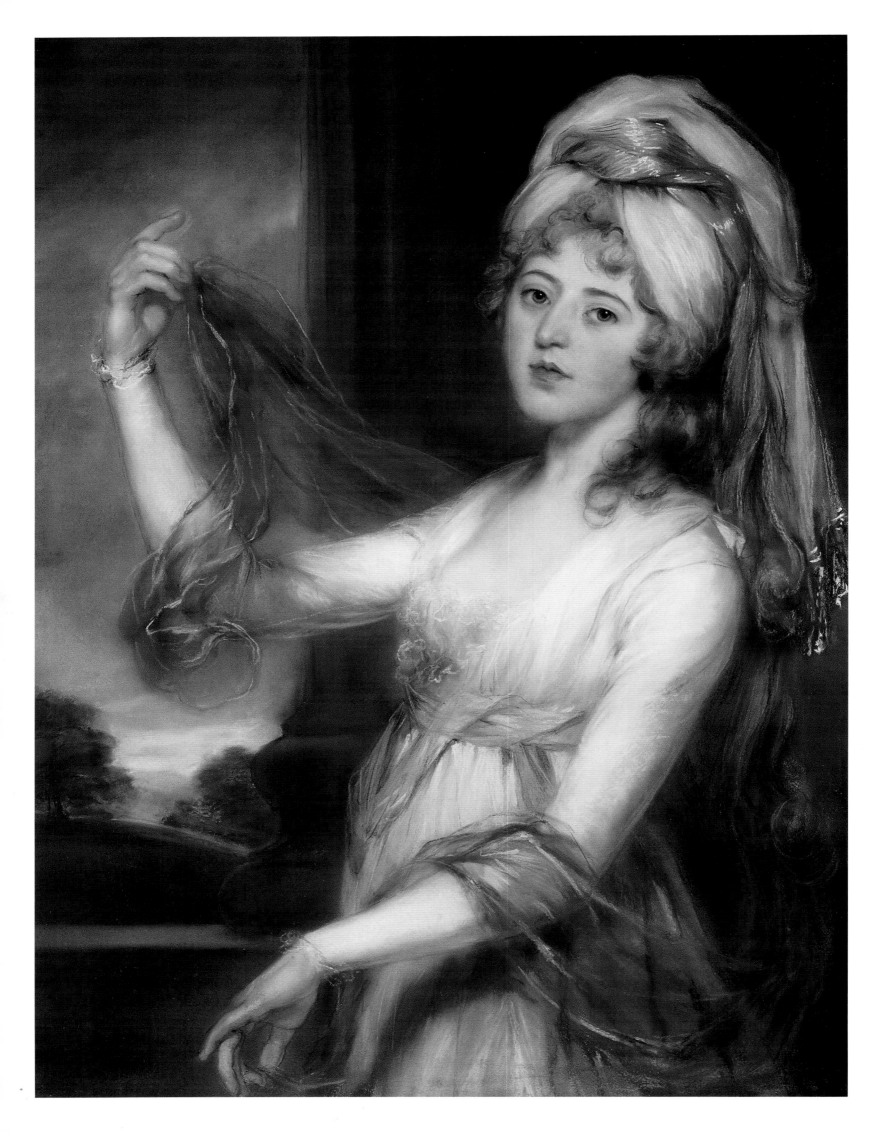

The fusion of empirical fact with artistic idealization, "a just imitation of nature," is central to Russell's oeuvre.[18]

A notebook written in Byrom's shorthand survived in Russell's family and was transcribed by one of them into English; it survives today in the National Art Library, London.[19] Byrom's shorthand was widely used in early modern England— interestingly, in connection with Methodists like Russell, to record their intimate religious thoughts. Russell has used it here to record secret details of his pastel fabrication process, details omitted from his published treatise. "It is not mentioned in the pamphlet (being a family secret) that just before using, the crayons were to be moistened with fresh turpentine."[20] In fact the instructions for each color are varied and highly complex. The family gave up crayon making in 1809; his son William wrote to his mother, "If there was a tolerable good crayon painter or if the art was in any degree in fashion I should alter my tone."[21]

Russell used a series of chalk drawings to plan his painted pastel portraits, not unlike Maurice Quentin de La Tour's *préparations* in function, though different in execution. In his pamphlet he claimed that drawing on "stained paper, with black, or red and white chalks . . . is allied to the manner of using the *Crayons*, and imparts knowledge of the middle Teint."[22]

A pastel box, sticks, and a paper sample, said to have been Russell's, survived in his family and was presented to the Victoria and Albert Museum by his descendant, F. H. Webb. Russell was concerned with the durability and permanence of his works and often affixed labels bearing instructions as to the care of his pastels to the verso of frames, where they would be clearly seen:

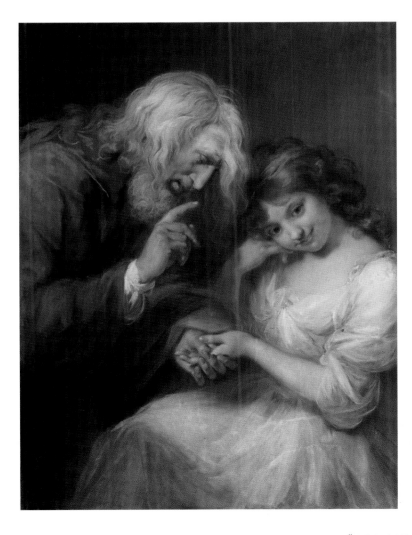

Please attend to these directions—

After the voyage clean the outside of the Glass, examine if there is any foulness on the inside of it, if so, take the Picture out of the Frame, and with the utmost care place it where nothing can brush the front, or touch it. Clean the Glass and return the Picture into the Frame in the same manner as it is now done with nails and the back-board. Paper must then be pasted over the cracks to prevent dust. Should there be at any time spots upon the Picture, from damp, such spots should be taken off by means of a leather stump, such a one as is used in chalk drawing.

Please to let this Paper remain.[23]

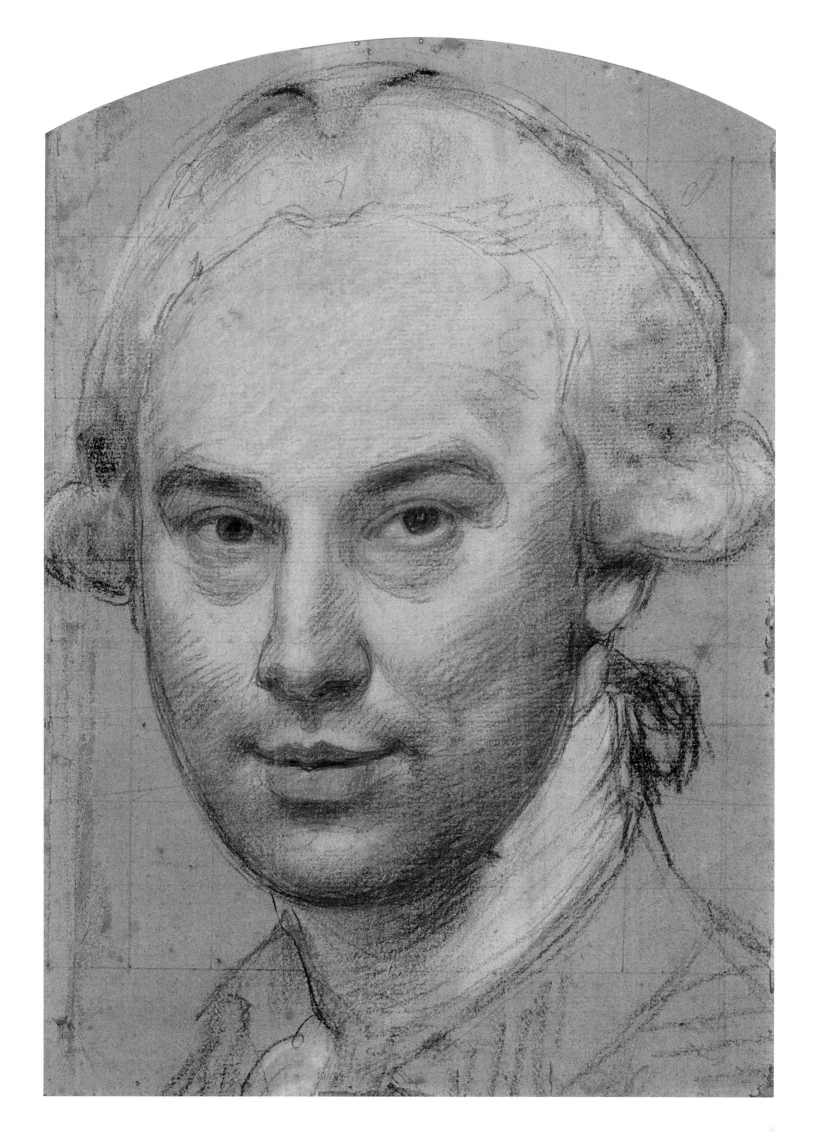

10.

Pastel in the British Periphery: Ireland, Scotland, and America

Hugh Douglas Hamilton
Portrait of Frederick North, Later Fifth Earl of Guilford, in Rome (detail), c. 1788
Pastel on paper, glued to canvas,
37⅜ × 20¾ in. (95 × 68 cm)
National Gallery of Art, Washington, DC

IRELAND
HUGH DOUGLAS HAMILTON (1740–1808)

Born in Dublin, Hugh Douglas Hamilton was apprenticed to a "pattern drawer" and studied drawing at the Dublin Society Schools. This training determined the graphic linear quality of his early work, and the French emphasis at the school introduced him to pastels.[1] He practiced briefly and successfully in Dublin before moving to London in 1764, specializing in fashionable small oval pastels, apparently quickly and economically executed. The bust-length portrait of Mary Fox (c. 1770) is typical.[2] The light background, quiet color, and loosely delineated black veil concentrate attention on the closely observed, rather plain face of the sitter, sharply characterized yet delicately modeled. It is very thinly painted on a textured off-white medium-weight laid paper sheet that Hamilton wrapped around and adhered to the back of an oval wood board prior to painting.

Hamilton may have achieved financial security in London, where his sitters included "the highest nobility."[3] Around 1780, he traveled to Rome. While based in Florence from 1783 to 1786, he visited Venice (1784) and Naples (1788). In Italy his portraits evolved from small ovals to full-length portraits; he had executed few of the latter before going to Rome. There, seeing the portraits cluttered with antiquities made popular by Pompeo Batoni, he was caught up in the emerging neoclassical taste and quickly absorbed into Grand Tour society.[4] He attracted an impressive array of British patrons with his "remarkable . . . likenesses."[5]

His pastel *Portrait of Frederick North* was painted on a large off-white paper of moderate laid down on a plain-weave beige canvas already attached to a wood strainer. The sheet of paper, possibly the immense commercially available "double elephant" format cut down at the top from its original 101.6 to its present 95 cm, is slightly smaller than the canvas, and the sheet's edges, including three deckles,

145

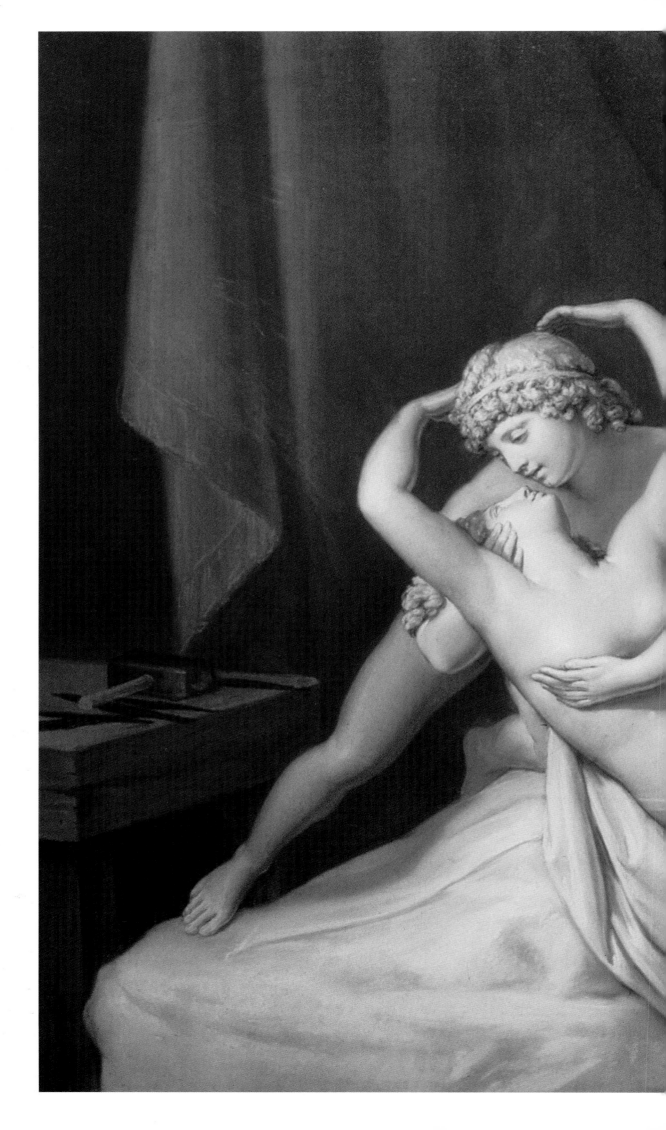

are visible on all sides despite its being framed.[6] Clarity of execution and a firm sense of line and unified light characterize this technically superb work.[7] Against a richly detailed classical setting, Hamilton placed accents of unblended pastel, contrasting smooth and crumpled textures, and beautifully drawn details. This portrait is highly disciplined and controlled. The pastel is applied more thickly than in the Fox portrait. The setting in the Roman Forum is evidence of Hamilton's talent as a landscapist.[8] A close look reveals that the sky and clouds were painted with wetted pastel applied by brush; brush bristles are embedded here and there in the background. The clear linearity and sharply lit stage of such portraits may be indebted to Jean-Etienne Liotard's pastels, which Hamilton could have seen earlier in London. Hamilton attempted history painting while in Rome, but a switch from his flourishing portrait business proved financially impracticable.[9]

Hamilton returned to Dublin in 1792 and established a studio, though he was critical of the local unenlightened artistic situation. In 1794 he wrote to a friend, the sculptor Antonio Canova, that he had abandoned pastel for oil, which he had already tried in Rome; his oil paintings are mostly portraits and are similar in type to his pastels.[10] These he continued to paint, from economic necessity, until his retirement in 1804, when he turned his attention to "the nature and various combinations of pigments he daily used" and the permanence of his works.[11]

SCOTLAND
ARCHIBALD SKIRVING (1749–1819)

Archibald Skirving was a Scottish miniature painter who later turned to larger-scale portraiture in pastel. After obscure beginnings in Edinburgh, Skirving worked as a miniaturist in London (1778–86) and then set off on a formative and prolonged visit to Rome (1787–94). This was the usual path of artists seeking to complete basic training acquired in Scotland, where until 1798 there was no permanent fine art academy.[12] In Rome he improved his pastel technique, possibly studying with Hamilton, then the finest pastelist in the city, and painted, for example, an arresting and powerful pastel self-portrait. Skirving eventually returned to Edinburgh with a reputation for pastels and set up a studio there.[13] He took great care with his work, apparently demanding as many as fifty or sixty sittings on occasion to achieve his "highly realistic likenesses."[14] An informative obituary of 1820 noted that his "servile . . . pains-taking solicitude" in the imitation of nature was in part the result of the misanthropic pleasure he took in exhausting the patience of his sitters.[15] His finest pastels—clear, humane, simple, and sober portraits—were produced by 1805.[16]

Later in life Skirving served as a drawing master to the wives and daughters of the professional and aristocratic elite of Edinburgh.[17] He gave lessons to Jane Welsh (1801–1866), the future wife of Thomas Carlyle, to the daughters of Francis Charteris, the eighth Earl of Wemyss, and to Elizabeth Cay (1771–1831), a gifted amateur pastelist and wife of a prominent Edinburgh lawyer and judge.[18] Cay's workbox survives. It contains not pastel sticks but small glass bottles and ceramic *cachou* boxes of pigment in powder form and leather stumps in various sizes.[19] The pastel powder is present in the containers as mixtures, not as the pure pigments normally found in miniature painters' boxes. It was probably obtained by Cay as mixtures, as it is unlikely that a lady amateur would have herself blended together the dry pigments, some highly unpleasant and even toxic. She apparently used pastel as a powder and applied it by means of stumps. Other artists, too, used pastel powder; for example, James Sharples (c. 1751–1811), an English portraitist active for a time in North America. Pastels in stick form were available in Edinburgh by the second half of the eighteenth century, and Cay would not have needed to go to the considerable trouble of fabricating her own had she chosen to use them.[20] Cay's pastel workbox may be rare surviving evidence of one way in which itinerant professionals and amateurs practiced pastel painting fully or in part.

HENRIETTA JOHNSTON (c. 1674–1729)

Henrietta Johnston, of French Huguenot extraction, was an amateur artist in the sense that, apparently, she was not trained academically but self-taught, working in a style derived from the pastels of late seventeenth-century British artists. Yet in her world she was a mainstream practitioner who earned a much-needed income from her work.[21] She painted pastel portraits in Dublin, where she supported her family after the death of her first husband (1703), and from 1708 in Charleston, South Carolina, then a raw frontier outpost, where, as the first recorded woman artist active in North America, she supplemented the income of her second husband, the Reverend Gideon Johnston.[22] She filled numerous commissions there, portraying a rising middle class, despite difficulties with obtaining the supplies she needed: "When the artist arrived in Charles Town in 1708 she brought a supply of materials with her. . . . [Later] her drawing materials had given out, and, there were no supplies to be had in the Province without ordering from England."[23] In 1711 John Chamberlayne of the Society for the Propagation of the Gospel in London wrote to Johnston, "I have Clubb'd with Mr. Shute in sending a small present of Crayons to Mrs. Johnston."[24] She likely used sets of pastels of the sort favored by her English contemporaries Sir Peter Lely, Edmund Ashfield, and Edward Lutterell, though their sharper modeling differed from her soft stylistic effects.

Johnston undoubtedly selected pastel for its low cost, ease of use, and portability. The range of hues in her pastels is limited—mostly white, red, yellow, brown, and black. Differences in the scale and format of her portraits and breadth of her color palette over time depended on the availability of paper and colors in Ireland and America. Whereas Johnston's Irish pastels are rich in color and have more fully developed backgrounds that situate sitters in palpable spaces, the smaller American portraits have simpler poses, are more lightly rendered, and have minimal backgrounds—a result, doubtless, of Johnston's economical use of available materials.[25]

JOHN SINGLETON COPLEY (1738–1815)

Copley, son of poor Irish immigrants to Boston, began his career as a portrait painter in oils about 1753 and soon experimented with pastel, in which he specialized.[26] In 1762 he wrote to Liotard in Geneva, asking for "a sett of Crayons of the very best kind . . . for liveliness of color and Justness of tints."[27] Copley's elegant posthumous portrait of Ebenezer Storer exemplifies the high level of technical and artistic skill he achieved in pastel. "Taking full advantage of the brilliance it afforded, Copley rendered Storer's damask *banyan* in rich tones of green that convey not only the fabric's floral pattern but also its weight and sheen."[28]

Copley was largely self-taught, learning to compose pictures from studying prints of Old Master and English portraits collected by his stepfather, the printmaker Peter Pelham (1695–1751). This enabled him to cater to the anglophile pretensions of wealthy and powerful American patrons, members of an ascendant merchant and professional class, who coveted English-style portraits and were willing and able to purchase them. His aristocratic self-fashioning, business competitiveness, and identification with the social, economic, and political habits of his sitters allowed him to understand, internalize, and convey their social pretentions and to project likenesses of themselves in his portraits.[29]

There were few English pastels in America for Copley to emulate, and no accomplished pastelists to teach him. Pelham, who had associated in England with printmaker-pastelists such as George Knapton and Arthur Pond, may have introduced Copley to pastel. Marjorie Shelley has described how Copley, lacking a master,

Henrietta Johnston
Portrait of Henrietta Charlotte Chastaigner, 1711
Pastel on paper, 11⅝ × 9 in.
(29.6 × 22.8 cm)
Gibbes Museum of Art, Charleston, South Carolina

OPPOSITE
John Singleton Copley
Portrait of Ebenezer Storer, Jr.,
c. 1767–69
Pastel on paper, glued to canvas, 24 × 18 in.
(61 × 45.7 cm)
The Metropolitan Museum of Art, New York

John Singleton Copley
Portrait of Mr. Joseph Barrell,
c. 1771
Pastel on paper,
23⅜ × 18⅛ in. (59.4 × 46 cm)
Worcester Art Museum,
Worcester, Massachusetts

OPPOSITE
John Singleton Copley
Portrait of Mrs. Joseph Barrell
(Hannah Fitch), c. 1771
Pastel on paper, glued to
canvas, 23 × 17¼ in.
(58.4 × 43.8 cm)
Museum of Fine Arts,
Boston

developed a pastel technique based on his experience with oil.[30] Over the years he moved from a looser handling in his early pastels to an exacting refined modeling with gradual tonal transitions and a rich handling of color; the uniform surface of his papers and smooth blended pastel application enhanced the realism and specificity of his forms.

In 1774 Copley traveled from an America socially and economically destabilized by revolutionary politics to England to seek professional training and advancement unavailable in America, and remained there.[31] He had long glorified Europe, and in 1768 "even confessed . . . to feeling deprived in a country with 'neither precept, example, nor Models.'"[32] Once he left America for good, he seems never again to have made pastels; possibly the changed taste and artistic climate in Europe discouraged him from doing so.[33]

JAMES SHARPLES (C. 1751–1811)

James Sharples was a pastel portrait painter trained in England who exhibited there as a "Portrait Painter in Oil and Crayons" until 1794, when he moved to America. The Anglo-American career of Sharples and his family typifies the artistic exchange between Britain and America in the late eighteenth to early nineteenth centuries. Sharples's specialty was pastel profiles, and he portrayed influential Americans, including George and Martha Washington. His third wife, Ellen Wallace Sharples (1769–1849), copied James's portraits on commission and taught herself to paint miniatures in watercolor on ivory; their children also became successful portraitists. The Sharples brought their skills to America to take advantage of a growing demand for portraiture, establishing a successful business amid great competition.[34] James's work has been characterized as "sturdily honest," and it was noted by his contemporaries for its accuracy. In the 1790s, although he lived in New York and Philadelphia, much of James's work was itinerant, and "he generally traveled in a four-wheeled contrivance, which carried the whole family and all his implements."[35] Later the family returned to England and, in 1809, settled in New York, returning again to England upon James's death.[36]

James's portraits were reported to take two hours to finish and, though small, were meant to hang on a wall. Thomas Peyton's pastel profile is typically bust-length and placed against a rough, mottled dark-gray-black-blue background. The handling is firm, the face finely detailed, and the remaining forms carefully, though more broadly, delineated and softly modeled.[37] He is said to have made his "crayons or pastils" himself, and to have kept them "finely powdered in small glass cups, [from which they] were applied with a camel's hair pencil."

PASTEL IN THE BRITISH PERIPHERY

AN AUDACIOUS ERA
The Nineteenth Century

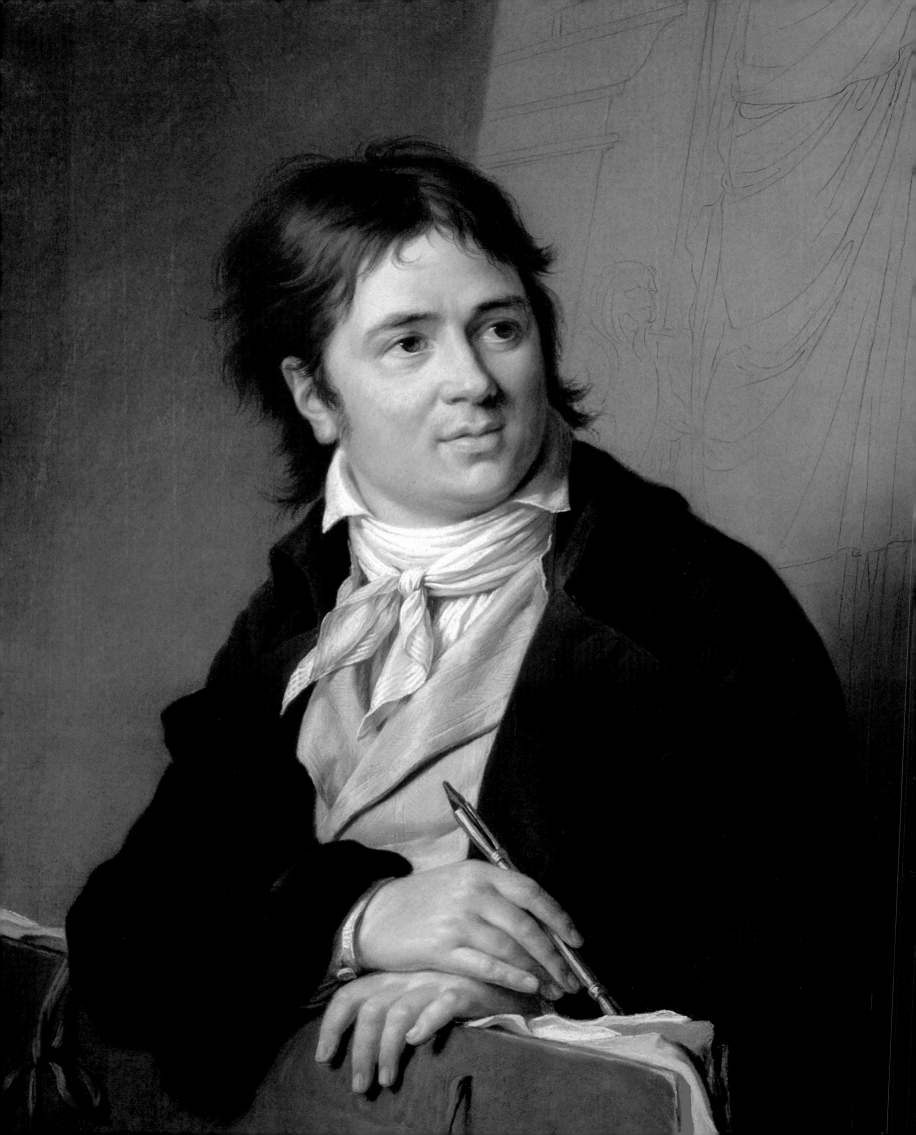

11.

A Lengthy Exile

Eugène Delacroix
Sheet of studies for
The Death of Sardanapalus
(detail), 1827
Chalk, black pencil, lead
pencil, pastel, and red chalk
on brown paper,
17⅜ × 22⅞ in. (44 × 58 cm)
Musée du Louvre, Paris

OPPOSITE
Marie-Gabrielle Capet
Portrait of Charles Meynier,
1799
Pastel on paper,
28⅜ × 24⅜ in. (72 × 62 cm)
Ecole Nationale Supérieure
des Beaux-Arts, Paris

PRECEDING SPREAD
Edgar Degas
End of the Arabesque (detail),
1876–77
Pastel and *peinture à l'essence*
(oil thinned with
turpentine) on canvas,
26⅞ × 15 in. (67 × 38 cm)
Musée d'Orsay, Paris

*I*n 1841, ten years after pastels reappeared in the salon's exhibitions, the journal *L'Artiste* commented upon the French Revolution's devastating impact on this delicate art form: "In the era when a mania for shepherdess's crooks and pastoral affectations held sway in France, under the aegis of Mesdames de Pompadour and Dubarry, the pastel was a highly favored art form. But following the tragic events of '93, this pleasure-loving society disappeared, and the art of pastel with it. Madame Le Brun took its rich and mysterious secrets abroad with her, so effectively that in future years, and despite this distinguished artist's return to France, pastel could not regain its place under the Empire. It barely survived the good times of the Restoration, and it took twenty years of peace and material prosperity to give the technique a new lease on life."[1]

A connoisseur of the beaux arts who strolled through the Salon in the early years of the nineteenth century would have noticed a few pastels if he had an attentive eye. Several artists, all born after 1750, perpetuated the art form. Claude Jean-Baptiste Hoin (1750–1817) was awarded the title of *peintre de monsieur* ("monsieur" referred to the comte de Provence, the official title of the king's brother) in 1785. He continued to produce fine pastel portraits after 1800, having earned a distinguished reputation in this medium over several decades. Hoin was a great admirer of Rosalba Carriera (he bequeathed two of her pastels to the city of Dijon, his birthplace), honoring her "timeless lessons of suppleness and grace."[2] His Lyonnais friend Antoine Berjon (1754–1843) also worked with pastels, creating portraits and strikingly naturalistic still lifes. Marie-Gabrielle Capet (1761–1818), one of Adélaïde Labille-Guiard's students, exhibited a number of pastel portraits until 1814. It is clear that even following the revolution and the disappearance of the

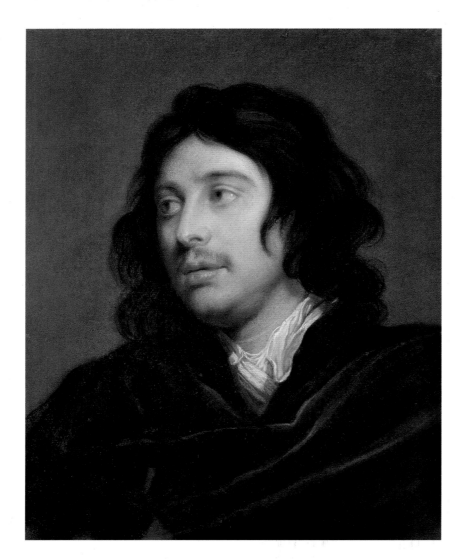

Claude Jean-Baptiste Hoin
Portrait of a Man (after Jakob von Oost), c. 1780
Pastel on board,
21⅝ × 17⅞ in. (55 × 45.5 cm)
Musée des Beaux-Arts,
Dijon, France

ancien régime's "pleasure-loving society," there remained a market for this art form in France. Elsewhere, the English artists John Russell (1745–1806) and Thomas Lawrence (1769–1830) and the Swiss painter Joseph Petitot (1771–1844) kept the pastel tradition alive in the first half of the nineteenth century. However, these artists were the exceptions to the rule. Pastel was barely surviving as an art; it was no longer a fashionable medium. Antoine Callet (1741–1823) and Pierre-Paul Prud'hon (1758–1823) experimented with pastels on occasion, but it was generally for their traditional use in preliminary sketches. Callet's Baroque fantasy *The Break of Day* and Prud'hon's serene *Profile of Constance Mayer* are certainly charming pastels, but they were intended to be preparatory drawings for oil paintings. Thus, fifty years on, pastel had resumed its traditional role as a handmaid to painting. It would be accurate to say that pastel was eclipsed over a forty-year period, but the role actually played by the French Revolution is somewhat debatable. Without denying the impact of that upheaval, it probably completed a process that had actually begun in the mid-eighteenth century.

A PROBLEMATIC POPULARITY

The eighteenth century is rightly regarded as pastel's golden age, and the French artist Maurice Quentin de La Tour in particular is considered one of the most talented pastel masters of all time. However, his immense popularity generated a certain degree of skepticism in academic circles. Various aspects of his success irritated some observers. He amassed all the most desirable commissions: the king, the queen, the royal favorites, and numerous other luminaries competed to have their portraits executed by La Tour's skilled hand. Above all, the strikingly lifelike aspect

OPPOSITE
Pierre-Paul Prud'hon
Profile of Constance Mayer,
study for *Innocence Choosing between Love and Riches*, 1804
Pastel on canvas,
21⅞ × 19¼ in. (55.5 × 49 cm)
Musée du Louvre, Paris

Antoine Callet
The Break of Day, 1803
Pastel on paper,
17¾ × 39⅜ in. (45 × 100 cm)
Musée Antoine Lécuyer,
Saint-Quentin, France

of his work in pastels overshadowed the traditional principles that the Académie Royale, under pressure from the administration, was attempting to reestablish. La Tour owed his success to the genre of portraiture, as opposed to history painting. The venerable academy, however, was bent on reaffirming the preeminent position of history painting in the hierarchy of genres. Pastel painting also had the peculiarity of combining the roles of drawing and color, whereas the guiding principles of the academic tradition strove to distinguish and create a hierarchy between these two media. Surely drawing should precede the use of color, as the exercise of intellect and reason should exert control over emotion. However, the most irksome aspect of La Tour's success was the sheer number of his followers. "Everybody has colored pencils in hand," observed Etienne La Font de Saint-Yenne (1747), adding, "The number of Pastel Painters is infinite."[3]

Envious of his enormous popularity, a number of academy members denounced the supposed facileness of a technique that openly competed with oil painting. In 1745 a faction organized against La Tour set out to diminish the status of the artist and of pastel painting in general. "Several members of the Academy," reported the Abbé des Fontaines, "have been plotting ever since to overthrow Monsieur de la Tour, who has produced so many pastels. They contend that any clever painter could do this easily, and they wish to convince the public that this type of painting is far simpler to do than oils."[4] They implied that the most rudimentary drawing skills sufficed for an amateur to venture into pastels. For one artist of La Tour's quality, how many mediocre portraitists plied their trade?

The plethora of free drawing schools now open to the public, intended for apprentices and artisans, certainly played a role in the burgeoning enthusiasm for this technique. In the eyes of the Académie Royale, these elementary schools had the pernicious effect of inadequately educating students, who went on to cheapen the artistic profession. They were teaching a multitude of simple artisans and art workers, many of whom would unhesitatingly launch themselves into artistic careers without possessing the requisite talent.

The public's embrace of pastel painting should not obscure the concerns that this technique inspired in academic circles. Not only did they suspect pastel of being a merely facile art, but the medium also attracted women to pursue artistic careers. In the 1760s, no more than a dozen women were exhibiting their pastels, but in the 1770s and 1780s almost forty were displaying their work in various Parisian salons (including the Salon de la Correspondance, the Salon de la Jeunesse, and the Salon du Colisée). This female presence gave pastel a reputation for facileness and amateurism that did little to attract young artists aspiring to loftier recognition.

Furthermore, taste had shifted with the passage of time. A new generation of painters, with Jacques-Louis David in the forefront, had won public recognition. David repudiated boudoir painting and the operatic mythology pieces. He adopted a classically stoic stance in his work, which was dedicated to exalting the loftiest examples of civic heroism—energy, determination, and a sense of self-sacrifice. He successfully revived the tired genre of history painting and made it reverberate with the passions of his era. By contrast, the gentle art of pastel seemed no more than a self-indulgent expression of frivolity.

In the end, despite its surge of popularity in the eighteenth century, the art of pastel never achieved the legitimacy that its most illustrious exponents desired. Situated somewhat uneasily between painting and drawing, very closely associated with portraiture (a genre that the Académie Royale still looked down upon), it was a realm inhabited by a multitude of amateurs. Pastel remained a prisoner of the hierarchies that persisted among techniques and genres. Its most distinguished practitioners all died within the space of a decade—Jean Siméon Chardin in 1779, Jean-Baptiste Perronneau in 1783, La Tour in 1788, and Jean-Etienne Liotard in

OPPOSITE
Jules Robert Auguste
Three Nudes in a Landscape,
c. 1820
Pastel on paper, 11¾ × 8⅝ in.
(30 × 22 cm)
Musée des Beaux-Arts,
Orléans, France

A LENGTHY EXILE

1789. Even before the outbreak of the Revolution, their deaths began a period of obscurity that would persist until the early 1830s.

THE CRUCIBLE OF ROMANTICISM

As pastel went out of fashion, watercolor took the stage. This technique had minimal requirements: water-soluble colors were applied to a simple paper support. Up until this point, use of watercolors had been generally confined to topographers, cartographers, and military men. The medium lent itself to quickly recording the configuration of locales that were being surveyed under difficult conditions. Artists also occasionally used watercolors during their travels to paint small landscapes, but they generally did not attach much significance to these sketches. As people developed a taste for nature and landscape, however, the perception of watercolor gradually changed. An increasing number of artists, most of them English (including John Robert Cozens, Thomas Girtin, and John Constable), adopted the technique.

Watercolor's effects of transparency revived an interest in landscape painting. The medium's appeal was heightened by strong popular demand: by the beginning of the nineteenth century, the watercolor was to landscape what the pastel had been to portraiture a few decades earlier. Watercolor's success was so great that the Society of Painters in Water Colours was established in England in 1804, especially dedicated to promoting this medium. The French were also receptive

Eugène Delacroix
Sheet of studies for
The Death of Sardanapalus,
1827
Chalk, black pencil, lead
pencil, pastel, and red chalk
on brown paper,
17⅜ × 22⅞ in. (44 × 58 cm)
Musée du Louvre, Paris

RIGHT
Eugène Delacroix
Study for *The Death of
Sardanapalus*, 1827
Black ink and pastel on
paper, 15¾ × 10⅝ in.
(40 × 27 cm)
Musée du Louvre, Paris

to this economical technique. "The peculiar charm of watercolor," wrote Eugène Delacroix, "beside which all oil painting appears an unpleasant reddish yellow, arises from the continuing visibility of the paper beneath; the proof is that it loses this quality when a little gouache is applied; the transparency is lost entirely in a wholly gouache work."[5] Watercolor created effects that were impossible to achieve with traditional painting, proving that there were other techniques of painting besides oils that merited attention.

Even as watercolor eclipsed pastel, its success in the first decades of the nineteenth century laid the groundwork, in a sense, for conditions hospitable to pastel's revival. Among the first members of the new generation to take up the art of pastel again was Jules Robert Auguste (1789–1850). "Monsieur Auguste," as he was known in Romantic circles, was awarded the Grand Prix de Rome for sculpture in 1810. This early success might have made him a faithful disciple of the academic school, but he was in fact nothing of the sort. He left for Rome the following year and demonstrated little patience with traditional artistic discipline. Instead of perfecting his sculptural technique, the young man frequented racetracks and visited Roman galleries. He was attracted to painting, and his meeting with Théodore Géricault, a rising star in the Romantic movement, contributed to his defiance of convention. "The revelation was overwhelming and utterly persuasive.

The past was repudiated and, spurred on by Géricault, Auguste dismissed and banished academic rules and all the cold, conventional, deceptive scholarship that contributed nothing to his aspirations or his vision."[6] Demonstrating this newfound sense of freedom and openness, he soon embarked for the Middle East, a little-traveled destination synonymous with adventure. Auguste returned with a multitude of exotic souvenirs—rich fabrics, costumes, arms, and furnishings. These discoveries attracted an entire generation of artists who flocked to the studio in search of inspiration. Auguste very quickly found himself in the midst of an avant-garde circle, where he sampled novelty in all its permutations. Richard Parkes Bonington, Delacroix, Géricault, Paul Huet, Léon Riesener, and many others frequented Auguste's Parisian atelier on rue des Martyrs. All were familiar with watercolor and lithography and equally curious about the new techniques that were becoming fashionable.

Auguste took a special interest in the charms "of pastels that crumbled into brilliant fragments like jewels," but instead of portraits, he explored subjects more compatible with his Romantic temperament. The exotic East was a particular source of inspiration: he painted figures of Turks, Arabs, and black men posed in splendid costumes, as well as young women revealing their voluptuous forms. Auguste also evoked the Middle Ages: his knight in armor, for example, seems to have emerged from the Romantic imagination of a novelist such as Walter Scott. These pastels are of modest scale, but their spontaneous style and vividly contrasting colors give them a distinctive appeal. Though little known today, Auguste was a pioneer in the rebirth of pastel, although the use of the medium did not become widespread again until around 1830.

Far better known today is the series of pastel sketches that Delacroix executed for his vast painting *The Death of Sardanapalus* (1827). These studies concentrate all the drama of the painting's final version. Vivid colors and emphatic expressiveness lend immense power to the rendering of the slave with his throat slashed, and even to the details of an Eastern slipper. These few small leaves of paper were merely preparatory works, but they were full of promise. Like Auguste's pastels, they opened a path for a new generation. Less cautious than their predecessors, these artists would discover the virtues of a medium revived after thirty years of obscurity.

OPPOSITE
Eugène Delacroix
Black Man Wearing a Turban, 1826
Pastel on beige paper,
18½ × 15 in. (47 × 38 cm)
Musée du Louvre, Paris

A LENGTHY EXILE

12.
The Past Rediscovered

*T*he nineteenth century witnessed the triumph of the bourgeoisie. Brought to power by the Revolution of 1789, their prosperity soared with Louis-Philippe's ascent to the throne. The bourgeoisie now dominated the economic and political spheres. They had a tight grip on finance, industry, and the complex apparatus of bureaucracy. Due to a tax-based voting system, they also dominated the Chamber of Deputies. Acclimated to liberal ideas and engaged in an economic revolution on three fronts—industry, banking, and transport—they wholeheartedly embraced the admonition attributed to the prominent political figure François Guizot, "Enrich yourselves."

Meanwhile, the nobility lived on inherited wealth, largely from fortunes tied up in property holdings. Averse to anything that might diminish its status, this class made no investment in commerce, industry, or the liberal professions. The nobility had lost much of its power following the demise of the ancien régime. However, despite losing its ancient prerogatives, it continued to exert a very strong influence on society. Returning from a period of forced exile, this aristocratic class longed to revive the way of life it had enjoyed before the tragic years of the Revolution. Members of the nobility yearned to reinstate the principle of continuity so dear to them, a bastion against the vicissitudes of history. Their prestige remained immense, and the wealth they had amassed during centuries of privilege was coveted by the new elite. It was a way of life that appealed greatly to the *grande bourgeoisie*. Everyone wanted a country property, a private residence in Paris, a substantial household staff—all the trappings of an aristocratic way of life. Sheltered amid a new version of royalty whose members sported redingotes inspired by English hunting attire, the bourgeois elite enjoyed the comfortable sense of self-assurance

175

demonstrated by the confident Monsieur Bertin in Jean-Dominique-Auguste Ingres's famous portrait of 1832. After all, real success demands the acknowledgment of an admiring audience.

"THE PRETENSIONS OF THE SITTERS!"
—DELPHINE GIRARDIN, 1837

Portraits proliferated throughout the nineteenth century, one of the most influential developments in the artistic world. In the early 1840s, almost a third of the works exhibited in the salons were portraits. This surge of activity was attributable to the rising power of a self-assured bourgeoisie. These upstarts deeply dismayed Delphine de Girardin, who expressed her deep distaste: "It's not this craze for portraits—which gives work to so many artists—that should be attacked; it's the pretentions of the sitters!"[1] The reappearance of pastels in the 1831 Salon (after more than ten years of total absence) was part of this popular trend.

Like a delicate perfume, pastels were a reminder of eighteenth-century sensibilities. It was a medium that appealed very much to members of a society bent on recapturing a hint of the old aristocratic spirit. Laure Girard (1806–1866) understood this phenomenon very well. "It was during the last years of the Restoration that Madame de Léoménil, then Mademoiselle Laure Girard, revived pastels, which had been neglected since the Revolution. She was the first to enliven her black-and-white portrait drawings with a few light touches of color. Gradually she added more color to her figures, and ultimately used nothing but pastel."[2] It was a wise decision; "Almost all the beauties of the fashionable world came to pose in her studio." In 1835 she was awarded a medal of honor for her pastel portraits. Her reputation was so well established that when the duc d'Orléans married Princess Helen of Mecklenburg-Schwerin in 1837, Queen Marie-Amélie commissioned Girard to make pastel portraits of the royal family to send to the bride's parents. Meanwhile, Edmond Bassompierre (1809–1896) rapidly made a place for himself as a favored portraitist; he thrived in a society whose members were eager to have themselves immortalized in pastel, recalling the good old days before the Revolution. The artist's aristocratic origins—he was the grandson of the marquis del'Aigle—and his residence in the very fashionable Faubourg Saint-Germain facilitated his activities. For over forty years (1839–85) he exhibited carefully executed portraits of well-born and wealthy subjects in the Salons. Emmanuel-Henri Thomas de Barbarin (1821–1892) had a similar career; he was related to the duchesse de Boiano, and he also specialized in painting pastel portraits of members of the aristocracy.

Others were guided by necessity. For unrecognized artists or those confined to sectors accorded minimal prestige (engraving, miniatures, illustration, industrial design), pastel opened a world of new possibilities. Adopting this technique, midway between drawing and painting, they could invest in the profitable activity of portraiture without undue difficulty. Among the pastel artists who emerged in the 1830s were engravers including Louis-Pierre Henriquel-Dupont (1797–1892), Jean-Auguste Dubouloz (1800–1870), and Eugène Giraud (1806–1881). Giraud, who came from a modest background, initially devoted himself to engraving, which had a market in book publishing and the press. A recipient of the prestigious Prix de Rome for engraving in 1826, the young man was nevertheless obliged to give up a stay in Italy to support his family. Trying to diversify his activities, Giraud began to produce many small portraits with pastel highlights. The series he exhibited in the 1834 Salon brought him instant acclaim, and he soon became the portraitist of choice for prominent Parisians. He was even welcomed into the private circles of Princess Mathilde as her portraitist and drawing teacher. Financial considerations partially explain the attraction of pastel at some point in the careers of many artists.

OPPOSITE
Eugène Giraud
Princess Mathilde, 1861
Pastel on paper, 50 × 37⅜ in.
(127 × 95 cm)
Musée National du Château,
Compiègne, France

When the landscape artist Constant Troyon (1810–1865) started out, he had to do what was expedient, which involved painting pastel portraits, "work that was necessary to earn his daily bread."[3]

The story of the sculptor Antonin Moine (1796–1849) is typical. Struggling to win commissions and in sore need of earning a living, he tried his hand at pastel. As one critic wrote, "No doubt he believed that this technique, which had formerly captivated members of the world's most aristocratic society, could be triumphantly resurrected in the fashionable society of his own time. However bourgeois its members may have been, they longed to possess a modicum of the nobility and distinction of times past."[4] After languishing five years without an official commission, the sculptor presented himself as a pastel portraitist in the 1843 Salon. It proved to be a remunerative strategy. "People seeking to be painted flocked to him from all sides, the most illustrious and the most elegant members of society! He worked for politicians, he worked for financiers. . . . They wanted to be pictured in those charming oval frames hung upon the *boiseries* of their perfumed boudoirs, flattered in appealing compositions à la [Jean-Antoine] Watteau where neither the drawing nor the morality is too severe."[5]

Of course there were other pastel artists, such as Charles-Louis Gratia (1815–1911), who were less driven by economic necessity. Between 1837 and 1898 this portraitist of Louis-Philippe's children exhibited almost nothing but pastels. His passion for the medium led him to make his own crayons, which demanded "long years of study, trials, and effort."[6] Léon Riesener (1808–1878) was considered to be a virtuoso of the mid-century. A close associate of Jules Robert Auguste and Paul

OPPOSITE
Léon Riesener
Portrait of Madame Léon Riesener, née Laure Peytouraud (detail), 1849
Pastel on paper,
34⅞ × 21½ in. (88.5 × 54.5 cm)
Musée Eugène Delacroix, Paris

Léon Riesener
Portrait of Madame Louis-Auguste Bornot with Her Son Camille, 1850
Pastel on paper,
38¾ × 31⅛ in. (98.5 × 79 cm)
Musée Eugène Delacroix, Paris

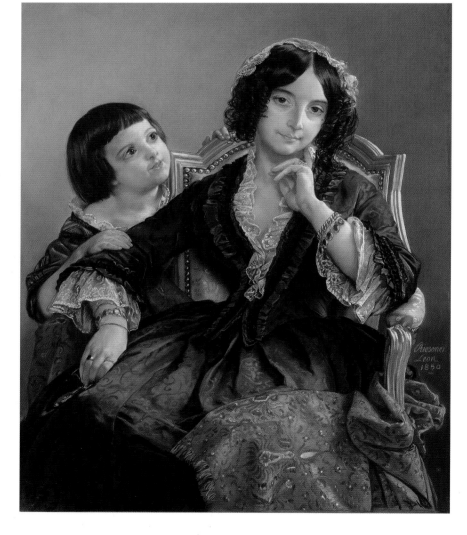

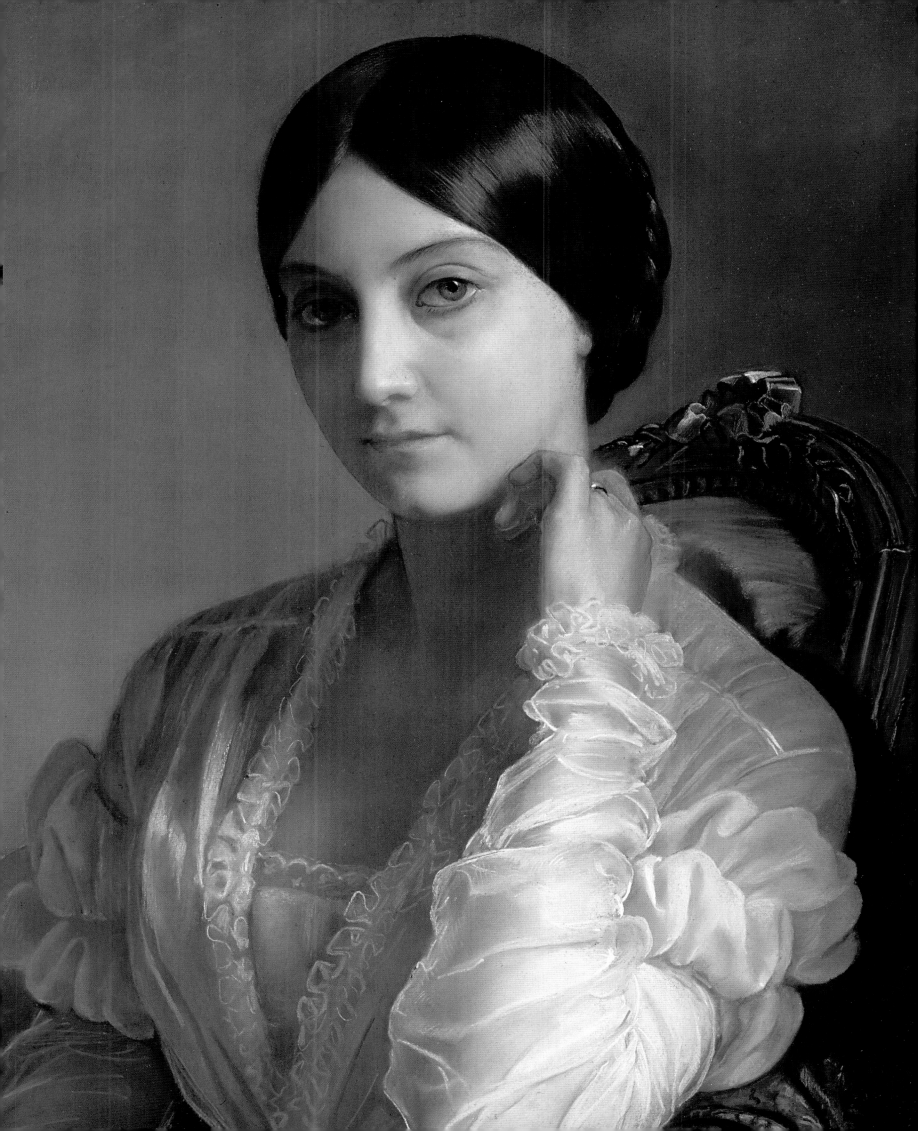

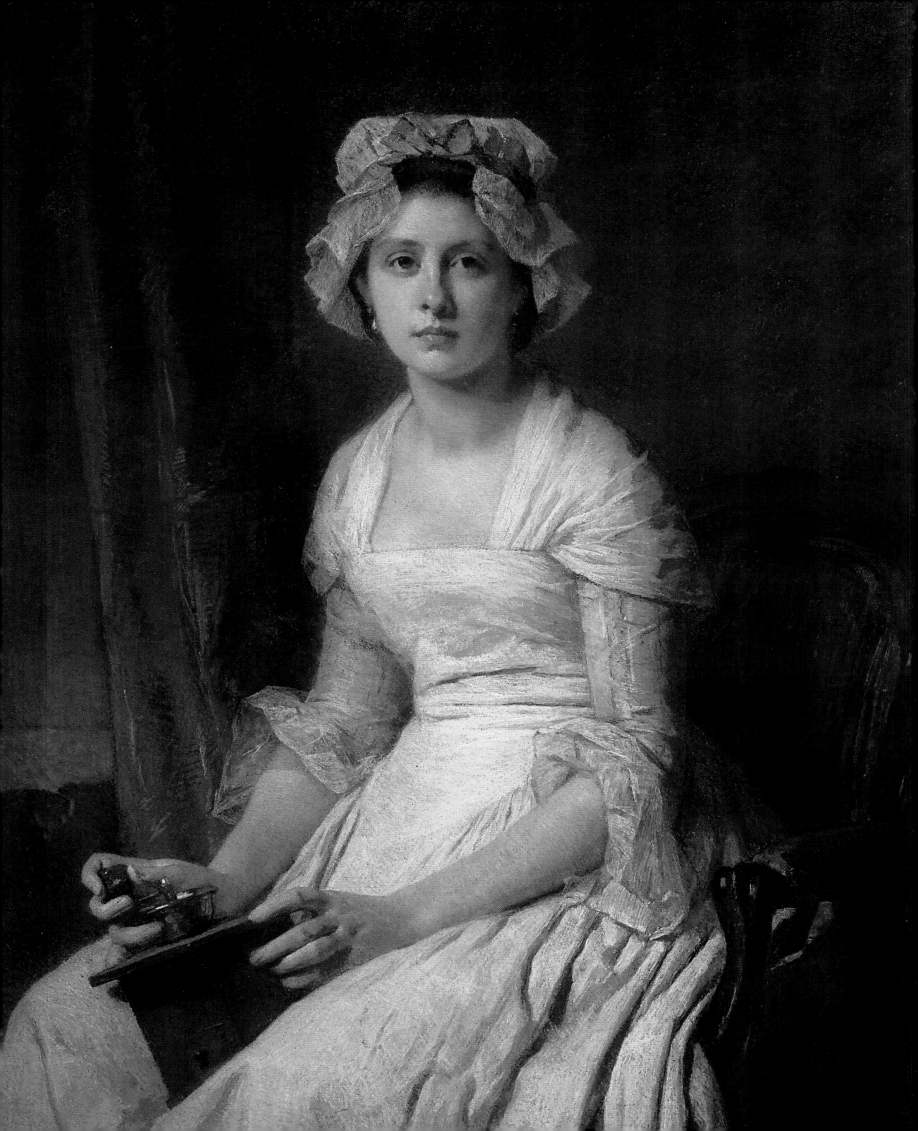

Huet, both pioneers of pastel, and a cousin of Eugène Delacroix, he executed pastel portraits of several friends and family members whose elegant finish rivaled that of oil painting. A friend of Henri Fantin-Latour and Berthe Morisot, Riesener was a vital intermediary between the Romantic and Impressionist eras. "These counterrevolutionaries who bore the name of [Maurice Quentin de] La Tour emblazoned on their hats"[7] were joined by numerous other artists—Henriquel-Dupont, Bassompierre, Giraud, as well as Louis-Eugène Coedès (1810–1906), Clotilde Gérard (1806–1904), and Alphonse-Louis Galbrund (1810–1885). Pastel's soft quality, which showed models to their best advantage, certainly did not inhibit its newly rediscovered popularity. "Women—it is well-known—prefer their portraits to be done in pastel by a painter of an inferior quality to an oil painting signed by a great master. The velvety quality and transparency of the skin are infinitely more agreeably rendered in pastel than with a brush; the contours of the face are softer, the hair becomes gossamer-light and those silver threads less visible. Wrinkles are usually so faintly indicated that it seems bold indeed that oil painters sometimes dare to show furrowed cheeks and brows. In short, if the only subjects of portraiture were fetching young women, oil painting would have to beat a hasty retreat before the onslaught of pastel."[8]

Charles Escot
Louise-Florence-Pétronille de Tardieu d'Esclavelle, Marquise de la Live d'Epinay (copy after Jean-Etienne Liotard), 1874
Pastel on brown-green paper applied to canvas,
28⅜ × 20⅛ in. (72 × 51 cm)
Musée du Louvre, Paris

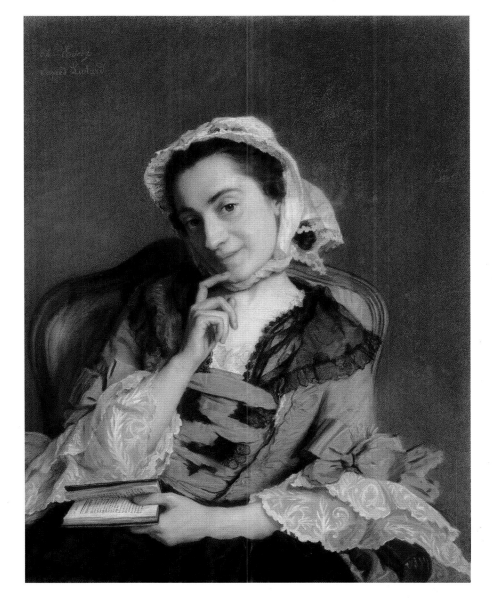

The revival of pastel corresponded to renewed general interest in the eighteenth century. In 1836 the journal *L'Artiste* observed that the "genre of Watteau and [François] Boucher dominates the Faubourg Saint-Germain."[9] Imitation was rampant, and the taste for the medium extended well beyond the limits of this aristocratic neighborhood. There was now a vast market for pastel artists. They included Antonin Moine, known for his vaporous bacchantes and his portrait of Madame Janin in shepherdess garb; the Lille-born Constant-Joseph Brochart (1816–1899), with his amply endowed society belles; Théodore Fantin-Latour (1805–1872), famed for his carefully powdered marquises; Constant Troyon (1810–1865), recognized for his pastels "in the manner of Watteau and Boucher;"[10] and Narcisse Díaz de La Peña (1807–1876). These paintings often had an oval format, a nod to the portraits of the preceding century. It is quite possible that part of this vast output fed a market for imitations, if not forgeries.

OPPOSITE
James Abbott
McNeill Whistler
The Blue Dress, 1871
Chalk and pastel on brown
paper, 11 × 7¼ in.
(27.9 × 18.4 cm)
Freer Gallery of Art and
Arthur M. Sackler Gallery,
Smithsonian Institution,
Washington, DC

Henri Fantin-Latour
Daughters of the Rhine, 1876
Pastel and charcoal on
paper, 20⅞ × 13⅞ in.
(52.9 × 35.2 cm)
Musée d'Orsay, Paris

Edouard Manet
Portrait of Madame Edouard Manet on a Blue Sofa, 1874
Pastel on brown paper,
19¼ × 23⅝ in. (49 × 60 cm)
Musée d'Orsay, Paris

The pastel portrait commissioned by Princess Mathilde from Eugène Giraud in 1849 posed a challenge along these lines. The cousin of the future Napoléon III wanted a full-length, life-size portrait, and her desired prototype was none other than Maurice Quentin de La Tour's celebrated likeness of the marquise de Pompadour. Somewhat uneasy about this ambitious project, Giraud "discovered all kinds of impediments," reported Alexandre Dumas fils, "and attempted to circumvent the assignment in every way imaginable."[11] It was impossible to find paper of sufficient dimensions; the glass would be exorbitantly expensive. Once these obstacles were overcome, Giraud claimed that the princess would have to pose in the stables, "the only place where he could work in comfort," a demand that the princess clearly would not accommodate. But if Giraud was evidently reluctant to compete with La Tour, the great eighteenth-century pastelist, Charles Escot (1834–1902), on the other hand, had no such scruples. This artist studied in Toulouse before spending several years in Paris. His specialty was making literal copies of masterpieces by artists including La Tour, Jean-Etienne Liotard, and Elisabeth Louise Vigée Le Brun. The Musée de Saint-Quentin, where he executed some of these copies,[12] held no secrets for him. Upon his return from the southwest, Escot set up a sort of small private museum next to his studio to display his copies, which were considered exemplars of quality by his local clientele. These examples demonstrate a taste for the eighteenth century that reached its peak during the Second Empire. Empress Eugénie developed a cult around Marie-Antoinette and her era. She busied herself with reviving the Louis XVI style in both the Tuileries and the Château de Saint-Cloud. This fascination existed at the highest levels of state. For Eugénie it was also a way to establish her lineage and legitimize the imperial regime. A consuming interest in the past was eloquently conveyed in the writings of the Goncourt brothers: they envisioned themselves as zealous advocates of eighteenth-century art.

Jean-Etienne Liotard
*Portrait of Marie Fargues in
Turkish Costume*, 1756–58
Pastel on parchment,
40½ × 31⅜ in. (103 × 79.8 cm)
Rijksmuseum, Amsterdam

This reverence for the eighteenth century was very valuable to pastelists, endowing the genre with enhanced legitimacy. When the new Société de Pastellistes Français organized its first exhibition in 1885, it included a group of pastels from the preceding century. "The eighteenth century, which serves as a radiant inspiration for our work," explained the society's founder, "taught us lessons, as well as lending us patronage, and recommended us to a contemporary audience that is captivated by its charms."[13] The obligation to acknowledge a debt to the established masters did not necessarily mean that contemporary pastelists had to give them the last word. For those who embraced the spirit more than the letter, the art of the eighteenth century could serve as a model of freedom, inviting new experimentation. Champfleury, an ardent defender of living, naturalistic art, advocated the close study of La Tour's work: However, he pointed not to the flawless portrait of the marquise de Pompadour that hung in the Louvre—it too closely imitated oil painting—but rather to the lively studies that were the glory of the Musée de Saint-Quentin: "There is no word in our language to convey the captivating visages of these tender, provoking, wayward, joyful, distinctive, mocking beauties, their eyes full of promise, their lips full of desire, rarely melancholy and always seductive."[14] La Tour's incredibly lifelike figures linked his art to contemporary nineteenth-century taste. The critic Camille Mauclair believed that La Tour, like Jean-Siméon Chardin, Philibert-Louis Debucourt, Jean-Honoré Fragonard, and Gabriel de Saint-Aubin, were modernists before their time, participating in the vast movement toward freedom of expression in their own ways: "Between 1740 and 1785 there was a universal desire among painters and art lovers to search for a more direct expression of French life, and these artists blended some mysterious leavening of freedom into the thick impasto of their paints." Mauclair concluded, "Revisiting the eighteenth century is like taking a cure at the right moment. . . . It is living, deeply felt, artistic, genuine, and spiritual in its force."[15] Such was the lesson of the eighteenth century, which taught how conventions could be overcome.

Artists in quest of novelty fully appreciated the rich legacy of their great predecessors. In contrast to his father Théodore, Henri Fantin-Latour (1836–1904) was not content to execute pastiches of works of the past. His *Daughters of the Rhine* subtly draws upon Wagnerian inspiration combined with the grace of Boucher and Giovanni Battista Tiepolo's sense of motion. Jules Chéret (1836–1932), known as "the Watteau of the streets," indulged in color harmonies that his elders probably would have applauded. An advocate of "cheerful art," he animated his pastels with "his fanfare of colors."[16] James Abbott McNeill Whistler (1834–1903) re-created Watteau's spellbound atmosphere. His elegant, evanescent figures, drawn in pastels on dark paper, seem to resonate with those of the master of Valenciennes. But it was Edouard Manet (1832–1883) who drew most upon the work of eighteenth-century pastel artists. By 1874, he had already completed a masterly pastel portrait of his wife seated on a blue sofa. Edgar Degas was to own this masterpiece, which was worthy of Liotard himself. The series of female portraits executed by Manet between 1878 and 1883 constitutes the most striking demonstration of his genius as a pastel artist. His lifelike figures, deftly rendered, form a fascinating portrait gallery of contemporary Parisian women. With his flawless blend of "simplicity, rightness, and elegance," Manet raised the art of pastel to the level of the most daring works of the eighteenth century without ever lapsing into the platitude of pastiche.[17]

OPPOSITE
Pierre-Auguste Renoir
Portrait of a Young Girl,
c. 1900
Pastel on paper,
21¼ × 17⅛ in. (54 × 43.5 cm)
Musée d'Orsay, Paris

THE PAST REDISCOVERED

187

13.
The Quest for Legitimacy

Mathilde Letizia
Wilhelmine Bonaparte,
Princess Mathilde
*Young Woman in Albanian
Costume*, 1864
Pastel on paper,
36¼ × 29¼ in. (92 × 74.3 cm)
Musée National du Château,
Compiègne, France

OPPOSITE
Charles-Laurent Maréchal
Footprints, 1876
Pastel on paper applied to
canvas, 45¼ × 37 in.
(115 × 94 cm)
Musée du Louvre, Paris

*I*n 1835 a special section of the Salon was allocated to the realm of drawing. This decision was intended to address a growing sense of confusion. The sheer quantity of works had increased year by year, and they had thus far been shown together, regardless of medium or technique. Now the Salon's organizers created a more orderly exhibition, displaying paintings and sculptures separately from the graphic arts. This arrangement also recognized a degree of autonomy for drawing in its own right. Emerging from the broader domain of painting, it was becoming a distinctive art, apart from its traditional role as a preparatory step. This recognition was potentially risky, however. The viewer might also take the opposite point of view, concluding that the new division between painting and drawing only reasserted the long-standing hierarchy between these two disciplines. Although the graphic arts were now exhibited in a specially dedicated area, intended to promote their status, these works were also effectively being shunted aside. The subsequent addition of miniatures, enamels, paintings on enamel and porcelain, and stained glass cartoons gave this exhibition area a confused, even patchwork quality that threatened the reputation of pastels.

PASTEL AND PAINTING

Allocating pastel works to the drawing section was no trivial matter. Traditionally considered as an art that was midway between painting and drawing, pastel was now deemed—at least by the official bodies that oversaw the Salon's regulations—as one of the graphic arts. The term *pastel painters* continued in use for a while, but by the early 1840s this term generally disappeared, to be replaced by *pastelists*. On

Eugène Tourneux
Gypsy Family at Rest, 1851
Pastel on paper,
45¼ × 50⅜ in. (94 × 128 cm)
Musée du Louvre, Paris

BOTTOM RIGHT
Charles-Laurent Maréchal
Christopher Columbus, 1857
Pastel on paper applied to
canvas, 49⅝ × 68½ in.
(126 × 174 cm)
Musée Barrois, Bar-le-Duc,
France

one hand the art of pastel gained autonomy by being separated from painting, but it was now grouped with techniques whose prestige was far lower. This diminished standing was clearly reflected in writings by the Salon's critics. Painting, and to a lesser extent sculpture, received the most extensive coverage; pastels were evoked only at the conclusion of these articles, along with watercolors, engravings, miniatures, and so on. "In each of the world's arts," explained Jules Janin, "there is a greater art and there is a lesser art: the Théâtre Français and Vaudeville . . . , gold working and statuary, oil painting and pastel, engraving and lithography."[1] The public loved pastel, but even these aficionados did not really give it the same degree of respect as painting.

However, this indeterminate state had its advantages, because pastel could function as a springboard for aspiring artists. Not only did it offer outlets for beginners; it also allowed the most skilled and gifted practitioners to more easily gain recognition. The competition was less daunting and expectations not so elevated as they were in the painting sector. Charles-Laurent Maréchal (1801–1887) won overnight success with vast pastels of subjects formerly reserved for painting. From his *Sisters of Misery* (1840) to *Christopher Columbus* (1857), Maréchal executed monumental, ambitious scenes that rivaled history painting. This unusual choice of subject matter immediately gave high visibility to this Metz-born artist of modest background (he was a laborer until the age of nineteen). He would certainly not have achieved such recognition if he had cleaved to traditional formulas. "This artist from Lorraine is the king of pastel, an unknown only yesterday and a celebrity today," a reviewer wrote. "This humble genre, pushed to such an elevated level, can fearlessly challenge the noblest, loftiest oil paintings."[2] Maréchal was soon followed on this path to success by his student Eugène Tourneux (1809–1867), whose pastels demonstrate the same ambition to compete with painting. *The Meeting of Jesus and the Disciples at Emmaus* (1842), *The Departure of the Magi* (1845), *Gypsy Family at Rest* (1851), *The Philosophical Discussion* (1857), and *A Pause (The Maestro Gabrieli Rehearsing One of His Motets)* (1859) are artistic statements that contrast directly with conven-

tional pastels of the time. In the words of a contemporary critic, "Tourneux did not imitate the students of [Maurice Quentin de] La Tour, who limited themselves to representing the affectations of pretty women; he boldly tackled the great themes of religion and the imagination."[3] Eager to claim equality with painting, Maréchal and Tourneux invented a new category altogether: the pastel tableau. "They were draftsmen who wanted to make themselves into painters, striving to be of greater importance, and . . . they extended their scope to a remarkable degree."[4]

This decision may appear to have been motivated by a desire to attract attention at any price, but Maréchal actually seems to have been primarily driven by the highest artistic ideals. Steeped in the principles of Saint-Simon, he believed that art and artists should occupy an exalted place in society. He refused to indulge in the facile aspects of the pastel genre, preferring to render the edifying themes of religion and history. But this ambition was beyond the comprehension of his contemporaries, who were simply staggered by this desire to equalize the status of pastel and painting. Why not simply opt for painting, some wondered, instead of breaching the boundaries between the two disciplines? As a critic wrote in 1844, "The breathtaking abilities of Monsieur Tourneux, the elevated nature of his thoughts, and the power of his color make us regret that he does not apply his skills to a great painting that would display the brilliant qualities that distinguish his work."[5] Two years later, the Salon's jury reined in the aspiring applicant's activities. Under the pretext that the young artist "has only one more step to master oil painting," it refused four of Tourneux's large pastels.[6] By attempting to place his pastels on the same level as oil paintings, the artist antagonized the Salon's organizers, who had relegated pastel to the drawings section since 1835.

The initiatives taken by Maréchal and Tourneux were actually less transgressive than they seemed, since ultimately these artists acknowledged that painting was the benchmark. In their efforts to elevate pastels to the exalted level of great painting, they implicitly acknowledged the preeminence of the painter's art. The established hierarchies remained fundamentally unmoved. Most importantly, it is debatable that the medium of pastel actually gained from this incursion into the world of major painting. "To obtain the effects of oil painting, the artist must to a certain extent diminish pastel's nature and technique, and this more often than not results in a double failure."[7] Several years earlier, a number of watercolorists had manifested similar ambitions to replicate the effects of oil painting. This quest led them to sacrifice the transparency of their medium to gain greater intensity in their colors, which gave rise to similar criticism. "The virtue of this type of painting is its freedom, lightness, delicacy in the use of color, and a moderated vigor of expression that cannot exceed certain limits without departing from its own genre. The most distinctive requirement of watercolor is preserving its clarity, which is by no means easy, instead of laying on color as is the practice in oil painting and gouache."[8] In short, the lesser arts should only assert their legitimacy by reaffirming their own innate qualities, rather than by imitating the dominant art forms.

A FEMININE PASTIME?

Most commentators of the period were of one mind about the amateur and feminine aspects of the practice of pastel. This reputation for amateurism was not unfounded; two-thirds of the 2,000 pastelists listed in the salons between 1800 and 1900 exhibited to the public only once or twice. Over the same period, women accounted for no fewer than 40 percent of those 2,000. Men did indeed remain in the majority, and exhibited only one or two times in the same proportion as women. Nevertheless, women were better represented in the art of pastel (as in watercolor and miniature painting) than in the dominant disciplines (painting,

OPPOSITE
Mathilde Letizia Wilhelmine Bonaparte, Princess Mathilde
Young Woman in Albanian Costume (detail), 1864
Pastel on paper,
36¼ × 29¼ in. (92 × 74.3 cm)
Musée National du Château, Compiègne, France

THE QUEST FOR LEGITIMACY

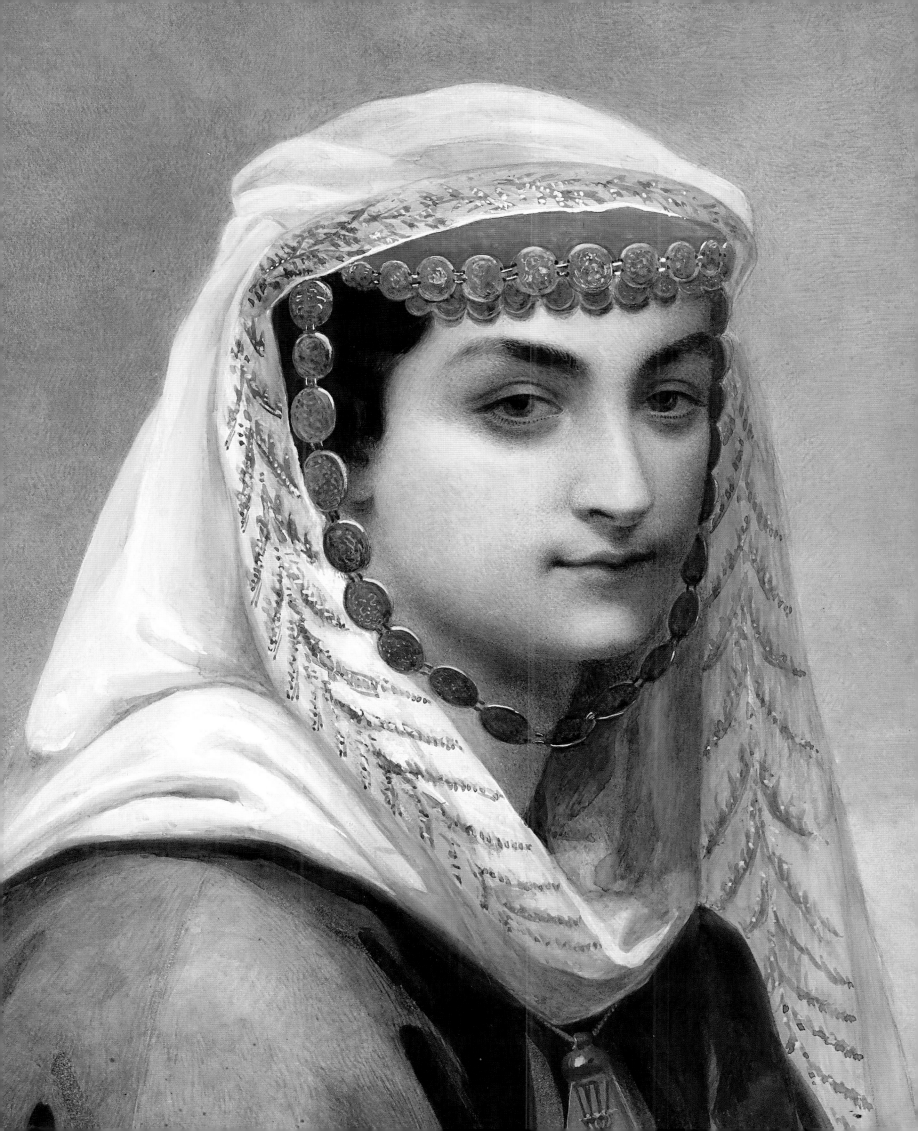

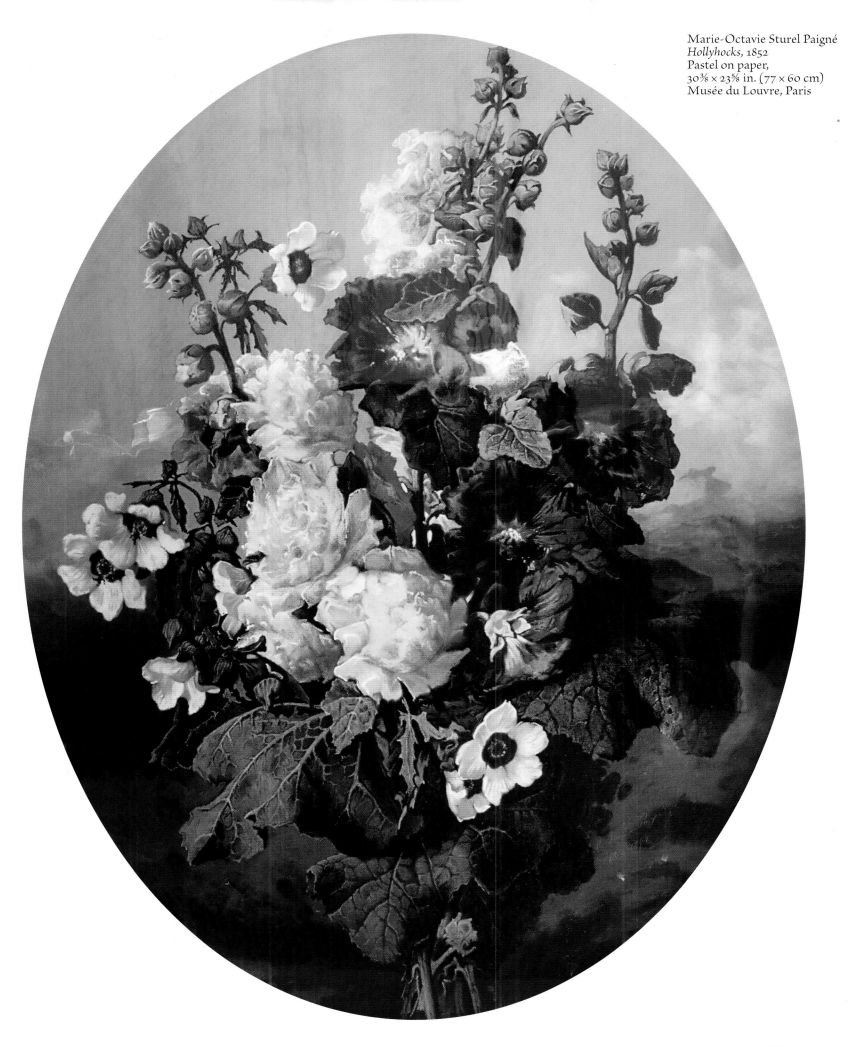

Marie-Octavie Sturel Paigné
Hollyhocks, 1852
Pastel on paper,
30⅜ × 23⅝ in. (77 × 60 cm)
Musée du Louvre, Paris

195

Louise Breslau
Two Girls Seated on a Banquette, 1896
Pastel on paper, 31⅛ × 36⅝ in.
(79 × 93 cm)
Musée d'Orsay, Paris

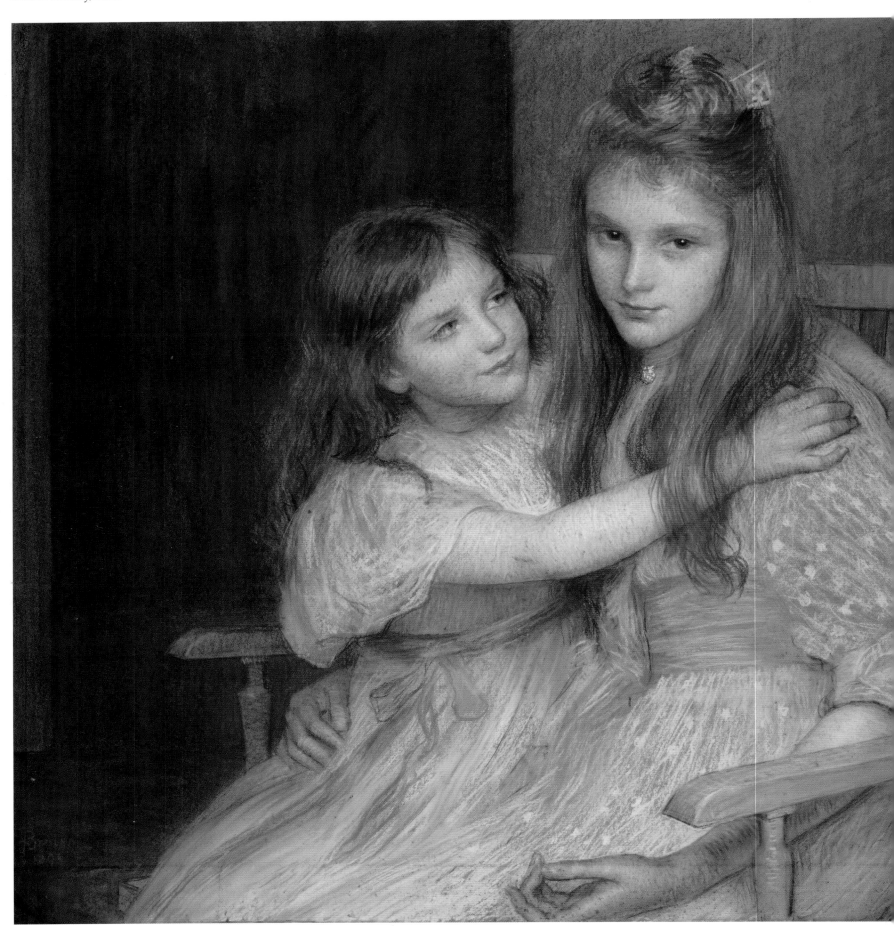

196

sculpture, and architecture). Women who ventured to take up the brush or chisel to embark on an actual professional career confronted a hostile world. They were forbidden to do studies of nudes—one of the pillars of academic training—in the name of good moral order, and the doors of the Ecole des Beaux-Arts were closed to them until 1897.

Before explaining this overrepresentation of women in pastel, we should recall that elite society frowned upon women who pursued professional careers. The father or husband was expected to provide for his family's needs. In this male-dominated society, women had a clearly defined role, and to question the traditional differentiation between the roles of the sexes was unthinkable. As an ornament of the household, a woman had to embody the grace and modesty expected of her in her comportment, dress, and occupations. Given these expectations, it was extremely difficult for her to engage in a messy artistic activity or anything that required major physical effort, such as sculpture. On the other hand, there was no impediment to a woman's practicing one or more of the ornamental arts in her home as a simple pastime. These activities had the merit of providing a distraction; without compromising a lady's position, they might introduce a measure of becoming cultural accomplishment to the household. Girls of good family received an education that included piano, singing, miniature and porcelain painting, and embroidery, as well as watercolor and pastel. These two techniques were tidy and convenient; they could easily be interrupted and resumed, fitting into required daily tasks. They did not necessitate setting aside space for a studio and posed no threat to the household's economy or domestic order. Pastel was traditionally associated with portraiture; it did not entail study of the nude and could be practiced within society's norms, in the circle of the immediate family, close friends, and relatives. Perceived as a social grace, pastel attracted many women of the aristocracy and the bourgeoisie, including Princess Mathilde, the Duchess of Chevreuse, Countess Marie de Keller, and Betty de Rothschild, all ladies who were attentive to maintaining the proper degree of decorum. The presence at the Salon of several young women who were students at the prestigious Maison d'Education de la Légion d'Honneur was further proof of this suitability.

Women were not merely limited to less highly valued techniques; they were also confined to secondary genres. Pastel still lifes were generally relegated to women; one of the most talented creators of these was Marie-Octavie Sturel Paigné (1819–1854), a very gifted student of Maréchal. These limitations were based on the presumed inferiority of women. On one hand, there was the notion of "male genius" that could only find its full expression in "great architectural concepts, statuary in its most elevated form of expression, engravings of works that demand the highest conception of the ideal—in brief, great art."[9] In contrast, ostensibly feminine qualities—attention to minutiae, meticulousness, and grace—inclined the fair sex to creating careful copies and practicing delicate techniques. This universally accepted idea was so prevalent, even among women, that most found it completely natural to confine themselves to flower painting, watercolors, and pastel. Of course the differentiation between the artistic "choices" made by men and women was in fact the result of larger forces. By relegating women to less prestigious disciplines, men restricted competition in the highly prized sectors of artistic endeavor. Needless to say, however, in an increasingly competitive world, men did not rule out working in pastel themselves.

Despite these obstacles, many women managed to distinguish themselves in the art world. Some built on their success, particularly in the realm of pastel, to achieve a degree of professional recognition. Among those artists who exhibited more than ten times in the Salon's pastel and watercolor division, half were women, who thus demonstrated that it was possible to have a career as a pastelist. Many women

strengthened their position by combining their work in pastel and watercolor with miniature paintings; no one begrudged them any of these domains. The most determined ventured into oil painting. Madeleine Lemaire (1845–1928) exemplifies this pattern. Originally a watercolorist specializing in flower bouquets ("She creates the most roses after God Himself," said Alexandre Dumas fils), she boldly employed pastel crayons along with brushes in her studio, emerging as a member of the societies for both watercolorists and pastelists in France. Finally, pastel, like all the arts, had to be taught and learned, giving women the opportunity to become teachers in both schools and homes. Marie Pauline Adrienne Coeffier (1814–1900), Claire Mallon, and Rosalie Thévenin (1829–1892), for example, trained numerous women in the art of pastel. They followed the example of Léon Cogniet, who was the first to open his studio to women and allow them to study live models (Rosalie Thévenin was Cogniet's sister-in-law). In the 1870s and 1880s, they were succeeded by Marie Mac-Nab (1832–1911) and Angèle Dubos (born in 1844). Subsequently, several Parisian ateliers (Académie Julian, and the studios of Félix Barrias, Carolus-Duran, Jean-Jacques Henner, and Krug, among others) became accessible to both sexes, effectively limiting the transmission of the skills exclusively among women.

These advances were, however, insufficient in the view of women who were truly resolved to build an artistic career. The Swiss artist Louise Breslau (1856–1927), for example, determined to make a name for herself in painting, just like the men she strove to equal, assiduously took courses at the Académie Julian. She was determined above all else to exhibit in the Salon. But male or female, necessity ruled; she neglected no avenue to promote herself and earn a living. Madeleine Zillhardt, Breslau's friend and biographer, recalled, "When she started out, her portraits were deemed so harshly realistic that nobody would commission one. That was when she bought a box of pastels, a medium that was no longer fashionable. She mastered them with such artistry and charm that her first portrait of a baby in a long white gown brought in more commissions. She soon became known as one of the finest portraitists of children, allowing her to earn a living while continuing to do the painting she loved."[10] This incursion into pastel was actually far more than a mere concession to necessity. In 1882 Breslau met Edgar Degas; this encounter not only marked her decisive conversion to a freer approach to painting; it also substantially altered her understanding of pastels. She was not alone: Mary Cassatt, Eva Gonzalès, and Berthe Morisot were not afraid of being mistaken for amateurs when they occasionally set aside their oil paints for pastel crayons. Artists as gifted as Jacques-Emile Blanche, Degas, Giuseppe De Nittis, Paul César Helleu, and Edouard Manet took an interest in the medium, and the reputation of pastel rose considerably. The establishment of the Société de pastellistes français in 1884 confirmed this newfound legitimacy.

THE QUEST FOR LEGITIMACY

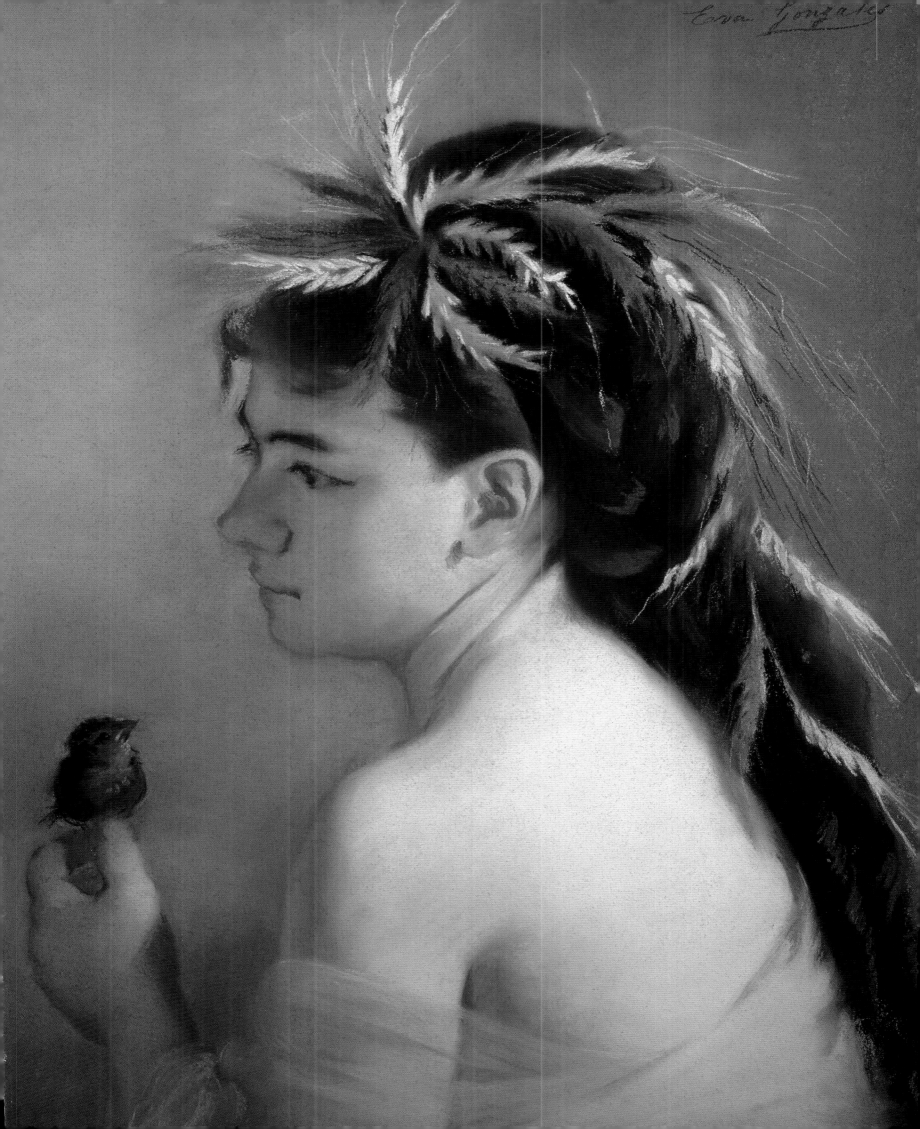

14.

Outside the Walls:
Pastel Landscapes

Edgar Degas
An Island in the Ocean,
c. 1890
Pastel on monotype,
11¾ × 15¾ in. (29.8 × 40 cm)
Musée d'Orsay, Paris

*T*ravel creates landscape artists. Consider the small pastel works executed by Elisabeth Louise Vigée Le Brun in 1807 during a sojourn in Switzerland. Marie-Antoinette's erstwhile favorite, famed throughout Europe for her brilliant portraits, discovered the soul of a landscape artist within. "The vista before me delighted me so much that I forgot my weariness," she later wrote, her enthusiasm still undimmed. She went on to explain how, viewing the sublime panorama of the Glarus Alps range one evening, she could not resist the urge to immortalize such beauty. "The summits were the color of fire; other mountains, closer to us and lower, were already in shadow; this melancholy effect so enchanted me that I seized my pastels to record it."[1] Returning from her travels in Switzerland, Vigée Le Brun brought with her "about two hundred pastel landscapes" by her own count.

THE BIRTH OF PASTEL LANDSCAPE

In taking up her pastels to immortalize a landscape, Vigée Le Brun inaugurated a practice that had a bright future. Pastel landscapes had experienced growing popularity since the late 1830s, a burgeoning growth that gradually overtook the popularity of watercolor. The moderate cost of materials compared to the expense incurred for oil painting was certainly a factor in its success. Pastels could economically reach a large clientele attracted to a genre that was both expressive and familiar. Even easier to handle than watercolor, and enhanced by the availability of new colors, pastel was well suited to any excursion, as Vigée Le Brun demonstrated in the early 1800s. Pastel landscape was a lucrative genre that artists neglected at their peril. Constant Troyon (1810–1865), for example, produced numerous little

201

BELOW
Camille Flers
Norman Landscape,
c. 1840–45
Pastel on paper, 9¼ × 19⅜ in.
(23.6 × 49.3 cm)
Palais des Beaux-Arts, Lille,
France

BOTTOM
Ernest Duez
Landscape, c. 1890
Pastel on paper, 17⅞ × 22 in.
(45.3 × 55.8 cm)
Musée d'Orsay, Paris

RIGHT
Pierre Prins
Sky at Pouldu, 1892
Pastel on paper,
17¾ × 21½ in. (45 × 545 cm)
Musée d'Orsay, Paris

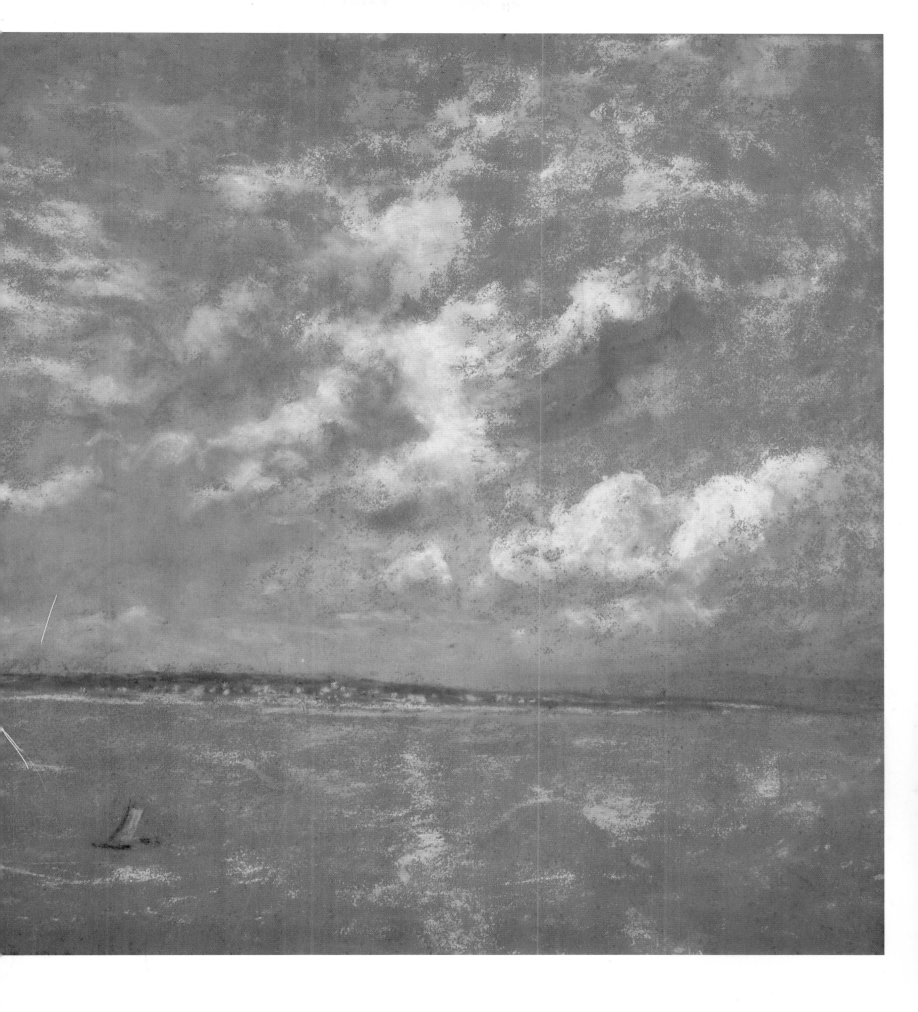

pastel rustic scenes and bucolic landscapes in the manner of the Dutch school. Apparently there was a significant market for these works. The luminous landscapes of the Midi and seascapes of Vincent Courdouan (1810–1893), a native of Toulon, quickly found an appreciative audience. The landscapes of Lorraine by Auguste Rolland (1797–1859) and the scenes of Brittany and the East by Michel Bouquet (1807–1890) were also warmly received. As these artists demonstrated, wrote Camille Flers, "The pastel landscape is a bottomless well; no one can comprehend its richness; it is a resource so vast that the boldest speculation could not grasp its scope."[2]

 It is evident that Flers (1802–1868) was an ardent advocate for pastel landscape. He came from a modest background and began his career as a decorator of porcelain. Following a period spent in Brazil, he associated himself with numerous landscape painters, including Alexandre Decamps, Camille Roqueplan, Paul Huet, Louis Cabat, and Louis Godefroy Jadin. They all loved to leave their studios behind and ramble through the countryside, returning with countless sketches done from nature. The banks of the Seine and the environs of Paris soon held no secrets from these artists. All these outings encouraged Flers to bring along his box of pastels. The experience proved to be a revelation. Flers told Théophile Gautier that he "passionately loved" this material.[3] However, the Salon's jury was lukewarm at best: in 1842, it rejected Flers's two pastel landscapes, and in 1846 it accepted only two of the twelve he submitted. Stung by this rebuff, Flers published a powerful plea in favor of pastel landscape painting in the journal *L'Artiste*. He made numerous arguments in the medium's favor—technical, practical, and aesthetic. Flers first turned his attention to pastel's reputation for fragility, which he claimed was grossly exaggerated; as long as the pastel was properly applied to the support, it would adhere very effectively. As an example, Flers pointed to his own pastels, which had been transported all along the roads of France without misadventure. He also proclaimed the stability of pastel color over time, in contrast to that of oil, which modern fabricators adulterated with additives that did not age well. Use of pastel also avoided "the nuisance and tedium of the drying process" for oil paintings. Convenience and efficiency were significant advantages: "If you are traveling, how many times have you passed by a lovely sight, not without a sigh of regret, giving it a last longing glance . . .

Ernest Duez
*Landscape by the Norman
Seaside*, c. 1880–85
Pastel on paper,
19¼ × 23⅞ in. (49 × 60.5 cm)
Private collection

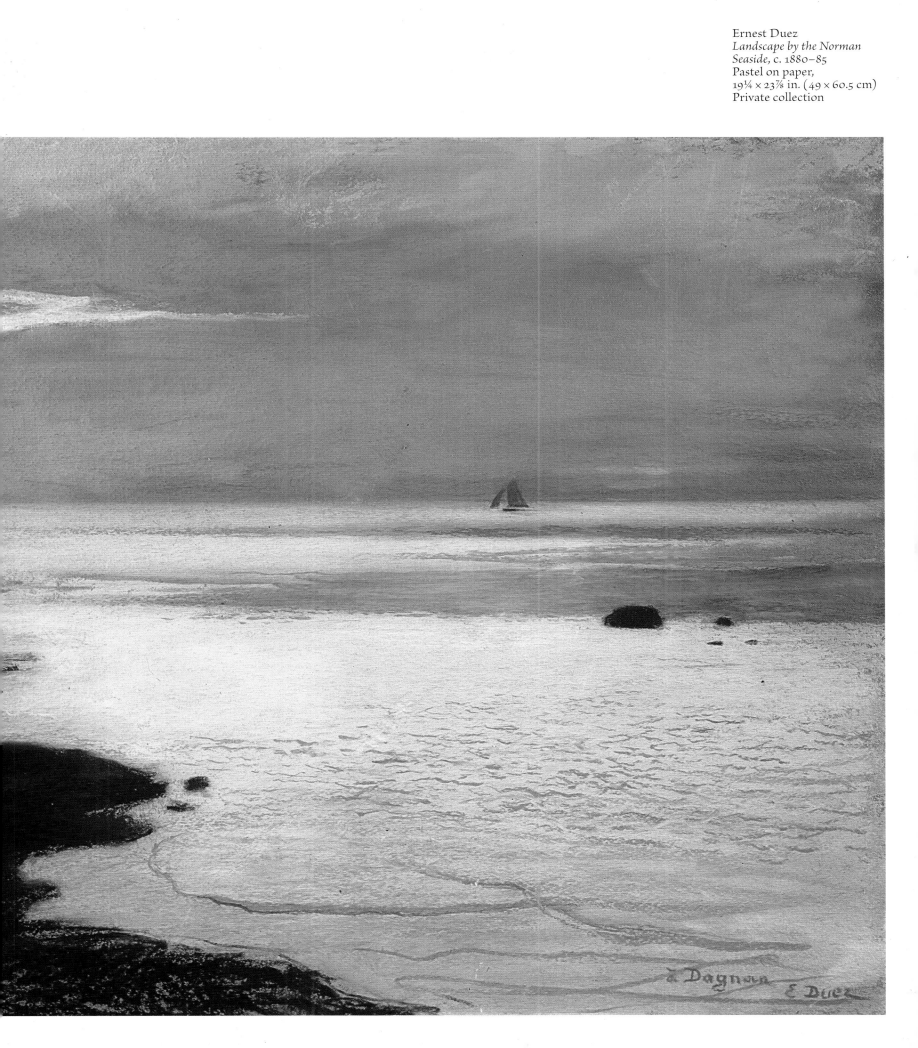

Jules Dupré
The Plain, 1834
Pastel on paper,
5⅞ × 15¾ in. (15 × 40 cm)
Musée Eugène Delacroix,
Paris

all because it would take too long to prepare your palette! What do I suggest? With pastels, you need only open your box to take advantage of fleeting opportunities, leaving off and resuming at your whim, as befits any artist who seeks and studies."[4] He did concede that "to reach this point, the artist must struggle against serious challenges because pastel requires a hand with a different touch, an extra hand, if I may express it thus."[5] Leaving aside this one difficulty, pastel offered nothing but advantages. With its brilliant matte colors of outstanding purity, the medium made it possible to capture natural effects with great immediacy. Connoisseurs of plein air painting enthusiastically took up pastels with this in mind. *Springtime in the Bagatelle* and *Autumn in Saint-Cloud* by Paul Huet (1803–1869) and *The Plain* by Jules Dupré (1811–1889) genuinely convey all the charm of their subjects. These simple renditions express a desire that was shared by an entire generation of artists (who were often outside official circles) to capture "nature above all, nature itself," in the words of Charles Augustin Sainte-Beuve.

FLEETING IMPRESSIONS

As a critic wrote in 1844, "Pastel has a great advantage over painting; the crayon moves as rapidly as inspiration itself; an idea that would take a painter six months of labor would be completed by a pastelist in just a few hours." He went on to recount this anecdote: "One of our friends was visiting Eugène Tourneux's studio one evening. 'What a beautiful sky,' he exclaimed, approaching the window overlooking the Luxembourg Gardens. 'Do you want it?' the artist distractedly replied. 'What do you mean?' 'Just wait a moment.' And he immediately seized a piece of paper and pastel crayons. In less than a half hour, he very faithfully rendered the poetic nuances of a springtime sky at sunset."[6] For artists ranging from Eugène Boudin to James Abbott McNeill Whistler, and Huet to Claude Monet, capturing the fleeting appearance of a changeable sky was a mandatory rite of passage. Confronted with the challenge of representing ephemeral events, pastel seemed to find its true raison d'être. In a race against the clock to capture a moment in time and immortalize it on paper, the merits of this light, convenient medium that required neither preparation nor drying time spoke for themselves.

SPREAD OVERLEAF
Edgar Degas
Seascape, c. 1869
Pastel on paper,
12⅜ × 18½ in.
(31.4 × 46.9 cm)
Musée d'Orsay, Paris

ABOVE
Eugène Boudin
Setting Sun or Stormy Sky,
c. 1860
Pastel on beige paper,
8½ × 11¼ in. (21.5 × 28.6 cm)
Musée d'Orsay, Paris

Eugène Boudin
White Clouds, Blue Sky,
c. 1854–59
Pastel on paper, 6⅜ × 8¼ in.
(16.2 × 21 cm)
Musée Eugène Boudin,
Honfleur, France

It was therefore natural for Eugène Delacroix, en route to North Africa in 1832, to use his pastels to record the various features of the coastline around the Strait of Gibraltar with just a few deft strokes. He carefully noted the time and place on each one. The works effectively served the role of a snapshot, a medium not as yet available. In the late 1840s, Delacroix resumed sketching with pastels, something he had only practiced occasionally in the past. He was inspired by his visits to the countryside, particularly around Champrosay (now part of the commune of Draveil), where he rented a house. His lovely sky studies, captured under a range of conditions, are intimate insights in which Delacroix, with his empathy for the natural world, reveals his inner, contemplative self. At about the same time, Paul Huet was also relishing the liberating pleasures of the medium. Writing from Nice in late 1844, he told a friend, "I've done a few pastel landscape sketches, and I'm very taken with this simple, convenient genre. . . . I enjoy a little stroll and the next day happily sketch a reminiscence of yesterday's beautiful sunset with pastel colors that are so fresh, so matte."[7]

Within this group of artists, Eugène Boudin (1824–1898) was indisputably the most gifted, although there was nothing in his background to suggest that he would become, in the admiring words of Jean-Baptiste-Camille Corot, "the king of skies." Born in Honfleur in 1824, he received no formal artistic training, but was quickly hired as an assistant by a paper and frame dealer in Le Havre. It was there that he realized his calling. The shop was frequented by numerous artists who patronized the merchant to purchase their materials, frame their works, and in some cases exhibit their pictures in hopes of making a sale. The young Boudin was in contact with Jean-Baptiste Isabey, Thomas Couture, Jean-François Millet, and Constant Troyon, who were all attracted to the scenic Norman coast. Boudin's love of that landscape led him to try his own hand at creating art. His first attempt was "a landscape in the manner of Troyon." He recalled, "how often [he had had] the opportunity to frame and sell his pastels."[8] From the outset, Boudin embraced the plein air school. Equipped with his pencils, watercolors, and pastels, he was out from morning till night, exploring the beaches and countryside. After spending three years in Paris perfecting his skills, he returned to Le Havre, where he tirelessly pursued his studies of nature.

When Baudelaire went to visit his mother in Honfleur in 1859, he discovered "his collection of skies." These were small sheets of paper, scarcely four inches in size, on which Boudin had recorded the movements of clouds across the sky. The poet fell under their charm: "These studies of waves and clouds, so quickly and faithfully sketched, record something so ephemeral, so elusive in form and color. All are marked in their margins with the date, time, and wind direction. For example: 'October 8, noon, wind from the northwest.' If you ever have the chance to acquaint yourself with these meteorological beauties, you could verify by memory the precision of Monsieur Boudin's observations. You could hide the caption with your hand, and you would easily guess the season, time, and wind direction. This is no exaggeration. I've seen it with my own eyes. . . . All these profundities, all these splendors go to my head like the intoxication of a drink or the eloquence of opium."[9] Baudelaire did indeed grasp the impact of these pastels, which had all the qualities that Diderot had vaunted for painted sketches a century earlier: "It is the artist in the heat of the moment, pure inspiration with no hint of the artifice that comes from prolonged reflection; it is the soul of the painter freely expressing itself."[10] Boudin struck just the right note, and the genuineness of his expression attracted admiring imitation. The development of the art of pastel was linked to the embrace of plein air painting and the pictorial revolution it inspired. Like those of his revered elder Boudin, Monet's little pastels of the 1860s—most of which were done in Normandy—reflect the open, sensitive vision that would soon be the

LEFT
Paul Huet
Sunset, 1854–60
Pastel on paper,
6¼ × 11⅞ in. (16 × 30 cm)
Private collection

ABOVE
Eugène Boudin
Cloudy Sky, 1854–60
Pastel and charcoal on gray
paper, 8½ × 11⅞ in.
(21.5 × 30 cm)
Musée d'Orsay, Paris

214

essence of the Impressionist aesthetic. The same themes recurred in the series of landscapes—Norman scenes—that Degas executed in the autumn of 1869.

The creators of these pastels viewed them as simple notations to be mined in the future as material for more finished landscapes executed in oils. Their small dimensions and absence of mounting show that they were not intended to be exhibited. Nevertheless, the perceived status of these unpretentious works began to change. Boudin was invited to present several of his famous skies in the Impressionists' first group exhibition in 1874. In 1883 these sketches were once again deemed worthy to be displayed side by side with 150 pictures in the artist's great retrospective at the Galeríe Durand-Ruel. In 1890 Pierre Prins (1838–1913), one of Edouard Manet's close associates, was glad to display at the Galerie Georges Petit lovely pastel landscapes that were on a much larger scale than the small works of Boudin and Monet. Camille Flers had not pleaded his case in vain. In the space of a few decades, the beauty of nature had become the subject that every pastelist worthy of his or her calling strove to master. Rendering a vision of exquisitely ephemeral phenomena was the quintessence of the pastelist's art.

Claude Monet
Setting Sun, c. 1865
Pastel on gray paper,
8⅜ × 14⅞ in. (21.2 × 37.9 cm)
Musée des Beaux-Arts,
Nantes

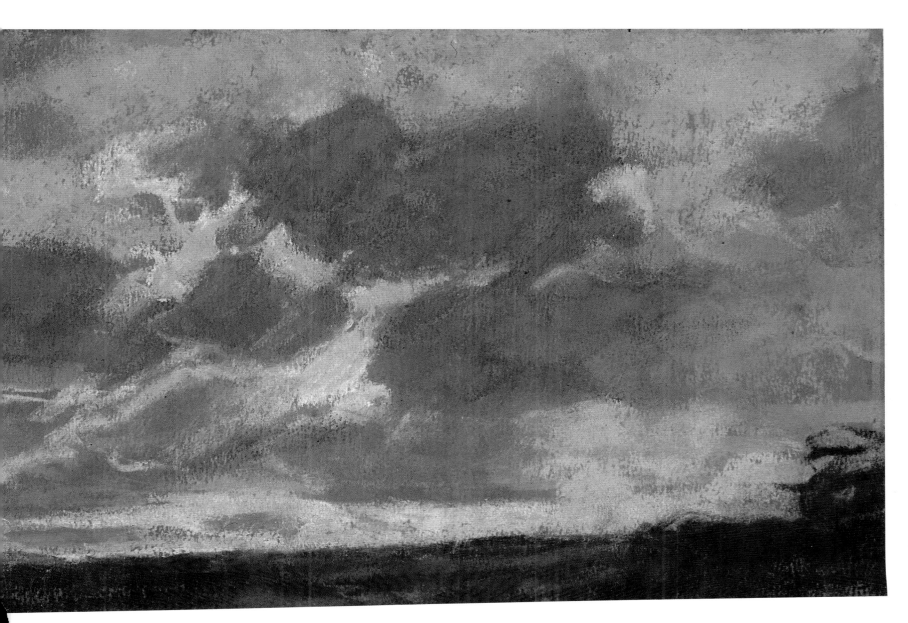

15.
The Revelation of
Jean-François Millet

Jean-François Millet
Churning Butter, c. 1866
Pastel and black pencil on
paper applied to canvas,
48 × 33⅝ in. (122 × 85.5 cm)
Musée d'Orsay, Paris

OPPOSITE
Jean-François Millet
The Bouquet of Daisies
(detail), c. 1871–74
Pastel on paper applied
to canvas, 27½ × 36⅝ in.
(70 × 83 cm)
Musée d'Orsay, Paris

*A*fter visiting the Salon in 1864, the critic Edmond About did not hide his
disappointment: "The two rooms dedicated to drawing, pastel, and watercolor
are a vast shambles where you can find anything—even something with merit,"
he observed with a note of irony.[1] It was true that over the last thirty years, the
number of pastelists exhibiting in the Salon had been growing incrementally, as was
the case with artists in other sections of the show. Some of these exhibitors were
historic figures, pioneers of the revival in pastels, who had begun exhibiting in the
Salon in the 1830s and 1840s: Charles-Louis Gratia, Louis-Eugène Coedès, William
Borione, and most notably Eugène Giraud and Alphonse-Louis Galbrund, who
were recognized as the most gifted practitioners in the field. Younger players had
entered the artistic scene: Pierre-Adolphe Huas (a student of Giraud), Adélaïde
Baubry-Vaillant (a student of Galbrund), Louis-Frédéric Grosclaude, Louis-
Stanislas Faivre-Duffer (much admired by Théophile Gautier), Marie Pauline
Adrienne Coeffier, and Louise Marie Becq de Fouquières took up the torch.

These highly accomplished artists in the pastel division shared an undeniable
technical mastery that was facilitated by the vastly enlarged range of colors avail-
able in their medium. However, they also shared a reluctance to innovate; faithful
to the traditions of the eighteenth century, they remained prudently committed
to the safe realm of portraiture. These exponents of elegance in their shimmering
gowns were certainly formidable trophy subjects, but the viewer rarely found
anything unusual in these conventional depictions. One Salon followed the next,
with little to distinguish it from its predecessors. Other works filled with expres-
siveness and spontaneity by artists including Boudin and Huet were reserved for

the cognoscenti, certainly not displayed on the walls of the Salon. The same applied to the very distinctive pastels produced by Jean-François Millet (1814–1875) beginning in the mid-1860s.

NECESSITY RULES

That he was a pastelist more by necessity than by conviction takes nothing away from Jean-François Millet's genius. His early pastel works dating from the late 1830s had a clearly commercial aim. Like many of his fellow artists, he executed pastiches of Jean-Antoine Watteau and François Boucher in oil and sometimes pastel. These offerings met with considerable success and sold well to dealers including Claude Schroth, Armand Deforge, and Jean Durand-Ruel. A man has to live, after all. However, when Millet exhibited his *Riding Lesson* in the 1844 Salon, he seemed to be aspiring to a different type of recognition. This large pastel representing "a group of children playing a game of horse, with one climbing onto the other's back" rivals the effect of a painting. Millet was following in the footsteps of Charles-Laurent Maréchal and Eugène Tourneux, who were promoting the merits of pastel painting at the same time: "It was a fine composition that Diaz and Eugène Tourneux pointed out to every artist."[2] But Millet had not yet found his own voice, and he temporarily abandoned pastel. The exhibition of his *Winnower*, an homage to peasant labor, in the 1848 Salon was a turning point for Millet. He now assumed the role of eulogist of peasant life, which he rendered authentically, without affectation. It was an approach that risked rubbing both critics and the public the wrong way; they had become accustomed to sentimentalized versions of the subject. His figures, rendered with great verisimilitude as laborers "bent beneath the tyranny of the soil and the relentless toil that it demands,"[3] are not individuals but types, the universality that Millet conferred on them enhancing their power.

The artist suffered from being characterized as a socialist by a bourgeois audience. Commissions were few and far between, and Millet moved to Barbizon, where he lived with his wife and children in near destitution. Fortunately, Millet established ties with an official in the Beaux-Arts ministry, Alfred Sensier (1815–1877). This ally not only lent Millet money during the most difficult periods but also strove to place his works and find him new clients. Millet's situation remained precarious, however. His poverty compelled him to produce more drawings, which were less expensive and therefore easier to sell than paintings. "Summing up, it's the only resource currently available," he wrote to Sensier in 1859, "and I'm turning them out as best I can."[4] The following year, he signed a contract with the Belgian dealer Arthur Stevens (brother of the painter Alfred), agreeing to deliver all the pictures and drawings he could produce in exchange for payment of a thousand francs per month. Increasingly, he exhibited his works in venues other than the Salon, including the Galerie Martinet and the Cercle de l'Union artistique, until the architect and collector Emile Gavet became enamored of his art in 1865.

Millet took up his pastels, abandoned since the late 1840s, at the behest of this new patron, who bought most of the approximately 150 pastels he executed between 1865 and 1870. For Millet, this resumption was not indicative of a conversion to the charms of pastel, but rather a response to the demands of a new client. On a number of occasions, the artist recycled earlier pencil or oil compositions as

Jean-François Millet
Path through the Wheat, c. 1867
Pastel and black pencil on
gray paper, 15¾ × 20 in.
(40 × 50.8 cm)
Museum of Fine Arts, Boston

THE REVELATION OF JEAN-FRANÇOIS MILLET

Jean-François Millet
A Shepherdess and Her Flock,
c. 1862
Pastel and black chalk on
paper, 14¼ × 18⅝ in.
(36.3 × 47.4 cm)
The J. Paul Getty Museum,
Los Angeles

Jean-François Millet
Meridian, c. 1865–67
Pastel on paper, glued to
board, 28⅜ × 38¼ in.
(72.1 × 97.2 cm)
Philadelphia Museum of Art

pastels. More appealing than simple drawings, these works (some as much as three feet wide) were also more accessible than paintings and required less work. Sensier, who benefited financially from the sales of his friend's paintings, shared Millet's renewed interest in pastel, encouraging him to explore a technique that offered new marketing opportunities. In 1865 Sensier published the journal Rosalba Carriera had kept during her stay in Paris in 1720 and 1721. It was a clever move: the attention thus drawn to one of the eighteenth century's greatest pastelists could only enhance the reputation of the medium . . . and of Sensier's protégé.

Millet's pastels admittedly could be considered the product of necessity; it could be claimed that the artist was effectively doing little more than coloring in his drawings. But in fact, Millet had invented his own language. The dignity and authenticity of his subjects, his distinctive crosshatching technique, and his sparing use of color represented a complete break with the established conventions of pastel. Eschewing all show and pretension, he allowed the inherent poetry of his compositions to dominate. It is easy to imagine the mingled sense of surprise and satisfaction his contemporaries experienced as they contemplated artworks that so clearly proclaimed their singularity.

LEFT
Jean-François Millet
The Bouquet of Daisies, c. 1871–74
Pastel on paper applied to canvas,
27½ × 36⅝ in. (70 × 83 cm)
Musée d'Orsay, Paris

COUNTERCURRENTS

Millet, who had made his reputation with depictions of the peasant's world, died in January 1875. Three exhibitions of his work were organized shortly thereafter. They revealed pastel works undreamed of by his contemporaries. "What is so exceptional here?" wrote one critic. "Nothing much, at first glance. Big pieces of coarse-grained paper covered with pencil marks, some more colorful than others, displayed under glass or mounted within a narrow gold frame. But these suffice to bring us to a standstill. The works grip us, speak to us, and call us back, pursuing us long after we've moved on. Through the omnipotence of art, this unassuming work . . . demands the attention of us all, the admiration of many, and the contemplation of a few, artists and thinkers both. It is a small, but perhaps the most striking aspect of the work left to us by the painter Jean-François Millet when he died."[5]

It was clear that finally an artist had taken a truly original approach to pastels. Millet had dared to introduce scenes from rustic life to this delicate art. His sowers, shepherds, and farmyards were subjects that no one before had ever contemplated depicting in pastel. The medium's entire tradition of aristocratic femininity was uprooted.

In addition to the novelty of his subject matter, Millet's technique was distinctive. He almost never used a stump, the tool with which pastelists blended colors together, creating a velvety effect. Instead, he used small strokes and crosshatching, frequently not attempting to hide the black pencil outlines in his compositions. His pastels are actually closer to highlighted drawings—in which pastel serves as an accent—than pastels in the traditional understanding of the term. This unprecedented approach demonstrates that Millet had the temperament of a draftsman and an engraver, giving his compositions a ruggedness and an austerity not found in conventional works. In contrast to the Salon's pastelists, who took full advantage

Jean-François Millet
Dandelions, 1867–68
Pastel on colored paper,
16 × 19¾ in. (40.6 × 50.2 cm)
Museum of Fine Arts, Boston

of the complete range of colors to maximize their shimmering effects, Millet confined himself to a limited palette that possessed its own subtle lyricism. Some of his pastels—particularly his landscapes veiled in snow and his evening scenes and nocturnes—are almost monochromatic. The art critic Ernest Chesneau gave the assembled works an enthusiastic and poetic review that emphasized its varied sources of inspiration: "Sometimes used in flat plains of color, sometimes as simple highlights, the pastels determine the tonality on the background of values already established by his use of black and white. This magic is combined with an incomparable sense of truth and an inexpressible majesty. It conveys the profundity of moonlit nights; the colors of sunsets with fiery rays gleaming in vast cloudbanks on the distant horizon; the glint of water still trapped in melting snow; the subtleties of the innumerable bare and leafy branches in winter forests; the powdery effect of slanting sunlight on the fleeces of grazing sheep; the pounding of the thousand hooves of shepherded flocks; the heaps of hay that have been harvested, turned, and spread out along the vast plains; the living, geometrical symmetry of broad cultivated fields. From the foreground to background of the composition, he flawlessly renders all the wonders of nature."[47]

Although he did not intend to undermine other pastelists, Millet showed many of them to be facile practitioners of the art. Those committed to innovation, however, were now convinced that the art of pastel was no longer doomed to endlessly repeat itself.

Jean-François Millet
The Sower, c. 1865
Pastel and pencil on paper,
17⅛ × 21 in. (43.5 × 53.5 cm)
Walters Art Museum,
Baltimore

Jean-François Millet
*Dead Birch, Carrefour de
l'Epine, Forêt de
Fontainebleau,* 1866
Pastel on paper,
18⅞ × 24⅜ in. (48 × 62 cm)
Musée des Beaux-Arts,
Dijon, France

16.
The Impressionist Pastel

Jean-Louis Forain
*Portrait of the Writer
Joris-Karl Huysmans*, c. 1886
Pastel on paper,
21⅝ × 17⅜ in. (55 × 44 cm)
Musée National des
Châteaux de Versailles et de
Trianon, Versailles

OPPOSITE
Berthe Morisot
Little Girl with a Blue Jersey,
1886
Pastel on canvas,
39⅜ × 31⅞ in. (100 × 81 cm)
Musée Marmottan, Paris

*M*ost Impressionist artists were intrigued by pastel, and with good reason. It is a convenient medium that was well suited to rapid work *en plein air*. Pastels lend a sense of immediacy to depictions of situations and phenomena, very much in accord with the Impressionist aesthetic. In addition to these eminently practical considerations, the Impressionists were always curious about various media and were eager to explore all the resources available to them. In contrast to academically trained artists, who would not even consider compromising themselves with watercolor, engraving, or pastel, the Impressionists refused to confine themselves to the traditional hierarchy of genres. They believed that the choice of technique, whatever it might be, should not be a factor in assessing an artist's talent. Pastel was an excellent medium that served their distinctive aesthetic, which embraced spontaneous expression, rapid brushwork, and luminous effects.

Nevertheless, the Impressionists continued to favor oil painting. They were compelled to compete in oils if they were to advance their vision more broadly. A sketchy style was almost inherent in the medium of pastel. The Impressionist approach diverged sharply from that of traditional pastelists, who sought to gain respect by mimicking the effects of paint. In contrast, the Impressionists wanted to assert the merits of their approach by transposing the spontaneous effects innate in pastel into the more respected technique of oil painting. Despite the uninformed opinion of some of their contemporaries, the Impressionist technique was very difficult to master, particularly with oil paint, where the prolonged drying time was a distinct drawback. Although most Impressionist artists rarely used pastel, the medium offered an ideal method with which to express their heightened sensibilities.

Camille Pissarro
Boulevard de Clichy in Paris, 1880
Pastel on paper, 23⅝ × 29¼ in.
(59.9 × 74.2 cm)
Sterling and Francine Clark Art
Institute, Williamstown,
Massachusetts

Among the Impressionists, Claude Monet (1840–1926) was the most direct heir to the generation of Constant Troyon, Paul Huet, and Camille Flers, who abandoned their studios to fully experience the spectacle of nature itself. Monet's family moved to Le Havre when he was a child. There he developed ties with Eugène Boudin (Monet would later say that he owed his vocation to the older painter). During the 1860s in Paris, he developed his own style as he moved within realist painting circles. He was on close terms with Troyon and Amand Gautier, who both occasionally used pastel. Indulging his passion for plein air work, Monet embarked on a series of travels to destinations including Honfleur, Trouville, Sainte-Adresse, and Yport. He returned with vibrant sketches that brimmed with life, almost like a collection of snapshots. These enchanting little pastels executed during the 1860s were created almost instantaneously; with just a few rapid strokes, Monet captured the essence of the countryside, its landscapes, and its light. Although these sketches may seem to be simple exercises, the artist exhibited several of them during the first show organized by the Impressionists in 1874. These works are not highly finished, but they exemplify Monet's signature style, with all its sensitivity and spontaneity; they are a magnificent summation of the distinctive qualities of Impressionist art.

Although he did not participate in the group's exhibitions, Edouard Manet (1832–1883) made his own contributions to Impressionist pastel during the 1870s. His commitment to verisimilitude inspired him to use this technique in his daring depictions of women bathing themselves. Pastels can be executed far more rapidly than oils, reducing the time required for the model's pose and retaining the naturalism that Manet valued so highly, the essence of the picture's charm. The model's nude body is shown with all its imperfections in an unaffected pose that expresses the ordinariness of this intimate moment. His sister-in-law Berthe Morisot (1841–1895) shared his interest in the demanding technique of pastel. During a visit to Beuzeval in Normandy in 1864, she discovered the work of the pastelist Léon Riesener. Morisot's mastery of the medium gained her an invitation to exhibit in the Salons of 1872 and 1873. The following year, she took part in the exhibition arranged in Nadar's gallery, where she presented pastels, as she did again in 1876, 1877, 1881, and 1882. Fully equal in quality to the work of her male colleagues, her pastels are fresh and bright, rendered in broad strokes that demonstrate a complete mastery of pastel's properties. In the words of the critic Paul Desjardins, "Pastel is the lightest, most fugitive of techniques—like the pollen of a lily or the dust from a butterfly's wing that an artist scatters and fixes on the paper. Pastel should be used to convey what is most ephemeral in nature—the expression passing over the human face, the rapid interplay of sunlight and shadow—nothing more. Mere mortals, do not press it too far! What La Tour actually sketched on that gray background was not Madame du Barry's features, but rather her fleeting smile. In just a few bold strokes, a few slashes of pencil, the face and charm live again. That's the triumph of this technique. It must capture what is most elusive."[1] In sum, the true pastelist should draw inspiration from the living waters of the eighteenth-century ideal. The artist should respect the medium's distinctive features and resist the temptation to weigh it down with trivial details to assure the work its spontaneous, animated quality.

Pierre-Auguste Renoir (1841–1919) certainly shared this point of view. There is nothing rigid or labored in his pastel portraits executed around 1879. On the contrary, they abound with rapid crosshatching in all directions, giving the works a vibrant, lifelike quality. These appealing renderings were intended to attract new patrons during a difficult period for the painter. Facing financial hardship, Renoir was trying everything possible to win public favor. He returned to the official Salon,

Berthe Morisot
In the Park, c. 1874
Pastel on brown paper glued
to board, 28½ × 36⅛ in.
(72.5 × 91.8 cm)
Petit Palais, Musée des
Beaux-Arts de la Ville de
Paris

primarily showing pastel portraits, and developed ties with the publisher Georges Charpentier, who exhibited Renoir's paintings in his gallery, La Vie Moderne, in 1879.

Alfred Sisley (1839–1899) also executed numerous pastels, but, in contrast to Renoir, who confined himself almost entirely to pastel portraiture, he preferred landscape. Faithful to the founding principles of Impressionism, Sisley conscientiously trolled the banks of the Seine and the Loing, especially after he moved to Moret-sur-Loing, near Fontainebleau, in the 1880s. He composed a number of pastels, most depicting rustic subjects such as cows or goose girls along the riverbanks. These rather routine works were intended for sale, and he received support from dealers including Jean Durand-Ruel, Georges Petit, Léon Boussod, and René Valadon. The rest of his activity as a pastelist was sporadic and infrequent. Like many of his associates, Sisley took up pastels depending on his inclination, mood, and needs. Pastel lent itself better than oil to challenging working conditions, and he executed several snow scenes using this technique.

Gustave Caillebotte (1848–1894) adopted a similar approach, thinking of pastel as a leisure activity, which he practiced primarily in familiar settings. His work includes views of the garden in his family estate in Yerres and portraits of those close to him (such as Camille Daurelle, the son of his valet). Caillebotte's mastery makes it regrettable that he did not commit more of his time to this art. Camille Pissarro (1830–1903) generally restricted his use of pastel to preparatory steps,

LEFT
Edgar Degas
Portrait of Zachary Zakarian,
c. 1885
Pastel on board,
15¾ × 15 in. (40 × 38 cm)
Private collection

THE IMPRESSIONIST PASTEL

Pierre-Auguste Renoir
The Boaters, c. 1881
Pastel on paper,
17¾ × 23 in. (45.1 × 58.4 cm)
Museum of Fine Arts,
Boston

237

Gustave Caillebotte
Bathers, 1877
Pastel on paper,
28 × 35⅝ in. (71.1 × 90.5 cm)
Musée d'Orsay, Paris

ABOVE
Gustave Caillebotte
Portrait of Camille Daurelle,
1877
Pastel on paper,
15¾ × 12⅝ in. (40 × 32 cm)
Private collection

particularly in the 1880s, when he began making many sketches in preparation for his paintings and abandoned the Impressionist cult of spontaneity.

MODERN LIFE

The undisputed master of pastel within the group was Edgar Degas (1834–1917). In contrast to Monet, who used pastel mostly for landscapes, Degas focused on the human figure and contemporary life. His *Laundress* was exhibited in Nadar's studio in 1874, immediately earning him the reputation of a pastelist without peer, capable of overcoming the banality of his subject matter with his consummate grasp of drawing and the impact of his colors. In 1877 he exhibited ten pastels representing female nudes, dancers, and cabaret scenes, all new subjects in the realm of pastel. His use of the medium was admittedly tied to financial considerations—Degas was confronting severe economic hardship, and he was struggling to increase sales. But more importantly, pastels permitted him to express a powerful sense of naturalism, since they could depict multiple points of view of the same subject much more readily than oils. In his series of female nudes exhibited in 1886, Degas the inveterate draftsman rendered natural gestures and poses that transcended the banality of his subject matter.

OPPOSITE
Edgar Degas
Café Concert at Les Ambassadeurs, 1876–77
Pastel on monotype,
14⅝ × 10¼ in. (37 × 26 cm)
Musée des Beaux-Arts, Lyon

Jean-Louis Forain
Woman Smelling Flowers,
c. 1883
Pastel on paper,
35 × 31 in. (88.9 × 78.7 cm)
The Dixon Gallery and
Gardens, Memphis

THE IMPRESSIONIST PASTEL

A great admirer of Degas, Jean-Louis Forain (1852–1931) worked along the same lines. An accomplished draftsman and mordant caricaturist, he had a difficult life before achieving success in the artistic world. Driven from his family home at the age of sixteen, he frequented the bohemian circles of Paris and soon became acquainted with the independent artists who gravitated to the Café Guerbois and the Nouvelle Athènes. He familiarized himself with the new style of painting and proved to be very adept with pastels, a medium he often preferred to oil. Like Degas, he favored the brisk, incisive stroke, and also like Degas, he eschewed pastel's reputation for elegance. Consistently focusing on the spectacle of daily life in his scenes of brothels and of the stage wings where elderly gentlemen went to solicit the favors of young dancers, Forain cast an unsparing eye on the frivolity and foibles of contemporary Parisians. His close relationship with Degas gained him four invitations (1879, 1880, 1881, and 1886) to participate in the Impressionist exhibitions.

The Italian artist Giuseppe De Nittis (1846–1884) also professed great admiration for Degas, writing, "His drawings express the most complete expression of his observation of truth, in gesture, form, and color."[2] Invited to participate in the Impressionist group's first exhibition in 1874, De Nittis embarked upon landscape painting with a sensibility that captivated Edmond de Goncourt: "De Nittis has pastel views of Paris in his house that absolutely enchant me. They capture the foggy air of Paris, the gray hue of her pavements, the elusive figure of a passerby."[3] De Nittis did not limit himself to landscapes; he also took on scenes of contemporary life and executed large pastel portraits, which he tried to make as lifelike as possible by showing his models in their customary activities. "This painter works out of a large vehicle that he has transformed into a studio," explained an observer. "He goes along at his own speed and, when the mood strikes, he pulls over. It might be on the Champs-Elysées, teeming with fashionable black carriages, or at the racetrack on Sundays, or in some allée in the Bois de Boulogne at that moment in the early morning when the black silhouettes of women riding are glimpsed through green branches, illuminated by sunlight. He takes these figures by surprise in their living reality, in natural light, in unaffected poses. He sees landscapes in their haze of golden dust and their ever-changing aspects, with the throngs of people who fill the scene and complete the harmony."[4] Also influenced by Degas, as well as by Renoir, the Italian artist Federico Zandomeneghi (1841–1917) had a particularly strong commitment to pastel. He was closely associated with the Macchiaioli, a group of Italian artists opposed to academic art, before moving to Paris in 1874. Embracing the innovations of the Impressionists, he explored in depth all the potential offered by colorful pastels, quickly mastering the technique, which remained neglected in his own country. A contract signed with the art dealer Durand-Ruel in 1893 gave him additional support. An extraordinary colorist, Zandomeneghi was a prolific painter of portraits and female figures, which were a considerable source of income. In addition to this commercially motivated, somewhat facile output, he also produced more audacious scenes. These include the striking *Waking Up* (1895), whose unique point of view, saturated colors, and impeccable draftsmanship compare favorably with the finest pastels by Degas.

Federico Zandomeneghi
Waking Up, 1895
Pastel on paper mounted on board, 23⅝ × 28⅜ in.
(60 × 72 cm)
Palazzo del Te, Mantua, Italy

A passion for drawing also attracted Jean-François Raffaëlli (1850–1924) to Edgar Degas, who introduced the work of his protégé to the Impressionist exhibitions of 1880 and 1881. The creator of numerous pastel works throughout his career, Raffaëlli relished the way the medium allowed the artist's hand to be in direct contact with the support. He would have liked to do the same with oil paint. "Raffaëlli had discovered Titian's curious remark, 'If only we could paint with colors that came from our fingers!'—a sentiment that conveys the artist's impatience when he feels his hand struggling to match the speed of his thoughts."[5] In the late 1800s the painter concocted colored crayons made from hardened oil colors. These "Raffaëlli crayons"—the ancestors of today's oil pastels—met with moderate success, although their glossy quality differentiated them from the matte finish that is so appealing in dry pastels.

By the end of the nineteenth century, the public was very familiar with the Impressionist aesthetic. This taste benefited pastel, a medium perfectly adapted to rapid, spontaneous renderings. The artist Pierre Prins, who had remained in obscurity for many years, finally achieved recognition in 1890 when he exhibited over forty pastels at the Galerie Georges Petit. Following this success, this self-taught artist, a loyal friend of Manet, went on to exhibit luminous pastels of Brittany, England, Provence, and the Parisian environs in 1891 and 1895, some reminiscent of J. M. W. Turner's work in England. When the German artist Max Liebermann (1847–1935) turned to Impressionism in the early 1890s, he very naturally took up pastel. It seemed obvious that a newly liberated vision and a heightened sensibility would be best expressed in this graphic medium.

OPPOSITE
Jean-François Raffaëlli
Bohemians at a Café, 1886
Pastel on paper applied to
canvas, 21⅞ × 17⅜ in.
(55.5 × 44 cm)
Musée des Beaux-Arts,
Bordeaux, France

Max Liebermann
La Kirchenallee, Hamburg,
1890
Pastel on paper,
18⅞ × 28½ in. (47.8 × 72.5 cm)
Hamburger Kunsthalle,
Hamburg

THE IMPRESSIONIST PASTEL

J.F. RAFFAELLI

17.
Manet and
the Parisian Women
of His Time

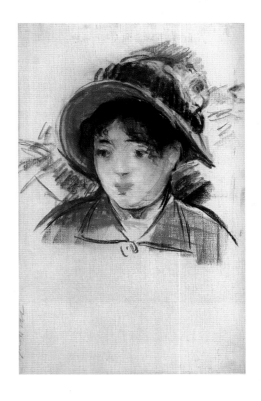

Edouard Manet
Girl Wearing a Summer Hat,
c. 1879
Pastel on canvas, 22 × 13¾ in.
(56 × 35 cm)
Private collection

OPPOSITE
Edouard Manet
Méry Laurent, 1882
Pastel on canvas,
21¼ × 17⅞ in. (54 × 44 cm)
Musée des Beaux-Arts,
Dijon

*T*he painter Edouard Manet (1832–1883) manifested very little interest in pastel until about 1880, when he suddenly immersed himself in this demanding technique. In the next few years he executed over one hundred pastels, mostly portraits of women, that ranked him among the foremost pastelists of his time. His embrace of a different medium is often explained by his illness at the time (loco-motor ataxia, a symptom of tertiary syphilis). Easier to handle than oil painting, pastel would have been a relatively relaxing medium that allowed him to recover in the company of congenial women. This was the explanation proposed by Théodore Duret, a critic and close friend of Manet, after the artist's death; it has been widely accepted since.

More generally, we should consider the artistic milieu that surrounded Manet while he developed as an artist. Like his Impressionist friends, Manet demonstrated tremendous curiosity about graphic techniques of all kinds. "He always kept sheets of paper ready for drawing close by in his studio and a notebook and pencil in his pocket. The smallest object, or even detail of an object, that attracted his attention was immediately recorded on paper."[1] Although Manet regarded oil painting as the queen of the arts, he was also fascinated by techniques that were considered to be less noble, such as engraving. (He was among those who contributed to the revival of traditional engraving, as demonstrated by his membership in the Société des Aquafortistes, established in 1862.) He began working in pastel himself around 1873–74 with a portrait of his wife, Suzanne, no doubt encouraged by the example of the Impressionists. Degas in particular was in the process of reviving an art form that had been constrained by timeworn, formulaic conventions.

247

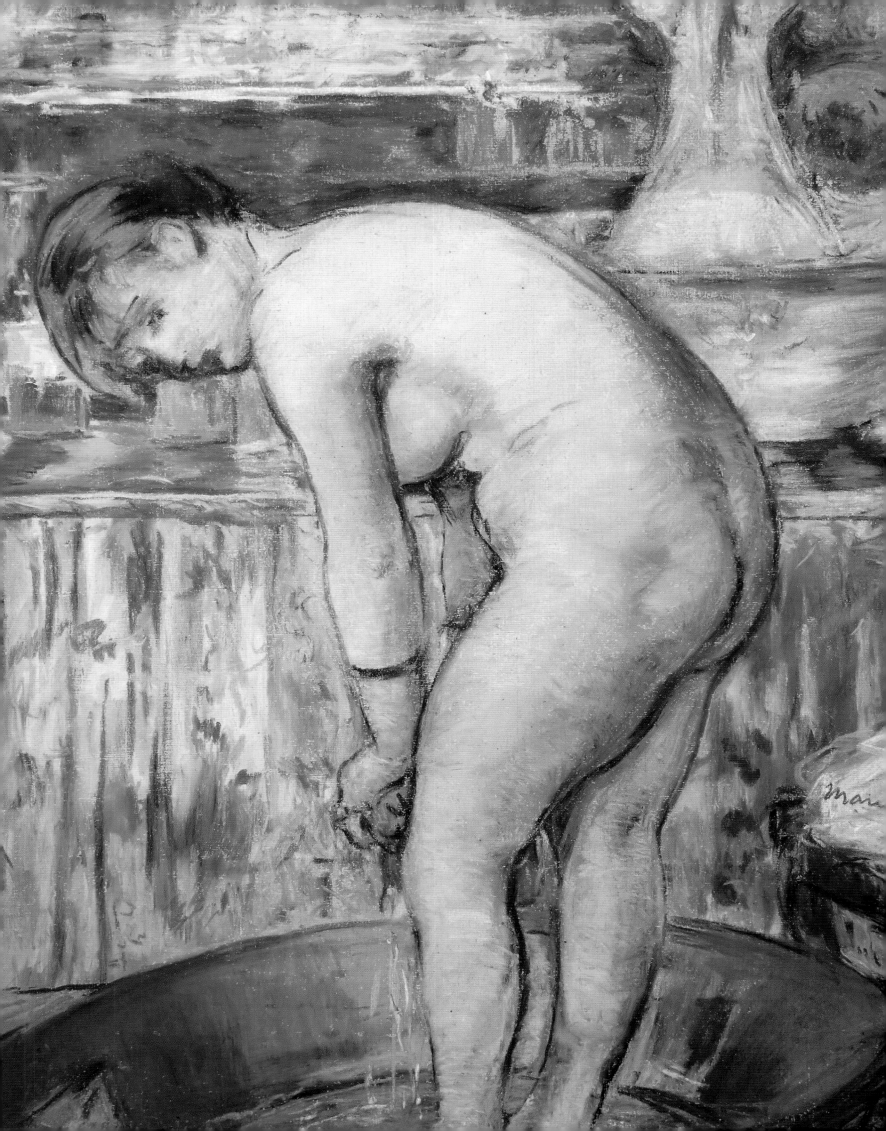

MANET IN A NEW DAY

Manet's growing interest in pastel beginning in 1879–80 was also motivated by financial imperatives. Having experienced a difficult period (rejection by the Salon, poor sales, disappointing prices at the Faure and Hoschedé auctions in 1878), he was counting on the victory of the Republican party (whose ideals he shared) to spur demand. Winners of the legislative elections in 1877 and the majority party in the Senate beginning in 1879, the Republicans had the reputation of being open to the "new painting," as the critic Edmond Duranty called it. The Impressionist style was beginning to gain broad acceptance. Jules Bastien-Lepage and the Italian artist Giuseppe De Nittis were experiencing considerable success by embracing Impressionist innovations while remaining within conventionally acceptable limits. ("He championed the triumph of Impressionism by diminishing its essence, acclimating it to bourgeois taste," wrote Zola of Bastien-Lepage). Convinced that his moment had arrived, Manet decided to move to an enormous studio on rue d'Amsterdam in 1879, a space that would have been the envy of a well-established painter. His hopes were soon dashed; the new government granted him no commissions and purchased none of his paintings.

Manet always felt himself to be at a disadvantage in academic and official circles. He was thus compelled to alter his strategy, and he neglected no potential opportunity. He adopted two distinct marketing approaches. He did not spurn the Salon (the ultimate official artistic arbiter), but he also cultivated private galleries. He strengthened his ties with Georges Charpentier, the advocate of naturalism, who had launched a new journal, *La Vie moderne*, along with an eponymous gallery, in 1879. Both prudently embraced the latest trends. Their target audience was the enlightened Parisian bourgeoisie, and they welcomed pastel, the delicate art synonymous with elegance. In 1879 an exhibition at La Vie Moderne was dedicated to Pierre-Auguste Renoir's pastels. The following year, it was Manet's turn to exhibit there. His ten paintings and fifteen pastels, all representing the female figure, formed a ravishing array that the public found irresistible. "The celebrated leader of the Impressionist school shows himself here in a completely new guise as a painter of elegant women," wrote Philippe Burty.[2] With these inoffensive female figures, especially in pastel, Manet gave viewers the sense that his art was becoming more restrained. Confronted with these images so brilliantly rendered in pastel, no one thought to object to their unfinished aspect, an Impressionist quality that had always alienated admirers of highly polished academic painting. "Manet's pastels are less well known than his oil paintings; they have the same finesse of tone, and due to the greater freedom afforded by this genre, their flaws are less jarring."[3]

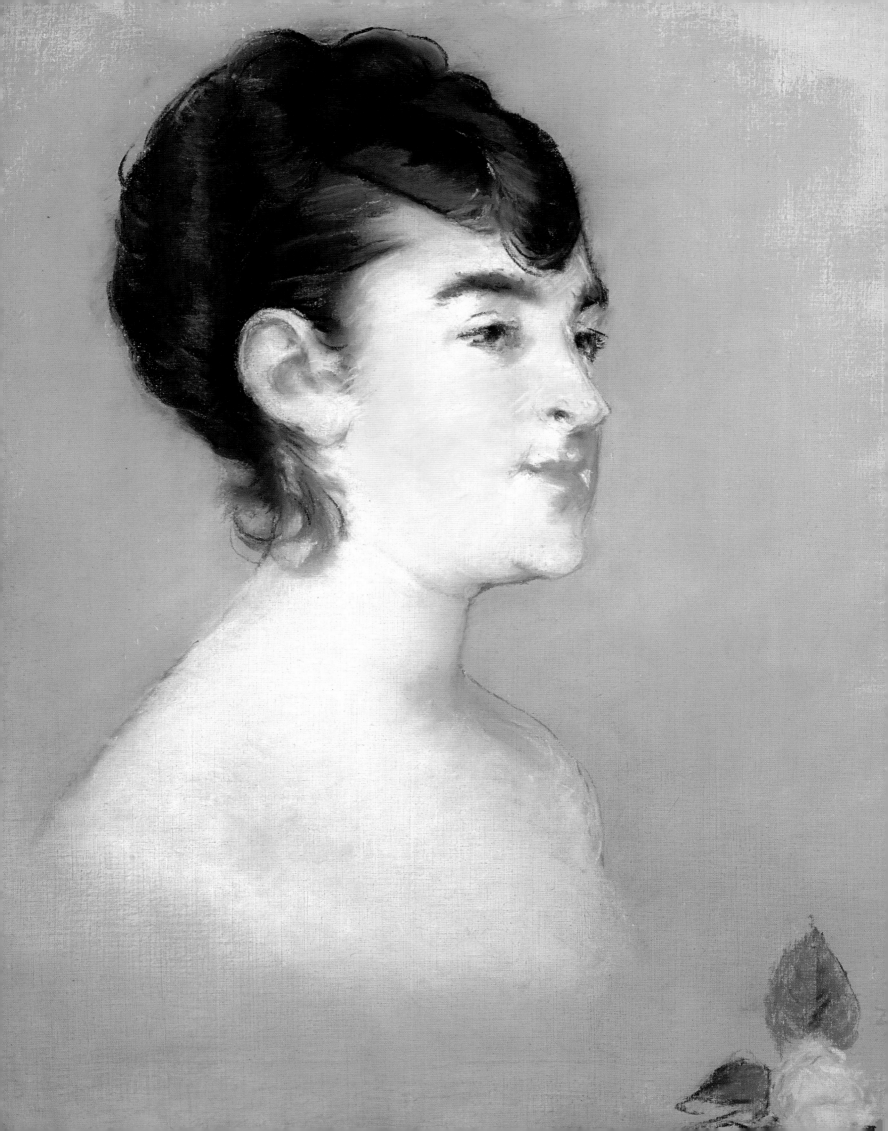

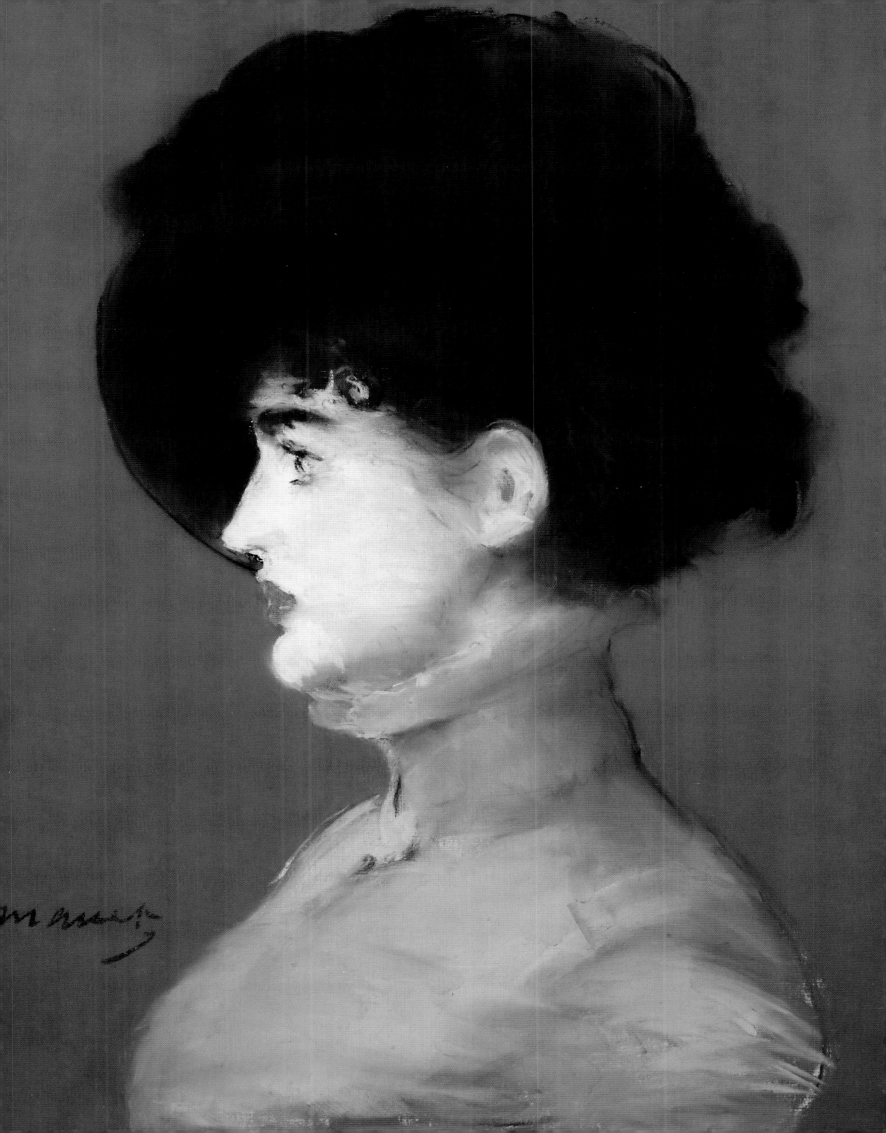

Manet's numerous pastels were certainly not all intended for sale. The artist often gave them away as tokens of friendship. "Most were made for personal friends; it pleased him to make them happy with these gifts," explained Théodore Duret, who believed he could state authoritatively that Manet "gained very little from a financial point of view. He sold only a very few, and those went at very low prices."[4] In actual fact, the artist recorded no less than twelve sales of pastels between 1879 and 1883 in his account books, often at prices of five hundred francs. Less expensive than oils, and thus more readily salable, pastels represented a substantial source of income. They allowed Manet to target "select collectors of taste who are not wealthy and able to pay very high prices," recalling Duret's successful marketing tactics.[5] The works that Manet gave away to his models to hang in their salons were also, in their fashion, *cartes de visite* that served as valuable publicity.

Edouard Manet
Eva Gonzalès, c. 1879
Pastel on paper,
16⅞ × 13⅝ in. (43 × 34.5 cm)
Private collection

Edouard Manet
Madame Guillemet, 1880
Pastel on canvas,
21⅝ × 13⅞ in. (54.8 × 35.2 cm)
The Saint Louis Art
Museum

"THE MOST INTIMATE SENSE OF LIFE"

"Of all the portrait painters of this era, Manet was indisputably among those who injected the most contemporary truth, the most intimate sense of life, the greatest natural grace, and the most spirit—particularly in his portraits of women."[6] With just a few strokes of pastel, Méry Laurent, Valtesse de La Bigne, Marguerite Charpentier, and many others appear before us as living presences. Manet preferred bust-length portraits that recognized the role of clothing and adornment in revealing the financial and social status of the model. Nevertheless, the artist penetrated directly to what was essential in the image. There is no unnecessary detail and nothing excessively descriptive in these portraits: their unfinished quality is a very deliberate choice. Manet took delight in his art: he loved deep blacks and combined them with a sparing use of vigorous crosshatching, enlivened with subtle touches of white, pink, blue, and green, sometimes accented with touches of deep red. "Manet's originality lay precisely in his ability to capture his contemporaries just as they were, committing all his artistic soul and vision to expressing the nature of these individuals. He painted only the essential elements of the setting, the costumes, and the accessories, and, we might say, the model's soul."[7] Hats, fur caps and collars, necklaces, and negligees are often more sketched suggestions than finished details. The faces stand out against a deliberately neutral solid background, dominated by soft grays or the white of the unpainted support, usually canvas. Paul Alexis was correct in observing that Manet's talent as a pastelist "consists of three things: simplicity, precision, and elegance."[8] The artist's apparent ease in capturing his models evokes their financial and social well-being, and sometimes suggests the freedom of their morals. It was in fact Manet's ambition to define the woman of his own time. "The woman of the Second Empire [1852–70] has not been represented, and yet she was the archetype of an era," he stated. "I do not paint the women of the Second Empire, but the women who followed. Madame de Callias, Madame Bergolle, Léontine Massin, Henriette Hauser, the Countess Cabalesti, Ellen Andrée and a number of others, who all have their own personalities."[9] Society ladies, courtesans, or simply friends—Manet's skilled hand transformed them all into an arresting gallery of portraits. Through these works, the artist explored a very real embodiment of contemporary society: the Parisian woman. In the words of Anatole France, she had the role of "belonging to everyone, like a work of art," with the duty of "presenting herself." In his own way, Manet prepared the public for the nudes that Degas exhibited in 1886. Like Manet, who painted his contemporaries with a sense of spontaneous authenticity, Degas strove to represent nudity as naturally as possible; his models, seemingly glimpsed through a keyhole, are apparently unaware of the observer. Although their techniques and subjects were very different, both artists transcended the mere representation of individuals. They aspired to evoke a comprehensive vision that was archetypal and universal.

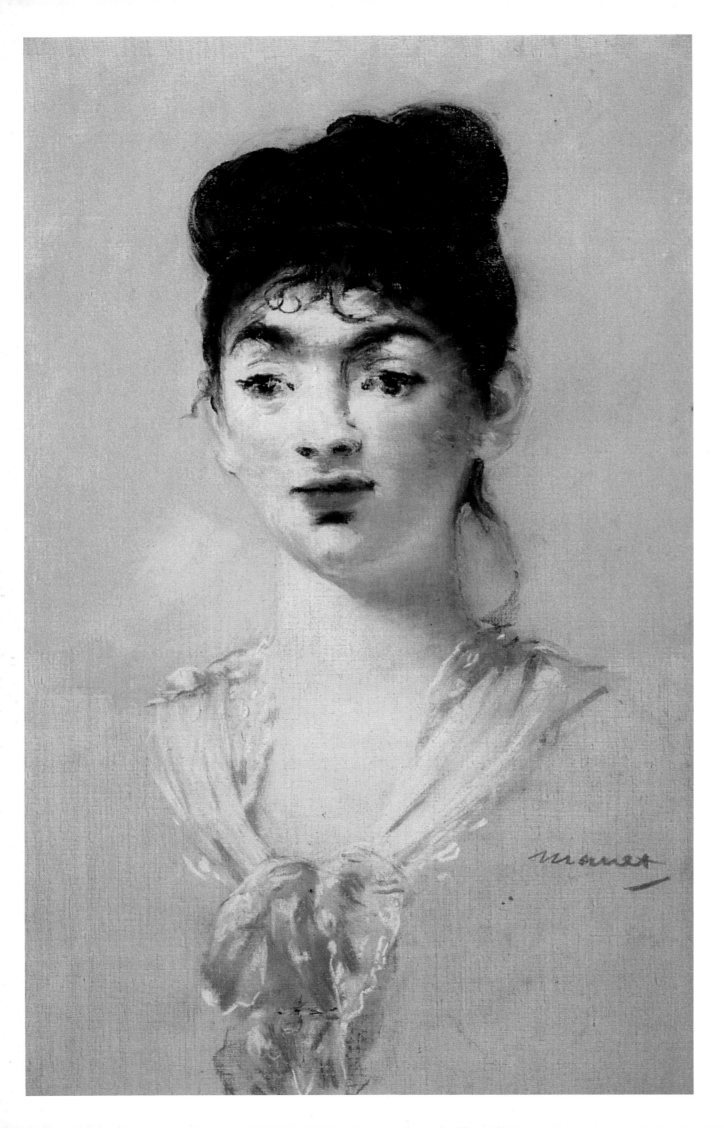

Edouard Manet
*Mademoiselle Suzette
Lemaire*, 1880–81
Pastel on canvas,
20⅞ × 13 in. (53 × 33 cm)
Private collection

<small>OPPOSITE</small>
Edouard Manet
On the Bench, 1879
Pastel on canvas,
24 × 19⅝ in. (61 × 50 cm)
Suzuki Collection, Tokyo

18.

Degas and Cassatt: Advocates of Truth

orn into a bourgeois family, Edgar Degas (1834–1917) led a privileged existence as a young artist. For almost twenty years he was able to devote himself solely to his art, heedless of financial constraints and public taste. Almost immediately after being admitted to the Ecole des Beaux-Arts in Paris, he decided to leave the school. With no parental opposition, he then embarked on a sojourn in Italy that lasted almost three years. With unstinting family support, the young man was able to put off the moment when he would have to earn a living from his painting. There was no pressure on him whatsoever, and he did not exhibit anything in the Salon before 1865, when he was thirty-one years old. But a major financial reversal occurred in 1874: Edgar Degas found himself confronted with serious and persistent financial problems. His father, Auguste, had died in February, leaving the family's situation in a precarious state. Furthermore, his brother René was having business difficulties, and Edgar was compelled to guarantee his very substantial debts. This unwelcome confluence of circumstances was a serious setback to the way that Degas practiced his art. As he wrote to a client who expressed concern over delays, "I have to earn my miserable living before I have the time to pay attention to your concerns. Despite the alarm I feel every day thinking about your return, I just have to keep doing these little pastels."[1] Coming from a man who was generally not very forthcoming, this admission reveals how hard-pressed Degas was by economic necessity, and it demonstrates the role of pastel in these changed circumstances. Taking advantage of this medium that facilitated speedy execution, he could produce multiple "items" (as he referred to these pastels). He repeated compositions that had market appeal, making small modifications in gestures and details—there are several variants of the charming *Ballet*, also known as *The Star*—

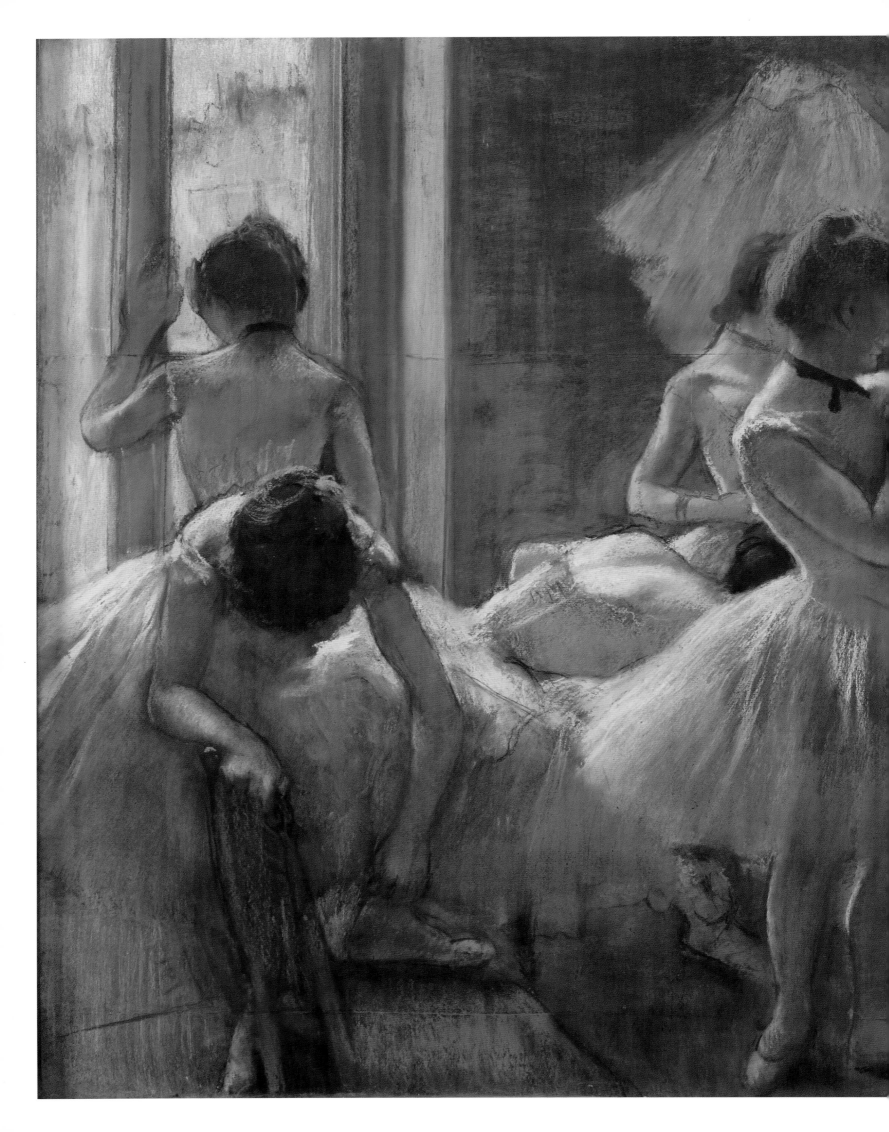

and sometimes added highlights to his engravings. As the critic Gustave Coquiot wrote in 1924, "The public was of course irresistibly drawn to these pastels that so easily lent themselves to being the focal point of a sitting room."[2]

Misfortune sometimes serves a useful purpose. Degas's financial difficulties gave a decisive impetus to his use of pastel. It was a medium that had not much interested the artist earlier in his career, except for a series of landscapes of the Norman coast in 1869. However, he was to become one of the preeminent practitioners of pastel in all of art history. Degas was transformed from being an occasional, opportunistic pastelist to a committed devoté, and he made sure to include these works in all of his displays in the Impressionist group's exhibitions. His admirable *Suite of Nudes Bathing, Washing Themselves, Drying Themselves, Combing Their Hair or Having It Dressed*, exhibited in 1886, secured his place as the group's foremost pastelist. The seven hundred odd pastels he executed over the course of his career—a quantity

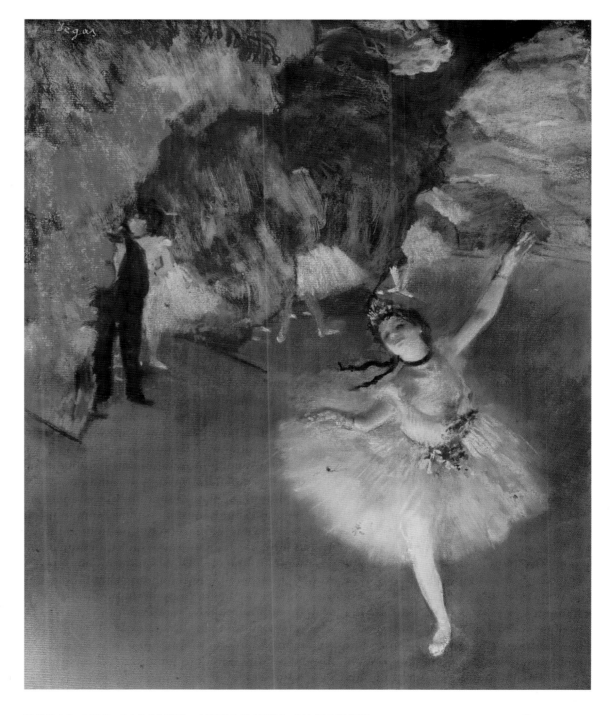

explained by the fact that Degas virtually abandoned oil painting in 1890—demonstrate that the technique was far from a fleeting passion for him. In fact, pastel was the ideal medium for the expression of Degas's aesthetic principles.

TRUTH MUST BE REVEALED

Before discovering his true vocation, Degas had made many attempts to paint literary and historical subjects. These included *Jephthah's Daughter* (1859–60), *Young Spartan Girls Provoking Boys* (1860–62), *Semiramis Building Babylon* (1861), and *Scene of War in the Middle Ages* (c. 1865). Academic tradition placed these genres at the summit of their artistic hierarchy, but Degas was not really in his element here. He had difficulty organizing these compositions, and still greater trouble completing them. Portraiture inspired him far more. It was a genre that revealed Degas's acute powers of observation, and his achievements culminated in *The Bellelli Family*, a very large painting of his uncle, aunt, and their two daughters. This portrait, which took nine years to complete (1858–67), is a masterpiece of psychological realism that shows the artist at the peak of his powers. The artist did indeed take his time to complete the work, but he had finally found his calling: a dedication to naturalism, with subject matter drawn from his own time. Henceforth, authenticity would be

OPPOSITE
Edgar Degas
Ludovic Halévy and Albert Boulanger-Cavé in the Wings of the Opera, c. 1878–79
Pastel and tempera on paper,
31⅛ × 21⅝ in. (79 × 55 cm)
Musée d'Orsay, Paris

Edgar Degas
Entrance of the Masked Dancers, c. 1884
Pastel on paper,
19¼ × 25½ in. (49 × 64.7 cm)
Sterling and Francine Clark
Art Institute, Williamstown,
Massachusetts

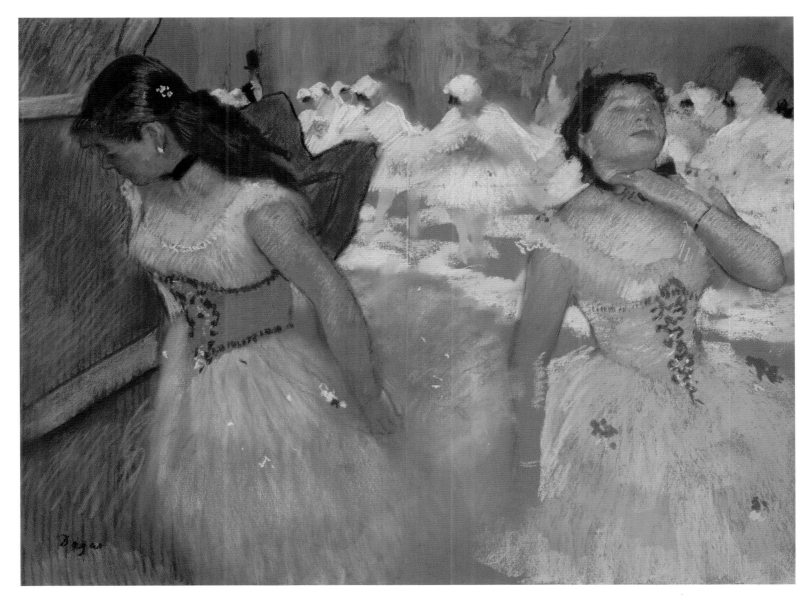

Edgar Degas
Women on a Café Terrace, 1877
Pastel on monotype,
16⅛ × 23⅝ in. (41 × 60 cm)
Musée d'Orsay, Paris

Edgar Degas
Six Friends at Dieppe, 1885
Pastel on paper applied
to canvas, 45¼ × 28 in.
(114.9 × 71.1 cm)
Rhode Island School of
Design Museum,
Providence

Degas's main theme. It would lead him to explore novel subjects: dancers, horse races, laundresses, milliners, and café scenes. All these topics allowed him to explore the telling gestures and true-to-life expressions of real people. These contemporary subjects were far more interesting to his artistic eye than the complicated, remote scenes he had once attempted to depict.

Degas's real originality was not confined to his subject matter, however novel it may have been; it was equally apparent in the way he disrupted the established conventions of figural representation. He exaggerated the effects of perspective, threw compositions off balance, cropped scenes aggressively, and strongly emphasized foreground details. In sum, the artist drew the audience's attention to everything a clear-sighted eye would perceive if freed from conventional habits of observation. As Edmond Duranty stated in *La Nouvelle Peinture* (1876), "In real life, aspects of both people and things can be perceived in a thousand unpredictable ways. Our point of view is not always centered on a room with two lateral walls receding to the rear. . . . Our eye comes to a pause a certain distance from us, seemingly confined within a frame. It does not see the objects on the side unless they are within the confines of this frame."[3] Thus, the truthfulness of a representation is achieved through a heightened degree of emphasis, and even exaggeration. Pastel lends itself to such expression. With its brilliant colors and powdery surface, it holds the light, creating genuinely compelling images. Degas was naturally drawn

DEGAS AND CASSATT: ADVOCATES OF TRUTH

LEFT
Edgar Degas
At the Milliner's, 1881
Pastel on paper applied to
canvas, 27¼ × 27¼ in.
(69.2 × 69.2 cm)
The Metropolitan Museum
of Art, New York

Edgar Degas
In Front of the Mirror, 1889
Pastel on paper,
19⅜ × 25⅛ in. (49.3 × 63.8 cm)
Hamburger Kunsthalle,
Hamburg

Edgar Degas
The Tub, 1886
Pastel on board,
23⅝ × 32⅝ in. (60 × 83 cm)
Musée d'Orsay, Paris

to this medium, whose vividness intensified the impression made by his subjects. Rendered in pastel, the faces of the café-concert singers, illuminated by gaslight, have a glowing pallor that is almost truer than life, and the dancers' tutus take on a phosphorescent glow beneath the stage lights.

Degas found that pastel had essential qualities—a matte surface and brilliant color—that were very difficult to achieve with oil paint. He continued to pursue comparable effects through other mediums, including distemper, tempera with egg, and de-oiled paint. His experimentation with these other techniques reveals a deep-seated mistrust of the oil colors created using modern chemicals; these paints did not hold up well over time and had an undesirable glossiness. De-oiled paint, tempera, and pastel allowed Degas to replicate the matte surface that he so admired in medieval and Renaissance frescoes. Pierre-Auguste Renoir commented, "When you see his pastels! . . . When you think that he could reproduce the tonality of frescoes with a substance that's so disagreeable to handle! When he presented that extraordinary exhibition at Durand-Ruel in 1885, I was in the midst of researching how to achieve the look of frescoes with oil paint. You can imagine how staggered I was by what I saw that day!"[4]

In working with pastel, Degas took pleasure in using colors that were matte, pure, and unadulterated with modern chemicals. To be absolutely certain that the colors of his pastels retained their brilliance, he had to artificially "age" them before use. As he exclaimed to the dealer Ambroise Vollard, "What an incredible amount of effort it is to extract fugitive colorants from pastels! I have to wash them, wash them again, leave them out to dry in the sun. . . ."[5] Finally equipped with colors that he was confident would not be altered by the passage of time, Degas could blend the right tones, working with crosshatching and superimposing colors after applying fixatives to the intermediary layers. This way of working heightened the varying tonalities of the works and enhanced the impact of his compositions. Degas had the spirit of a true artisan; he ignored conventional practices and experimented with all sorts of combinations. He developed a "pastel-soap," moistened his crayons, crushed them in a water solution to apply them with brushes, and pulverized them in boiling water on a sheet already covered with pastel, among other procedures. Grinding his own colors, aging them, and experimenting with a variety of processes, Degas emulated the old masters who had controlled the entire creative process. He was a prodigiously hardworking artist, perfectly willing to deal with the most material aspects of his trade, to the point where his studio resembled an old-fashioned laboratory in which he lived "surrounded by his models, canvases, and a strange clutter of bottles, colored powders, scrapers, brushes, and turpentine that he used in his canvases. The specialists who study them today are perplexed and unable to determine the various proportions of lithography, pastel, gouache, and oil combined together in a single work."[6]

Pastel offered an additional advantage. It was perfectly adapted to Degas's working methods. As the art critic Félix Fénéon observed in 1888, "He accumulates a multitude of sketches on the same subject and uses them to give the completed work an indisputable veracity."[7] Pastel had the immense appeal of convenience in this long creative process. It made it easy for the artist to experiment. If Degas was not satisfied by one or another detail, he could cut the composition and correct it or complete it by attaching additional strips of paper, which would not have been possible with canvas. Pastel was the appropriate medium: far more than oil, it allowed this perpetually dissatisfied artist, who was plagued by uncertainty, to endlessly retouch his work in his relentless search for perfection. "There is nothing spontaneous about my art; it is entirely the result of reflection," he frequently repeated.[8] In this he was very different from Impressionist colleagues like Monet, whose apparent spontaneity was alien to Degas. This aversion explains why Degas

LEFT
Edgar Degas
Reclining Nude, 1886–88
Pastel on paper,
18⅞ × 34¼ in. (48 × 87 cm)
Musée d'Orsay, Paris

did little landscape or plein air painting. He mistrusted his initial impulses and resisted anything that triggered an uncontrolled emotional response. In contrast to common perception, most of his works were not painted in situ; they were re-created in his studio, with the assistance of models or based on his own little sculptures (which he used as miniature models)—without jeopardizing the authenticity of his representations.

MARY CASSATT AS A FOLLOWER OF DEGAS

Too independent and conscious of his own worth to welcome collaborators or students, Degas had a reputation as a misanthrope. His strongly held aesthetic convictions prevented him from becoming a member of the eclectic Société de Pastellistes français. He preferred to exhibit with artists that he admired and respected. One of these was a woman who found favor in the eyes of this confirmed misogynist: the American artist Mary Cassatt (1844–1926). When he viewed her *Portrait of Madame Cordier* in the 1874 Salon, Degas exclaimed, "There's someone who feels as I do."[9] Although they were not yet acquainted, she reciprocated his admiration. When she saw a pastel by Degas in a dealer's window, the young Cassatt finally found her own voice. "I used to go flatten my nose against that window and absorb all I could of his art. It changed my life. I saw art then as I wanted to see it,"[10] she recalled many years later, the intensity of her emotion unabated.

Born in Pittsburgh, Cassatt was fifteen when she received her initial training at the Pennsylvania Academy of the Fine Arts in Philadelphia. Determined to have an artistic career, she went to Paris in late 1865, accompanied by her friend Eliza Haldeman. She studied under Jean-Léon Gérôme, Charles Chaplin, and later Thomas Couture, while assiduously making copies of old master paintings in museums. She participated in the Salon for the first time in 1868, then left for Rome

OPPOSITE
Mary Cassatt
At the Theater, c. 1879
Pastel on paper,
21⅝ × 18⅛ in. (55.4 × 46 cm)
The Nelson-Atkins Museum
of Art, Kansas City,
Missouri

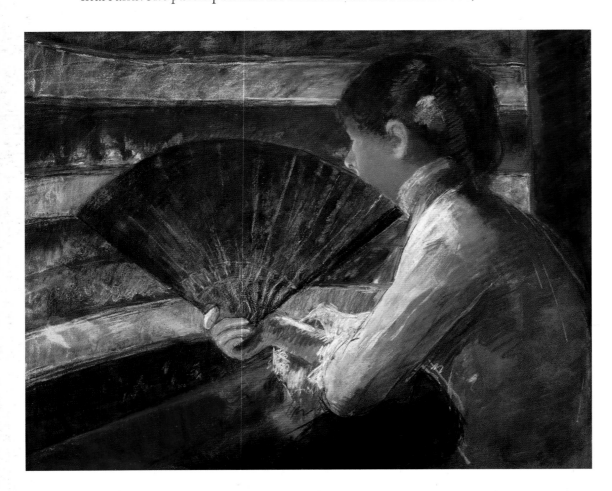

Mary Cassatt
In the Loge, 1879
Pastel and metallic paint on canvas, 25⅝ × 32 in.
(65.1 × 81.3 cm)
Philadelphia Museum of Art

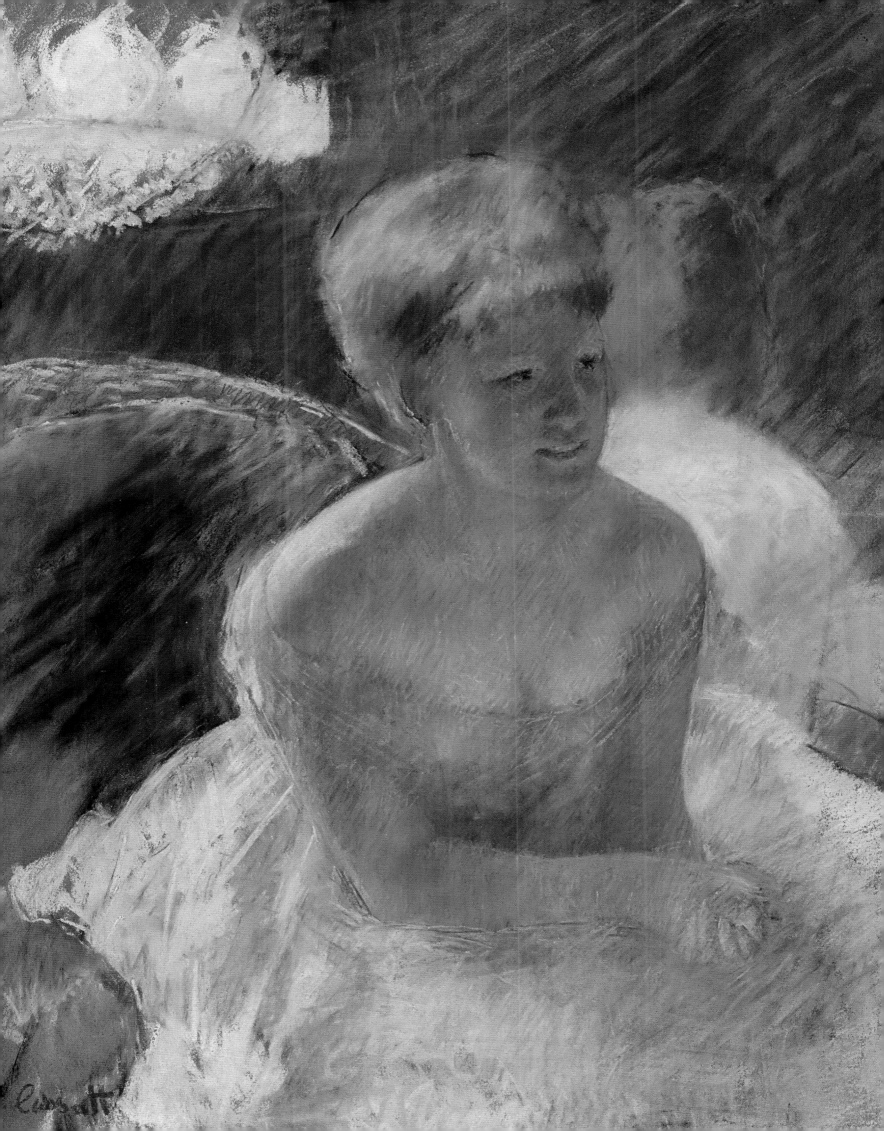

in early 1870. She then journeyed home to Philadelphia, before returning to Europe in 1871. For the next two years, she traveled through Spain, Belgium, and Holland, visiting museums. She finally moved to Paris in 1874. Her familiarity with Diego Velázquez, Frans Hals, Peter Paul Rubens, and Francisco Goya, among others, gave rise to her distaste for conventional academic art. Instead of the models and formulas of studio study, she preferred to learn the lessons of the great geniuses of the past who knew exactly how to convey a powerful sense of reality. Critical of the preeminent place occupied by William-Adolphe Bouguereau and other officially recognized luminaries of her time, she aspired to a new approach to art. It was another revelation when she discovered the very modern art of Degas (and soon thereafter the work of his Impressionist colleagues): "The ease and supreme assurance of this rigorously executed drawing filled her with admiration. She grasped the novelty of the feelings expressed, the accurate depiction of movement captured at the opportune moment, the refinement of the visual sensibilities. Certain almost acidic tonal harmonies gave her the sensation of green fruit in her mouth, while other combinations seemed soft and mellow as if a very noble and intellectual sentiment were blended together with the crushed colors of the pastel crayons."[11]

The ties between Degas and Cassatt did not become close until 1877, when he invited the young woman to participate in the next Impressionist exhibition. This occasion was not only the beginning of an enduring collaboration (she exhibited in 1879, 1880, 1881, and 1886); there was also a profound aesthetic affinity between the two. Like Degas, Cassatt preferred the human figure to landscape, and she was enthusiastic about the demanding art of pastel; and like the older artist, she too had her favorite subjects. After several forays into the flamboyant world of theater (*In the Loge*, 1879), she generally devoted herself to portraiture. She was a devotee of the cult of Maurice Quentin de La Tour, the great eighteenth-century pastelist whose vibrant figures she studied at the museum in Saint-Quentin. Ultimately, she found representations of mothers and children to be the most compelling subject matter, doubtless because "this expression of the human experience is so rich that it is inexhaustible,"[12] as Achille Segard so tellingly observed. Not only did these daily, intimate scenes recall Degas's famous observation, "Grace resides in the commonplace,"[13] but in their spontaneity and freshness they evoke the unaffected simplicity of those primitive painters who were so deeply admired. These tender maternal scenes were contemporary interpretations of the Virgin and Child; they shared with their predecessors a certain candor, a spirit of "Make it true, simple, and vigorous."[14] The matte quality recalls that distant time when oil colors did not yet exist and painting was done in tempera or fresco.

Cassatt quickly showed herself to be a peerless pastelist. It was the ideal technique, allowing her to combine her talents as a draftsman and a colorist. "There's not a painting or pastel by Miss Cassatt that is not an exquisite symphony of color. Mary Cassatt loves pure colors and knows the secret of blending them together in compositions that are daring, mysterious, and filled with freshness, a true miracle of simplicity and elegance."[15] The faces are always very carefully rendered, but the clothing and backgrounds are generally treated with less detail. Rather than using a stump to soften the outlines, Cassatt preferred vigorous crosshatching to add a lively, spontaneous aspect to her pastels. Her bold technique modernized the still rather traditional genre of portraiture and illuminated these universally recognizable images of mothers and children that she loved so much.

Mary Cassatt
Women Admiring a Child, 1897
Pastel on paper, 26 × 32 in.
(66 × 81.2 cm)
The Detroit Institute of Arts

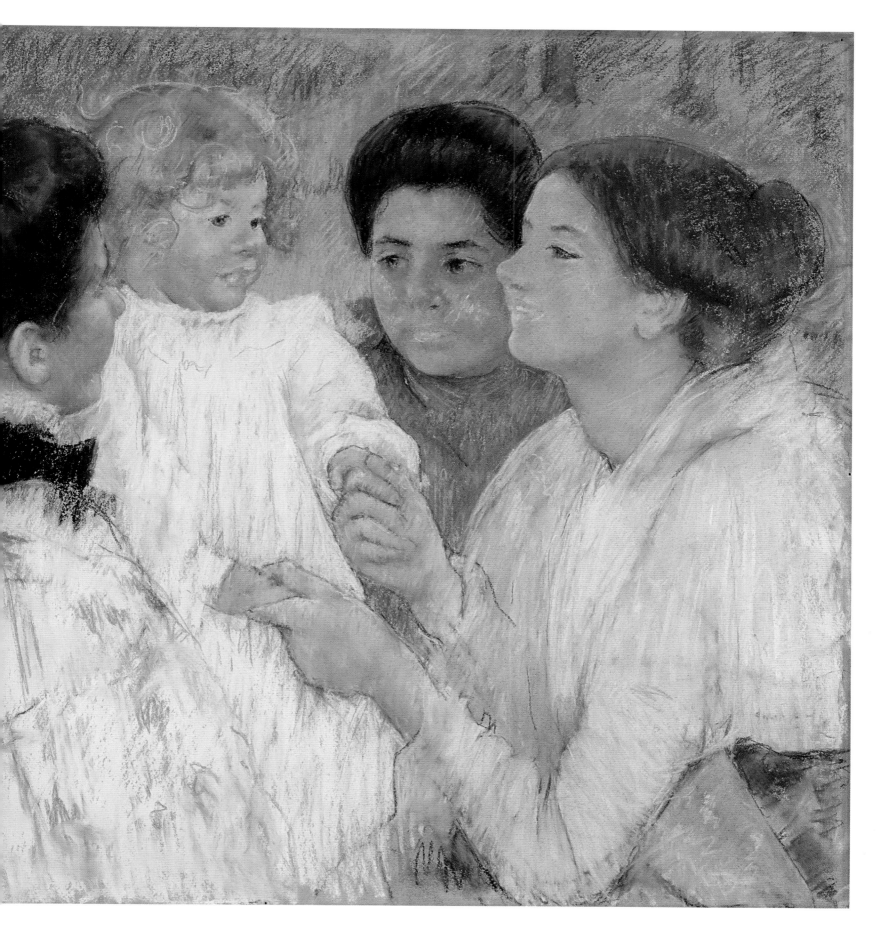

19.

The Nuances of Whistler

Thomas Wilmer Dewing
Woman in a Green Dress
Pastel on brown paper,
10½ × 7 in. (26.8 × 17.7 cm)
Corcoran Gallery of Art,
Washington, DC

The oeuvre of the American artist James Abbott McNeill Whistler (1834–1903) occupies a unique place in the history of pastel. His works are on a very small scale, executed on tinted sheets of paper and realized with just a few strokes of color. Whistler demonstrated an economy of means that was in sharp contrast to the art of his contemporaries. His delicacy and subtlety were the antithesis of the flamboyant virtuosity of recognized pastelists, who were always eager to demonstrate how they could replicate the effects of oil painting. As a knowledgeable critic had observed some years before, "To obtain the effects of oil painting, the artist must to a certain extent diminish pastel's nature and technique, and this more often than not results in a double failure."[1] In contrast, Whistler, who divided his professional life between France and England, explored various mediums, including engraving, pastel, and watercolor, respecting the distinctive characteristics of each. His passion for engraving (he played a major role in the revival of traditional etching) led him to reorder the standard hierarchy of techniques. His initiation to pastel occurred in the mid-1860s, when he received a commission for a decorative frieze of figures in the residence of British shipowner and art collector Frederick Leyland. Whistler sketched some of these figures in pastel. In the early 1870s he also executed several small pastel portraits, mostly depicting members of the Leyland family. Their modest scale, sketchy quality, and use of beige paper made these works so out of the ordinary that when Whistler exhibited some of them in Paris in 1875, they were thought to be unfinished (when they were not simply passed over or ignored).

A few years after enduring a series of tribulations, Whistler, partially motivated by the spirit of revenge, created one of the most astonishing series of pastels ever executed. In November 1878 Whistler initiated a lawsuit against the famed critic John Ruskin, accusing him of defamation. Ruskin claimed that Whistler had made a mockery of the public the prior year when he exhibited a startling painting at London's Grosvenor Gallery, a quasi-abstract night scene depicting a fireworks display at Cremorne Gardens. Whistler won the case, but he was obliged to pay court expenses while simultaneously dealing with claims made by his former client Leyland. In May 1879 he was forced into bankruptcy. Very fortunately, the London merchants of the Fine Art Society commissioned Whistler to execute a series of twelve etchings of Venice. In September 1879 Whistler departed for that legendary seaside city, hoping that this commission and the exhibition that followed would mark his triumphant return to the artistic scene. From the outset, he planned to use his visit as an opportunity to complete a series of pastels as well. Staying at the end of the Riva degli Schiavoni, he had a splendid view of the church of Santa Maria della Salute and its surroundings across the Grand Canal, the Doge's Palace, and the church of San Giorgio. The weather that winter proved to be particularly harsh and unfavorable for working in oil or watercolor, and Whistler therefore decided to stay longer than the three months originally planned. Following narrow secondary canals and exploring the nooks and crannies of remote Venetian neighborhoods, he abandoned the touristic parts of the city, particularly the Grand Canal, to reveal its more obscure quarters. "I have learned to know a Venice in Venice that the others never seem to have perceived," he wrote.[2] Instead of depicting the palaces and triumphant monuments of wealthy patrician areas of the city, Whistler was attracted to the picturesque byways of decrepit old neighborhoods, where sheets hung down from open windows in shabby little courtyards. Equipped with colored paper and an old box of broken pastels, he composed delicate, poetic scenes. These vignettes, in which pastel is actually used very sparingly, remind us of carefully highlighted drawings, and their minimalism recalls the art of Japan. Nevertheless, some of these pastels required dozens of drawing sessions; Whistler took obsessive care with his work. A second box of newer pastels helped him to rework his compositions under more tranquil circumstances.

LESS IS MORE

This meticulous care was certainly due in part to Whistler's plans to exhibit his pastels upon his return to London. The enthusiastic reaction of the American artistic circle that he cultivated in Venice encouraged him to pursue this project. "I can assure you that these gentlemen—my painting colleagues—who have seen them are very struck by their impact," he wrote to his sister-in-law.[3] To his friend Matthew Robinson Elden, he predicted, "I suppose that this story will set off a new fashion—I mean to say that many of my colleagues will begin to explore this technique."[4] Having spent the summer at Casa Jankowitz, Whistler returned to London with a portfolio of some fifty etchings as planned, as well as about one hundred pastels and several paintings. When the exhibition of the etchings he called his Venetian Suite concluded, he launched a presentation of fifty-three pastels at the Fine Art Society. He designed the frames and decorated the gallery himself with a narrow plinth of yellow gold surmounted by a broad band of green drapery and a pale reddish-brown frieze. The pastels, some in lovely yellow-gold frames (and a few in green-gold frames), were all hung at the same height. The resulting display was exceptionally elegant. The painter John Everett Millais exclaimed, "Magnificent!

James Abbott McNeill Whistler
Corte del Paradiso, 1880
Pastel and chalk on brown paper, 12 × 6 in.
(30.5 × 15.2 cm)
Private collection

OPPOSITE
James Abbott McNeill Whistler
Courtyard on Canal; grey and red, 1879–80
Pastel and chalk on brown paper, 11⅞ × 8 in.
(30.1 × 20.2 cm)
Saint Louis Art Museum

SPREAD OVERLEAF
James Abbott McNeill Whistler
White and Pink (The Palace), 1879–80
Pastel and black chalk on gray paper, 7¾ × 11⅞ in.
(19.7 × 30.1 cm)
National Gallery of Art, Washington, DC

It's not devoid of insolence, but it's very beautiful all the same." Whistler showed his audience an exquisite, delicate, and intensely poetic collection. Just a few outlines and pastel highlights sufficed to suggest everything essential while retaining an element of mystery. He believed that pastel was a very subtle medium that should be used with great discernment: "You should never ask more of a technique than it can give," he asserted.[5] While most pastelists emphasized the brilliance of their colors and their virtuosity and brio, Whistler, an aesthete with a high sense of self-regard, played instead with nuance and restraint, allowing the paper to lend its own tonality to his compositions. In his hands, the technique of pastel assumed an almost experimental character that amazed the London public, not to mention his selection of subject matter (landscapes and city views) that were still relatively novel in an art form traditionally associated with portraiture.

Thanks to the success of his exhibition at the Fine Art Society, Whistler's career took on new momentum, and sales soared. The artist did not abandon pastel with the completion of his Venetian series. His models inspired him to draw charming draped figures and nudes that captured the imagination of the American painter Thomas Wilmer Dewing (1851–1938). Beginning in 1890 and for some twenty years thereafter, Dewing executed a great many pastels of diaphanously gowned women who emerge like apparitions from a background formed by solid brown paper. Whistler's reputation was now at its peak in the United States. The numerous artists who had kept company with the master during his time in Venice—including Otto Bacher (1856–1909), Robert Blum (1857–1903), and Frank Duveneck (1848–1919)—had returned to their own country with the conviction that pastel, as well as engraving, was a technique suited for significant works of art. In the same spirit Blum, William Merritt Chase, James Carroll Beckwith, and several others founded the Society of Painters in Pastel in New York in 1882, a strong indication of the rebirth of this medium in the United States.

THE NUANCES OF WHISTLER

20.

The Last Word in Elegance

Jacques–Emile Blanche
Portrait of Jeanne-Julie Régnault,
Known as Julia Bartet, Member of
the Comédie-Française, 1889
Pastel on canvas, 61⅞ × 30⅛ in.
(157.3 × 76.5 cm)
Musée National des Châteaux
de Versailles et de Trianon,
Versailles

*D*uring the 1870s and 1880s, the pioneers of pastel's earlier revival disappeared one by one from the artistic scene, ceding their place to a crowd of pastelists from the Salon. These artists were typically talented but without much sense of originality. Admittedly, the weight of tradition that loomed over the genre (particularly the immense prestige of its eighteenth-century practitioners) did not foster innovation. Nevertheless, Millet's singular pastels and the Impressionists' fondness for the technique induced a number of artists to explore the possibilities of the medium, which was to experience a remarkable renaissance due to their engagement.

DE NITTIS AND "THE SEDUCTIONS OF OUR REALIST AND REFINED CULTURE"

The Italian artist Giuseppe De Nittis (1846–1884) was among the outstanding exponents of pastel's renewal. Closely associated with the Impressionist painters, he quickly grasped the potential of a technique that was so well adapted to recording multiple aspects of contemporary life. Jules Claretie recalled the artist's enthusiasm when he entered the shop of a pastel maker in 1875, "contemplating the possibilities of the works he could create with pastel."[1] De Nittis soon mastered the challenging technique. In 1878, he presented a pastel entitled *In the Bois de Boulogne.* Subsequently, in 1881, he had a one-man show at the Cercle de l'Union Artistique in the Place Vendôme, where he displayed a stunning collection of eighteen pastels, many in large format. The key work presented in this exhibition was indisputably the immense triptych *At the Racetrack in Auteuil,* wherein De Nittis represented elegant society figures at the racetrack. On the left, a woman has climbed atop a chair

Giuseppe De Nittis
At the Racetrack in Auteuil, 1881
Pastel on canvas, triptych: 77⅛ × 41¾ in.
(196 × 106 cm), 77⅛ × 75⅜ in. (196 × 191 cm),
77⅛ × 41¾ in. (196 × 106 cm)
Galleria Nazionale d'Arte Moderna, Rome

to get a better view; on the right, spectators holding binoculars in the upper gallery are sheltered from the rain; in the central panel, a group of viewers gather around a brazier, engaged in cheerful conversation. The monumental scale, open-air atmosphere, variety of scenes, and novel point of view (like Degas, De Nittis emphasizes the details in the foreground) combine to make this pastel a masterpiece "striking in its sense of movement, poses, and startling, eloquently expressed truth."[2] "It's an entirely new process, almost a different art form," the poet Emile Blémont enthusiastically reported.[3] De Nittis's portraits are no less striking. Edmond de Goncourt is posed as if surprised at his worktable at home, seeking inspiration for a new novel. Overwhelmed by such virtuosity, Claretie continued, "We all know that pastel can do a splendid job of depicting flowers arranged in a Sèvres vase, and that is admirable. We are used to this. But we have never seen a pastelist so completely frame a human figure in a salon, a theater, an office, a landscape, or even in the midst of everyday life."[4]

De Nittis brought new energy to pastel, adapting it to mirror his own era. His genius lay in his ability to adapt the lessons of this "new painting" without denying its well-established reputation for elegance. Although the picturesque aspects of

Giuseppe De Nittis
The Salon of Princess Mathilde, c. 1883
Pastel on paper applied to canvas,
28 × 31½ in. (71.2 × 80 cm)
Musée Joseph-Denais, Beaufort-
en-Vallée, France

OPPOSITE
Emile Lévy
*Portrait of Madame José Maria
de Heredia*, 1885
Pastel on paper, 93¼ × 64 in.
(237 × 162.5 cm)
Musée des Beaux-Arts, Rouen, France

SPREAD OVERLEAF
Emile Lévy
Portrait of Marie de Heredia (complete
work, left; detail, right), 1887
Pastel on beige paper, 46⅝ × 33⅞ in.
(118.5 × 86 cm)
Musée d'Orsay, Paris

Emile Lévy
1885

288

modernity fascinated him, he most frequently depicted upper-class leisure activities and fashionable venues. The public was captivated. In a sense, De Nittis stole the show from the Impressionists. As one critic wrote, "Monsieur De Nittis has realized in beauty what Monsieur Degas and several others have imagined or realized in ugliness; here nature and contemporary society are depicted with a sharp, but not excessively mordant, sensibility."[5] In his diary, Ludovic Halévy, a friend of Degas, hailed an art "that is truly modern. It is indeed realism, but it is elegant, friendly, devoid of brutality and banality." He also recorded the reaction of his friends, with Degas particularly in mind: "Ire of the intransigent Impressionists against De Nittis's pastels; they have the unpardonable fault of being successful and appealing."[6] Degas countered his Italian colleague, who had died in 1884, with his famous series of female nudes (1886): his frankly naturalistic models were the antithesis of the elegant beings that brought De Nittis such recognition.

Perhaps it was observation of this success that induced Emile Lévy (1826–1890) to demonstrate his abilities as a pastelist at the Triennial Salon in 1883. Until this point, the fifty-five-year-old painter was "scarcely more known and appreciated by the general public than when he emerged from the Villa Medici [the site of the French Academy in Rome]." He decided "suddenly . . . to create pastels." "His exhibition, which includes eleven portraits, is in its way a real event, rather like a coup de théâtre."[7] The perfection of his large portraits was really breathtaking. However, compared to the work of De Nittis, Lévy's art retained a highly conservative quality. His "solemn effigies" were represented within the confines of hushed salons. They seem never to have ventured out of doors, and the pastelist allowed no distraction to impinge upon his faultless presentation. "No capricious breeze disturbs this motionless ideal. No sense of passion, no hint of spontaneity," noted one critic.[8] The poet José Maria de Heredia rightly hailed "the certitude of his vision" and "the assurance of his hand, persistently and patiently at work."[9] This tribute was motivated by friendship and admiration; it associated Lévy's art with an Olympian aesthetic of impassivity and the cult of perfect form. So much erudition eventually breeds ennui. "In our view, if he allowed a bit more passion and bolder crayon strokes à la Chardin to enliven his work, the merits of pastel would seem to be better understood by the artist," the normally very conservative Baron Portalis ventured to suggest.[10] Nevertheless, Lévy made a genuine contribution in his own way to reviving interest in pastel.

WOMEN IN MAJESTY

It took only two or three years for "a return by artists to pastel"[11] to occur. James Tissot (1836–1902) was among them. After spending several years in England, the painter returned to France in late 1882 and very quickly immersed himself in the vogue for pastel. Like De Nittis, Tissot opted for very large formats and representations of society's upper echelons. The monumental portrait of the Princess of Broglie, for example, nonchalantly seated on the edge of an Empire table, arrayed

Giovanni Boldini
Portrait of a Dandy, 1880–90
Pastel on paper,
24¾ × 16⅛ in. (62.9 × 41 cm)
Norton Simon Art
Foundation, Pasadena,
California

Jacques-Emile Blanche
Portrait of Madame Wallet,
1887
Pastel on canvas,
51⅜ × 25¾ in.
(130.5 × 65.3 cm)
Musée d'Orsay, Paris

Paul César Helleu
Alice and Peacocks at the
Château de Boisbaudran, 1891
Pastel on paper,
24⅜ × 30¼ in. (62 × 77 cm)
Private collection

Helleu

in a sumptuous fur-trimmed silk costume, is a subtly modernized version of a classic state portrait. The large format, elaborate attire, and luxurious setting are tempered by a heightened sense of narrative and the natural assurance of the sitter's pose. The patrons who gave commissions to Tissot included the most illustrious names in Parisian society. They had the satisfaction of feeling they had an entrée into the world of Paul Bourget's "psychological novels," whose plots involve the privileged classes. But Tissot had to reckon with competition from the Italian artist Giovanni Boldini (1842–1931), who also positioned himself in the lucrative niche of pastel portraiture beginning in the 1880s. He successfully adapted the technique to his personal style, featuring broad virtuosic strokes, with "arrows, beams, and rays darting in every direction."[12] The flamboyance of his pastels was the visual equivalent of the aristocratic, worldly values of his sitters. By emphasizing their imperious poses, elegant accessories, and elongated limbs, Boldini quickly became the darling of elegant society. Like his colleagues and competitors, he preferred the large formats then in vogue. Pastel now unapologetically rivaled oil painting: its inimitably soft, powdery effect only added to its appeal.

Soon a younger generation appeared on the artistic scene. Paul César Helleu (1859–1927), trained at the Ecole des Beaux-Arts, quickly joined the ranks of the Impressionists and began to experiment with pastel in the early 1880s. An admirer of Manet and Monet, with ties to Degas, Jean-Louis Forain, John Singer Sargent, and James Abbott McNeill Whistler, he frequented artistic circles that embraced the medium. His pastel of a woman reading, exhibited in 1883 at the Cercle des Arts Libéraux, attracted the notice of Ernest Duez. In 1885 Helleu again got attention in the Salon with two pastels, a portrait of the young Alice Louis-Guérin (later to become his wife) and a view of Gare Saint-Lazare. Charles Ephrussi had enthusiastically promoted the merits of Pierre-Auguste Renoir, Alfred Sisley, Degas, and Monet to Parisian financial moguls. He now encouraged society figures who were receptive to new trends to seek out Helleu. Commissions soon began to flow. His coronation occurred in 1887 at the exhibition organized by the Société de Pastellistes français, where his six submissions, elegantly set in narrow gold frames, excited widespread admiration. Helleu had managed to strike a distinctive note. "In the midst of works by Duez, [Henri] Gervex, [Gustave] Jacquet, [Albert] Besnard, De Nittis, and their like, all stars at the height of their brilliance, Helleu's warm gray tonalities have a surprising originality, a touch of strangeness," recalled Jacques-Emile Blanche.[13] Echoing Paul Verlaine, who had proclaimed several years earlier: "For we wish for more nuance / No color, nothing but nuance!" the young artist expressed himself in a minor key, no doubt influenced by the subtle harmonies of Whistler, his idol at the time. The portrait commissioned around 1890 by Countess Greffulhe, the reigning queen of fashionable Parisian society, confirmed Helleu as the "aristocracy's pastelist."[14] The full-length format (inspired by Japanese kakemonos as well as by Whistler's portraits) attenuates the model's figure to the extreme. The artist subtly suggests the setting, a salon where the woman who was the inspiration for Marcel Proust's Duchess of Guermantes is posed. These elements combine to create an image of consummate elegance. Society figures began to jostle for their turn as sitters. No sooner had Helleu completed the portrait of the Countess Greffulhe than Baroness Deslandes ordered her own likeness, which exceeded six feet in height!

Helleu faced competition from his friend Jacques-Emile Blanche (1861–1942). Like the older Helleu, Blanche subscribed to the cult of the Impressionists and Whistler, and he too ventured into the art of pastel. He clearly valued his contacts with accomplished practitioners including Degas, Forain, Gervex, Helleu, Rafael de Ochoa, and Sargent. His earliest success in the medium occurred in 1883. Well received in Parisian society, he soon began to win significant portrait commissions.

Jacques-Emile Blanche
Portrait of Jeanne-Julie Régnault, known as Julia Bartet, Member of the Comédie-Française (detail), 1889
Pastel on canvas,
61⅞ × 30⅛ in.
(157.3 × 76.5 cm)
Musée National des Châteaux de Versailles et de Trianon, Versailles

In these works, he demonstrated the "domination of Whistler," to use his own words. The influence is evident in the rendering of the actress Julia Bartet and the lovely Henriette de Bonnières (1887), both arrayed in black gowns accessorized by extravagant white fur wraps. Blanche, still a young man, had become a pastelist to be reckoned with. In 1888, with the support of Gervex and Helleu, who were already members, he was admitted to the very recently established Société de Pastellistes Français.

In less than ten years, pastel had recovered its allure for talented artists who were receptive to the latest trends. The role of Giuseppe De Nittis in this movement was of key importance. This Italian artist was able to combine the attributes of the "new painting" with the demanding expectations of a sophisticated clientele. Pastel was both modernized and strengthened in its traditional reputation for refinement. The 1880s marked a decisive step forward in the recognition of this technique.

LEFT
Paul César Helleu
*Madame Marthe Letellier
Seated on a Sofa*, c. 1895
Pastel on canvas,
50½ × 48½ in.
(128.2 × 123.1 cm)
Minneapolis Institute
of Arts

RIGHT
Paul César Helleu
Portrait of Countess Greffulhe,
c. 1890
Pastel on canvas,
82⅝ × 55⅛ in. (210 × 140 cm)
Private collection

21.

International Renewal

Pierre Carrier-Belleuse
Emile Deschanel as a Child, 1913
Pastel on paper applied to
canvas, 57⅞ × 35 in.
(147 × 89 cm)
Musée des Beaux-Arts de
l'Art Français, Rennes

OPPOSITE
Carl Larsson
*In the Studio: The Artist's
Wife with Their Daughter
Suzanne*, 1885
Pastel on paper,
26 × 19⅝ in. (66 × 50 cm)
Nationalmuseum,
Stockholm

*I*n France, pastel experienced an unprecedented surge of popularity around 1880 due in significant part to the exhibition of Giuseppe De Nittis's work at the Cercle de l'Union Artistique (1881), which attracted large crowds. It encouraged new participants, among them many foreigners who flocked to Paris to learn about the newest trends. The Finnish artist Albert Edelfelt (1854–1905) was among them. Attuned to the Impressionist aesthetic and plein air painting, and a close friend of Jules Bastien-Lepage, he began working in pastel in 1882, inspired by the example of his brilliant Italian contemporary. In addition to submitting paintings, he often sent pastels to the Salon, and critics saw these submissions as closely related to the work of De Nittis: "He knows how to convey the expressive features of sophisticated figures, placing them in an elegant setting, but never losing an aura of simplicity and naturalness."[1] His Norwegian friend Frits Thaulow (1847–1906) expressed enthusiasm for this art form, which was earning him an excellent reputation by 1883: "Frits Thaulow's most admirable works are not confined to oils. He also employs pastel and charcoal. The lovely studio he occupies near the old fortifications of Paris is full of delicately sketched notations, rendered in just an hour's time."[2] Edelfelt and Thaulow were also responsible for the revival of pastel in the Scandinavian countries, together with the Norwegian artist Peder Severin Krøyer (1851–1909) and the Swedish painters Carl Larsson (1853–1919) and Anders Leonard Zorn (1860–1920), who were both introduced to pastel during stays in France. These few examples testify to the impressive inroads made by pastel, which was becoming a formidable presence on artistic scenes ranging from Paris to London, Brussels, and New York.

THE SOCIETY OF PAINTERS IN PASTEL (NEW YORK) AND THE REBIRTH OF PASTEL IN THE UNITED STATES

When the Society of Painters in Pastel was established in New York in 1882, it was the first association dedicated exclusively to promoting this art. American pastel had now entered the modern age. The society's founders—James Carroll Beckwith, Edwin H. Blashfield, Robert Blum, William Merritt Chase, Hugh Bolton Jones, Francis Miller, and Charles Ulrich—had almost all traveled in the Old World. There they had learned that pastel, generally neglected in the United States, was attracting genuinely gifted artists who used the medium to express themselves with considerable spontaneity, without confining themselves to the traditional genre of portraiture. Following the establishment of the American Society of Painters in Water Color (1866) and subsequently the Society of Decorative Art (1877), the New York Etching Club, and the Tile Club, this newly formed association was part of a broad-based movement to recognize techniques previously considered as minor or secondary, such as engraving and watercolor. In 1884 the society was in a position to organize its first exhibition. With sixty-five works, executed by the seven founding members and nine invited guest participants, the show was notable for its diversity of themes. The works all bore a stamp with the initials "PP" ("painters in pastel"). By recruiting exhibitors from the younger generation, the society acknowledged that pastel was a modern art form. From a stylistic point of view, two basic trends were evident. One direction—represented by Julian Alden Weir and John Henry Twachtman, among others—clearly followed in James Abbott McNeill Whistler's wake, embracing a sketchiness evocative of drawing and using colored papers as supports. The second trend was more theatrical, closer to the work of De Nittis, and more generally to the realism of Bastien-Lepage. William Merritt Chase's lively, luminous pastels clearly reflected these latest developments in French art.

OPPOSITE
Albert Edelfelt
Parisienne, 1885
Pastel on paper mounted
on canvas, 26⅛ × 21¼ in.
(66.5 × 54 cm)
Finnish National Gallery,
Ateneum Art Museum,
Helsinki

Frits Thaulow
Melting Snow, 1887
Pastel on colored paper
attached to canvas,
21½ × 37¼ in.
(54.6 × 94.6 cm)
Art Institute of Chicago

INTERNATIONAL RENEWAL

301

Despite a favorable critical reception, the audience for the show was limited, and the sales were disappointing. As a result there was a four-year lapse before a second exhibition was organized in 1888. In the meantime, the society experienced some defections but also rallied new recruits, including Kenyon Cox and John La Farge. The exhibitions held in 1889 and 1890 again presented pastel works by both members and guests. Blum and Chase were indisputably preeminent figures in contemporary pastel, together with Childe Hassam (1859–1935), who participated in the society's 1890 show. Hassam had trained in Paris between 1886 and 1889, and he was very current on developments in contemporary pastel in France. Like Edelfelt and Thaulow, he was also well aware of the success of the newly organized Société de Pastellistes Français, which was founded in 1884. Hassam's urban views, as contemporary in their style as they were polished in their execution, irresistibly recall the work of De Nittis (some of whose pastels Hassam actually owned) and the pastels of the Impressionists.

When the society's dynamic president, Robert Blum, left America to spend three years in Japan, it was a fatal blow; the society ceased all activities after its fourth exhibition. Nevertheless, in just a few years the organization had contributed to converting numerous American artists to an art form that had only recently become established as legitimate and modern. Some members of the Society of Painters in Pastel, including Thomas Wilmer Dewing and Julian Alden Weir, joined a new organization, the Pastellists. Founded in 1910 by Leon Dabo, this society proved to be even more short-lived, however; it was dissolved in 1915.

THE SOCIÉTÉ DE PASTELLISTES FRANÇAIS

Three years after the founding of the New York Society of Painters in Pastel, a similar organization was formed in Paris to "display, develop, and encourage the art of pastel, primarily through exhibitions."[3] The Société de Pastellistes français was an important step forward for pastel, helping it to gain visibility and definitively establish its autonomy from painting and the various other graphic arts.

In contrast to its older sister organization, the Société de Pastellistes français was established not by artists but rather by a senior official in the government's Beaux-Arts ministry, Roger Ballu (1852–1908), who subsequently pursued a political career. The idea first surfaced in 1884 at the Dessins du Siècle exhibition, which was presented at the Ecole des Beaux-Arts and featured Jean-François Millet's

William Merritt Chase
Spring Flowers (Peonies),
before 1889
Pastel on paper,
18⅞ × 18⅞ in. (48 × 48 cm)
Terra Foundation for
American Art, Chicago

William Merritt Chase
Study of Flesh Color and Gold,
1888
Pastel on paper, 18 × 13 in.
(45.7 × 33 cm)
National Gallery of Art,
Washington, DC

marvelous pastels. Ballu explained, "I felt regret to think that this genre, which was so eminently French, so rich in inspiration, was close to being abandoned."[4] Encountering the famed gallery owner Georges Petit at exactly that moment, Ballu boldly announced his decision to create a society dedicated solely to pastel. Since its membership was "almost organized already," he declared, "it should open its first exhibition at the Ecole des Beaux-Arts itself." The collaboration was quickly established. Eager to achieve recognition as the foremost art dealer in Paris, Petit was receptive to any new idea: two years earlier, he had wrested the Société des Aquarellistes Français from his rival Jean Durand-Ruel. He was well aware that pastel was very much in fashion (De Nittis and Edelfelt, among others, had already shown their work in his gallery).

Robert Blum
Studio of Robert F. Blum, c. 1883–84
Pastel on paper, 28 × 53¾ in.
(71.1 × 136.5 cm)
Cincinnati Art Museum

307

The first exhibition was scheduled for 1885. Challenges to the project soon presented themselves, Ballu explained, because "we had to find pastelists." There was no dearth of pastelists in the Salon, but Ballu and Petit did not want to recruit from these ranks. They had too little public recognition, with the exception of Ernest Duez and Emile Lévy, of course. The two organizers wanted celebrated artists who would add luster to their enterprise. Ballu and Petit exercised their powers of persuasion and succeeded in gathering "about fifteen artists quite quickly," some of whom had never touched pastels before. Almost all, however, had been trained at the Ecole des Beaux-Arts and were already recognized. They included Paul Baudry, Jean Béraud, Albert Besnard, John Lewis Brown, Duez, Henri Gervex, Gustave Guillaumet, Ferdinand Heilbuth, Gustave Jacquet, Lévy, Frédéric Montenard, Alexandre Nozal, Jean-François Raffaëlli, and James Tissot. But all these recruits, rather hastily assembled, were not sufficient to make this first exhibition a genuine event on the artistic scene. It was therefore decided to "summon the dead to the rescue" and display seventeenth- and eighteenth-century pastels, as well as the works of De Nittis (who had died the year before), Millet, and Léon Riesener, as a "radiant prelude" to the presentation of living artists.

The exhibition, displayed in Petit's luxurious Parisian gallery, was a complete success. The public was captivated, and requests for membership to the pastel society flowed in. It was therefore decided to organize the association as a closed

RIGHT
Pierre Puvis de Chavannes
The Shepherd, 1887
Pastel on paper,
23⅞ × 16½ in. (60 × 41 cm)
Musée d'Orsay, Paris

Léon Lhermitte
Two Bathers by a Pond, c. 1893
Pastel and charcoal on brown
paper, 17¾ × 21¾ in. (45 × 55.3 cm)
Musée d'Orsay, Paris

Pierre Carrier-Belleuse. 1892.

Lucien Lévy-Dhurmer
*Portrait of Mademoiselle
Carlier (The Lady in the
Turban)*, 1910
Pastel on paper,
34¼ × 52½ in. (87 × 133.3 cm)
Musée d'Orsay, Paris

Pierre Carrier-Belleuse
Dancer Tying Her Slipper,
1892
Pastel on canvas, 47½ × 33 in.
(120.6 × 83.9 cm)
Musée des Beaux-Arts,
Dunkirk, France

private club. The number of members would be limited to thirty, and any new member would have to replace an existing one. "Strong associations that endure are closed, with restricted memberships," Ballu said, believing that this elitist structure would assure the high caliber of its exhibitions. In 1886 the society had twenty-nine of the thirty members authorized by its bylaws. Paul César Helleu, who had just attracted notice with his pastels, was among the new recruits. The presence of François Flameng, Jules Lefebvre (who won the Grand Prix de Rome in 1861), Albert Maignan, Albert Moreau, and Pierre Puvis de Chavannes was more surprising. These established artists had thus far evinced scarcely any interest in pastel. As anticipated, the membership system favored already visible artists who were academically trained; many had already won medals in the Salon. Women, on the other hand, were restricted to the most meager representation. In its thirty years of existence, the society admitted only two—Marie Cazin and Madeleine Lemaire, both accepted in 1886.

Reflecting the aesthetic liberalism of its president, the society did not favor any particular artistic genre. An extraordinary variety of subject matter, and a spirit of eclecticism that embraced all works of genuine quality, allowed the audience to find their own favorites. "Everything falls within the domain of the members of the Société de Pastellistes Français on the rue de Sèze," observed one visitor.[5] Duez's poetic landscapes and Lévy's impeccable portraits cohabited in the gallery with Flameng's elegant society ladies, stately beings who were apparently resurrected from the days of the ancien régime and the Napoleonic Empire. Bucolic vistas by Léon Augustin Lhermitte were hung beside John Lewis Brown's hunting scenes, while Louis-Emile Adan, Heilbuth, and Moreau recycled their genre subjects in

pastel. This agglomeration formed an astounding display, but it neglected the work of cutting-edge contemporary artists. "Manet, Degas, Renoir, and J.-L. Forain are absent," Félix Fénéon lamented in 1885; he was left wanting more than what was displayed.[6] Some objected that Manet had died in 1883. Forain was to rejoin the society in 1890, as did Raffaëlli, who was closely affiliated with the Impressionists; he exhibited his peasants and humble subjects in 1887 and 1888. Renoir and Degas had no justification for deserting their longtime dealer Durand-Ruel, and indeed Petit was his most aggressive competitor. It would perhaps have been more appropriate to raise questions on the recruitment of artists who had virtually no experience in pastel before joining the society. One example of this phenomenon was the orientalist painter Gustave Guillaumet (1840–1887). Winner of the Second Grand Prix de Rome in 1861, the Salon's leading light for years, he embarked on pastels virtually overnight. He made no effort to adapt his style or his subject matter to the new medium, but he demonstrated remarkable talent from the outset. Faced with these sudden new vocations and interchangeable techniques, observers were quick to voice their suspicions that opportunism lurked among these recent converts. A great many of the pastelists in the society were also members of the Société des Aquarellistes. "The modern painter has a natural cunning; he is aggressive and hungry for publicity. . . . He sets up a light and opens out an easel anywhere; he displays himself to the public, even if he has to master a new tool or explore a new process. A watercolorist today, a pastelist tomorrow, and next month on the Champs-Élysées or the Champ-de-Mars, he eventually resumes his original incarnation."[7] The society welcomed truly committed pastelists, such as Pierre Carrier-Belleuse (1851–1932), a student of Alexandre Cabanel, who had devoted himself to the medium almost exclusively since 1885. "I much prefer pastel to oil painting," he acknowledged. "Using pastel, I model with my hand. I work on my picture exactly as if I were dealing with clay, as if I were sculpting. . . . I am in immediate contact with my canvas, and I can manipulate the material as I wish. When I was working with oil paint, there was this cursed brush that came between me and my canvas that interfered with me—yes, interfered with me—and really prevented me from expressing what I felt."[8]

The variety of subjects and styles demonstrated all the capabilities of an art that was fully capable of rivaling painting. But it also created a certain uncomfortable friction; as one critic complained, "Pastel is now a process like any other; it has become a tool, an instrument with no particular virtues; it is no longer that volatile medium full of unforeseen promise, that palette with its thousands of shades holding the secret of unexpected freshness, the delights of new tonalities—in short, something that was fresh, brilliant, rich, and luminous, both artful and magical."[9] This was a severe judgment that did not seem applicable to an artist like Albert Besnard (1849–1934), for example. Winner of the Prix de Rome in painting, he was also an etcher and watercolorist. He was also keenly interested in the decorative arts, and an unconditional admirer of the eighteenth century. Besnard had a rare gift for pastel. "He uses the medium exactly as Rosalba Carriera, [Maurice Quentin de La Tour] and Perronneau did. He chooses gray or beige board, similar to packaging cartons, and rubs in the background colors with his fingers to subtly establish the work's principal values. Then he adds accents with semi-hard pastel crayons, actually using the colored crayon to draw with a series of strokes and overlapping crosshatching. This is exactly the look and technique that Jean-Siméon Chardin used in his last works executed in pastel."[10] Although his practices were a direct legacy of the eighteenth century, Besnard—"a contemporary version of [Jean-Honoré] Fragonard who is familiar with gas and electrical lighting"[11]—was a man of his own time. Using colors that were the product of modern chemistry, he executed delightful "chromatic fantasies"[12]: "Monsieur Besnard's pastels resemble

Albert Besnard
The Model, 1887
Pastel on paper,
14⅝ × 30¼ in. (37 × 77 cm)
Private collection

the dazzling wake of a beautiful bird of paradise that promenades across the canvas letting its sumptuous feathers drift behind, scattering shards of brilliant color."[13] Also working in this colorful, decorative vein was Jules Chéret (1836–1932), a member of the society from 1890. He was a friend of Besnard, and they visited Spain and Morocco together in 1891. Chéret's Parisian ladies have the allure of saucy showgirls behind the glare of theater lights. Edmond Aman-Jean (1858–1936) and Lucien Lévy-Dhurmer (1865–1953), to cite just two others, were credits to the society, which they joined in 1897 and 1899, respectively, for their mastery and inventiveness.

Although membership was reserved for French artists, the society closely followed current international developments in the realm of pastel. It invited a number of foreign artists (Giovanni Boldini, James Abbott McNeill Whistler, William Turner Dannat, Thaulow, Louise Breslau, and Frantz Charlet) to exhibit next to its own members and also responded to invitations from abroad. In 1887 the society was invited to Copenhagen and in 1897 to Antwerp. By its participation, the organization made its own contribution to the success of pastel beyond the French borders, inspiring the establishment of comparable associations in London and Brussels.

THE RISE OF PASTEL IN ENGLAND AND BELGIUM

Unlike watercolor, pastel was a neglected art in nineteenth-century England, where the technique was far less established than in France. "The vast majority of the British have only the vaguest notion of what pastel drawing is," stated one critic, adding, "The most advanced pastels are French, not surprisingly, since this art has

been practiced in Paris for a long time and benefits from an established reputation. In England, on the other hand, it has been almost completely neglected and even disdained in recent years."[14] Admittedly, a limited number of British artists used the medium. Among them was Dante Gabriel Rossetti, who frequently used colored chalk and pastels for sketches or copies of his paintings. However, a real upsurge in popularity did not occur until the 1880s. The press covered Whistler's exhibition of pastels in London (1881) and the shows organized by the *Société de Pastellistes français* in Paris, attracting the public's attention to the technique. Always on the lookout for the latest artistic trends, Sir Coutts Lindsay, who founded the Grosvenor Gallery in 1877, organized the very first exhibition devoted to pastel in England. Opened in October 1888, it included numerous British artists, among them William Holman Hunt, Louise Jopling, Theodore Roussel, Charles Haslewood Shannon, and Bernard Sickert. There were also several of Whistler's famous Venetian pastels and others by recognized foreign artists. French pastelists—Besnard, Edouard Dubufe, Henri Fantin-Latour, Helleu, Lhermitte, and Montenard—held the place of honor. "It must be confessed, and confessed without delay, that the most middling of the French works in the medium were manifestly superior to those of our fellow citizens," acknowledged one critic.[15] It was true that many of the British artists in the exhibition had evidently taken up pastel exclusively for this occasion. Nevertheless, the Grosvenor show did rally every artist that Britain could muster to the cause of contemporary art. These included several members of the New English Art Club, established in 1885; they were among the strongest partisans of pastel and also looked favorably on the Impressionists (in April 1888 the club had exhibited works by Degas). George Clausen, Sidney Starr, Philip Wilson Steer, and William Stott

brought a modern sensibility to pastel, drawing upon the influence of Whistler, as well as that of Bastien-Lepage and the Impressionists. Clausen was notable for his luminous bucolic scenes and peasant figures, the direct descendants of French realism. William Stott's work alluded to Whistlerian subtleties. A member of the Glasgow school, like Clausen and James Guthrie, and trained in Paris, where he had developed a passion for the paintings of Bastien-Lepage, Stott was also an associate of Whistler.

Another exhibition of pastels was organized the following year, but it did not completely live up to expectations. In the opinion of the critics who attended, too many amateurs and landscapes populated the show. This disappointment may have spurred Sir Coutts Lindsay to establish the Society of British Pastellists in 1890 to enforce a degree of control over the participants and monitor the quality of the exhibitions. Under the aegis of this society of forty-three members, 375 works were exhibited to the public that year. Clausen and Steer were among the most prominent members, and others included Arthur Melville, Ernest Siche, Elizabeth Stanhope-Forbes, and Henry Scott Tuke. As in prior years, foreign artists were welcomed as long as their work was in keeping with the society's standards. French participants included Jacques-Emile Blanche, Jean-François Raffaëlli, and Alexandre Nozal, along with the Belgian Fernand Khnopff and the Dutch artists Hubert Vos and Jan Toorop. Unfortunately, this society did not survive the financial reversals of its patron, Sir Coutts Lindsay. It was not until 1898 that a group of artists was able to reestablish a new association to continue the mission. Headed by George Frederic Watts and open to foreign artists, such as the American Edwin Austin Abbey, the Pastel Society welcomed former members of the Society of British Pastellists, including George Clausen. It also accepted new members, including William Orchardson, John Henry Lorimer, and the elderly watercolorist Hercules Brabazon Brabazon.

The renaissance of pastel in Belgium also dated to the 1880s. The country's proximity to France played a significant role. Albert Baertsoen (1866–1922), for example,

spent the years 1888 and 1889 in Paris studying with Alfred Roll, a member of the Société de Pastellistes français. During his stay, he developed ties to the most prominent players in the revival of pastel, among them Blanche, Thaulow, and Cazin. Guillaume Van Strydonck (1861–1937) was introduced to the art of pastel while visiting Paris and in 1883 became one of the founders of the avant-garde circle known as Les Vingt, which welcomed all modern European artists, particularly those from France, to congregate in Brussels. Pastel was a technique associated with the most recent artistic developments, and it naturally had a prominent place in the group's exhibitions. (The British artist William Stott exhibited several pastels there in 1884.) For Emile Claus (who exhibited with the Pastel Society in London in 1898), Frantz Charlet, Theo Van Rysselberghe, Auguste Donnay, William Degouve de Nuncques, and Rodolphe de Saegher, among others, pastel was now established as one of several routinely used techniques. The establishment of the Société Nationale des Aquarellistes et Pastellistes in 1900 was the culmination of this process. It had taken just a few years for the practice of pastel to proliferate among artistic circles throughout the world. Men and women, conventional or contemporary—it seemed that everyone could express personal visions in the medium. The technique had finally proved its legitimacy and freed itself from timeworn clichés that had inhibited its acceptance. It was becoming standard practice to hang paintings side by side not only with pastels but also with drawings, watercolors, and works in other mediums. But the widespread acceptance of pastel was accompanied by a certain tendency toward the commonplace. Once an art apart with its own distinctive qualities, pastel was gradually becoming one technique among many available to artists.

Guillaume Van Strydonck
Portrait of Monsieur Damiens,
1889
Pastel on paper,
27⅛ × 39⅜ in. (70 × 100 cm)
Musée Charlier, Brussels

Fernand Khnopff
Memories, 1889
Pastel on paper applied to canvas,
50 × 78¾ in. (127 × 200 cm)
Musées Royaux des Beaux-Arts
de Belgique, Brussels

INTERNATIONAL RENEWAL

22.
The Exaltation of Color

Maurice Denis
The Sweepers, 1889
Pastel on bluish-gray paper,
9⅞ × 6⅜ in. (25 × 16.3 cm)
Musée d'Orsay, Paris

Opposite
Louis Anquetin
Woman Wearing a Hat, 1890
Pastel on paper, 41½ × 28 in.
(105.5 × 71 cm)
Private collection

Spread overleaf
Left
Louis Anquetin
*The Rond-Point des Champs
Elysées*, 1889
Pastel on paper, 60¼ × 39 in.
(153 × 99 cm)
Musée Départemental
Maurice Denis, Saint-
Germain-en-Laye, France

Page 323, left
Edouard Vuillard
Sorrowful Figure, 1890–91
Pastel on paper, 15¾ × 6⅝ in.
(40 × 17 cm)
Musée d'Orsay, Paris

Page 323, right
Edouard Vuillard
*Biana Duhamel in the Role of
Miss Helyett*, c. 1890–92
Pastel on paper,
16½ × 10¼ in. (42 × 26 cm)
Private collection

"It was in the autumn of 1888," Maurice Denis recalled, "that we first heard the name 'Gauguin' from Paul Sérusier when he returned from Pont-Aven. He showed us, with a certain aura of mystery, a cigar box cover. On it, we could make out a landscape that was undefined, because it was an imagined synthesis of a landscape, in violet, vermilion, Veronese green, and other pure colors, right as they come from the tube, almost without any admixture of white. 'How do you see this tree?' Gauguin asked at the edge of the Bois d'Amour in Brittany. 'Is it really green? Use green then, the most beautiful green on your palette. And this shadow—it's rather blue, isn't it? Don't be afraid to paint it as blue as possible.' . . . Thus we came to understand that a work of art is a transposition, a characterization, the passionate equivalent of a received sensation."[1] This little landscape by Sérusier, entitled *The Talisman*, had a defining influence on Maurice Denis and his friends, a group of artists who would come to be known as the Nabis. While they wanted to begin a new chapter in the aftermath of Impressionism, they were confronted with a revelatory approach to painting that was completely rejuvenated by its use of color. These artists—among them, in addition to Denis, Henri-Gabriel Ibels, Paul Ranson, Pierre Bonnard, and Edouard Vuillard—embarked on innovations that took an antirealist perspective. With their daring chromatic juxtapositions, their pictures were subjective visions of rare intensity.

"THE ESOTERIC NATURE OF BEAUTIFUL COLOR"

Louis Anquetin (1861–1932) was closely affiliated with the Nabis. His inspired treatment of color made him one of the most remarkable fin de siècle pastelists.

Ker-Xavier Roussel
The Gate, c. 1892
Pastel on paper,
8½ × 6⅝ in. (21.5 × 17 cm)
Musée d'Orsay, Paris

BELOW
Paul Sérusier
Landscape, 1912
Pastel on paper,
12⅝ × 19¼ in. (32 × 48.9 cm)
Musée d'Orsay, Paris

A friend of Henri de Toulouse-Lautrec, Emile Bernard, and Vincent van Gogh, he was trained in Fernand Cormon's studio, where he made a lasting impression on his fellow students. Emile Bernard recalled: "I admired his love of art, his unswerving ambition to accomplish great things. He was always passionately talking about Michelangelo."[2] The painter was also fascinated by Richard Wagner; his example of superhuman genius drove Anquetin to think of his own work as an absolute that required his total commitment. He invested color with a very particular role. In 1887, collaborating with Emile Bernard, he created a style of painting featuring vivid colors applied in broad areas outlined in black. Referred to as Cloisonnism, this stylized art created an abstraction of reality in order to convey the subject's essence. Anquetin turned to pastel at this point, attracted by its incomparable brilliance. Until the early 1890s, he remained an enthusiast of this graphic technique that combined his two passions—intense color and eloquent line—in a single medium. His very large pastel *The Rond-Point des Champs-Elysées* simultaneously encompasses the Nabi aesthetic of "a flat surface covered with colors assembled in a certain order," according to Maurice Denis's well-known formulation, and an expressive interplay of sinuous lines. This explains the art collector and critic Ernest Hoschedé's exclamation: "What admirable stained glass windows Monsieur Anquetin would design!"[3] Cloisonnism's culminating success occurred in 1890 with his *Woman Wearing a Hat*, in which the subject, attired in an immaculately white blouse, stands out arrestingly against a mystically blue cloth hanging, decorated with birds of paradise. This pastel astounds the viewer with its uniquely incandescent colors and the clarity of its contours. Eventually, however, Anquetin wearied of his relentless aesthetic quest. In 1892 he began a return to more traditional formulas, inspired by the great masters of the past, and refocused on oil painting.

During these same years Edouard Vuillard (1868–1940) was also developing a very elevated concept of creativity. In 1890, captivated by the pictorial revolution

Emile Schuffenecker
Landscape, 1890
Pastel on paper,
24⅞ × 30⅞ in. (63 × 78.5 cm)
Cleveland Museum of Art

that his comrades were undertaking, he allied himself with Paul Sérusier, Maurice Denis, and Paul Ranson. He flourished in a milieu where heated conversations abounded on the philosophy of Emanuel Swedenborg, the aesthetic of Richard Wagner, and the esotericism of Edouard Schuré. These intense intellectual exchanges correlated with Vuillard's aesthetic concepts. As he wrote in his private journal: "The purer the elements employed, the purer the finished work. . . . The more mystical the painter, the more vivid the colors (reds blues yellows [sic]), and the more materialistic the painter, the more he employs murky colors (earth-tones ochers blacks charcoal gray)."[4] Spurred by this powerful conviction, Vuillard executed pastels featuring colors of great intensity. The one depicting Biana Duhamel in the role of Miss Helyett is among the most audacious: the actress's silhouette—a vivacious arabesque—stands out against a yellow ground whose monochromatic intensity suggests the glare of stage lights. The stridency of the colors is equaled by the boldness of the composition and the extraordinary stylization of the forms. *The Boa* is another small masterpiece of originality. On a long, narrow sheet of paper, Vuillard drew a fashionable woman with a serpentine silhouette. With her sultry gaze, this creature in her boa is a true femme fatale, a contemporary interpretation of Eve with the serpent. The orange background symbolizes temptation and exemplifies the expressive role of color in Vuillard's work. Color was also fundamental to the aesthetic principles of Emile Schuffenecker (1851–1934), an artist who was very close to Paul Gauguin, Emile Bernard, Odilon Redon, and Louis Anquetin. During

Edouard Vuillard
The Singer, 1891–92
Pastel on paper,
10⅞ × 7⅞ in.
(27.7 × 20 cm)
Museo Thyssen-
Bornemisza, Madrid

the Exposition Universelle in 1889, he and Bernard were the primary contributors to the Synthetist group's exhibition organized by Gauguin on the walls of the Café Volpini. For Schuffenecker, color assumed a spiritual function that went far beyond its role in the mere representation of objects. He almost certainly adopted this idea from Gauguin: "A piece of advice," he wrote to Schuffenecker in 1888. "Don't copy nature too closely. Art is an abstraction: draw upon nature while dreaming in its presence, and think more about the act of creation than the result. It is the only way to rise toward God—by being like our divine master in creating."[5]

In the early 1890s the artist was attracted to circles involved in the occult, including the followers of Jules Bois, editor-in-chief of the journal of esotericism *Le Coeur*. In 1893 he joined the Theosophical Society and became interested in Buddhism. In this mood of spiritual exaltation, the artist embraced pastel. When he had a one-man show in 1896 at the Librairie de l'Art Indépendant (a shrine of the world of occultism), over half of the works displayed were pastels. That Schuffenecker "knows and practices the esotericism of beautiful colorations"[6] is demonstrated by the iridescent quality of his landscapes, where areas of acid greens are interspersed with turquoise blues and vivid yellows that Gauguin would have applauded.

A BLAZE OF COLOR

Jules Chéret (1836–1932) and Edmond Aman-Jean (1858–1936) were also members of this generation of artists who were fascinated by the purity of pastel colors. Chéret, a prolific pastelist, is primarily known for his innumerable posters that added a note of gaiety to the urban landscape. But he was not content to be a mere artisan, producing an abundance of ephemeral images; he also wished to be a full-fledged artist. In late 1889 he exhibited a group of sketches, pastels, and posters in the small La Bodinière gallery in Paris. "The magical glinting lights that this accomplished pastelist has used to illuminate his work"[7] created a sensation. The works radiate a sense of gaiety and freedom that recalls Jean-Antoine Watteau, Giovanni Battista Tiepolo, and Jean-Honoré Fragonard. In his carnival scenes and free-spirited Parisian figures, Chéret updated the art of the eighteenth-century masters to contemporary tastes. The critic Gustave Geffroy was "literally transported by

OPPOSITE
Jules Chéret
Masquerade, c. 1890
Pastel on paper,
14⅛ × 10⅝ in. (36 × 27 cm)
The State Hermitage
Museum, Saint Petersburg,
Russia

Jules Chéret
Fête de nuit, c. 1900
Pastel on canvas,
13¾ × 29½ in. (35 × 75 cm)
Musée d'Orsay, Paris

THE EXALTATION OF COLOR

Edmond Aman-Jean
Idleness, c. 1895
Pastel on paper, 24 × 19⅝ in.
(61 × 50 cm)
Musée d'Orsay, Paris

OPPOSITE
Edmond Aman-Jean
*Under the Orange Trees,
Amalfi*, c. 1899–1900
Pastel on paper,
24⅜ × 20¼ in. (62 × 51.5 cm)
Collection Lucile Audouy

Aman Jean.

these pastels that create an effect completely undiscovered till now. The drunken figure of Pulcinella glows scarlet, nymphs clad in pink cavort, and a great red drum resounds to golden cymbals. Greenish glints, phosphorescent glows, and fiery colors resound, combine, and set each other ablaze against backdrops as blue as the seas of the orient and the night skies of summer."[8] The virtuosity and originality of these works "whose colors flare like fireworks"[9] earned Chéret the title of Chevalier de la Légion d'Honneur (1890) and admission to the Société de Pastellistes Français, where he exhibited regularly until 1897.

Two years later the organization admitted Edmond Aman-Jean, who had also been reveling in the luscious color harmonies that were possible with pastel. Closely affiliated with Symbolist circles in the early 1890s (he exhibited in the first two Rose+Croix salons), he gradually distanced himself from their influence. "Rather than those scrawny little virgins clutching lilies or other symbolic flowers, he prefers sweetly plump female flesh caressed by light, one of the loveliest images that life has to offer," one critic observed.[10] Aman-Jean made a specialty of depicting female figures arrayed in diaphanous scarves and loose chemises slipping off their shoulders. Pastels' powdery colors added to the overt sensuality of these languid beings. A two-year journey with his wife (1895–97) along the Amalfi Coast awakened Aman-Jean to the effects of color and light. "This interlude, known as his 'Amalfi period,' " wrote his son, "shows how a colorful setting impresses the eye of a painter, who discovers the potential ferocity of colors without changing their symbolic resonance. In Amalfi, Positano, and the Gulf of Sorrento, the couple devoured oranges and marveled at seascapes where dolphins frolicked in the deep blue sea. The local girls were tanned, the lemons green, the sky periwinkle blue, and far below, the seashore and distant islands glowed pink."[11] Aman-Jean's pastels often had conventional titles (*Reverie, Intimacy, Woman in a Shawl*), and he did not aspire to discern the inner life of his models. He wished to delight the eye with his magnificent chromatic symphonies. "He had no subject. That does not mean his pictures have no meaning. Merely that words cannot express what they mean. His art has no connection with literature: it is purely pictorial, sufficient unto itself, in both its means of expression and the ideas that it expresses."[12]

Pastel's distinctive properties—the purity and brilliance of its colors—inspired a number of artists to explore the nature of color itself. Edgar Degas was an exemplar of this formalist bent, and became dedicated almost exclusively to pastel beginning in the 1890s. This choice of medium was not guided solely by convenience, although pastel did very much facilitate his practice of making multiple sketches to achieve just the right effect. In 1891 Degas remarked to his friend Daniel Halévy, "What is truth, really? Truth is what I want it to be, truth is what I think."[13] Degas claimed his freedom to select the subjects that pleased him and treat them as he wished. That is the implication of another comment: "They call me a painter of dancers, but they do not understand that for me a dancer is an excuse to paint pretty fabrics and show movement."[14] As the years passed, these purely formal issues became increasingly important to Degas. His works became pretexts for extraordinary coloristic compositions that had no other purpose than chromatic expression. In 1886 the

Edmond Aman-Jean
Reverie, c. 1902
Pastel on paper, 18⅞ × 23 in.
(48 × 58.5 cm)
Collection Lucile Audouy

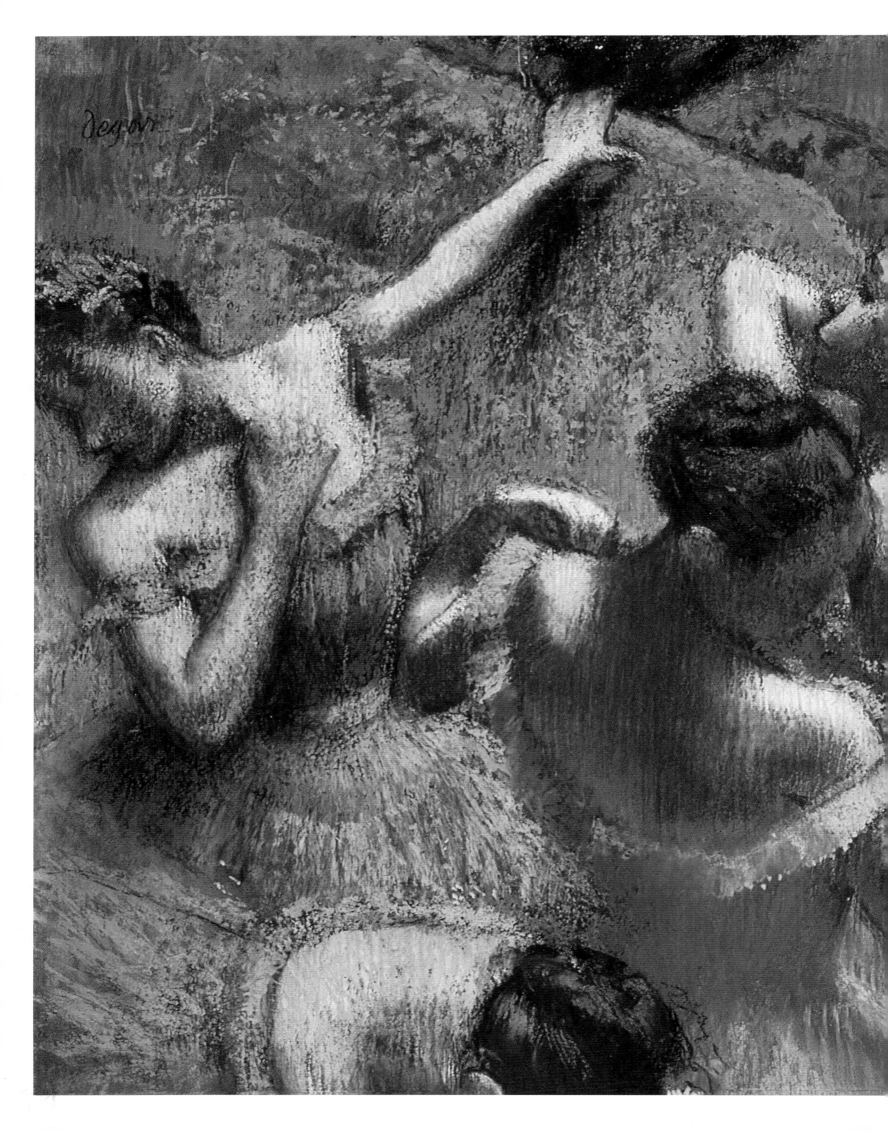

Edgar Degas
Blue Dancers (detail), c. 1899
Pastel on paper,
25¼ × 25⅝ in. (64 × 65 cm)
Pushkin Museum, Moscow

Edgar Degas
At the Millner's, c. 1905–10
Pastel on paper,
35⅞ × 29½ in. (91 × 75 cm)
Musée d'Orsay, Paris

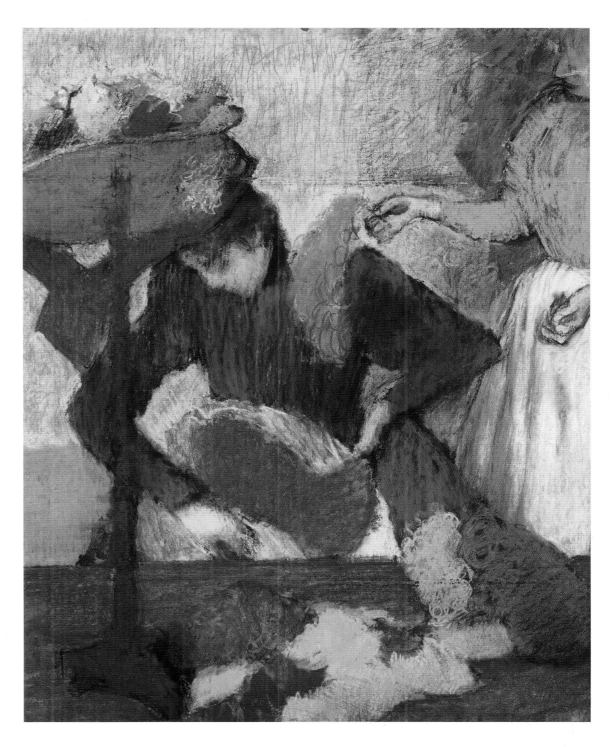

art critic Félix Fénéon had already noted Degas's propensity for playing with the properties of color, with the subject matter being no more than a means to an end: "His color is an expression of an artful and personal mastery. He externalized it in flamboyant multicolored jockey silks, the ribbons and lips of ballerinas. He now uses color in more subdued effects that are almost hidden; the pretext is a shock of red hair, the purplish folds of wet cloth, the pink of a hanging cloak, or the iridescent shimmers that roll acrobatically around the rim of a bowl."[15] As Degas lost his sight, "his brain became pure retina," to recall Paul Valéry's expression.[16] Pastel became more than ever the ideal material to express his aesthetic. Characteristic of his late work, *Blue Dancers*, "as vivid as flowers,"[17] reveals an artist who has abandoned himself to the spell of pastel and the magic of its colors.

OPPOSITE
Edvard Munch
The Scream, 1895
Pastel on board,
31⅛ × 23¼ in. (79 × 59 cm)
Private collection

Pablo Picasso
The Bullfight, 1900
Pastel on paper,
14⅛ × 14⅞ in. (36 × 38 cm)
Private collection

THE EXALTATION OF COLOR

23.
The Symbolist Pastel

Antoine Bourdelle
Portrait of a Young Woman,
1898
Pastel on paper,
29½ × 22⅞ in. (75 × 58 cm)
Musée Ingres, Montauban,
France

*I*n 1881 Guy de Maupassant expressed his dilemma over scientific progress. He observed that the philosophy of positivism and the empire of reason were creating a widespread sense of disenchantment, leaving a sense of emptiness in their wake. "We are marching in certainty toward certainty. Alas, despite my willingness and joy to embrace this liberation, all these lifted veils sadden me. . . . The Invisible has been eliminated. And everything seems to me mute, empty, abandoned."[1] In the art world as well, voices were raised against the realism that had dominated the 1880s. As Paul Gauguin explained, "In painting, as in music, it is better to aim for suggestion rather than for description." Keeping reality at a distance, leaving the imagination to do its work—such was the credo of the Symbolist generation, born around 1860. Instead of scenes based on daily life, which could at times seem banal, the Symbolists preferred subjects that were rarefied, often literary, with an aura of mystery and the uncanny. Their images were intended to be suggestive, inviting contemplation.

In their quest for a poetic ideal, the Symbolists frequently employed pastel. Although the medium was now recognized for its many advantages, it retained an aura of delicacy and fragility that was attractive to these artists. In contrast to oil paints, whose use necessitated a clutter of implements and materials, pastel's light, simple aspects suggested refinement. As one critic observed in the early 1890s, "Suddenly it was understood that this delicate, insubstantial material, with its aura of mystery, lent itself perfectly to the underlying subtleties of this ritual-istic approach to art. During the earlier era of peasant brutality and commonplace subjects, watercolor experienced a renewal, as well as charcoal and expressive soft pencils. We were interested then in real life, which is often banal, with its unrefined

coarseness and rude good health. Then for a brief interlude, everything became clouded, blurred, lost in vague suggestion. For eliminating delineation and avoiding obstacles, pastel is marvelous. It allows the interpenetration of tonalities, with soft, dense mistiness, and all the accents and virtuosic touches that could be desired. For those who are devotees of mystical grays, nothing has ever offered such dreamlike reverence and calm; the most daring may venture to add a hint of pale blue or tender violet."[2] Rather than the glare of outdoor light, the Symbolists preferred twilit settings that invited the use of soft tonalities and delicately pale colors.

NOCTURNAL VARIATIONS

James Abbott McNeill Whistler was indisputably one of the tutelary figures of Symbolism. The American artist was an accomplished purveyor of images that were often more suggestive than descriptive. His famous almost monochromatic nocturnes border on abstraction. The theme of the nocturne (and its sisters, dusk and dawn scenes) appealed to those who wished to imbue their art with poetry: these representations were the mystical counterpart to Impressionist landscapes, which were sunlit, daytime scenes. Pastel was ideal for expressing a more nebulous atmosphere. Its powdery texture, combined with skillful stumping, made it possible to convey exactly the moment in the gloaming when forms began to melt into phantoms before disappearing into the night. *The Evening Star*, by the American artist Childe Hassam (1859–1935), demonstrates his debt to Whistler: blue hatching is all that is needed to render a shimmering, monochromatic seascape accented by a bright point of light and a luminous vertical strip to indicate the star and its reflection in the sea. *A Park at Night* by the Hungarian artist József Rippl-

THE SYMBOLIST PASTEL

Rónai (1861–1927) plays on the same theme, but the result is more disquieting. The strangeness of this pastel is attributable to the remarkably skilled use of stumping. The trees in the park, illuminated by streetlights, have a phosphorescent, even spectral quality. This nocturne, typical of the artist's "black" period, was directly inspired by Whistler, whom Rippl-Rónai had discovered around 1890. At the same time, the Belgian artist William Degouve de Nuncques (1867–1935) was among the most inspired Symbolist pastelists. A friend of Jan Toorop, Henry de Groux, and Frits Thaulow (all of whom were devotees of pastel), he cultivated a sense of mystery. His muted landscapes resonate with an extraordinary quality of silence. Although human figures are absent from these works, they seem haunted by an indefinable presence. Swans, peacocks, and even trees are elevated to the ranks of mysterious symbols or doom-laden portents. A great reader of the poet and dramatist Maurice Maeterlinck, Degouve de Nuncques demonstrated a similar sensitivity to the underlying strangeness of places and situations.

For Emile-René Ménard (1862–1930), landscapes were "pacified versions of nature, bathed in the light of dawn or dusk, where the soul seems to immerse itself in the radiance of daybreak and breathes in the sacred balm of golden evenings."[3] In *The Cloud*, the artist takes advantage of pastel's powdery quality to drench the seaside landscape in evening light. Ménard makes us feel the fragility of a world that is about to become invisible, but which emanates a magnificent cloud haloed in gold, like a divine presence. *The Bay of Ermones* evokes the same atmosphere of suspended motion: everything seems to be on the brink of disappearance, from the setting sun over the horizon to the evanescent bather about to slip into the sea. "It seems," observed Achille Segard, "that every object is about to lose its own being and vanish once again into formlessness. A kind of pantheism, perhaps unconscious,

William Degouve
de Nuncques
Dawn, 1897
Pastel on paper,
20½ × 32⅛ in. (52 × 81.5 cm)
Museum voor Schone
Kunsten, Ghent, Belgium

THE SYMBOLIST PASTEL

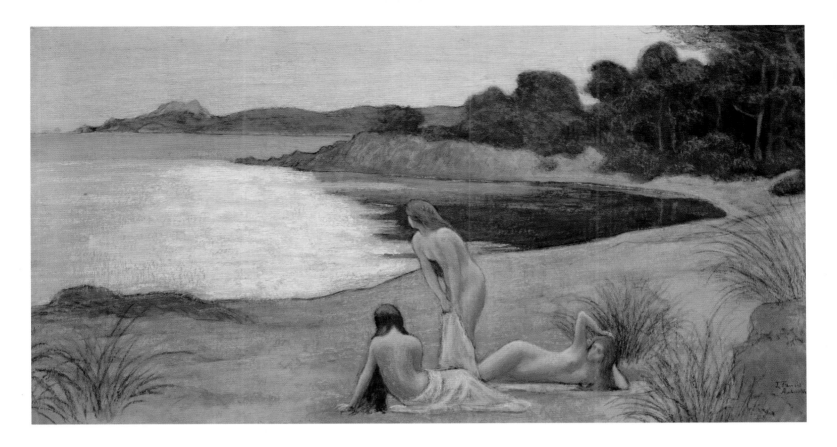

Jean-Francis Auburtin
Evening, Îles de Porquerolles,
1904
Pastel on paper applied to
canvas, 29½ × 52⅜ in.
(75 × 133 cm)
Musée des Beaux-Arts, Pau,
France

drew him to these daily experiences of birth and destruction."[4] The fascination of Ménard's compositions arises from a sense of precariousness that is marvelously expressed by the delicacy of pastel. These elegiac landscapes introduced Symbolism to the exhibitions of the Société de Pastellistes Français, which Ménard joined in 1897.

A similar poetic quality appears in the work of watercolorist and pastelist Jean-Francis Auburtin (1866–1930). He explored the passing times of the day in landscapes ranging from Porquerolles to Belle-Île and Varengeville, particularly favoring the fleeting moments of twilight. Shortly after moving to Normandy in 1904, he met the banker Guillaume Mallet in Varengeville. Mallet was very well versed in spiritualist teachings and a convert to Theosophy, beliefs that had a profound appeal to Auburtin. The artist began to include mythical figures—fauns, nymphs, mermaids, and sirens—in his compositions, fabulous beings that manifested the existence of the supernatural. In his *Evening, Îles de Porquerolles,* the three female figures reposing on the beach are not mortal women. They are divine beings inspired by the Muses, like those the famous painter and designer Puvis de Chavannes loved to include in his compositions, such as *The Sacred Wood* (1884). Auburtin revered Puvis's work, admiring his balanced, almost stylized compositions and serene figures, as well as his use of matte colors that recalled fresco painting. Auburtin used pastel, as well as gouache, as a way to emulate the matte quality of the oeuvre of Puvis, who had died a few years earlier.

The American painter Birge Harrison (1854–1929) also strove to master this effect. He was trained in Philadelphia and Paris (which he visited with John Singer Sargent). A painter of twilights, nocturnes, and winter landscapes, Harrison discovered pastel around 1913 when he was forced to abandon painting for a while due to a case of lead poisoning. He embarked on fabricating his own pastels, enthusiastic about their durability and vivid colors. "Over the last two years," he wrote, "I have painted a series of pastel pictures that are just as sound and durable as oil paintings of the highest quality, while retaining the exquisite freshness and the atmospheric quality that gives pastel its unique beauty, a quality that is certainly attributable to its velvety, dry, non-reflective surface."[5] Using pastel, Harrison executed singu-

Emile-René Ménard
The Bay of Ermones, c. 1903–4
Pastel on paper,
18⅛ × 25⅝ in. (46 × 65 cm)
Collection Lucile Audouy

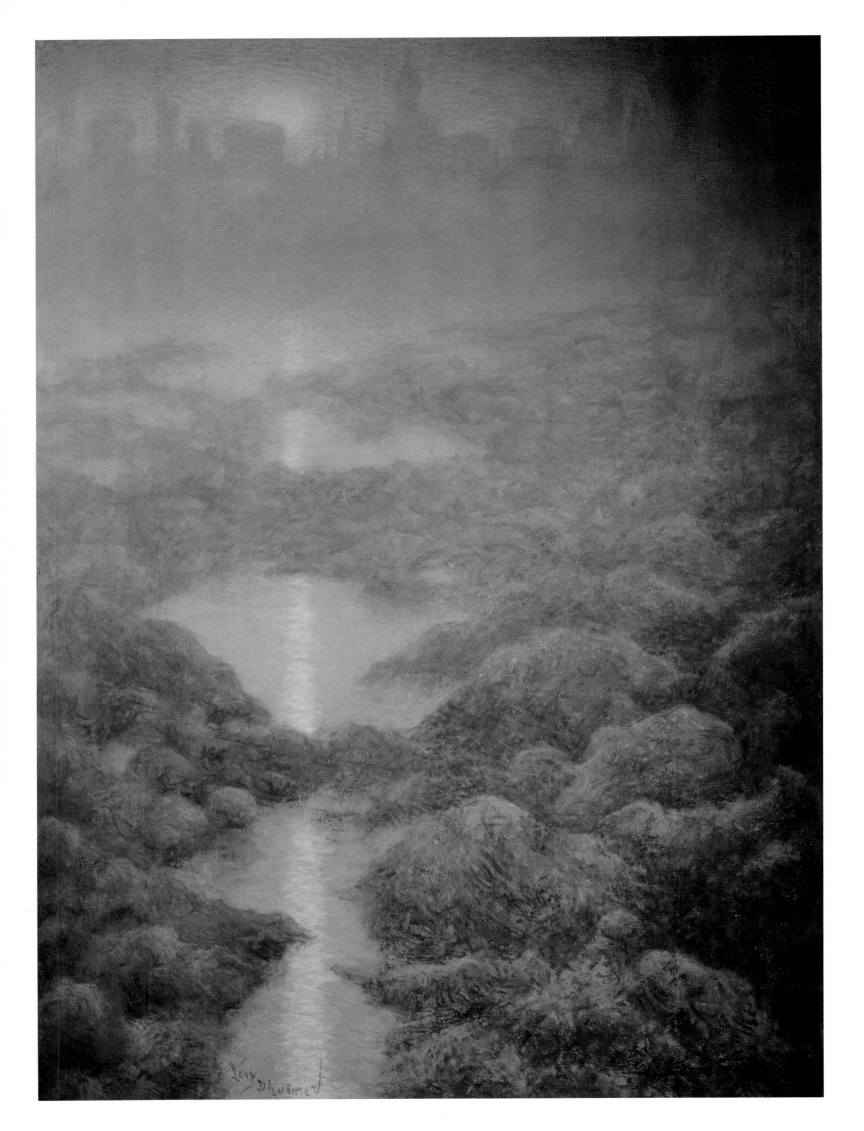

OPPOSITE
Lucien Lévy-Dhurmer
*One Evening, My Mother Saw
the City of Ys*, 1898
Pastel on board,
36⅝ × 27⅛ in. (93 × 69 cm)
Musée Municipal, Brest

larly evocative landscapes. Influenced by Whistler, he preferred suggestive, muted settings rather than excessively detailed representations. The modern painter, he wrote, "has learned that what is glimpsed appeals more to the human imagination than the facts devoid of mystery that are offered by nature."[6] His *Sunlight on the Sea* gives the viewer this striking vision: a sublime symphony in blue is pierced with luminous rays that seem to reveal the presence of God. In contrast to the Impressionists and their followers, who sought to capture the fleeting moment and convey the experience of the outdoors, the Symbolists preferred spectacular moments that expressed their idealistic aspirations. This revival of the art of landscape was closely tied to the rediscovery of pastel. But now the rapid, sketchy touch characteristic of the Impressionists was abandoned as artists embraced the powdery, diaphanous quality that imbued these works with mystery.

APPARITIONS

For the pastelist Lucien Lévy-Dhurmer (1865–1953), painting landscapes had nothing to do with rendering reality. He strove to convey a dream image, as in his work *One Evening, My Mother Saw the City of Ys* (1898), where the artist evokes the Breton legend of the drowned city built by the king of Cornwall. In the evening mist, the shadowy outlines of the rich metropolis emerge in the background of a strange seascape of seaweed-covered rocks. This striking pastel demonstrates the visionary talent that was able to give substance to Lévy-Dhurmer's dreams. This singular gift earned the artist speedy acceptance in the Parisian artistic scene. Having started his career as a decorator in a ceramics manufactory in Golfe-Juan, he began to exhibit his work in Paris with other idealistic artists associated in a group known as "Painters of the Soul." In 1896 Georges Petit's prestigious gallery gave the artist a one-man show that established him as one of the finest pastelists of his generation; he was admitted to the Société de Pastellistes Français the following year. He

Lucien Lévy-Dhurmer
Portrait of Georges Rodenbach,
c. 1895
Pastel on paper, 13¾ × 21¼ in.
(35 × 54 cm)
Musée d'Orsay, Paris

THE SYMBOLIST PASTEL

347

Lucien Lévy-Dhurmer
Fireworks in Venice, c. 1906
Pastel on gray paper
mounted on board,
34½ × 21⅛ in. (87.5 × 53.8 cm)
Petit Palais, Musée des
Beaux-Arts de la Ville de
Paris

OPPOSITE
Lucien Lévy-Dhurmer
Sonata in the Moonlight
Pastel on paper, 38¼ × 28 in.
(97 × 71 cm)
Musée d'Orsay, Paris

developed useful ties with a number of influential writers and art critics, including Georges Rodenbach and Camille Mauclare, who introduced him to Symbolist circles. Lévy-Dhurmer admired landscapes and often used them to enhance the effect of his portraits. Pierre Loti, the author of *Fantôme d'Orient*, a novel with a Turkish setting, is shown against a view of Istanbul; the city of Florence is the backdrop for Countess Vitali. Rather than limiting himself to the representation of their physical characteristics, Lévy-Dhurmer wished to suggest the tastes and imaginations of his sitters. The background landscapes are far more than decorative additions. In his portrait of the poet and novelist Georges Rodenbach, the author of *Bruges-la-Morte* looms before a view of the legendary Flemish city. As one commentator observed: "It is scarcely necessary to note the painter's subtle intuition, which evokes this apparition of the old town of Bruges behind the poet's head; it seems to envelop the sitter in its cloistered atmosphere, with the mists that rise from its canals."[7] Pastel's powdery quality allowed the artist to meld the image of the poet—

Lucien Lévy-Dhurmer
Eve, 1896
Pastel, gouache, and gold on paper, 19¼ × 18⅛ in.
(49 × 46 cm)
Private collection

THE SYMBOLIST PASTEL

Lucien Lévy-Dhurmer
Silence, 1895
Pastel on paper, 21¼ × 11⅜ in.
(54 × 29 cm)
Musée d'Orsay, Paris

like a phantom—into an urban landscape that evokes the funereal atmosphere of his poem. With the skilled use of pastel, "the poet's work is reflected in his features."[8]

Like Lévy-Dhurmer, the Belgian artist Fernand Khnopff (1858–1921) made use of all the graphic mediums available to him (pencil, charcoal, colored pencil, crayon, pastel, gouache, watercolor) to create enigmatic figures who are withdrawn into their inner selves. In works such as *The Offering* and *The Secret*, we feel that we are present at the completion of some esoteric ritual. Khnopff was a demanding and cerebral artist who tried to exercise complete control over the techniques he used. Emphasizing how the process should be the handmaiden of the artist's ideas, he stated, "The process of creation is of little consequence. The impression produced is everything." In his pastels, he demonstrated an extraordinary, very personal, finesse. Khnopff circumscribed his pastel colors to a few zones that he delimited with impeccable drawing; he also roughened the support instead of rubbing the colored crayons against the paper. This approach eliminated the sketchy quality and brilliant colors that often characterize pastels. There is no use of vigorous hatching; instead the surface is flawlessly blended with extensive use of stumping, erasing any hint of the painter's touch. In *Be Silent*, for example, pastel is employed with great subtlety to render the tunic's folds, emphasize the pupils, and create a nimbus around the face.

Fernand Khnopff
The Secret, 1902
Pastel and colored pencil on paper, 19½ in. (49.5 cm)
Groeningemuseum, Bruges, Belgium

THE SYMBOLIST PASTEL

As the century drew to a close, there was a heightened receptivity to spirituality in all its manifestations: traditional and esoteric religion, Theosophy, esotericism, the occult sciences, mythology, and legend. Many artists were no longer content to limit their subject matter to the pleasing scenes favored by Impressionism and its offspring. It "set the ceiling too low," as Odilon Redon wrote. The Symbolists' inspiration was drawn from the remote past, when faith was still pure, or from the more recent model of the British Pre-Raphaelites and their mentor, John Ruskin, who studied the Italian primitive paintings to recapture a sense of enchantment. It was difficult to escape this exalted mood around the turn of the century. The young artist Lucien-Victor Guirand de Scévola (1871–1950), who was trained strictly according to tradition by the academic painter Fernand Cormon, set out to please contemporary taste. Employing watercolor and pastel, he turned out a multitude of hieratic images of stately, remote princesses set in Renaissance-inspired frames. Shown full face or in profile, often with elaborately arranged coiffures (an homage to Leonardo's *Belle Ferronnière*), their eerie stillness exudes an ostensibly mystical quality. The brilliant colors and diaphanous aura lent by pastel endows these beauties, who have evidently wandered out of the pages of a medieval legend, with a distinctive note of sensuality. "In those deep eyes, swimming in shadow, lies an unattainable charm, a caress that envelops the innermost soul; the lovely face, with its harmonious contours, obsesses you like a vision in a dream, and haunts you like an enigma."[9] The public was entranced, and in 1903 the artist was admitted to the Société de Pastellistes Français. At the same time the lithographer, illustrator, and caricaturist Charles Léandre (1862–1934) also yielded to the taste for mysticism.

Fernand Khnopff
Be Silent, 1890
Pastel on paper,
33½ × 16⅛ in. (85 × 41 cm)·
Musées Royaux des
Beaux-Arts de Belgique,
Brussels

FAR RIGHT
Fernand Khnopff
Sappho, c. 1912
Pastel on paper applied to
canvas, 24⅝ × 11¾ in
(62.5 × 29.7 cm)
Private collection

In 1897 he executed a large pastel portrait of his sister Mathilde in which he eschewed a simple likeness. Instead of being shown in full light, as was usually the case with the realists and Impressionists, the figure is backlit, garbed in a long black dress with a bared shoulder, in the style of Aman-Jean's portraits. In the background, hatching in tones of yellow, red, and orange creates an ardent glow behind this sensual image, entitled *On a Field of Gold*. The sculptor Antoine Bourdelle (1861–1929) pushed this notion to its limits in his pastel portraits. Against often monochromatic backdrops, only the most significant aspects of the face are revealed. As if disembodied, the figure virtually dissolves in the powdery haze of pastel. This approach, which verged on abstraction, appealed to clients because it presented a change from the timeworn conventions of portraiture.

The Symbolists transformed pastel into a poetic substance. As one observer noted: "We could say that pastel has become the poetry of painting, while oils have remained the prose. Silhouettes of dreaming women, flowers, a few glimpses of nature and the sea—that is the sum of what our pastelists evoke in their art."[10]

Charles Léandre
On a Field of Gold: Madame Lemoine, the Artist's Sister, 1897
Pastel on canvas,
64 × 45⅛ in.
(162.5 × 114.5 cm)
Petit Palais, Musée des Beaux-Arts de la Ville de Paris

THE SYMBOLIST PASTEL

24.
Odilon Redon and the Reinvention of Pastel

Odilon Redon
The Visitation, c. 1895–1901
Pastel on paper, 21 × 15⅜ in.
(53.5 × 39.2 cm)
Musée d'Orsay, Paris

*O*ne man stands out in the renewal of pastel in the late nineteenth century—
Odilon Redon (1840–1916). In 1890 this remarkable artist, best known for black-
and-white engravings and charcoal drawings—his *noirs*—began to investigate all
the possibilities offered by color. Within a few years, pastel had become his favorite
medium. In 1902 Redon claimed that he was "wedded to color," and he was pushing
pastel to the limits of its potential. The richness of this fascinating material allowed
him to give free rein to his fertile imagination. Like a magician, Redon invoked bold
contrasts of colors, galvanizing the impact of this powdery medium. The effect of
his deep blues, blood reds, acid greens, cobalt and ultramarine purples, and strident
orangey yellows was intensified by audacious juxtapositions. The viewer would
have to look back to the stained glass windows of the Middle Ages to find such
intensity of color.

A DAZZLING CONVERSION

It may seem surprising that an artist who had built his entire reputation on his
noirs would undergo such a profound change of heart. Born in Bordeaux, Redon
began his career at a relatively advanced age; he was twenty-four when he decided
to complete his artistic training in Paris. In the 1870s and 1880s, he executed a large
number of charcoals and lithographs, which soon began to attract notice. Redon
was steeped in the work of Rembrandt, Francisco Goya, Eugène Delacroix, Jean-
Jacques Grandville, and Rodolphe Bresdin; he was well aware of the theory of
evolution from his friend Armand Clavaud, a botanist; and he was a devotee of

357

Edgar Allan Poe. His works on paper and board were "quintessential compositions," in the words of Emile Hennequin. Decadent and Symbolist writers, with Joris-Karl Huysmans at the forefront, were eager to contribute their own commentaries. Redon's subject matter included decapitated heads, eyeballs the size of a hot-air balloon, grimacing spiders, and monstrous tadpoles, demonstrating an imagination teeming with bizarre ideas. Hennequin characterized them as a "treasury of dreams and suggestions," and Jules Destrée called them "extraordinary catalysts for dreams." In Redon's oeuvre, strangeness yields to the fantastic and the fantastic gives way to the nightmarish, inspiring heated conjecture. Redon gradually acquired a formi-

Odilon Redon
Flower of Blood, 1895
Pastel on gray paper,
11⅞ × 16⅞ in. (30 × 43 cm)
Musée d'Orsay, Paris

dable reputation among those who found that realism offered too narrow a spectrum for their tastes. Within a period of ten years his career advanced rapidly. His impressive accomplishments included publication of the lithograph albums *Dans le rêve* (1879), *A Edgar Poe* (1882), *Origines* (1883), *Hommage à Goya* (1885), *La Nuit* (1886), *La Tentation de Saint Antoine* (1888), and *A Gustave Flaubert* (1889). There were laudatory commentaries by a growing number of critics, and Huysmans eloquently praised Redon's work in his novel *A Rebours* (*Against Nature*; 1884). These achievements combined to make Redon's *noirs* one of the iconic expressions of the Symbolist movement. Given these circumstances, Redon's transition to color, which began in 1890, is remarkable, seemingly undermining the years of work on which he had built his reputation.

Redon had never actually abandoned his ambition to be recognized as a painter, and he continued to paint numerous landscapes using oils. During his honeymoon trip with Camille Falte in 1880, he executed his first pastels. Beginning in 1890, Redon used colored papers as supports with increasing frequency. They were "the foundation," he wrote, "for the colors that I would later relish and allow myself to delight in."[1] He also sometimes used pastel to add highlights to his charcoals and occasionally transposed charcoal drawings into pastel. His *Mystical Conversation*, for example, repeats the subject of a lithograph done in 1892. Gradually his pastels began to outnumber his charcoals, and color prevailed entirely toward the turn of the century. In May 1898 he exhibited pastels and charcoals together at the gallery of art dealer Ambroise Vollard, who published Redon's last album of lithographs, *The Apocalypse of Saint John*, the following year. After 1900 Redon became so thorough a convert to color that charcoal seemed alien to him. "I wanted to make a charcoal as I used to do," he wrote to Maurice Fabre. "Impossible! I've made a complete break with charcoal. Ultimately the secret to our survival lies in new materials. I am wedded to color; ever since, it has been difficult to manage without it."[2]

RIGHT
Odilon Redon
*Portrait of Madame Redon
Embroidering*, 1880
Pastel on paper,
22⅞ × 16½ in. (58 × 42 cm)
Musée d'Orsay, Paris

Some have explained Redon's aesthetic conversion to developments in the artist's psychology. During the 1890s he made many representations of the figure of Christ, and the incandescent pastel colors that he used in them may reflect the intense spiritual crisis that he was experiencing. Redon was close to Gauguin and the young Nabis, who were convinced that vivid colors carried an emotional and symbolic charge; these associations almost certainly influenced the artist's evolution. In addition, Redon was probably feeling a very natural desire for a fresh start following an extended self-imposed restriction to black. (Gauguin referred to "a great depletion of the imagination when utterly confined to a single note."[3]) In 1897 Redon told André Bonger that pastel "rejuvenated" him. Redon's recognition by the young generation of Nabis, his participation in a Durand-Ruel exhibition in 1889, his collaboration with Bonger, who promoted his work in the Netherlands, and more generally his standing as the leader of the Symbolist movement—all contributed to the artist's prestige. Redon finally had the stature needed to explore new avenues. As Dario Gamboni demonstrated, Redon sought to reestablish control over his career, which had largely been built on favorable literary commentary. He wanted to address his work to a new, broader audience. Times were changing, and the artist noted with pleasure that "art existing outside a rigid framework is now beginning to be viewed by a public that can make its own judgments. This is an audience that buys, collects, and even speculates."[4] Color—whether oil or pastel—reinvigorated the artist's imagination and curiosity; it was also more likely to appeal to a broad audience than his austere *noirs*. In 1900 he alluded to his "great joy" at being a pastelist. His reputation was so well established that he could write about his pastels to his friend Bonger: "They are popular, they are sought after, and they are bought as soon as they're completed."[5]

In converting to color, Redon distanced himself from the literary commentary that his works had inspired. Regretting that they had attributed "too much analytical spirit" to him, he proclaimed that his work would henceforth stand on its own, no longer subject to being reduced to the written word. "All of the critical errors made about me in the early stages of my career were made because these writers did not understand that nothing should be defined, nothing understood, nothing limited, nothing specified; anything that is genuinely and unassumingly new—like beauty—carries its meaning within itself."[6] In support of such assertions, Redon seemed to embrace a strictly formalistic approach; his works expressed spontaneous creativity and the interplay of formal and coloristic elements. "Art has no goal other than art," he told Maurice Denis in 1911, "and the best of mine is undefined." Indeed, the intense colors of his pastels capture the viewer's attention so completely that the subject matter is effectively relegated to a place of secondary importance. Color with this degree of vividness seems to take on a life of its own. The many flower paintings he began to do in 1905 are enigmatic sheaves of blossoms on abstract backgrounds. They imply an art that renounces speech, or more broadly, even suggestion, in favor of a purely visual approach that advocates color for its own sake.

THE EXTENSION OF A WORLD OF DREAMS

The transition to color did not really fundamentally alter the nature of Redon's art. Imagination continued to guide his hand. His bouquets, for example, were, as he asserted, "at the confluence of two streams, one of representation, the other of memory."[7] Indeed, contemplating *Stained Glass Window* (c. 1900), his friend the pianist Ricardo Viñes (who ultimately purchased the work) alluded to an "enchantment of dazzling, harmonious color."[8] This apparently casual observation should not mislead us. Like Redon, Viñes was an active participant in the vast world

Odilon Redon
Stained Glass Window,
c. 1900
Pastel and charcoal on chamois paper, 34¼ × 26¾ in. (87 × 68 cm)
Musée d'Orsay, Paris

of occultism. Jules Bois, Edmond Bailly, Antoine de La Rochefoucauld, René Philippon, and Déodat de Séverac were just a few of numerous devotees among whom the artist sensed a familial welcome. Redon's parents were intensely spiritualist. Although he resisted these beliefs, it is striking that he found himself drawn to circles of men and women who were firmly convinced of the existence of an invisible world and the possibility of communication with higher beings. Redon's art is certainly the work of a visionary. As he wrote to Edmond Picard, he had assumed "with pastel, the hope of giving [his] dreams more externality, if possible."[9] Just as Degas dedicated himself to pastel to render truth with unmatched coloristic brilliance, Redon found this medium "more radiant and more spiritual than oil,"[10] a means of restoring power to his inner world. There is clearly a mystical and religious resonance in subjects such as *Parsifal, Stained Glass Window, The Buddha,* and *Apollo's Chariot,* a magnificent symbol of day's triumph over night. In addition, the effusions of strident color in his pastels (as well as his works in tempera) have an ecstatic, hallucinatory, supernatural dimension that rivals the contemporary explorations of an artist like Wassily Kandinsky. The colors truly glow, and that is why pastel lent itself so well to Redon's goal of creating a "suggestive art," conceived of "as an illumination of things for dreaming, where thought also finds its path."[11] Claude Roger-Marx commented, "With the tip of his brush, he commands this seemingly living powder, which might have been gathered from a wing or a pistil. Devoid of any hint of sensuality, this is an art that soars toward the heavens like a prayer...."[12]

RIGHT
Odilon Redon
Anemones in a Blue Vase,
after 1912
Pastel and black pencil on
gray paper glued to board,
25⅛ × 24⅝ in.
(63.8 × 62.6 cm)
Petit Palais, Musée des
Beaux-Arts de la Ville de
Paris

OPPOSITE
Odilon Redon
The Shell, 1912
Pastel on paper,
20½ × 22¾ in.
(52 × 57.8 cm)
Musée d'Orsay, Paris

...five guys...
...a brief surv...

...neone will win a
...Gift Card each month
...worth $25 each!

...o purchase necessary
...stakes ends 12/31/2019.
...be at least 18 years old and
...ubmit survey within 30 days
...of the receipt date to enter.
...ease visit www.fiveguys.com/survey
...for Official Rules and how to enter
...without making a purchase or
...completing a survey.
...Void where prohibited.

Technical Appendix
Pastel: Materials and Techniques

Small boxes of Roché pastels from the early twentieth century at La Maison du Pastel, Paris

INTRODUCTION

The term *pastel* today is used to refer to sets of colored friable pigment sticks and to the works of art executed with them. Each stick in a set is formulated to be sufficiently cohesive to allow it to be grasped directly and worked with as a tool. Since the sixteenth century, when dry powdery pigments first appeared in drawings, artists and their assistants have mixed constituents into a stiff paste, shaped them into individual sticks, and set them to dry; the best-quality pastels are still hand-rolled. Molds or extrusion devices have often been used to form regularly shaped sticks. Pastels shaped by hand may be, but are not necessarily, irregular in size and shape. Caira Robbins's box of pastels, now in Boston, and John Russell's and Elizabeth Cay's boxes, both in London, are rare extant examples of variant formats found into the nineteenth century, before industrial manufacturers of artists' materials adopted a cylindrical format.

In early modern French, Italian, and English treatises, the terms *pasteaulx, pastello,* or *pastille* described the solid forms—cakes, loaves, lozenges, balls, or rods—in which apothecaries, grocers, and other merchants typically dispensed powders, whether medicinal, confectionery, or other types.[1] Pigments for pastels are colored powders of organic, inorganic, or synthetic origin; with some exceptions they are those found in oil and watercolor painting. Ideally, for pastels, the particles are very finely ground, and the pigments have good covering power, tinting strength, and permanent color.

Filler or *extender* is the term for the other dry powdered constituent, a white, inert mineral; for example, whiting (chalk or calcium carbonate) or plaster of Paris (calcined gypsum or calcium sulphate).[2] The filler may be added to the pigment to modify texture or color. It may contribute cohesiveness and modify the hardness or softness of a stick so that it powders in use rather than crumbling or scratching.

High-quality pastels can consist of almost pure pigment and very intense, almost luminous, in color; as more white filler is added, the pigment is increasingly diluted and the color reduced in intensity. In 1772 the artist John Russell reported that his pastel box contained twenty gradations for each hue.[3] In fact, since he made his own pastels, it probably contained mainly colors and gradations he was using at a particular time, whereas today the largest sets sold by commercial suppliers contain sticks of

every color artists may need, potentially a huge number.

A liquid binder is also needed—traditionally a vegetable gum (typically gum arabic or gum tragacanth)—but in fact many other liquids were recommended in the historical literature (sugar candy, beer, rotten size, fig milk, and so on).[4] We have little information about what binders were actually used, since their scientific analysis has rarely been undertaken. Today synthetic cellulose gums, which make a soft pastel, are often the binder of choice.

The amount of binder needed is tiny—just enough to allow the pigment-filler-binder mixture to be shaped into sticks that, once air-dried, will hold their shape in use. The ideal binder has weak cohesive properties. These are not sufficient to bind the pigment particles to the paper support, nor are they intended to; adhesion is purely mechanical. This is in contrast to watercolor cakes, which contain a greater proportion of binder to powdered pigment; the binder is activated by contact with the wet brush, and as the stroke dries, its water evaporates and the pigment particles are pulled to the paper surface and bound to it by the gum.

Pigments are not, as they are in oil painting, mixed together on a palette or support to create additional tones and gradations. Blending pastels together during their application compresses the particles, resulting in a hardened surface and muddied, less intense colors. To extend the range of colors, pigments are mixed during fabrication of the sticks. Thus sticks in all shades needed for a particular image must be made or purchased ready-made.

Adding a binder and filler to a pigment sounds straightforward, but in fact the historical process was complex. Pigments possess different cohesive forces and absorption characteristics, and most require the addition of exact amounts of particular binders and fillers to produce a usable stick that powders satisfactorily in use. Treatise writers such as Paillot de Montabert remarked on the difficulty of achieving these desiderata.[5] The same pigment, when mixed with different binders and fillers, makes sticks that range in consistency and handling properties from hard to soft. The same ingredients obtained from different suppliers or geographical sources may be sufficiently different in character to require adjustments in the amount or type of binder and/or filler to achieve a desired consistency.[6] This variability is the reason historical treatises avoid listing

Leonardo da Vinci
Codex Madrid I, fol. 191r.
Biblioteca Nacional de España, Madrid
Procedure for molding pastels. Parts *a, b,* and *c* are made of terra-cotta, similar to what is used in pottery; *e* designates the pastel, and *d* is the part made of wood. The counterweight for compression appears as *f.*

OPPOSITE
Roché pastels, 2012
La Maison du Pastel, Paris

Isabelle Roché fabricates pastels at La Maison du Pastel, Paris. Pastel is composed of pigments with exceptional resistance to light and a minimum of binders.

TOP TO BOTTOM: Setting the paste; rolling by hand; cutting into sticks.

exact proportions of ingredients. Today pigment manufacturers often use a universal filler composed of various inert substances.[7]

To work with pastel, the stick is stroked or drawn over the surface of the support. If the surface is adequately textured, it acts as a file and abrades the pigment particles from the stick, depositing an unbound porous pigment layer. This settles on the surface of the support as loose accumulations, held there by the pressure with which they have been applied. The particles are caught by each other, by the soft, granular textured surface, and by projecting fibers that historically were often raised from a paper surface beforehand by rubbing it with pumice. Depending on the cohesiveness of the stick and the hand pressure applied, particles may lie only on the high points of the surface grain. This may form a disturbing grid on laid paper. If enough pigment is abraded from the stick, the particles also fall into the interstices of the paper grain and evenly cover the paper surface. The pastel powder may be smoothed over and into the paper surface with a finger, or with tools made of rolls of soft leather or absorbent paper called "stumps." If the surface is too hard and slick, the pastel particles will not hold in place.

A soft matte velvety appearance and brilliant, intense tone are characteristic of works in pastel. The matte surface of an unfixed pastel is caused by diffuse reflection; that is, the scattering of light in all directions from the irregular surface. Application of a fixative or varnish intended to secure the powdered particles in place results in a glossy surface and darkens the saturation of some colors. This is because a liquid fixative fills in the spaces between the particles and, once dry, covers the surface with a light-reflective film. Visible changes to the appearance of the image counterindicate the application of a fixative or varnish as a conservation measure, although some artists, for example, Edgar Degas, have chosen to apply them in their art making. Rubbing, abrasion, and vibration or shock to an unfixed pastel surface will cause pigment layers to collapse, changing their refraction and causing conspicuous changes, including pigment loss.

DEVELOPMENTS IN THE MATERIALS AND TECHNIQUES OF PASTEL PAINTING

The fragility of pastels led the eighteenth-century Académie Royale to approve various processes intended to make pastel paintings more permanent and durable. The wider context for the French initiatives was the "Enlightenment belief in the power of science and conservation to defy natural decay" so that artworks might be preserved for posterity; numerous experimental techniques were investigated in the second half of the century in the interests of preserving the French national patrimony.[8] Not until the nineteenth century did developments in science and technology lead to changes in the components of pastels, the introduction of a greatly increased range of pigments and dyes, and the replacement of an array of earlier binders with gum tragacanth and cellulose derivatives.[9]

A MORE DURABLE PASTEL STICK

From the mid-eighteenth century, suppliers of pastel sticks claimed in the press "to have found the secret of softening those which are usually hard," "of having obtained the secret . . . of the famous Stouppan of Lausanne," and to have brought their own products "to perfection."[10] New recipes were devised that claimed to provide more durable pastels. In 1757 a German painter, M. Reifstein, published "a new manner of painting in pastel . . . wax pastel."[11] The support material—cloth, not paper—was covered with a layer of oil onto which glass powder was sieved. When it was dry, the artist painted on this surface with the hardest crayons, made as follows: pigments were first reduced to very fine powders, then gently heated; melted wax and some *graisse de cerf* (deer fat) were mixed in, stirred, and cooled. The mixture was poured onto unsized paper to allow excess moisture to be absorbed. Then crayons were formed and plunged into cold water to impart the right consistency.

In his salon criticism, Diderot made several references to "paintings executed with new *pastels à l'huile*" (oil pastels).[12] He described the pleasing solidity of Alexander Roslin's *Head of a Young Girl*, painted in 1763 with these oil pastels and executed on a special support, a process invented by the late Sieur Pellechet.[13] Several academicians, including Roslin and Maurice Quentin de La Tour, submitted the process to the academy for his widow. In 1764 the academicians, judging the colors bright and unchanging, declared the technique of merit, and in 1783 they certified it.[14] Roslin showed his oil pastel at the Salon of 1765. Madame Pellechet described this method in a letter to the marquis de Marigny, director of the Bâtiments du Roi, proposing its acquisition by the king: a white paper, lightly sized, was glued to a cloth; when dry, the paper was pounced to even out the surface and the composite nailed to a strainer. The day before painting, oil furnished by Madame Pellechet was applied with a sponge or cotton and allowed to soak into the support. Supplies for the process were sold by Mademoiselle Sellier near the Pont-Neuf in Paris.[15] Roslin's oil pastel, today in Stockholm, deteriorated severely over time and survives today heavily restored and varnished.

Rafaëlli Solid Oil Colours, patented in 1902, were perhaps the ultimate in durable pastel sticks. Pigments bound in drying and nondrying oils—the choice and proportions varied with the pigment—were melted together "in a complex and largely unknown mixture" with hardeners and stabilizers and then poured into molds.[16] To paint, the sticks were applied directly to the support, usually canvas, avoiding "the inconvenience of liquid oil colours and their attendant paint-box, palette and brushes."[17] The effects obtained were described as dry and matte—of "refined softness and luminous radiance"—and "absolutely indelible," the format allowing the artist to "follow his thoughts much more rapidly" than did oils.[18] Rafaëlli Solid Colours were for these reasons claimed to have "great advantages over pastel work" and were very popular with artists such as the Swiss Ferdinand Hodler and the Englishman George Frederic Watts.[19] They were marketed briefly in England by the colormen Winsor & Newton.

PERMANENCE OF PIGMENTS AND DYES USED TO COLOR PASTEL STICKS AND PAPER SUPPORTS

During the nineteenth century, significant advances were made in color chemistry, and many new colors were introduced into sets of pastels and into their supports. It came to be understood that colors selected for pastels had to be stable chemically, as the pigment particles were not protected from the degrading effects of light exposure and polluted air by encapsu-

Roché pastels at La Maison du Pastel, Paris

Victor Prouvé
The Family, 1898
Charcoal and pastel on paper, 52 × 42⅞ in.
(132 × 109 cm)
Musée d'Orsay, Paris

lation in oil and varnish films, as were those in oil paintings.

The production of new pigments for artists exploded between 1770 and 1820—zinc white, permanent white (*blanc fixe* or barium sulphate), cadmium yellow and orange, Schweinfurt green, chrome yellow, chrome orange, chrome red, emerald green, cobalt blue, and many others. Some were prepared from naturally occurring minerals, and others were manufactured synthetically.[20] Many new pigments were not available in sufficient quantities to make an impact on artists' palettes until the mid-nineteenth century. The new colors were brilliant and highly attractive to artists, but their permanence was unknown, and thus rigorous testing was needed; in 1891 the French painter Jehan Georges Vibert recommended a list of pigments "that can be employed safely."[21]

Nevertheless natural organic dyes—indigo, dyewoods, carmine derived from cochineal and kermes insects, and madder from the root of *Rubia tinctorum*, a European plant—were used in pastels despite their known fugitive na-

ture. The development of "seductively vibrant" coal-tar-derived synthetic aniline colors, beginning with mauve (*mauvéine*) in 1856, introduced new hues, some of which were "hopelessly fugitive," into the artists' palette.[22] Mauve, eosin (geranium lake), fuchsin (magenta), and Harrison red were certainly used in artists' colors between 1856 and 1906, though they were not particularly successful.[23] Vibert spoke out against pastels "tinted with aniline . . . of an excellent consistency and magnificent tones, but which disappear in the light."[24] A lake pigment resulted when a natural or synthetic dye was precipitated with an inert binder, usually a metallic salt. It is broadly true that lake pigments, in which the coloring materials are unstable organic molecules, are more susceptible to fading than mineral-based pigments.

Concerned about the damage to some pigments from light and polluted air, George Field, an English color maker, undertook exacting tests for the permanence of new pigments. Recorded in ten extant notebooks dating from 1804 to 1825, his are the first documented systematic

TECHNICAL APPENDIX

fading tests.[25] Similar concerns for the fading of pigments led William de W. Abney and Walter Russell, both scientists, to publish their important *Report . . . on the Action of Light on Water Colours*, the most systematic and extensive investigation of the time, in 1888.[26] In 1891 A. G. Green, C. F. Cross, and E. J. Bevan reported in the *Journal of the Society of Arts* on the fading of aniline in paper coatings, and Jehan Georges Vibert gave simple instructions for testing the stability of pigments in the kitchen.[27] In 1907 Wilhelm Ostwald warned readers in his *Letters to a Painter* about the problems posed by pastels made from aniline colors, regularly sold in shops, and suggested tests that could be undertaken to determine the stability of pastel colors; an improvement, he suggested, would be for artists to make their own pastels from known raw ingredients.[28] Before 1900 it was wise to beware of coal-tar colors. After 1907, manufacturers of synthetic colors for painters agreed to subject their products to stability tests. This agreement came to nothing; gradually, reliable synthetic pigments were identified, however, and artists were less and less inclined to avoid them.

SPECIALLY FORMULATED SUPPORTS FOR PASTEL

By the eighteenth century, parchment makers specially prepared the skins destined for pastel supports; the rougher, usually hair, side was mechanically processed to give a velvety nap that "plumped it up," ideal for holding pastel particles, whereas parchment destined for painting in miniature with watercolor and gouache was given a prized smooth surface "so that it readily accepted the lightest and most delicate strokes."[29] The English draftsman Edward Lutterell (c. 1650–before 1737) and the French painter Alexis Loir III (1712–1785), both engravers in mezzotint, used copper sheets for portraits and head studies executed in pastel. The copper was given a rough surface with a rocker, a tool used in preparing the plate for mezzotint engraving, which would have been familiar to them.[30] Purpose-made papers for artists were not fabricated until the nineteenth century; until then pastelists found most suitable for work in pastel the rough, soft-surfaced, unsized papers intended for wrapping and other ephemeral activities.[31] In addition, paper and cloth supports might be specially coated with sand or pumice powder or chalk mixed into parchment size to improve their "tooth"; "pastel holds very well on it."[32]

From 1839 the Lefranc & Bourgeois factory used efficient mechanical grinders, building on recent progress in the grinding of emery and glass and in the abrasive paper industry, to prepare purpose-made emery-coated papers and cloths for pastelists.[33] Various certificates (*brevets*) were issued in the 1840s—for the production of pumice papers (made with pumice and rabbitskin glue), of a paper prepared with oil (made from white lead, linseed oil, litharge, oil of turpentine, and pumice) to make it resistant to moisture, and of an improved version with sawdust added to the pumice powder and a siliceous cloth made of glue, oil, resin, silica powder, or gunpowder.[34] In 1889 José Frappa received a *brevet* to use ramie fibers to fabricate stronger supports for pastels; the tensioned cloth received a preparation of glue onto which was sprinkled either fine sawdust or cotton fibers.[35] This last, advertised as rot-resistant (*imputrescible*), more durable, and more stable hygrometrically than other products, was sold by Lefranc and featured in their 1897 catalog.[36]

Machine-coated canvases were widely used in Europe as supports for pastel—in Denmark, for example, where it was described as "flocked canvas" because the flax or cotton fibers were sprinkled over the still-wet ground applied to plain-weave canvas, and in Poland where, coated with a mixture of zinc white and cotton and wool fibers in a gelatin binder, it was called "velvet canvas," reflecting the character of the finished surface.[37] In America, too, from the 1850s pastelists occasionally used papers commercially coated with glue and powdered pumice, sometimes colored.[38] The 1854 American translation of Saintin François Jozan's text *Du Pastel* into English especially recommended pumice-stone paper as a pastel support.[39] Alongside these specially formulated supports, advances in papermaking made a greater variety of specialty support sheets available commercially—cartridge papers, rough-textured papers, Japanese tissues, "velour" paper, and blotting paper, as well as artists' illustration board and gessoed panels.[40]

Ostwald recommended a paper with a "pyramid grain," and Vibert, at the end of the century, suggested that the adoption of thick, rigid supports like cardboard would help avert damage to the fragile image from vibrations. In addition, if sealed with fixative or varnish front and back, cardboard would impede the passage of humidity into the support. Advances in the textile industry were incorporated into pastel supports; for instance, Lefranc advertised *madapolam*, a strong, heavy cotton featuring the same tensile strength and shrinkage in any two directions at right angles and equal liquid absorption along the x and y axes, in their 1896 catalog. Through the nineteenth and into the twentieth century, pastelists were instructed to prepare their own textured surfaces with a layer of pumice powder or finely ground sand, cork, or glass in glue ("pastel holds better than on any other") or, better, a rot- and moisture-resistant (*imputrescible et imperméable*) fixative or varnish.[41]

FIXATIVES

From the mid-eighteenth century, artists and colormen, sometimes assisted by "savants," sought methods for securing pastel particles by applying a final adhesive coating. It was hoped that this would increase the confidence of the public for a genre considered fragile and fugitive. Few were successful. The recipe of *mécanicien du roi* Antoine-Joseph Loriot was perhaps the most famous. In 1753 the Académie Royale certified that his invention fixed pastel without altering the matte, preserved the "flower" and the freshness of the colors without the least alteration, and consequently extended the life span of works in pastel.[42] Loriot's portrait by Jean Valade, shown at the Salon of 1763, featured a pastel surface said to have been half fixed by Loriot's new formulation. Some deemed Loriot's claims fraudulent, especially since he was permitted by the academy to keep his constituents secret until 1780, so that only he could apply his fixative.[43] Such fixative methods were more experimental than satisfactory; all caused gloss, the

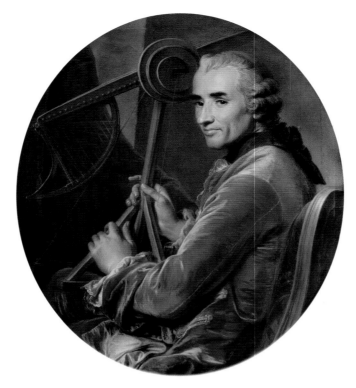

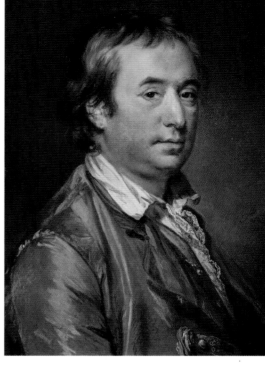

Jean Valade
Monsieur Loriot, Mechanical Engineer
Salon of 1763
Pastel on paper, 31½ × 27½ in. (80 × 70 cm)
Musée Antoine Lécuyer, Saint-Quentin, France

Francis Cotes
Portrait of Sir William Chambers, Architect, 1722–1796, 1764
Pastel on paper, 25 × 19 in. (63.5 × 48.2 cm)
National Galleries of Scotland, Edinburgh

loss of the prized "velvety" surface, and a darkening of the colors; a pastel by Francis Cotes of Sir William Chambers, "particularly warm, brilliant and agreeable [in] effect," was loaned early on to "an ingenious foreigner" for fixation with a "secret" liquid that left the image "cold and purple."[44] Nevertheless the late eighteenth-century French press constantly featured the fixative discoveries of rivals and competitors, who guaranteed increasingly satisfactory results.[45]

Le Pileur d'Apligny in 1779 and Paillot de Montabert in 1829 still recommended a method described in the seventeenth century for fixing chalk drawings; this consisted of plunging the completed pastel painting briefly into a bath of dilute adhesive liquid that, "once dry, imprisons the colours and stops them from detaching."[46] However, traditional methods were in fact unsuitable for works that employed a wide range of pigments of varying properties, which absorbed liquid fixatives unevenly and altered relationships among hues.[47] Framing behind glass remained the most effective way to preserve the vulnerable image surface.

Fixatives were also felt to protect the pigments and support of works on paper from the deleterious effects of exposure to air and moisture by encasing them within an impermeable film. "If left exposed to the air, paper yellows with time. Even in a box, they become dusty, and even under glass, the smoke of coal reaches and clogs them. The fixative cures all that."[48]

By the late nineteenth century, fixative solutions were introduced as part of the pastel working process. Philip Gilbert Hamerton, in 1883, described a process he called "colour upon monochrome"; the artist first made a charcoal drawing, fixed it, and then worked over it in pastel. Joseph Pennell may have used this technique in his *St. Mark's Sunset*.[49] Degas in particular introduced the fixative as a barrier between successive layers of pastel, which allowed colors to be superimposed without muddying their tone.[50]

WRITTEN EVIDENCE FOR THE USE OF PASTEL

Written evidence for the use of pastel sticks by artists and instructions for their fabrication is rare before the eighteenth century; materials and technical procedures were craft secrets, not divulged to outsiders, for whom they were perceived to be of little interest or use. The earliest known description of pastel ingredients is by Petrus Gregorius in 1583.[51] However, he wrote not to instruct artists but to compile information in an encyclopedic form relevant to sixteenth-century epistemological concerns.[52] Pastel was sometimes mentioned in early modern texts that described the visual arts as essential ingredients in the formation of a courtier—that is, a patrician who was not an artist. Artisanal practice was transmitted orally, on the job, by progressive immersion and assimilation.

An early eighteenth-century treatise, *Traité de la peinture en mignature* (1708), often attributed to Claude Boutet, was directed not to "experienced painters" but to amateurs and learners without a master, "nuns . . . [and] persons of quality . . . especially in the country," that is, to a genteel social class.[53] Art is a social practice based on precepts and rules; "one can hardly

give oneself a more honest occupation or more entertaining than this."[54] While instructions for choosing suitable pigments are detailed, those for selecting binders and fillers are highly abbreviated, and the complexity of fabricating pastels, including the intuitive and experiential knowledge that is essential to practice, is ignored; undoubtedly this discouraged home fabrication.

Paul Romain Chaperon (1732–1793), presumed author of the *Traité de la peinture au pastel* (1788), wrote to supplement the publications of the Académie des Sciences and Diderot's *Encyclopédie*, which, he claimed, neglected pastel painting.[55] He wrote for "true artists" who purchased prepared colors "at grocer-drug stores"—a bad idea, he suggested, because they skimped on quality; he described "the preparation of pastel sticks, although very simple when one knows how, doubtless deters those who do not know how."[56] His complicated instructions, while extremely detailed, are impracticable: "To . . . make [Prussian blue] it is calcined in a crucible, with tartar salt, dried beef blood, then this coal is boiled which gives a greenish precipitate by the addition of some Mars vitriol and alum."[57] Chaperon's work reflects the aims of the encyclopedists in its recording of all relevant knowledge, its respect for manual arts and crafts as subjects for serious study, and its constructive interest in the interrelation of different branches of knowledge.[58]

Increasingly pastel sticks were made by specialized artists' colormen. Nineteenth-century publications on pastel, often produced by colormen to advertise their products, described for the amateur market how pastels should be used in practice. Jozan's *Du Pastel* was published in French in 1847, and in 1854 in English translation by W. Schaus of New York City. Both versions instructed beginners on the principles of this art and briefly described the origins of and techniques, supports, and accessories for pastel painting.[59] In the original French text of 1847, Jozan also described the fabrication of pastel. Fabrication "required a lot of trial and error and usually . . . would make [the artist] waste precious time," but instructions would be helpful for making colors not readily available.[60] These recipes were copied, with omissions and additions, from an 1829 French translation of the detailed color treatise of a German technical writer, Johann Carl Leuchs. Neither author lists proportions: "Pernambuco lacquer, madder, carmine, mixed with clay, sometimes with starch. Made solid with yeast of beer or malt decoction, or milk, or gum water."[61] Schaus's translation omitted such fabrication instructions entirely, claiming that he supplied "all the materials used in pastel painting" and that "boxes . . . may be obtained almost anywhere."[62]

Joseph Meder outlined the historical use of colored friable drawing sticks for drawing but not painting in *Die Handzeichnung* (1919).[63] James Watrous devoted a chapter to technical descriptions of chalks, pastels, and crayons in *The Craft of Old Master Drawings* (1957).[64] The American conservator Marjorie Shelley, in particular, has written extensively on the use of pastel by selected artists.[65]

In *The Invention of Pastel Painting* (2007), Thea Burns explored the historical contexts in which artists chose to work with pastels, particularly the sudden emergence in the later seventeenth century of a new artistic practice, pastel painting.[66] She argued, based on a close consideration of the visual, documentary, and etymological evidence, that this change was aesthetic, not formal, grounded in social function and technical response: "Artistic techniques have a social history; they are signs endowed with cultural meaning by society."[67]

Joseph Pennell
St. Mark's at Sunset, 1901
Pressed Russian chalk and pastel on paper, 9⅝ × 11⅝ in. (24.4 × 29.4 cm)
Library of Congress, Washington, DC

Notes

CHAPTER 1. A FASHION FOR INDEPENDENT CHALK DRAWING IN ITALY AND FRANCE

1 "Leonardo da Vinci," in Jeffares 2006. Unless otherwise noted, all references to Jeffares are to the online edition, http://www.pastellists.com.
2 Viatte 1999.
3 Bambach 2003, pp. 18, 655–66.
4 Leuchs 1829, p. 367; Watrous 1957, pp. 91–112; Richter 2007, pp. 37–53.
5 Ridolfi 1648, 1:373.
6 Bickendorf 1998, p. 90.
7 "Barocci," in Jeffares 2006.
8 Bohn 2012, pp. 33, 40; Marciari and Verstegen 2008, pp. 291–320.
9 Bohn 2012, pp. 38–40.
10 Turner 2000, p. 177; Bohn 2012, pp. 39–40, 66.
11 Loisel 2008, p. 207.
12 Mann and Bohn 2012, pp. 185–86.
13 Bohn 2012, p. 40.
14 *Annunciation*, 1582–84, Rome, Vatican Museums, no. 40376; Mann and Bohn 2012, p. 190.
15 Dempsey 2010, p. 254.
16 Marciari and Verstegen 2008.
17 Bireley 2009, p. 229.
18 Loisel 2008; Monbeig Goguel 2009, p. 32–40.
19 Zerner 1996, pp. 180–82.
20 Lecoeur 2006, p. 12; Zerner 1996, p. 183.
21 Adhémar 1973, p. 123.
22 Meyer, "Dumonstier," in Turner 1996, 9:386; Zerner 1996, p. 181.
23 Heinich 1993, pp. 43–44. Unless otherwise noted, all translations are by the author.
24 Zerner 2006, p. 9.
25 Ibid., p. 5; Lecoeur 2006, p. 51.
26 Lecoeur 2006, pp. 59–61.
27 Williams 2007, pp. 97–98.
28 Spike 1984, pp. 12–13.
29 Baglione 1733, pp. 208–9.
30 Robbin 1996, 453.
31 Sani 1989–90, 187–88; Turner, 1999, p. 114; Tordella 2011, p. 89.
32 Sani 1989–90, p. 191; Tordella, 2003, 345.
33 Turner 1999, p. 115.
34 Tordella 1999, p. 90.
35 Tordella 2003, pp. 356–58.
36 Turner 1999, p. 115; Sani 1989–90, p. 188.
37 Lecoeur 2006, p. 187.
38 Brejon de Lavergnée 1987, pp. 75–76.
39 Lecoeur 2006, p. 187.

CHAPTER 2. THE EARLY MARKET FOR PAINTING IN PASTEL AND ITS PLACE IN THE ACADÉMIE ROYALE

1 Shelley 1989, p. 37.
2 "Vaillant," in Jeffares 2006.
3 Burns 2007, pp. 17–25, 38–40.
4 Adamczak 2011, cat. nos. 5–8; Burns 2007, pp. 53–54.
5 Burns 2001, pp. 43, 45–6, fig.2.
6 Burns 2007, pp. 23–25, 44–53.
7 "Nanteuil," in Jeffares 2006, illustration.
8 Coquery 1997, pp. 138, 160.
9 Baldinucci 1681
10 Piles 1684, 2:96.
11 La Hire 1730, 9:662; Félibien 1725, 3:290–291.
12 Lacombe 1753, p. 497.
13 "Luti," in Jeffares 2006.
14 Bowron 1996, 19:816.
15 Bowron 1980, 440.
16 Ibid., p. 443.
17 Ibid., p. 447.
18 Burns 2007, pp. 63–64.
19 Ibid., pp. 67–70.
20 Schnapper 2002, p. 95.
21 Burns 2007, p. 73; Lacombe 1753, p. 729; "Pastels, Soap and Villainy," in Jeffares 2006.
22 "Chevalier, Louis-Joseph, prince de Grimberghen," in Jeffares 2006.

23 Olivier 1976, pp. 55–82.
24 Montaiglon 1875–92, 1:275–76.
25 Schnapper 1983, 99.
26 Pevsner 1940, pp. 86–87.
27 Duro 1997, p. 85.
28 Heinich 1993, p. 77.
29 McTighe 1998, 6.
30 Schnapper 1983, p. 113.

CHAPTER 3. ROSALBA CARRIERA AND "THE GAME OF APPEARANCES"

1 Mehler 2009, pp. 171–73; Mehler 2006, pp. 9–17.
2 Sani 1985.
3 Sani 2009, pp. 97–101.
4 Mehler 2006, pp. 172–73; Labalme 1980, pp. 137, 139–40.
5 Bocazzi 209, pp. 130–34.
6 Goguel 2009, pp. 32–40; Loisel 2008, pp. 205–13.
7 Burns 2007, p. 82.
8 Posner 1993, 595–98; Sani 1985, 1:179, 416.
9 Burns 2007, pp. 77–99.
10 Piles 1989, pp. 8, 10.
11 Hobson 1982, p. 51.
12 Lichtenstein 1993, pp. 169–70.
13 Heinich 1993, p. 83.
14 Tormen 2009, p. 238.
15 Sani 2009, pp. 97, 109.
16 "Charles-Antoine Coypel," in Jeffares 2006.
17 "Gustav Lundberg," in Jeffares 2006; Laine and Brown 2006, pp. 236–37.
18 Laine and Brown 2006, p. 238.
19 Beaurain 2003, 109.
20 Rostand 1915–17, p. 108–10.
21 Beaurain 2003, pp. 112–13, 115–16.
22 Ibid., p. 114.
23 Ibid., p. 115.
24 Ibid., p. 118.
25 "I. Mengs" and "A. R. Mengs," in Jeffares 2006.
26 Baetjer and Shelley 2011, 15.
27 Ibid., p. 15.

CHAPTER 4. MAURICE QUENTIN DE LA TOUR AND THE TRIUMPH OF PASTEL PAINTING

1 Debrie 1991, pp. 26–35.
2 Marandet 2002, 504.
3 Hugues 2003, p. 167.
4 Shelley 2005, 105–10.
5 Hoisington 2006, pp. 58–61.
6 Laing 2005, pp. 56–57; Debrie and Salmon 2000, p. 39.
7 Hoisington 2006, p. 63; Debrie and Salmon 2000, pp. 175–76; Godet 1905, 209–10.
8 Montaiglon 1883, p. 205; Hoisington 2006, pp. 66–70.
9 Hoisington 2006, pp. 70–72.
10 Stein 1997, 497.
11 Hoisington 2006, pp. 178–82.
12 Debrie and Salmon 2000, p. 59.
13 Ibid., pp. 36–37.
14 Hoisington 2006, pp. 98, 100, 113, 268.
15 Neufville de Brunhaubois-Montador 1738, pp. 7–8.
16 Nicholson 1997, p. 52.
17 Yocco 2013.
18 Hoisington 2006, p. 115.
19 Ibid., pp. 121, 124–25.
20 Salmon 2007, p. 125.
21 Laing 2005, p. 57.
22 Hoisington 2006, p. 132.
23 Ibid., p. 179.
24 Ibid., pp. 145–70.
25 Ibid., pp. 147–48; Debrie and Salmon 2000, p. 35.
26 *Mercure de France* 1745, p. 135.
27 Hoisington 2006, pp. 148–49.
28 Le Blanc 1747, pp. 18, 90.
29 Hoisington 2006, p. 202.
30 Ibid., pp. 216–17.
31 Ibid., pp. 218–53.
32 Ibid., pp. 255–56; Debrie 1991, p. 30.

CHAPTER 5. THE GOLDEN AGE OF PASTEL PAINTING: FRANCE AT MIDCENTURY

1 Cochin 1875–76, 429; Folds McCullagh and Rosenberg 1985, pp. 47–8.
2 Denk 2001, pp. 279, 284; Rosenberg 1983, p. 15.
3 Sheriff 1988, 19, 40; Ogée 2000, 432–33; Cochin 1875–1876, pp. 419–20.
4 Denk 2001, p. 290.
5 Grimm 1968, 1:464.
6 Denk 2001, pp. 288, 291–92; Podro 1998, pp. 152–53.
7 Podro 1998, pp. 149–51.
8 Rosenberg 1979, pp. 364–65; McCullagh and Rosenberg 1985, p. 50.
9 Cochin 1875–1876, p. 431; Denk 2001, p. 279.
10 Denk 2001, pp. 280–83.
11 Ibid., pp. 280, 284.
12 Rosenberg, *Chardin*, pp. 83–84.
13 Cochin, "Essai sur la vie de M. Chardin," pp. 421–22.
14 Rosenberg 1983, pp. 84, 90.
15 Denk 2001, pp. 284–88; Podro 1998, p. 150.
16 Ogée 2000, pp. 443–44.
17 Trope 1993, p. 141; Jeffares 2003, 141.
18 "Valade," in Jeffares 2006.
19 Trope 1993, pp. 31, 36, 141–43.
20 Ibid., p. 37.
21 Clements 1995, 213.
22 Trope 1993, p. 35.
23 Ibid., p. 42.
24 Ibid., p. 25.
25 Trope 1993, p. 26.
26 Ibid., p. 38.
27 Vaillat and Ratouis de Limay 1923, pp. 5, 35–36. The definitive study of Perronneau, Dominique d'Arnoult's *Jean-Baptiste Perronneau, ca. 1715–1783: Un Portraitiste dans l'Europe des lumières* (Paris: Arthena, 2015), came out after the French edition of this volume had gone to press.
28 d'Arnoult 2008, 102.
29 Ibid., p. 105.
30 Vaillat and Ratouis de Limay 1923, p. 27.
31 The identification of Madame Grilleau in the accompanying figure is uncertain. Jeffares, written communication, January 14, 2015.
32 Caylus 1751, p. 166.
33 Coypel 1751, p. 24.
34 Vaillat and Ratouis de Limay 1923, p. 74.
35 Given to Perronneau by the National Gallery, Washington, DC, this portrait may possibly be attributed to Léon-Pascal Glain or Pierre Bernard. Jeffares, written communication.
36 Ratouis de Limay 1920, 71.
37 Olausson 2008a, pp. 19–20.
38 Facos 1998, pp. 7–9.
39 Olausson 2008a, p. 19.
40 Olausson 2008b, p. 26.
41 Salmon 2008a, p. 71.
42 Olausson 2008a, p. 19.
43 Salmon 2008a, p. 72.
44 Salmon 2008b, p. 87.
45 Olausson 2008b, p. 30.
46 Ibid., p. 29.
47 Salmon 2008a, p. 72.
48 See the technical appendix in this volume.

CHAPTER 6. THE TURKISH PAINTER: JEAN-ETIENNE LIOTARD OF GENEVA (1702–1789)

1 Roethlisberger and Loche 2008, pp. 323–24.
2 Smentek 2010, 97, 101, 109; Roethlisberger and Loche 2008, 324.
3 Roethlisberger and Loche 2008, pp. 19, 28, 104.
4 Roethlisberger 1990, 97.
5 Roethlisberger and Loche 2008, pp. 18, 103–4.
6 Ibid., p. 235–36.
7 Marandet 2003, 299–300.
8 Ibid., p. 298.

9 Roethlisberger and Loche 2008, pp. 19–20.
10 Bull 2002, p. 3.
11 Roethlisberger and Loche 2008, pp. 20–21, 250; Bull 2002, p. 10.
12 Herdt 1992, pp. 10–12, 16.
13 Roethlisberger and Loche 2008, pp. 251–53.
14 Ibid., p. 261.
15 Ibid.; Apostolou 2003, paragraphs 40–41.
16 Roethlisberger and Loche 2008, p. 355; Bull 2002, pp. 6, 13.
17 Jeffares 2015.
18 Apostolou 2003, paragraphs 23–24.
19 Roethlisberger and Loche 2008, pp. 275–76.
20 Apostolou 2003, paragraph 38.
21 Roethlisberger and Loche 2008, p. 321; Sheriff 1996, p. 100; Smentek 2010, p. 98.
22 Roethlisberger and Loche 2008, pp. 22–23.
23 Ibid., p. 25.
24 Ibid., pp. 16–17.
25 Smentek 2010, pp. 86–7.
26 Ibid.
27 Ibid., pp. 86–88.
28 Bleeker 2006, p. 16; Herdt 2003, p. 79.
29 Smentek 2010, pp. 98–100.
30 Roethlisberger 1985, 111–12.
31 Roethlisberger and Loche 2008, pp. 175–76, 667, 827–28; Roethlisberger 1985, p. 109.
32 Roethlisberger and Loche 2008, pp. 765–66.
33 Ibid., p. 669.
34 Roethlisberger 1985, pp. 111, 117.
35 Liotard 1762, pp. 172–90.
36 Ibid., pp. 181–82.
37 Ibid., pp. 187–89.
38 Ibid., p. 184.

CHAPTER 7. WOMEN PASTEL PAINTERS OF LATE EIGHTEENTH-CENTURY FRANCE

1 Bonnet 2002, 144.
2 Hyde 2002, p. 79.
3 Bellhouse 1991, 127–28; Hyde 2002, p. 77.
4 Heinich 1993, p. 83.
5 Hyde 2002, pp. 78, 81–86.
6 Diderot 1957–67, no. 150.
7 Radisch 1992, 442–43.
8 Bonnet 2002, p. 146.
9 Ibid., p. 148.
10 Ibid.
11 Ibid., pp. 140–44.
12 Ibid., p. 142.
13 Auricchio 2009, pp. 13–14, 19, 24; Lebreton 1802, p. 2.
14 "Labille-Guiard," in Jeffares 2006.
15 Auricchio 2009, pp. 18–19; *Portrait of Madame Labille-Guiard* (1782), pastel, location unknown. Reproduced in color in Passez 1973, opp. p. 16.
16 Bonnet 2002, p. 150.
17 Pernety 1972, p. 397.
18 Bonnet 2002, p. 150.
19 Auricchio 2009, p. 17.
20 Ibid., pp. 26–28.
21 Ibid., p. 32.
22 Sheriff 1996, pp. 75, 78–82.
23 Lebreton 1802, p. 4.
24 Jeffares 2006; Passez 1973, p. 16.
25 Bonnet 2002, pp. 141, 154.
26 Bonnet 2002, pp. 145, 155–56; Auricchio 2009, pp. 40–50.
27 Sprinson de Jesús 2008, 157.
28 Ibid., p. 160.
29 Auricchio 2009, pp. 58, 65ff.
30 Baetjer and Shelley 2011, p. 41.
31 Rosenberg 1981, 740.
32 Sheriff 1996, pp. 83–85.
33 Ibid., p. 106.
34 Ibid., pp. 74–78; Lajer-Burcharth 1997, p. 727.
35 Vigée Le Brun 2008, p. 231.
36 Tufts 1982, p. 336.
37 Barker 2006, 145.
38 Radisch 1992, p. 446.

39 Barker 1997, 338.
40 Radisch 1992, p. 465.
41 Barker 1997, p. 338.
42 Sheriff 1996, p. 46.
43 Radisch 1992.
44 Percival 2001, 203–4.
45 Allard and Scherf 2006, p. 228.
46 Sandoz 1979, 43,45.
47 Aubert 1979, 399–401.
48 Vigée Le Brun 2008, pp. 724, 726.
49 Bonnet 2002, p. 160.
50 Vigée Le Brun 2008, p. 122.
51 Lajer-Burcharth 1997, p. 726.

CHAPTER 8. BRITISH PASTEL ARTISTS IN THE SEVENTEENTH AND EIGHTEENTH CENTURIES

1 Krill 1987, p. 117.
2 Burns 2007, pp. 17–20.
3 Katlan 1987–92, 1:5.
4 For life dates, see "Ashfield" and "Luttrell" in Jeffares 2006.
5 West 1991, p. 132.
6 Ibid., pp. 145, 147.
7 Pears 1988, pp. 107–13.
8 "Knapton," in Jeffares 2006.
9 Lippincott 1983, p. 19.
10 Ibid., pp. 33–74.
11 Newby 1996, 18:142.
12 Lippincott 1983, pp. 18–19.
13 Ibid., p. 22.
14 London, British Museum, add. MS 23724 and 23725.
15 Pears 1988, pp. 109, 112–13.
16 Lippincott 1983, pp. 18–19, 29–31.
17 Ibid., pp. 76–79.
18 Hedley 2003, p. 113; Lippincott 1983, p. 88.
19 Whistler 2009, p. 197; Johnson 1976, p. 6.
20 Whistler 2009, p. 198.
21 Lippincott 1983, pp. 56–57, 62, 88, 90, 177.
22 Ingamells 2004, 31:866.
23 Lippincott 1983, pp. 64, 82.
24 West 1991, pp. 143, 146.
25 Lippincott 1983, pp. 83–86, 90–93.
26 Ingamells 2004, 31:866.
27 Pears 1988, p. 108.
28 Lippincott 1983, pp. 32–33.
29 Ibid., pp. 96–97.
30 Smart 1971, pp. 8–9.
31 Johnson 1976, pp. 2, 9.
32 Smart 1971, pp. 9–10.
33 Pears 1988, pp. 110–11.
34 "Francis Cotes," in Jeffares 2006.
35 Smart 1971, pp. 8, 11.
36 Ibid., p. 9.
37 Russell 1772, p. ii.
38 Smart 1971, pp. 12, 18.
39 Russell 1772, p. 20.
40 Johnson 1976, pp. 7–8, 26.
41 Festa 2005, 30.
42 Porter 1985, 389–91.
43 Chesterfield 1932, p. 140.
44 Porter 1985, pp. 391–92.
45 Rouquet 1970, p. 47.
46 Manning 1987, p. 215.
47 Festa 2005, pp. 27–28, 30.
48 Johnson 1976, p. 9.
49 Ibid., pp. 17–18.
50 Baetjer 1999, 35; Johnson 1976, pp. 12, 19.
51 Smart 1971, p. 10.
52 Ibid., p. 11.
53 Walpole 1782, 4:195.
54 Johnson 1976, p. 14
55 Ibid., p. 22.
56 Sunderland 1977, 869.
57 Johnson 1976, p. 1; Smart 1971, pp. 7–8.
58 Ibid., p. 161.

CHAPTER 9. JOHN RUSSELL, "PRINCE OF PASTELISTS"

1 Russell 1772, pp. 19–20.
2 Forsaith 2010, 98.
3 Baetjer and Shelley 2011, p. 52.
4 John Russell 1766–1802, 5:174 .
5 Baetjer and Shelley 2011, p. 52.
6 Matthews 2006, 252.
7 Williamson 1894, p. 13.
8 Russell 1766–1802, 1:135.
9 "John Russell," in Jeffares 2006.
10 Matthews 2006, p. 253.
11 "John Russell" in Jeffares 2006.
12 Steinhoefel 2007, p. 117.

13 Matthews 2006, pp. 256–57.
14 Steinhoefel 2007, p. 121.
15 Baetjer and Shelley 2011, p. 52.
16 Russell 1772, pp. ii, iv.
17 Matthews 2006, p. 256.
18 Russell 1772, p. 18.
19 John Russell 1884.
20 Williamson 1894, Webb annotation to p. 94.
21 Ibid., Webb annotation to p. 86.
22 Russell 1772, p. 9.
23 John Russell, *Queen Caroline When Princess of Wales*, Royal Collection Trust, Windsor, RCIN 453658.

CHAPTER 10. PASTEL IN THE BRITISH PERIPHERY: IRELAND, SCOTLAND, AND AMERICA

1 Cullen 1980, pp. 23, 48–50.
2 Since the sitter is shown as a widow, the pastel should be dated 1775. She was by then titled Lady Holland. Neil Jeffares, written communication.
3 Cullen 1980, pp. 24–25.
4 Crookshank and Glin 1997, p. 66.
5 Cullen 1980, p. 27.
6 O'Connor 2008, p. 45.
7 Cullen 1983, 418.
8 Crookshank and Glin 1997, p. 68.
9 Cullen 1980, p. 28.
10 Cullen 1982, p. 86.
11 Cullen 1980, p. 60.
12 Amblard 2010, 2.
13 Lloyd 1999, pp. 21–23.
14 Simon 1999, 310.
15 "Progress and Present State" 1820, cdlxxix–cdlxxx.
16 Lloyd 1999, p. 23.
17 Ibid., p. 30.
18 Cumming 2004, p. 431; Smiles 1861, p. 278.
19 Burns and Roy 2014, 279–88.
20 Fraser-Harris 1936, 13.
21 Shelley 2002, pp. 31, 61; Severens 1995, p. 708.
22 Severens 1995, p. 705.
23 Middleton 1966, pp. 1–22.
24 Chamberlayne 1711.
25 Severens 1995, p. 708.
26 Staiti 1995, p. 25.
27 Avery 2002, p. 86.
28 Ibid.
29 Staiti 1995, pp. 25–37.
30 Shelley 1995, pp. 127–41, 133.
31 Staiti 1995, pp. 43, 47.
32 Ibid., p. 43.
33 Shelley 1995, p. 138.
34 Waggoner 2001, pp. 1–6.
35 Dunlap 1834, pp. 70–71; Metz 1995, 3–4.
36 Waggoner 2001, p. 15.
37 Palmer 1871, p. 620.
38 Dunlap 1834, pp. 70–71.

CHAPTER 11. A LENGTHY EXILE

1 Annonymous 1841, 347.
2 Portalis 1900, pp. 10–24.
3 La Font de Saint-Yenne 1747, p. 28.
4 Des Fontaines 1745, p. 292.
5 Eugène Delacroix, *Journal*, entry for October 6, 1847, in Kayser 1995, p. 56.
6 Saunier 1910, p. 459.

CHAPTER 12: THE PAST REDISCOVERED

1 Launay 1837, p. 1.
2 Girardot 1850, 156–60.
3 Dumesnil 1888, pp. 34–36.
4 Galley 1898, p. 158.
5 Aimé Royet, cited in ibid., p. 171.
6 Gratia 1891, p. 33.
7 "Salon de 1843" 1843.
8 Cortambert 1861.
9 Cited in Simches 1964, p. 16.
10 Dumesnil 1888, p. 35.
11 Dumas fils 1850, p. 8.
12 Rivières 1902, 344–45.
13 Ballu 1887–1888, pp. 281–88.
14 Champfleury 1855, pp. 111–12.
15 Mauclair 1905, p. 46.
16 Rodenbach 1899, p. 248.
17 Alexis 1880, pp. 289–95.

CHAPTER 13. THE QUEST FOR LEGITIMACY

1 Janin 1839, pp. 337–45.
2 "Salon de 1841" 1841, p. 349.
3 "République des arts" 1844, p. 283.
4 . La Faloise 1844, pp. 198–213.
5 La Fizelière 1844, p. 421.
6 Chatouville 1845–1846, p. 223.
7 Lagenevais 1849, pp. 559–93.
8 "Musée royal" 1828, pp. 289–94.
9 Lagrange 1860, pp. 30–43.
10 Zillhardt 1932, p. 151.

CHAPTER 14. OUTSIDE THE WALLS: PASTEL LANDSCAPES

1 Vigée Le Brun 1835, 3:255.
2 Flers 1847, pp. 101–4.
3 Flers to Gautier (April 1846?) in Lacoste-Veysseyre 1991, 3:44.
4 Flers 1846, pp. 113–16.
5 Ibid.
6 "République des arts" 1844.
7 Huet to Sollier 1844, in Huet 1911, p. 154.
8 Cahen 1900, p. 6.
9 Baudelaire 1996, p. 342.
10 Diderot 1821, 8:259.

CHAPTER 15. THE REVELATION OF JEAN-FRANÇOIS MILLET

1 About 1864, p. 267.
2 Sensier 1881.
3 Millet to Sensier 1859, in Sensier 1881, p. 196.
4 Chesneau 1875, pp. 437–38.

CHAPTER 16. THE IMPRESSIONIST PASTEL

1 Desjardins 1889, p. 318–319.
2 Giuseppe De Nittis in *Giornale artistico*, July 1, 1874, in Dini and Marini 1990, p. 309.
3 Goncourt 1956, 2:1227.
4 Chassagnol 1881, pp. 1–2.
5 Alexandre 1909, p. 154.

CHAPTER 17. MANET AND THE PARISIAN WOMEN OF HIS TIME

1 Duret 1906, p. 210.
2 Burty cited by Guégan in *Manet inventeur du Moderne* 2011, p. 213.
3 Sédillot cited by Burnham in ibid., p. 87.
4 Duret 1906, p. 215.
5 Duret to Pissarro in Distel 1989, 58–65.
6 Sarradin 1909, pp. 224–25.
7 Ibid., p. 225.
8 Alexis, "Manet."
9 Manet, cited in Proust 1897, pp. 201–7.

CHAPTER 18. DEGAS AND CASSATT: ADVOCATES OF TRUTH

1 Degas 1945, p. 39.
2 Coquiot 1924, p. 175.
3 Duranty 1876, p. 28.
4 Vollard 1924, p. 69.
5 Ibid.
6 Halévy 1995, p. 41.
7 Fénéon 1931, 1:31.
8 Edgar Degas cited in Jamot's preface to *Degas* 1937, p. xii.
9 Segard 1913, p. 40.
10 Cited in *American Pastels […]* 1989, p. 4.
11 Segard 1913, pp. 21–22.
12 Ibid., p. 38.
13 Halévy 1995, p. 105.
14 Segard 1913, p. 73.
15 Robert Cassatt to Alexander Cassatt in Mathews 1984, p. 145.

CHAPTER 19. THE NUANCES OF WHISTLER

1 Lagenevais 1849.
2 Whistler to Huish in MacDonald 2001, p. 8.
3 Whistler to Helen Whistler in ibid., p. 146.
4 Whistler to Elden in ibid., pp. 148–49.
5 Simpson in Merrill 2004, p. 42.

CHAPTER 20. THE LAST WORD IN ELEGANCE

1 Clarétie 1881, p. 2.
2 Blémont 1881, p. 5.
3 Ibid.

4 Claretie 1881.
5 Blémont 1881, p. 6.
6 Halévy in Halévy 1995.
7 Lefort 1883, pp. 457–71.
8 Dutry 1892, p. 20.
9 Heredia 1890, p. 7.
10 Portalis 1885, pp. 437–49.
11 Janillon 1884, p. 366.
12 Mauclair 1905b, pp. 145–54.
13 Blanche 1928, p. 136.
14 Bruxelles 1888, p. 3.

CHAPTER 21. INTERNATIONAL RENEWAL

1 Leprieur 1888, pp. 1–29.
2 Uzanne 1901.
3 *La Vie artistique*, 1888, p. 51.
4 Ballu 1888, pp. 121–22.
5 Yriarte 1892, p. 1.
6 Fénéon 1885, pp. 26–27.
7 Yriarte 1892.
8 J. H. 1896.
9 Yriarte 1892.
10 Mauclair 1914, p. 133.
11 Flament 1899, p. 2.
12 Mauclair 1914, p. 134.
13 Flament 1899.
14 "Pastel at the Grosvenor Gallery" 1888, p. 15.
15 Ibid.

CHAPTER 22. THE EXALTATION OF COLOR

1 Denis 1912; reprint, Paris, 1920, p. 166–67.
2 Bernard in Destremau 2009, p. 261.
3 Hoschedé 1890, p. 308.
4 Vuillard 2003, p. 53.
5 Gauguin to Schuffenecker in Merlhès 1984, 1:210.
6 Tiphereth cited in Grossvogel and Puget 1996, p. 10.
7 Mauclair 1922, p. 166.
8 Geffroy 1890, pp. 55–58.
9 Frantz 1904, pp. 317–21.
10 Beauniere 1902, p. 133.
11 Aman-Jeanin 2003, pp. 24–25.
12 Beaunier 1902, p. 136.
13 Halévy 1995, p. 116.
14 Degas cited in Vollard 1924, pp. 109–10.
15 Fénéon in Bouillon 1990, p. 289.
16 Valéry 1949, p. 60.
17 Vollard 1924, p. 69.

CHAPTER 23. THE SYMBOLIST PASTEL

1 Maupassant 1881, p. 1.
2 Bouchot 1893, pp. 25–45.
3 Soulier cited in Jumeau-Lafond 1999, p. 100.
4 Segard 1914, p. 7.
5 Harrison 1915, pp. 154–57.
6 Harrison 1913, p. 1015–20.
7 Soulier 1898.
8 Segard 1899, [pp. 13–23].
9 Guitard 1904, p. 7.
10 Flament 1899, p. 2.

CHAPTER 24. ODILON REDON AND THE REINVENTION OF PASTEL

1 Redon 1922, p. 127.
2 Redon to Fabre, reprinted in Bacou 1956, 1:145.
3 Gauguin reprinted in Gamboni 1989, p. 171.
4 Redon to Bonger in Gamboni 1989, p. 174.
5 Redon to Bonger, in Bacou 1956, 1:147.
6 Redon 1922, p. 28.
7 Ibid., p. 115.
8 Lévy 1987, p. 49.
9 Fragment of a letter by Redon to Picard in Mellerio 1913, p. 82.
10 Roger-Marx 1924.
11 Redon cited in Gamboni 2008, p. 102.
12 Roger-Marx 1924.

TECHNICAL APPENDIX. PASTEL: MATERIALS AND TECHNIQUES

1 Burns 2007, pp. 6–8.
2 Watrous 1957, pp. 114, 116; Shelley 1989, p. 36.
3 Russell 1772, pp. 37–38.
4 Watrous 1957, pp. 112–13; Shelley 1989, pp. 36–37.
5 Paillot de Montabert 1829–51, 9:511.

6 Chaperon 1788, p. 41.
7 Shelley 1989, p. 36; Schwartz et al. 1984, p. 138.
8 McClellan 1994, pp. 70–72; Rice 1999, pp. 5–6.
9 Shelley 2002, p. 61.
10 *Avant-Coureur* 1762, p. 491.
11 Reifstein 1757, pp. 100–106.
12 Diderot 1995, 55.
13 Ibid., p. 77.
14 Montaiglon 1875–1892, 7:253–54, 9:176.
15 Ratouis de Limay 1946, pp. 141–42.
16 Beltinger et al. 2002, p. 392; Willoughby 1987, pp. 211–2.
17 Raffaëlli 1902: 297.
18 Willoughby in Althöfer 1987, p. 211; "Revolution in Oil Painting" 1903, p. 2.
19 Raffaëlli 1902, p. 298.
20 Ball 2001, pp. 147–67.
21 Vibert 1891, pp. 97–98.

22 Ball 2001, p. 266; Harley 1979, 80.
23 Feller 1965, p. 32; Ball 2001, p. 303.
24 Vibert 1891, pp. 238–39.
25 Harley 1979, p. 77.
26 Bromelle 1964, 140–52.
27 Green et al. 1891, pp. 152–53; Vibert 1891, pp. 292–99.
28 Ostwald 2010, pp. 20, 23, 35.
29 La Lande 1762, pp. 32, 34.
30 Burns 2007, p. 37.
31 Krill 1987, pp. 79–89.
32 Chaperon 1788, pp. 337–38.
33 Labreuche 2011, pp. 99–100.
34 Ibid., pp. 256–61.
35 Ibid., p. 280.
36 Labreuche 2011, pp. 280, 296–97.
37 Segel and Scharff 2008, pp. 141, 146; Marecka 2010.
38 Shelley 2002, p. 63.
39 Jozan 1854, pp. 23–4.

40 Shelley 1989, p. 42.
41 Vibert 1891, pp. 231–32, 321; Goupil 1858, p. 14.
42 *Mercure de France*, no. 12 (1753): 162–64, and no. 1 (1754): 156–58.
43 Burns 2007, pp. 149–50.
44 Russell 1772, p. 18; "Loriot, Pellechet, Jurine: The Secrets of Pastel," in Jeffares 2006.
45 Chatelus 1991, p. 69.
46 Le Pileur d'Apligny 1973, pp. 56–58; Paillot de Montabert 1829–1851, 9:515.
47 Burns 2007, p. 149.
48 Vibert 1891, p. 153.
49 Blood and Stiber Morenus 2007, pp. 27–28.
50 Shelley 1989, p. 43.
51 Gregorius 1600, 1:296.
52 Burns 2007, pp. 5–6.
53 Boutet 1708, pp. 4, 151; Kuehni, "Who Wrote the *Traité de la Peinture en Pastel?*:

A Speculative Essay," www.iscc.org/pdf / TraitePastel.pdf. Neil Jeffares describes the 1708 pastel appendix as anonymous and suggests possible authors; "Suppliers: Boutet," in Jeffares 2006.
54 Boutet 1708, p. 4.
55 Chaperon 1788, p. 3.
56 Ibid., pp. 15, 23–24, 29.
57 Ibid., p. 38.
58 Shackleton 1970, 394.
59 Jozan 1847, pp. 9, 22.
60 Ibid., p. 29.
61 Ibid., pp. 46, 48–49; Leuchs 1829, p. 373.
62 Jozan 1854, p. 27.
63 Meder 1919, pp. 133–39.
64 Watrous 1957, pp. 91–129.
65 Shelley 1989; Shelley 1995; Shelley 2005; Shelley 2006; Baetjer and Shelley 2011.
66 Burns 2007.
67 Jirat-Wasiutynski and Newton 2000, p. 5.

Bibliography

About, Edmond. *Le Salon de 1864.* Paris: Hachette, 1864.

Adamczak, Audrey. *Robert Nanteuil, 1623–1678.* Paris: Arthena, 2011.

Adhémar, Jean. "Les Portraits dessinés du xvie siècle au Cabinet des estampes, Partie I." *Gazette des beaux-arts* 82 (1973): 121–98.

Albert Besnard, 1849–1934. Honfleur, France: Musée Boudin, 2008.

Albert Edelfelt, 1854–1905: Jubilee Book. Helsinki: Ateneum Art Museum, 2004.

Alboize, Jules. "Les Pastellistes français." *L'Artiste,* April 1889, pp. 296–99.

Alexandre, Arsène. *Jean-François Raffaëlli: Peintre, graveur et sculpteur.* Paris: Floury, 1909.

Alexis, Paul. "Manet." *Revue moderne et naturaliste,* 1880, pp. 289–95.

Allard, Sébastien, and Guilhem Scherf. "The Allegorical Portrait." In *Citizens and Kings: Portraits in the Age of Revolution, 1760–1830,* pp. 226–43. London: Royal Academy, 2006.

Althöfer, Heinz. *Das 19. Jahrhundert und die Restaurierung.* Munich: Callwey, 1987.

Aman-Jean, François. "Souvenir d'Aman-Jean." In Farinaux-Le Sidaner and Jumeau-Lafond, *Aman-Jean, 1858–1936,* pp. 24–25.

Amblard, Marion. "The Scottish Painters' Exile in Italy in the Eighteenth Century." *Etudes écossaises* 13 (2010): 18. http://etudesecossaises.revue.org/index219.html.

Andrew, John. *La Peinture au pastel mise à la port ée de tout le monde.* Paris: L. Cumer, 1859.

Avant-Coureur, 1762, p. 491.

Avant-Coureur, 1761, p. 136.

Apostolou, Irini. "L'Apparence extérieure de l'oriental et son rôle dans la formation de l'image de l'autre au xviiie siècle." *Cahiers de la Méditerranée* 66 (2003): 15.

Arnoult, Dominique d'. *Jean-Baptiste Perronneau, ca. 1715–1783: Un Portraitiste dans l'Europe des lumières.* Paris: Arthena, 2015.

———. "Un Portrait de Jean-Baptiste Perronneau aux Musées Royaux des Beaux-Arts de Belgique: Tableaux au pastel et à l'huile dans la commande du Prince d'Ardore, ambassadeur du roi des Deux-siciles à la cour de Louis XV." *Bulletin de l'association des historiens de l'art italien* 13 (2008): 96–109.

The Artist's Assistant; or, School of Science. London: Robinson, 1801.

The Art of Thomas Wilmer Dewing: Beauty Reconfigured. New York: Brooklyn Museum, 1996.

Aubert, Jean. "Chambéry: Acquisitions récentes." *Revue du Louvre* 5, no. 6 (1979): 399–401.

Auricchio, Laura. *Adélaïde Labille-Guiard: Artist in the Age of Revolution.* Los Angeles: J. Paul Getty Museum, 2009.

Avery, Kevin J., ed. *A Catalogue of Works by Artists Born before 1835.* Vol. 1 of *American Drawings and Watercolors in the Metropolitan Museum of Art.* New York: Metropolitan Museum of Art, 2002.

Bacou, Roseline. *Odilon Redon: Pastels.* New York: G. Braziller, 1987.

———. *Odilon Redon.* Geneva: Pierre Cailler, 1956.

Baetjer, Katharine. "British Portraits in the Metropolitan Museum of Art." *Metropolitan Museum of Art Bulletin* 57, no. 1 (1999): 1, 5–72.

Baetjer, Katharine, and Marjorie Shelley. "Pastel Portraits: Images of 18th-Century Europe." *Metropolitan Museum of Art Bulletin* 68, no. 4 (2011): 1–56.

Baglione, Giovanni. *Le vite de' pittori, scultori, architetti ed intagliatori.* Naples, 1733.

Baldinucci, Filippo. *Vocabulario Toscano dell'arte del disegno.* Florence, 1681.

Ball, Philip. *Bright Earth: Art and the Invention of Color.* Chicago: University of Chicago Press, 2001.

Ballu, Roger. "A propos des Pastellistes: Les Absents; Comment la société est née." *La Vie artistique,* April 22, 1888, pp. 121–22.

———. "La Société de Pastellistes Français." *Revue illustrée,* December 1887– June 1888, pp. 281–88.

Bambach, Carmen. *Leonardo da Vinci: Master Draftsman.* New York: Metropolitan Museum of Art, 2003.

Barker, Emma. Review of *The Exceptional Woman: Elisabeth Vigée-Lebrun and the Cultural Politics of Art,* by Mary Sheriff. *Art History* 20, no. 2 (1997): 337–39.

———. "Women, Art, and Culture in Eighteenth-Century France." *Geneva* 40, no. 1 (2006): 144–48.

Baudelaire, Charles. *Ecrits esthétiques.* Paris: Union Génerale d'Edition, 1996.

Bazin, Charles. *Petit Traité ou méthode de peinture-pastel à l'usage des artistes et des amateurs.* Paris: Picart, 1849.

Beaunier, André. "Aman-Jean." *Art et Décoration,* January–June 1902, pp. 133–42.

Beaurain, David. "Louis Vigée, 1715–1767: Maître Peintre de l'Académie de Saint-Luc." *Bulletin de la société de l'histoire de Paris et de l'Île-de-France* 13 (2003): 109–34.

Bellhouse, Mary L. "Visual Myths of Female Identity in Eighteenth-Century France." *International Political Science Review* 12, no. 2 (1991): 117–35.

Beltinger, Karoline, Gabriele Englisch, Danièle Gros, Christoph Herm, and Anna Stoll. "A Technical Study of Ferdinand Hodler's Painting Technique: Work in Progress." In *ICOM-CC: 13th Triennial Meeting, Rio de Janeiro, 22–27 Sept., 2002, Preprints,* 1:388–393. London: James & James, 2002.

Bénédite, Léonce. "Les Dessins de Puvis de Chavannes au musée du Luxembourg." *Revue de l'art ancien et moderne* 7 (1900): 15–28.

Bergeret-Gourbin, Anne-Marie, and Dominique Lobstein. *Les Pastels: Collection du musée Eugène Boudin.* Honfleur, France: Société des Amis du Musée Eugène Boudin, 2009.

Berhaut, Marie. *Caillebotte: Sa Vie et son oeuvre: catalogue raisonné des peintures et pastels.* Paris: Bibliothèque des Arts, 1978.

Besnard, Albert. "Le Pastel." *La Grande Revue,* 1908, 624–41.

Bickendorf, Gabriele. " 'Disegni Coloriti': Die Pastelle Jacopo Bassanos." *Pantheon* 56 (1998): 85–94.

Bireley, Robert S. J. "Early Modern Catholicism as a Response to the Changing World of the Long 16th Century." *Catholic Historical Review* 95, no. 2 (2009): 219–39.

Bisman, Aurore. "La Société de Pastellistes français, 1884–1914." Thesis, Ecole du Louvre, Paris, 2010.

Black, Jeremy, and Jeremy Gregory, eds. *Culture, Politics and Society in Britain, 1660–1800.* Manchester, England: Manchester University Press, 1991.

Blanche, Jacques-Emile. *Propos de peintre: De Gauguin à la Revue nègre.* Paris: Emile-Paul, 1928.

Bleeker, Isabelle F. "Pastel, Liotard's Preferred Technique." In *Jean-Etienne Liotard, 1702–1789: Masterpieces from the Musées d'Art et d'Histoire of Geneva and Swiss Private Collections,* pp. 15–17. Paris: Somogy, 2006.

Blémont, Emile. "Les Pastels de M. De Nittis." *Le Beaumarchais,* May 28, 1881, p. 5.

Blood, Katherine, and Linda Stiber Morenus. "A Technical Study of Joseph Pennell's Pastels and Charcoals." In Jacques, *Proceedings from the Fifth International Conference,* pp. 25–32.

Boccazzi, Barbara Mazza. "Rosalba e Algarotti: Volti e Risvolte." In Pavanello, *Rosalba Carriera,* pp. 157–69.

Boggero, Laurence. "Emile-Antoine Bourdelle, un pastelliste méconnu." Thesis, Ecole du Louvre, Paris, May 2009.

Boggs, Jean Sutherland, and Anne Maheux. *Degas Pastels.* London: Thames and Hudson, 1992.

Bohn, Babette. "Drawing as Artistic Invention: Federico Barocci and the Art of Design." In Mann and Bohn, *Federico Barocci,* pp. 33–69.

Bolger, Doreen, ed. *American Pastels in the Metropolitan Museum of Art.* New York: Metropolitan Museum of Art, 1989.

Bonnet, Marie-Jo. "Femmes Peintres à leur travail: De l'autoportrait comme manifeste politique, xviiie-xixe siècles." *Revue d'histoire moderne et contemporaine* 49, no. 3 (2002): 140–67.

Bouchot, Henri. "Les Salons de 1893: Dessins, gravure architecture." *Gazette des Beaux-Arts,* July 1893, pp. 25–45.

Bouillon, Jean-Paul, *La Promenade du critique influent: Anthologie de la critique d'art en France, 1850–1900.* Paris: Fernand Hazan, 1990.

Boutet, Claude. *Traité de la peinture en miniature.* The Hague, 1708.

Bouyer, Raymond. "Modern French Pastellists: Fantin-Latour." *International Studio,* November 1904, pp. 39–44.

———. "The Pastel Drawings of Aman-Jean." *International Studio,* June 1907, pp. 285–90.

Bowen, Craigen, Susan Dackerman, and Elizabeth Mansfield, eds. *Dear Print Fan: A Festschrift for Marjorie B. Cohn.* Cambridge, MA: Harvard Art Museums, 2001.

Bowron, Edgar. "Benedetto Luti." In Turner, *Dictionary of Art,* 19:816–17.

———. "Benedetto Luti's Pastels and Coloured Chalk Drawings." *Apollo* 111 (1980): 440–47.

Breeskin, Adelyn Dohme. *Mary Cassatt: A Catalogue Raisonné of the Oils, Pastels, Watercolors and Drawings.* Washington, DC: Smithsonian Institution Press, 1970.

Brejon de Lavergnée, Barbara. *Inventaire général des dessins—Ecole française: Dessins de Simon Vouet, 1590–1649.* Paris: Réunion des Musées Nationaux, 1987.

Bromelle, Norman. "The Russell and Abney Report on the Action of Light on Watercolours." *Studies in Conservation* 9, no. 4 (1964): 140–52.

Brooks, J., ed. *Taddeo and Federico Zuccaro: Artist-Brothers in Renaissance Rome.* Los Angeles: J. Paul Getty Museum, 2007.

Bruxelles, Jean de. "Lettres belges." *Gil Blas,* February 14, 1888, p. 3.

Bull, Duncan. *Jean-Etienne Liotard, 1702–1789.* Amsterdam: Rijksmuseum, 2002.

Burnham, Helen. "Les Parisiennes de Manet: A propos de quelques pastels exposés en 1880." In *Manet, inventeur du Moderne,* p. 85–92. Paris: Musée d'Orsay / Gallimard, 2011.

Burns, Thea. *The Invention of Pastel Painting.* London: Archetype, 2007.

———. "The Prestige of Pastel: Robert Nanteuil's Pastel Portraits and Thesis Engravings." In Bowen, Dackerman, and Mansfield, *Dear Print Fan,* pp. 43–48.

Burns, Thea, and Ashok Roy. "A Passion for Portraits: Elizabeth Cay's Pastels." *Studies in Conservation* 59, no. 5 (2014): 279–88.

Cahen, Gustave. *Eugène Boudin: Sa vie et son oeuvre.* Paris: Floury, 1900.

Cahn, Isabelle. "Edouard Manet et son entourage." In Cogeval, *Le mystère et l'éclat.*

Carter, Jennifer J., and Joan H. Pittock, eds. *Aberdeen and the Enlightenment.* Aberdeen, Scotland: Aberdeen University Press, 1987.

Caylus, comte de. "Exposition . . . dans une des salles du Louvre." *Mercure de France* 10 (1751): 166.

Chamberlayne, John, to Gideon Johnston. "Correspondance, 1711–n.d., south Carolina, etc.," reel 17, vol. 17, n.p. Papers of the Society for the Propagation of the Gospel in Foreign Parts, London.

Champfleury. *Les Peintres de Laon et de Saint-Quentin: De La Tour.* Paris: Didron, 1855.

Chaperon, Paul Romain. *Traité de la peinture en pastel.* Paris: Defer de Maisonneuve, 1788.

Charles Léandre: Intime et multiple. Paris: Musée du Vieux Montmartre/Magellan, 2007.

Chassagnol. "Les Pastels de J. De Nittis." *Gil Blas,* May 26, 1881, pp. 1–2.

Chatelus, Jean. *Peindre à Paris au xviiie siècle.* Nîmes, France: Jacqueline Chambon, 1991.

Chatouville, C. de. "Salon de 1846." *Musée des familles,* October 1845–September 1846, p. 223.

Chesneau, Ernest. "Jean-François Millet." *Gazette des Beaux-Arts,* May 1, 1875, pp. 428–41.

Chesterfield, Philip. *The Letters of Lord Chesterfield to His Son,* ed. Charles Strachey. 3d ed. London: Methuen, 1932.

Claretie, Jules. "Chronique: Les Pastels de M. De Nittis." *Le Temps,* May 24, 1881, [p. 2].

Clements, Candace. "Noble Liberality and Speculative Industry in Early 18th-Century Paris." *Geneva:* 29, no. 2 (1995): 213–18.

Cochin, Charles-Nicolas. "Essai sur la vie de M. Chardin (1780)." *Précis analytique des travaux de l'Académie des sciences, belles-lettres et arts de Rouen 78 (1875–76):* 417–41.

Cogeval, Guy, ed. *Le Mystère et l'éclat.* Paris: Musée d'Orsay / Réunion des Musées Nationaux, 2008.

Cooper, Douglas. *Pastels by Edgar Degas.* New York: Macmillan, 1953.

Coquery, Emmanuel. "La Fabrique du portrait." In *Visages du Grand Siècle,* pp. 137–61.

Coquiot, Gustave. *Degas.* Paris: Ollendorff, 1924.

Cortambert, Richard. *Promenade d'un fantaisiste à l'Exposition des Beaux-Arts de 1861.* Paris: Revue du Monde Colonial, 1861.

Coypel, Charles. *Jugements sur les principaux ouvrages exposés au Louvre, le 25 août 1751.* Amsterdam, 1751.

Croës, Catherine de, Robert L. Delevoy, and Gisèle Ollinger-Zinque. *Fernand Khnopff.* Brussels: Lebeer Hossmann, 1987.

Crookshank, Anne, and the Knight of Glin. "Some Italian Pastels by Hugh Douglas Hamilton." *Irish Arts Review Yearbook* 13 (1997): 62–69.

Cullen, Fintan. "Hugh Douglas Hamilton in Rome, 1779–1792." *Apollo,* n.s., 115, no. 240 (1982): 86–91.

———. "Hugh Douglas Hamilton: 'Painter of the Heart.' " *Burlington Magazine* 125, no. 964 (1983): 417–19, 421.

———. "The Life and Works of Hugh Douglas Hamilton, 1740–1808." Master's thesis, University College, Dublin, Department of Art History, 1980.

Cumming, Mark, ed. *The Carlyle Encyclopedia.* Madison, NJ: Fairleigh Dickinson University, 2004.

Debrie, Christine. *Maurice Quentin de La Tour.* Thonon-les-Bains, France: Albaron, 1991.

Debrie, Christine, and Xavier Salmon. *Maurice Quentin de La Tour: Prince des pastellistes.* Paris: Somogy, 2000.

Degas. Paris: Orangerie des Tuileries, 1937.

Delot, Catherine, David Liot, and Arlette Sérullaz. *Millet, Rousseau, Daumier: Chefs d'oeuvre de la donation d'arts graphiques d'Henry Vasnier.* Paris: Somogy, 2002.

Dempsey, Charles. Review of *Federico Barocci: Allure and Devotion in Late Renaissance Painting,* by Stuart Lingo. *Art Bulletin* 92, no. 3 (2010): 251–56.

Denis, Maurice. *Théories, 1890–1910: Du symbolisme et de Gauguin vers un nouvel ordre classique.* 1912. Reprint, Paris, 1920.

De Nittis e Tissot: Pittori della vita moderna. Barletta, Italy: Pinacoteca G. de Nittis, 2006.

Denk, Claudia. " 'Chardin n'est pas un peintre d'histoire, mais c'est un grand homme': Les Autoportraits tardifs de Jean-Siméon Chardin." In Gaehtgens, Michel, Rabreau, and Schieder, *L'Art et les normes sociales,* pp. 279–97.

Des Fontaines, Abbé. "Lettre à l'Auteur." *Jugements sur quelques ouvrages nouveaux* 9 (1745), p. 292.

Desjardins, Paul. *Esquisses et impressions.* Paris: Lecène et Oudin, 1889.

Destremau, Frédéric. "Louis Anquetin et Vincent Van Gogh à l'atelier Cormon, 1886–1887." *Bulletin de la Société de l'histoire de l'art français,* 2009, p. 253–73.

Diderot, Denis. *Oeuvres.* Paris: Brière, 1821.

———. *Salon de 1771.* Edited by Jean Seznec and Jean Adhémar. Oxford, England: Clarendon Press, 1957–67.

———. *The Salon of 1765 and Notes on Painting.* Vol. 1 of *Diderot on Art.* Translated by John Goodman. New Haven, CT: Yale University Press, 1995.

Dini, Piero, and Giuseppe Luigi Marini. *Giuseppe De Nittis: La vita, i documenti, le opere dipinte.* Turin, Italy: Allemandi, 1990.

Diss, Gabriel. "Charles-Laurent Maréchal: Peintre, pastelliste et peintre verrier (Metz 1801–Bar-le-Duc 1887)." *Renaissance du vieux Metz,* no. 106 (1998): 3–10.

Distel, Anne. "Charles Deudon, 1832–1914, collectionneur." *Revue de l'Art* 86 (1989): 58–65.

Ducrot, A. *La Peinture à l'huile et au pastel apprise sans maître.* Paris, 1858.

Dufet-Bourdelle, Rhodia. *Bourdelle pastelliste.* Montauban, France: Musée Ingres, 1985.

Dumas fils, Alexandre. "Beaux-Arts: Le Portrait de la princesse Mathilde, par Giraud." *Le Napoléon,* January 6, 1850, p. 8.

Dumesnil, Henri. *Constant Troyon: Souvenirs intimes.* Paris: H. Laurens, 1888.

Dunlap, William, *History of the Rise and Progress of the Arts of Design in the United States.* New York, 1834.

Dunstan, Bernard. "The Pastel Techniques of Edgar Degas." *American Artist,* no. 362 (September 1972): 41–47.

Duranty, Edmond. *La Nouvelle Peinture: A propos du groupe d'artistes qui expose dans les galeries Durand-Ruel.* Paris: Dentu, 1876.

Duret, Théodore. *Histoire d'Edouard Manet et de son oeuvre.* Paris: Charpentier et Fasquelle, 1906.

Duro, Paul. *The Academy and the Limits of Painting in Seventeenth-Century France,* Cambridge, England: Cambridge University Press, 1997.

Dutry, Albert. *Notes d'art: Pastels et pastellistes.* Ghent, Belgium: A. Siffer, 1892.

Facos, Michelle. "Swedish Artists in Paris." In *Nationalism and the Nordic Imagination: Swedish Art of the 1890s,* pp. 7–26. Berkeley: University of California Press, 1998.

Farinaux-Le Sidaner, Yann, and Jean-David Jumeau-Lafond, eds. *Aman-Jean, 1858–1936: Songes de femmes.* Lectoure, France: Le Capucin, 2003.

Faure, Elie. "Emile Bourdelle: Peintre et Pastelliste." *L'Art et les artistes,* April 1906, pp. 24–29.

Félibien, André. *Entretiens sur les vies et sur les ouvrages des plus excellens peintres anciens et modernes.* Trévoux, 1725.

Feller, Robert L. "On the Fading of Dyes." *Bulletin of the American Group, International Institute for Conservation* 5, no. 2 (1965): 31–33.

Fénéon, Félix. "Chronique d'avril." *Revue indépendante* 1, 1885, pp. 26–27.

———. *Oeuvres plus que complètes.* Edited by Joan U. Halperin. Geneva: Librairie Droz, 1971.

Festa, Lynn. "Cosmetic Differences: The Changing Faces of England and France." *Studies in Eighteenth Century Culture* 34 (2005): 25–54.

Flament, Albert. "Un Art défunt." *La Presse,* April 14, 1899, p. 2.

Flers, Camille. "Du pastel, de son application au paysage en particulier." Part 1, *L'Artiste,* August 23, 1846, pp. 113–16. Part 2, *L'Artiste,* August 15, 1847, pp. 101–4.

Forsaith, Peter S. "Pictorial Precocity: John Russell's Portraits of Charles and Samuel Wesley." *British Art Journal* 10, no. 3 (2010): 98–103.

Frantz, Henry. "Modern French Pastellists: Jules Chéret." *International Studio,* October 1904, pp. 317–21.

Fraser-Harris, D. F. "William De La Cour, Painter, Engraver and Teacher of Drawing." *Scottish Bookman* 1, no. 5 (1936): 12–19.

Gaehtgens, Thomas W., Christian Michel, Daniel Rabreau, and Martin Schieder. *L'Art et les normes sociales au xviiie siècle.* Paris: Maison des Sciences de l'Homme, 2001.

Galley, Jean-Baptiste. *Un Romantique oublié: Antonin Moine, 1796–1849.* Saint-Etienne, France, 1898.

Gamboni, Dario. " 'Une Irradiation des choses pour le rêve': Les Pastels d'Odilon Redon." In Cogeval, *Le Mystère et l'éclat,* 102–7.

Gamboni, Dario. *La Plume et le pinceau: Odilon Redon et la littérature.* Paris: Minuit, 1989.

Ganz, James A. and Kendall, Richard, *The Unknown Monet. Pastels and Drawings,* Williamstown, MA, The Clark Institute. New Haven, CT: Yale University Press, 2007.

Gauguin, Paul. *Correspondance de Paul Gauguin.* Edited by Victor Merlhès. Paris: Fondation Singer-Polignac, 1984.

———. *Lettres de Gauguin à Daniel de Monfreid.* Paris: Falaize, 1950.

Geffroy, Gustave. "Chronique d'art: Jules Chéret." *Revue d'aujourd'hui,* January 1890, pp. 55–58.

———. "Modern French Pastellists: Charles Milcendeau." *International Studio,* March 1904, pp. 24–29.

Gerdts, William, Cody Hartley, Frank Goss, and Nathan Vonk. *The Pastels of Leon Dabo.* Santa Barbara, CA: Sullivan Goss, 2012.

Getscher, Robert H. *James Abbott McNeill Whistler: Pastels.* Arcueil, France: Anthèse, 1991.

Giovanni Boldini maestro della Belle Epoque: Il ritratto di Emiliana Concha de Ossa detto Il pastello bianco. Milan: Pinacoteca di Brera, Electa, 2006.

Girardot, A. de. "Le Pastel. Rosalba. La Tour. Mme de Léoménil." *L'Art en province,* n.s. 11 (1850): 156–60.

Godet, Philippe. "Un Portrait inédit de La Tour." *Gazette des Beaux-Arts,* 3d ser., 3 (1905): 207–19.

Goncourt, Edmond, and Jules de Goncourt. *Journal: Mémoires de la vie littéraire.* Edited by R. Ricatte. Paris: Fasquelle, Flammarion, 1956.

Goupil, Frédéric. *Le Pastel simplifié et perfectionné.* Paris: Desloges, 1858.

Gratia, Charles-Louis. *Traité de la peinture au pastel.* Paris: Veuve Bader, 1891.

Green, A. G., C. F. Cross, and E. J. Bevan. "Photography in Aniline Colours." *Journal of the Society of Arts,* January 1891, 150–53.

Gregorius, Petrus. *Syntaxeon artis mirabilis.* Cologne: Lazarus Zetzner, 1600.

Grimm, Friedrich Melchior. "Principaux Peintres du temps." In Grimm, *Correspondance littéraire,* 1750, 1:461–68. Nedeln, Liechtenstein: Kraus, 1968.

Grossvogel, Jill, and Catherine Puget. *Emile Schuffenecker, 1851–1934.* Saint-Germain-en-Laye, France: Musée Pont-Aven / Musée Maurice Denis, 1996.

Guégan, Stéphane. "Retour en grâce." In Cogeval, *Le mystère et l'éclat,* pp. 24–26.

Guitard, Frédéric. "Le Salon." *La Houle,* March 1904, p. 7.

Halévy, Daniel. *Degas parle.* Paris: Fallois, 1995.

Hamel, Maurice. "L'Exposition des pastellistes." *Les Lettres et les arts,* April 1, 1886, pp. 107–120.

Harley, Rosamond. "Field's Manuscripts: Early Nineteenth Century Colour Samples and Fading Tests." *Studies in Conservation* 24 (1979): 75–84.

Harrison, Birge. "The Case of Pastel." *Art and Progress* March 1915, pp. 154–57.

———. "The 'Mood' in Modern Painting." *Art and Progress,* July 1913, p. 1015–20.

Hedley, Jo. "French Influence on the Art of the English Portrait in the 18th Century." In Salmon, *De soie et de poudre,* 102–34.

Heinich, Nathalie, *Du peintre à l'artiste: artisans et académiciens à l'âge classique.* Paris: Minuit, 1993.

Henri Gervex (1852–1929). Paris: Paris-Musées, 1992.

Herdt, Anne de. *Dessins de Liotard, suivi du catalogue de l'oeuvre dessiné.* Geneva: Musée d'Art et d'Histoire, 1992.

———. "Liotard: Entre portrait de cour et portrait bourgeois." In Salmon, *De soie et de poudre,* pp. 75–101.

Heredia, José Maria de. *Atelier de feu Emile Lévy: Catalogue des tableaux, pastels, aquarelles et dessins par Emile Lévy.* Sale catalogue, December 15–16, 1890.

Hobson, Marian. *The Object of Art: The Theory of Illusion in Eighteenth-Century France.* Cambridge, England: Cambridge University Press, 1982.

Hodge, Anne, ed. *Hugh Douglas Hamilton, 1740–1808: A Life in Pictures.* Dublin: National Gallery of Ireland, 2008.

Hoisington, Rena. "Maurice Quentin de La Tour and the Triumph of Pastel Painting in Eighteenth-Century France." PhD diss., Institute of Fine Arts, New York University, 2006.

Hoschedé, Ernest. *Brelan de salons.* Paris: Tignol, 1890.

Huet, René Paul. *Paul Huet (1803–1869) d'après ses notes, sa correspondance, ses contemporains.* Preface by Georges Lafenestre. Paris: Laurens, 1911.

Hugues, Laurent. "La Famille royale et ses portraitistes sous Louis XV et Louis XVI." In Salmon, *De soie et de poudre,* pp. 135–75.

Hustin, Arthur. "L'exposition des Pastellistes." *La vie artistique,* 15 April 1888, p. 113–114.

Hyde, Melissa. "Women and the Visual Arts in the Age of Marie-Antoinette." In Kahng and Michel, *Anne Vallayer-Coster,* pp. 75–93.

Il Mondo di Zandomeneghi: dai macchiaioli agli impressionisti. Florence, Italy: Pagliai Polistampa, 2004.

Ingamells, John. "George Knapton, 1698–1778." In *Oxford Dictionary of National Biography,* 31:865–66. Oxford, England: Oxford University Press, 2004.

J. C. "Le Salon de 1857. Les pastels. *La Discussion philosophique* d'Eugène Tourneux." *Musée des familles,* October 1857, p. 25.

J. H. "Nos peintres peints par eux-mêmes: Pierre Carrier-Belleuse." *Le Figaro,* 27 June 1896.

Jacques-Emile Blanche, 1861–1942. Paris: Réunion des Musées Nationaux, 1992.

Jacques, Shulla, ed. *Proceedings from the Fifth International Conference of the Institute of Paper Conservation, 26–29 July 2006.* London: ICON Institute of Conservation, 2007.

Janillon. "Aquarelles, pastels, dessins, gravure." *L'Univers illustré,* June 7, 1884, p. 366.

Janin, Jules. "Salon de 1839." *L'Artiste,* 2d ser., 2 (1839): 337–45.

Jean-Francis Auburtin (1866–1930): Les Variations normandes. Paris: Somogy, 2006.

Jean, René. "Frits Thaulow." *Revue illustrée,* 15 May 1904.

Jeffares, Neil. *Dictionary of Pastellists before 1800.* London: Unicorn, 2006. http://www .pastellists.com.

———. "Jean Valade's Portraits of the Faventines Family." *British Journal for Eighteenth-Century Studies* 26, no. 2 (2003): 217–50.

Jirat-Wasiutyński, Vojtěch, and H. Travers Newton. *Technique and Meaning in the Paintings of Paul Gauguin.* Cambridge, MA: Cambridge University Press, 2000.

Johnson, Edward Mead. *Francis Cotes: Complete Edition with a Critical Essay and a Catalogue.* Oxford, England: Phaidon, 1976.

Johnson, Lee. *Delacroix: Pastels.* London: John Murray, 1995.

Jourdain, Frantz. "Modern French Pastellists. J. F. Raffaëlli." *International Studio,* August 1904, pp. 146–49.

Jozan, Saintin François. *The Art of Pastel Painting.* Translated by the Maria Parrott. New York: W. Schaus, 1854.

———. *Du Pastel: Traité de sa composition, de sa fabrication, de son emploi dans la peinture.* Paris: Danlos, 1847.

Jumeau-Lafond, Jean-David, *Les Peintres de l'âme: Le Symbolisme idéaliste en France,* Ghent: Snoeck-Ducaju, 1999.

———. "Symbolismes." In Cogeval, *Le mystère et l'éclat,* pp. 128–131.

Kaenel, Philippe. *Le Métier d'illustrateur: Rodolphe Töpffer, J.-J. Grandville, Gustave Doré.* Geneva: Droz, 2004.

Kahng, Eik, and Marianne Roland Michel, eds. *Anne Vallayer-Coster, Painter to the Court of Marie-Antoinette.* New Haven, CT: Yale University Press, 2002.

Katlan, Alexander. *American Artists' Materials Suppliers Directory.* 2 vols. Park Ridge, NJ: Noyes, 1987–92.

Katov, Paul de. "L'exposition des Pastellistes." *Gil Blas,* 6 April 1887, p. 2.

Kayser, Christine, ed. *Peindre le ciel, de Turner à Monet.* Paris: L'Inventaire, 1995.

Keyzer, Frances. "Modern French Pastellists: Alfred Philippe Roll." *International Studio,* May 1904, p. 228–235.

———. "Modern French Pastellists. L. Lévy-Dhurmer." *International Studio,* April 1906, p. 144–150.

Krill, John. *English Artists' Papers Renaissance to Regency,* 2d rev. ed. Winterthur, DE: Oak Knoll Press, 2002.

———. "Silk Paper for Crayon Drawing in the Eighteenth Century." *International Paper History Congress Book* 10 (1994): 117–21.

Kuehni, Rolf. "Who Wrote the *Traité de la Peinture en Pastel?*: A Speculative Essay." www.iscc.org/pdf/TraitePastel.pdf.

La Faloise, F. de. "Salon de 1844, III: Paysages, miniatures, pastels." *Revue de Paris* 27 (1844): 198–213.

La Fizelière, Albert de. "Salon de 1844." *Bulletin de l'ami des arts* 2 (1844): 421.

La Font de Saint-Yenne, Etienne. *Réflexions sur quelques causes de l'état présent de la peinture en France avec un examen des principaux ouvrages exposés au Louvre, le mois d'août 1746.* La Haye, 1747.

La Hire, Philippe de. "Traité de la pratique de la peinture." In *Mémoires de l'Académie Royale des Sciences, 1666–1699,* 9:637–730. Paris: Compagnie des Libraires, 1730.

La Lande, Jérôme de. *Art de faire le parchemin.* Paris: Saillant and Nyon, 1762.

La Rochenoire, Julien de, *Le pastel appris seul avec sept couleurs pour un franc.* Paris: Martinon, 1853.

Labalme, Patricia H. "Women's Roles in Early Modern Venice: An Exceptional Case." In *Beyond Their Sex: Learned Women of the European Past,* pp. 129–52. New York: New York University Press, 1980.

Labreuche, Pascal. *Paris: Capitale de la toile à peindre, xviiie–xixe siècles.* Paris: Institut National d'Histoire de l'Art, 2011.

Lacombe, Jacques. *Dictionnaire portatif des beaux-arts.* Paris: Jean-Thomas Hérissant, 1753.

Lacoste-Veysseyre, Claudine, éd. *Théophile Gautier, correspondance générale.* Paris: Droz, 1991.

Lagenevais, F. de. "Le Salon de 1849." *Revue des deux mondes,* August 15, 1849, pp. 559–93.

Lagrange, Léon. "Du rang des femmes dans les arts." *Gazette des Beaux-Arts,* October 1, 1860, pp. 30–43.

Laine, Merit, and Carolina Brown. *Gustaf Lundberg, 1695–1786: En porträttmålere och hans tid.* Stockholm, Nationalmuseum, 2006.

Laing, Alastair. "La Tour, Boucher." *Burlington Magazine* 147, no. 1 (2005): 56–58.

Lajer-Burcharth, Ewa. Review of *The Exceptional Woman: Elisabeth Vigée-Lebrun and the Cultural Politics of Art,* by Mary Sheriff. *Art Bulletin* 79, no. 4 (1997): 726–31.

Launay, vicomte Charles de [Delphine de Girardin]. "Courrier de Paris." *La Presse,* March 23, 1837, p. 1.

Le Blanc, Abbé Jean-Bernard. *Lettre sur l'exposition des ouvrages de peinture, sculpture &c de l'année 1747.* Paris, 1747.

Le Pileur d'Apligny. *Traité des couleurs matérielles,* [1779]. Geneva: Minkoff, 1973.

Lebreton, Joachim. *Nécrologie: Notice sur Mme Vincent, née Labille, peintre.* Paris: Chaignieau Aîné, 1802.

Lecoeur, Daniel. *Daniel Dumonstier, 1574–1646.* Paris: Arthena, 2006.

Lefort, Paul. "L'Exposition nationale de 1883." *Gazette des Beaux-Arts,* December 1, 1883, pp. 457–71.

Leprieur, Paul. "Le Salon de 1888: La Peinture." *L'Artiste,* July 1888, pp. 1–29.

Les Femmes impressionnistes: Mary Cassatt, Eva Gonzalès, Berthe Morisot. Paris: Musée Marmottan, 1993.

Lettres de Degas, recueillies et annotées par Marcel Guérin, préface de Daniel Halévy. Paris: Bernard Grasset, 1945.

Leuchs, Jean-Carolus. *Traité complet des propriétés, de la préparation et de l'emploi des matières tinctoriales et de couleurs.* Translated by M. Péclet. Paris: De Malher, 1829.

Lévy, Suzy. *Journal inédit de Ricardo Viñes: Odilon Redon et le milieu occultiste, 1897–1915.* Paris: Aux Amateurs de Livres, 1987.

Lichtenstein, Jacqueline. *The Eloquence of Color: Rhetoric and Painting in the French Classical Age.* Translated by E. McVarish. Berkeley: University of California Press, 1993.

Liotard, Jean-Etienne. "Explication des différens jugemens sur la peinture." *Mercure de France,* November 1762, pp. 172–90. Reprinted in Roethlisberger and Loche, *Liotard,* pp. 167–72.

Lippincott, Louise. *Selling Art in Georgian London: The Rise of Arthur Pond.* New Haven, CT: Yale University Press, 1983.

Littlejohns, Richard, and Sara Soncini. *Myths of Europe.* Amsterdam: Rodopi, 2007.

Lloyd, Stephen. *Raeburn's Rival: Archibald Skirving, 1749–1819.* Edinburgh: National Gallery of Scotland, 1999.

Loisel, Catherine. "L'Exemple de Bassano et Barocci et le premier pastel d'Annibale Carracci." *Mitteilungen des Kunsthistorisches Institutes in Florenz* 52, nos. 2–3 (2008): 205–13.

Lostalot, Alfred de. "Les Pastels de M. de Nittis au Cercle de l'Union artistique." *Gazette des Beaux-Arts,* August 1, 1881, pp. 156–165.

Louise Breslau: De l'impressionnisme aux Années folles. Milan: Skira/Seuil, 2001.

MacDonald, Margaret F. *James McNeill Whistler, Drawings, Pastels, and Watercolours: A Catalogue Raisonné.* New Haven, CT: London: Yale University Press, 1995.

———. *Palaces in the Night: Whistler in Venice.* Aldershot, England: Lund Humphries, 2001.

Manet inventeur du Moderne. Paris: Musée d'Orsay Gallimard, 2011.

Mann, Judith, and Babette Bohn. *Federico Barocci: Renaissance Master of Colour and Line.* New Haven, CT: Yale University Press, 2012.

Manning, David. " 'All Delicacy': The Concept of Female Beauty in Mid-Eighteenth-Century British Painting." In Carter and Pittock, *Aberdeen and the Enlightenment,* pp. 211–17.

Marandet, François. "The Apprenticeship of Maurice Quentin de La Tour, 1704–88." *Burlington Magazine* 144, no. 1193 (2002): 502–5.

Marandet, François. "The Formative Years of Jean-Etienne Liotard." *Burlington Magazine* 145 (2003): 297–300.

Marciari, John, and Ian Verstegen. " 'Grande quanto l'opera': Size and Scale in Barocci's Drawings." *Master Drawings* 40, no. 2 (2008): 291–320.

Marecka, Agnieska. Private communication, May 6, 2010.

Mathews, Nancy Mowll *Cassatt and Her Circle: Selected Letters.* New York: Abbeville Press, 1984.

Matthews, Antje. "John Russell's Mysterious Moon: An Emblem of the Church."

Proceedings of the Wesley Historical Society 55, no. 6 (2006): 252–58.

Mauclair, Camille. *Albert Besnard: L'Homme et l'oeuvre.* Paris: Librairie Delagrave, 1914.

———. *De Watteau à Whistler.* Paris: Fasquelle, 1905.

———. "G. Boldini." *Art et Décoration,* November 1905, pp. 145–54.

———. *Servitude et grandeur littéraire.* Paris: Ollendorff, 1922.

Maupassant, Guy de. "Adieu mystères." *Le Gaulois,* November 8, 1881, p. 1.

McClellan, Andrew. "Edme Gersaint and the Marketing of Art in Eighteenth-Century Paris." *Eighteenth-Century Paris* 29 (1995–96): 218–22.

———. *Inventing the Louvre: Art, Politics, and the Origins of the Modern Museum in Eighteenth-Century Paris.* Berkeley: University of California Press, 1994.

McCullagh, Suzanne Folds, and Pierre Rosenberg. " 'The Supreme Triumph of the Old Painter': Chardin's Final Work in Pastel." *Art Institute of Chicago Museum Studies* 12, no. 1 (1985): 42–59.

McTighe, Sheila. "Abraham Bosse and the Language of Artisans: Genre and Perspective in the Académie royale de peinture et sculpture, 1648–1670." *Oxford Art Journal* 21, no. 1 (1998): 3–28.

Meder, Joseph. *Die Handzeichnung: Ihre Technik und Entwicklung.* Vienna: Anton Schroll, 1919.

———. *The Mastery of Drawing.* 2 vols. New York: Abaris, 1978.

Mehler, Ursula. "Rosalba Carriera: Considerazioni sulla sua formazione artistica, su un disegno berlinese e sul 'Gentiluomo in rosso' di Ca' Rezzonico." In Pavanello, *Rosalba Carriera,* pp. 171–80.

———. *Rosalba Carriera, 1673–1757: Die Bildnismalerin des 18. Jahrhunderts.* Königstein im Taunus, Germany: Ortensia Koenigstein, 2006.

Mellerio, André, *Odilon Redon.* Paris: Société pour l'Etude de la Gravure Française, 1913.

Mercure de France, [September] 1745, p. 135.

Merrill, Linda, *After Whistler: The Artist and His Influence on American Painting.* New Haven, CT: Yale University Press, 2004.

Metz, Kathryn. "Ellen and Rolinda Sharples: Mother and Daughter Painters." *Women's Art Journal* 16, no. 1 (1995): 3–11.

Meyer, Véronique. "Dumonstier." In Turner, *Dictionary of Art,* 9:386–88.

Michel, André, Raymond Bouyer, and Léon Deshairs. *L'Art et les moeurs en France.* Paris: Laurens, 1909.

Middleton, Margaret S. *Henrietta Johnston of Charles Town, South Carolina: America's First Pastellist.* Columbia: University of South Carolina Press, 1966.

Miquel, Pierre, *Le paysage français au xixe siècle: 1824–1874. L'école de la nature* Maurs-la-Jolie, Editions de la Martinelle 1975.

Monbeig Goguel, Catherine. "Pour une histoire du pastel en Italie: Pratique des artistes, passion des collectionneurs." *Support/tracé* (ARSAG), no. 9 (2009): 32–40.

Monnier, Geneviève. *Le Pastel.* Geneva: Skira 1992.

———. *Pastels du xixe siècle: musée du Louvre, Cabinet des dessins, musée d'Orsay.* Paris: Réunion des Musées Nationaux, 1985.

Montaiglon, Anatole de. *Procès-verbaux de l'Académie royale de peinture et de sculpture, 1648–1793.* 10 vols. Paris: Baur, 1875–92.

Murray, Henry. *The Art of Drawing and Painting in Coloured Crayons.* London, 1850.

"Musée royal: Exposition de 1827 (25e article); De l'aquarelle." *Journal des artistes et des amateurs,* May 11, 1828, pp. 289–94.

Neufville de Brunhaubois-Montador, Jean-Florent-Joseph. *Description raisonnée des tableaux exposés au Louvre.* Paris, 1738.

Newby, Evelyn. "George Knapton." In Turner, *Dictionary of Art,* 18:142.

Nicholson, Kathleen. "The Ideology of Feminine 'Virtue': The Vestal Virgin in French Eighteenth-Century Allegorical Portraiture." In Woodall, *Portraiture,* pp. 52–72.

Nouveau Petit Manuel de dessin au pastel, à l'estompe, à la mine de plomb et aux trois crayons. Paris: Béthune, [1841].

O'Connor, Louise. "Hamilton's Pastel Portraits: Materials and Techniques." In Hodge, *Hugh Douglas Hamilton,* pp. 44–53.

Odilon Redon: Pastels et Noirs. Versailles, France: Artlys, 2005.

Odilon Redon: Prince du rêve, 1840–1916. Paris: Réunion des Musées Nationaux, 2011.

Odilon Redon: Prince of Dreams, 1840–1916. New York: Abrams, 1994.

Ogée, Frédéric. "Chardin's Time: Reflections on the Tercentenary and Twenty Years of Scholarship." *Eighteenth-Century Studies* 33, no. 3 (2000): 431–50.

Olausson, Magnus. "La Carrière d'un artiste." In Olausson and Salmon, *Alexandre Roslin,* pp. 24–53.

———. "L'Europe au temps de Roslin." In Olausson and Salmon, *Alexandre Roslin,* pp. 18–23.

Olausson, Magnus, and Xavier Salmon. *Alexandre Roslin, 1718–1793: Un Portraitiste pour l'Europe.* Paris: Réunion des Musées Nationaux, 2008.

Olivier, Louis. "Curieux, Amateurs and Connoisseurs: Laymen and the Fine Arts in the Ancien Régime." PhD diss., Johns Hopkins University, Baltimore, 1976.

Ostwald, Wilhelm. *Letters to a Painter on the Theory and Practice of Painting.* 1907; reprint, Whitefish, MT: Kessinger, 2010.

Paillot de Montabert, Jacques-Nicolas. *Traité complet de la peinture.* 10 vols. Paris: Delion, 1829–51.

Palmer, J. W. "The Sharples Crayons." *Lippincott's Magazine,* December 1871, p. 620.

Passez, Anne-Marie. *Adélaïde Labille-Guiard, 1749–1803: Biographie et catalogue raisonné de son oeuvre.* Paris: Arts et Métiers Graphiques, 1973.

"Pastel at the Grosvenor Gallery." *Spectator,* November 1888, p. 15.

Pavanello, Giuseppe, ed. *Rosalba Carriera, 1673–1757: Atti del Convegno Internazionale di Studi 26–28, aprile 2007, Venezia, Fondazione Giorgio Cini, Chioggia, Auditorium San Niccolo.* Verona, Italy: Scripta, 2009.

Pears, Iain. *The Discovery of Painting: The Growth of Interest in the Arts in England, 1680–1768.* New Haven, CT: Yale University Press, Paul Mellon Centre for Studies in British Art, 1988.

Peltre, Christine. *L'Ecole de Metz, 1834–1870.* Nancy, France: Presses Universitaires, 1988.

Percival, Melissa. "The Expressive Heads of Elisabeth Vigée Le Brun." *Gazette des Beaux-Arts* 38, no. 6 (2001): 215–15.

Pernety, Antoine-Joseph. *Dictionnaire portatif de peinture, sculpture et gravure.* 1757; reprint, Geneva: Minkoff, 1972.

Pevsner, Nicolas. *Academies of Art, Past and Present.* Cambridge, England: Cambridge University Press, 1940.

Piceni, Enrico. *Zandomeneghi: L'uomo e l'opera.* Bramante, Italy: Busto Arsizio, 1979.

Pierre Prins: Un Pastelliste impressionniste. Fécamp, France: Musée des Terre-Neuvas et de la Pêche, 2013.

Piles, Roger de. *Cours de peinture par principes.* 1708; reprint, Paris: Gallimard, 1989.

———. *Les Premiers Elemens de la peinture pratique.* Paris: Nicolas Langlois, 1684.

Pilgrim, Dianne H. "The Revival of Pastels in Nineteenth-Century America: The Society of Painters in Pastel." *American Art Journal,* November 1978, p. 43–62.

Pisano, Ronald G. *William Merritt Chase: The Paintings in Pastel, Monotypes, Painted Tiles and Ceramic Plates, Watercolors and Prints.* New Haven, CT: Yale University Press, 2006.

Podro, Michael. *Depiction.* New Haven, CT: Yale University Press, 1998.

Portalis, Baron Roger. "Claude Hoin (2e article)." *Gazette des Beaux-Arts,* January 1900, pp. 10–24.

———. "Exposition des pastellistes français à la rue de Sèze." *Gazette des Beaux-Arts,* May 1, 1885, pp. 437–49.

Porter, Roy. "Making Faces: Physiognomy and Fashion in Eighteenth-Century England." *Etudes anglaises* 38, no. 4 (1985): 385–96.

Posner, Donald. "Concerning the 'Mechanical' Parts of Painting and the Artistic Culture of Seventeenth-Century France." *Art Bulletin* 75, no. (1993): 583–98.

Poulsson, Vidar. *Frits Thaulow: En internasjonal maler.* Oslo: Labyrinth, 2006.

Poupart, Jeanne-Marie. "Un Peintre romantique lorrain: Les débuts de Maréchal de Metz." *Le Pays lorrain,* no. 4 (1952): 133–38.

"Progress and Present State of the Fine Arts in Scotland." *Edinburgh Annual Registry* 9 (1820): cdlxx–cdlxxxi.

Proust, Antonin. "Edouard Manet: Souvenirs." *La Revue Blanche,* March 1, 1897, pp. 201–7.

R. M. "Les Pastels de Louise Abbema." *Gil Blas,* 10 November 1887, p. 2.

Radisch, Paula. " 'Que peut définir les femmes?': Vigée-Le Brun's Portraits of an Artist." *Eighteenth-Century Studies* 25, no. 4 (1992): 441–67.

Raffaëlli, Jean-François. "Solid Oil Colors—an Innovation in Paints." *Brush and Pencil* 19 (1902): 297–98.

Ratouis de Limay, Paul. "Jean-Baptiste Perronneau, Painter and Pastellist." *Burlington Magazine* 36, no. 202 (1920): pt. 1, 35–45; pt. 2, 52, 65–67, 70–72.

———. *Le Pastel en France au xviiie siècle.* Paris: Baudinière, 1946.

Rebora, Carrie, et al. *John Singleton Copley in America.* New York: Metropolitan Museum of Art, 1995.

Redon, Odilon. *A soi-même: Journal, 1867–1915.* Paris: Floury, 1922.

Reifstein, M. "Pensées de M. Reifstein sur la peinture, avec l'exposé d'une nouvelle façon de peindre en pastel." *Journal étranger,* February 1757, pp. 100–106.

"République des arts et des lettres." *L'Artiste,* 4th ser., 2 (1844): 283.

"A Revolution in Oil Painting." *Star,* February 6, 1903.

Rewald, John. *Edouard Manet: Pastels.* Oxford, England: Cassirer, 1947.

Rice, Danielle. "Encaustic Painting Revivals: A History of Discord and Discovery." In Stavitsky, *Waxing Poetic,* pp. 4–15.

Richter, Mark. "Shedding New Light on the Blue Pigment 'Vivianite' in Technical Documentary Sources of Northern Europe." *Art Matters* 4, no. 3 (2007): 37–53.

Ridolfi, Carlo. *La Maraviglia dell'Arte.* 2 vols. Venice, 1648.

Rivières, Baron de. "Chronique du Midi." *Revue des Pyrénées et de la France méridionale* 14, no. 3 (1902): 344–45.

Robbin, Carmen R. "Scipione Borghese's Acquisition of Paintings and Drawings by Ottavio Leoni." *Burlington Magazine* 138, no. 120 (1996): 453–58.

Rochon, Anne-Marie. "Gustave-Achille Guillaumet, écrivain et peintre de l'Algérie." Master's thesis, University of Sorbonne-Paris IV, 1985.

Rodenbach, Georges. *L'Elite.* Paris: Fasquelle 1899.

Roethlisberger, Marcel. "Jean-Etienne Liotard as a Painter of Still Lifes." *J. Paul Getty Museum Journal* 13 (1985): 109–12.

———. "The Unseen Faces of Jean-Etienne Liotard." *Drawing* 11, no. 5 (1990): 97–100.

Roethlisberger, Marcel, and Renée Loche. *Liotard: Catalogue, sources et correspondance.* Doornspijk, the Netherlands: Davaco, 2008.

Roger-Marx, Claude. *Odilon Redon.* Paris: Nouvelle Revue Française, 1924.

Roquebert, Anne. "Edgar Degas réinvente le pastel." In Cogeval, *Le mystère et l'éclat,* pp. 64–69.

Rosenberg, Pierre. *Chardin, 1699–1779.* Cleveland: Cleveland Museum of Art / Indiana University Press, 1979.

———. *Chardin: New Thoughts.* Franklin D. Murphy Lectures 1. Lawrence: Helen Foresman Spencer Museum of Art, University of Kansas, 1983.

———. "A Drawing by Madame Vigée-Le Brun." Translated by Paul Falla. *Burlington Magazine* 123, no. 945 (1981): 739–40, ill.

Rostand, André. "Documents inédits concernant le peintre Louis Vigée." *Bulletin de la société de l'histoire de l'art français*, 1915–17, pp. 108–10.

Rouart, Denis. *Degas: A la recherche de sa technique.* Paris: Floury, 1945.

Rouquet, Jean-André. *The Present State of the Arts in England, 1755.* London: Cornmarket, 1970.

Russell, John. *Diaries.* Manuscript, 1766–1802. 12 vols. National Art Library, London.

———. *Elements of Painting with Crayons.* London: Wilkie & Warren, 1772.

———. "Receipts for Making Crayons: As Discovered by the Late John Russell." Manuscript, 1884. Translated by A. M. Cross. National Art Library, London.

Salé, Marie-Pierre. "Jean-François Millet le renouveau du pastel au milieu du xixe siècle." In Cogeval, *Le mystère et l'éclat*, pp. 40–42.

Salmon, Xavier. "Alexandre Roslin, pastelliste." In Olausson and Salmon, *Alexandre Roslin*, pp. 70–77.

———. *De poudre et de papier: Florilège de pastels dans les collections publiques françaises.* Versailles, France: Artlys, 2004.

———, ed. *De soie et de poudre.* Arles, France: Actes Sud, 2003.

———. *Les Pastels.* Paris: Réunion des Musées Nationaux, 1997.

———. "A New Preparatory Sketch by Maurice Quentin de La Tour." *Metropolitan Museum of Art Bulletin* 42 (2007): 125–31.

———. "Roslin et la société parisienne." In Olausson and Salmon, *Alexandre Roslin*, pp. 86–87.

"Salon de 1841: Dessins aquarelles et pastels." *L'Artiste*, 2nd ser., 7 (1841): 347–50.

"Salon de 1843." *Les Beaux-Arts: Illustration des arts et de la littérature*, 1843, p. 10.

Sandoz, Marc. "Un Portraitiste du 18e siècle se découvre une vocation de peintre de montagne: Mme Vigée Lebrun." *Revue savoisienne Annecy* 119 (1979): 42–57.

Sani, Bernardina. "Precisazioni sul giovane Ottavio Leoni." *Prospettiva* 57–60 (1989–90): 187–94.

———. "Precisazioni su Rosalba Carriera, i suoi maestri e la sua scuola: Un percorso europeo tra Rococò e Illuminismo." In Pavanello, *Rosalba Carriera*, pp. 97–113.

———. *Rosalba Carriera: Lettere Diari, Frammenti.* Florence: Olschki, 1985.

Sarradin, Edouard. "Edouard Manet. De Nittis. Heilbuth." In *L'Art et les mœurs en France*, ed. André Michel, Raymond Bouyer and Léon Deshairs, pp. 224–25. Paris: Laurens, 1909.

Saunier, Charles. "Un Artiste romantique oublié: Monsieur Auguste." *Gazette des Beaux-Arts*, June 1910, pp. 441–60, and July 1910, pp. 51–68.

Saunier, Philippe. "El pastel en Degas un material necesario." In *Degas: El proceso de la creación*, pp. 53–64. Madrid, Fundación Mapfre, 2008.

Schnapper, Antoine. "Bordures, toiles et couleurs: Une Révolution dans le marché de la peinture vers 1675." *Bulletin de la Société de l'Histoire de l'Art Français*, 2002, pp. 85–104.

———. "Le Portrait à l'Académie au temps de Louis XIV." *Xviie Siècle* 35, no. 1 (1983): 97–123.

Schwartz, Catherine, et al. "Les Pastels: Histoire-technologie-analyse et étude de leur comportement à la lumière, à l'oxyde d'éthylène et vis-à-vis des fixatifs." In *Analyse et conservation des documents graphiques et sonores: Travaux du centre de recherches sur la conservation des documents graphiques, 1982–1983*, pp. 122–61. Paris: CNRS, 1984.

Scoutetten, Dr. *Notice sur Madame Sturel née Marie-Octavie Paigné.* Metz, France: S. Lamort, 1854.

Segard, Achille. *Un Peintre des enfants et des mères: Mary Cassatt.* Paris: Ollendorff, 1913.

Segard, Achille. "Lévy-Dhurmer." *La Revue illustrée*, December 15, 1899, [pp. 13–23].

———. Preface to *Exposition René Ménard.* Paris: Galerie Georges Petit, 1914.

Segel, Kathrine, and Mikkel Scharff. "Flocked Canvasses: A Special Fabric for Pastel Paintings." In Townsend, Doherty, Heydenreich, and Ridge, *Preparation for Painting*, pp. 141–46.

Sensier, Alfred. *La Vie et l'œuvre de Jean-François Millet.* Paris: Quantin, 1881.

Severens, Martha. "Who Was Henrietta Johnston?" *Antiques*, 1995, pp. 704–9.

Seznec, Jean, and Jean Adhémar, eds. *Salons.* 2d ed. Oxford, England: Clarendon, 1957–67.

Shackleton, Robert. "The 'Encyclopédie' as an International Phenomenon." *Proceedings of the American Philosophical Society* 114, no. 5 (1970): 389–94.

Shelley, Marjorie. "American Pastels of the Late Nineteenth and Early Twentieth Centuries: Materials and Techniques." In Bolger, *American Pastels in the Metropolitan Museum of Art*, pp. 33–45.

———. "Assimilating Modernism: The Pastel Technique of William Merritt Chase." In Pisano, *William Merritt Chase*, pp. 97–111.

———. "The Craft of American Drawing: Early Eighteenth to Late Nineteenth Century." In Avery, *American Drawings and Watercolors*, 1:28–78.

———. "Painting in Crayon: The Pastels of John Singleton Copley." In Rebora, *John Singleton Copley*, pp. 127–41.

———. "Pastellists at Work: Two Portraits at the Metropolitan Museum by Maurice Quentin de La Tour and Jean Baptiste Perronneau." *Metropolitan Museum Journal* 40 (2005): 12–13, 105–19. [2005]

Sheriff, Mary. *The Exceptional Woman: Elisabeth Vigée Le Brun and the Cultural Politics of Art.* Chicago: University of Chicago Press, 1996.

———. "Reflecting on Chardin." *Eighteenth Century* 29, no. 1 (1988): 19–45.

Simches, Seymour Oliver. *Le Romantisme et le goût esthétique du xviiie siècle.* Paris: Presses Universitaires de France, 1964.

Simon, Jacob. "Edinburgh, Archibald Skirving." Review. *Burlington Magazine* 141, no. 1154 (1999): 310–11.

Simpson, Marc. "Venice, Whistler, and the American Others." In Merrill, *After Whistler*, pp. 32–49.

Smart, Alastair. *Introducing Francis Cotes, R.A., 1726–1770.* Nottingham, England: Nottingham University Art Gallery, 1971.

Smentek, Kristel. "Looking East: Jean-Etienne Liotard, the Turkish Painter." *Ars Orientalis* 39 (2010): 84–112.

Smiles, Samuel. *Lives of the Engineers, with an Account of their Principal Works.* London: J. Murray, 1861.

Soulier, Gustave. "Lévy-Dhurmer." *Art et Décoration*, January 1898.

Spies, Werner, *Picasso: pastels, dessins, aquarelles.* Paris: Herscher, 1986.

Spike, John. "Ottavio Leoni's Portraits *alla macchia.*" In *Baroque Portraiture in Italy: Works from North American Collections*, p. 12–19. Sarasota, FL: Ringling Museum, 1984.

Sprinson de Jesús, Mary. "Adélaïde Labille-Guiard's Pastel Studies of the Mesdames de France." *Metropolitan Museum Journal* 43 (2008): 157–72.

Staiti, Paul. "Accounting for Copley." In Rebora, *John Singleton Copley*, pp. 25–51.

Stavitsky, Gail, ed. *Waxing Poetic: Encaustic Art in America.* Montclair, NJ: Montclair Art Museum, 1999.

Stein, Perrin. "Versailles: Pastels at Versailles." *Burlington Magazine* 139, no. 1132 (1997): 497–98.

Steinhoefel, Antje. "Viewing the Moon: Between Myth and Astronomy in the Age of Enlightenment." In *Myths of Europe*, by Richard Littlejohns and Sara Soncini, pp. 113–22. Amsterdam: Rodopi, 2007.

Sunderland, John. Review of *Francis Cotes*, by Edward Mead Johnson. *Burlington Magazine* 119, no. 897 (1977): 869.

Thénot, Jean-Pierre. *Le Pastel appris sans maître, ou l'Art chez soi.* Paris: Desloges, 1856.

Tordella, Piera Giovanna. "Ottavio Leoni Designatore e Pittore: I Cesi e il Cardinal Montalto." *Mitteilungen des Kunsthistorischen Institutes in Florenz* 47, nos. 2/3 (2003): 345–74.

———. *Ottavio Leoni e la Ritrattistica a Disegno Protobarocca.* Florence: Olschki, 2011.

Tormen, Gianluca. "Rosalba negli inventari delle collezioni venete del Settecento." In Pavanello, *Rosalba Carriera*, pp. 237–54.

Townsend, Joyce H., Tiarna Doherty, Gunnar Heydenreich, and Jacqueline Ridge, eds. *Preparation for Painting: The Artist's Choice and Its Consequences.* London: Archetype, 2008.

Trope, Marie-Hélène. *Jean Valade: "Peintre ordinaire du Roi, 1710–1787."* Poitiers, France: Musées de la Ville de Poitiers and de la Société des Antiquaires de l'Ouest, 1993.

Tufts, Eleanor. "Vigée Le Brun." *Art Journal* 42, no. 4 (1982): 335–38.

Turner, Jane, ed. *The Dictionary of Art.* New York: Grove, 1996.

Turner, Nicholas. *Federico Barocci.* Paris: Vilo International, 2000.

———. *Roman Baroque Drawings, c. 1620 to c. 1700: Catalogue.* London: British Museum Press, 1999.

Uzanne, Octave. *Figures contemporaines tirées de l'Album Mariani.* Paris: Floury, 1901.

———. "Modern French Pastellists: Charles Léandre." *International Studio*, January 1905, p. 242–45.

———. "Modern French Pastellists: Gaston La Touche." *International Studio*, June 1904, p. 281–288.

Vaillat, Léandre, and Paul Ratouis de Limay. *J.-B. Perronneau, 1715–1783: Sa Vie et son œuvre.* 2d rev. ed. Paris: Van Oest, 1923.

Valéry, Paul. *Degas Danse Dessin.* Paris: Gallimard, 1949.

Viallefond, Geneviève, *Le peintre Léon Riesener 1808–1878: sa vie, son œuvre, avec des extraits d'un manuscrit inédit de l'artiste "De David à Berthe Morisot."* Paris, A. Morancé, 1955.

Viatte, Françoise. *Léonard de Vinci: Isabelle d'Este.* Paris: Réunion des Musées Nationaux, 1999.

Vibert, Jehan-Georges. *La Science de la peinture.* 8th ed. Paris: Ollendorff, 1891.

Vigée Le Brun, Elisabeth Louise. *Souvenirs, 1755–1842 (1835–1837).* Edited by Geneviève Harouche-Bouzinac. Paris: Honoré Champion, 2008.

———. *Souvenirs de Madame Louise-Elisabeth Vigée-Lebrun.* Paris: Fournier, 1835.

Viguier, Florence, *Emile-Antoine Bourdelle (1861–1929): œuvres graphiques.* Montauban: Musée Ingres, 2001.

Vincent Courdouan (1810–1893), catalogue d'exposition. Toulon: Musée d'Art, 2000.

Vollard, Ambroise. *Degas.* Paris: Crès, 1924.

Vuillard. Paris: Galeries Nationales du Grand Palais, Réunion des Musées Nationaux, 2003.

Waggoner, Diane. *The Sharples Collection: Family and Legal Papers, 1784–1854.* 2001. www.microform.co.uk/guides/R97579.pdf.

Walpole, Horace. *The Anecdotes of Painting in England.* London, 1782.

Watrous, James. *The Craft of Old Master Drawings.* Madison: University of Wisconsin Press, 1957.

West, Shearer. "Patronage and Power: The Role of the Portrait in Eighteenth-Century England." In Black and Gregory, *Culture, Politics and Society in Britain, 1660–1800*, pp. 131–53.

Whistler, Catherine. "Rosalba Carriera e il mondo britannico." In Pavanello, *Rosalba Carriera*, pp. 181–206.

Williams, Robert. "The Artist as Worker in Sixteenth-Century Italy." In Brooks, *Taddeo and Federico Zuccaro*, pp. 94–103.

Williamson, George Charles. *John Russell, RA.* London: G. Bell, 1894. The copy consulted (National Art Library Special Collections, London) contains the manuscript notes of F. H. Webb.

Willoughby, Carol. "Search for Permanence: Materials and Methods of G. F. Watts, 1817–1904." In Althöfer, *Das 19. Jahrhundert und die Restaurierung*, pp. 203–16, 371–72.

Woodall, Joanna, ed. *Portraiture: Facing the Subject.* Manchester, England: Manchester University Press, 1997.

Wyzewa, Teodor de. "Les Pastellistes à l'Exposition universelle." *Revue illustrée* June–December 1889, p. 151–154.

Yocco, Nancy. Written communication to the author, May 30, 2013.

Yriarte, Charles. "Exposition de la Société des pastellistes français." *Le Figaro*, March 29, 1892, p. 1.

Zerner, Henri. *L'Art de la Renaissance en France: L'Invention du classicisme.* Paris: Flammarion, 1996.

———. Preface to Lecoeur, *Daniel Dumonstier.*

Zillhardt, Madeleine. *Louise-Catherine Breslau et ses amis.* Paris: Portiques, 1932.

Index of Artists

383

ACKNOWLEDGMENTS

Thea Burns thanks:
Nancy Bell, The National Archives, Kew, Surrey; Sally Riley, Arlington, Mass.; Leila Sauvage, Cecile Gombaud, and Idelette van Leeuwen, Rijksmuseum, Amsterdam; Robien van Gulik, Teylers Museum, Haarlem; Karin Wretstrand and Eva-Lena Karlsson, Nationalmuseum, Stockholm; Merit Laine, Royal Court, Stockholm; Kimberly Nichols, Art Institute of Chicago; Krysia Spirydowicz, Queen's University, Kingston, Ontario; Katie Coombs, Victoria Button, Rupert Faulkner, Ming Wilson, Victoria and Albert Museum, London; Elisabeth West FitzHugh, Sackler and Freer Gallery, Smithsonian Institution, Washington, DC; Peter Matthiesen, Matthiesen Gallery, London; Mark Pomeroy, Morgan Feely, Royal Academy of Arts, London; Gemma Hamilton, National Records of Scotland, Edinburgh; Agnieszka Marecka, Krakow; Stephanie Midon, National Museum of Women in the Arts, Washington, DC; Andrea Furstenau, Bayerische Verwaltung der Staatliche Schlösser, Gärten und Seen, Munich; Sylvie Taillandier, Saint-Honoré Art Consulting, Paris; Ros Buck, Chantry Library, Oxford; Dr. Ashok Roy, Jo Kirby-Atkinson, Ann Stephenson-Wright, National Gallery, London; Valentine Dubard, Valérie Luquet, Musée du Louvre, Paris; Nancy Yocco, The J. Paul Getty Museum, Los Angeles; Simon Lake, Leicester Museum and Art Gallery, Leicester; Alice Aurand, Courtauld Institute of Art, London; Queen's University, Kingston: the staff of Stauffer Library Special Collections, Interlibrary Loan, especially Bonnie Brooks and Lucinda Wall; Bibliothèque Nationale de France, Paris; National Art Library, London; Kim Schenck, Greg Jecmen, Michelle Facini, Marian Dirda, and Michelle Stein, National Gallery of Art, Washington, DC; Theresa Fairbanks-Harris, Yale University, New Haven; Isabelle Roché, Margaret Zayer, La Maison du Pastel, Paris; Hervé Cabezas, Musée Antoine Lécuyer, Saint-Quentin; David Ritchie and David Forfar, James Clerk Maxwell Foundation, Edinburgh; and Jacob Simon, London, National Portrait Gallery.

Philippe Saunier thanks:
Lucile Audouy, Galerie Elstir, Paris; Aurore Bisman; Damien Boquet Art, Paris; Antoine Bouchayer-Mallet; Emmanuel Bréon, Cité de l'Architecture et du Patrimoine, Paris; Étienne Bréton, Saint-Honoré Art Consulting, Paris; Sandra Buratti-Hasan; Helen Burnham, Boston, Museum of Fine Arts; Hervé Cabezas, Musée Antoine Lécuyer, Saint-Quentin; Isabelle Gaétan, Musée d'Orsay, Paris; Emmanuelle Gaillard, editor; Christian Garoscio, Musée d'Orsay, Paris; Cécile Gombaud; Isabelle Julia, Musée d'Orsay, Paris; Alexia Lebeurre, Université Michel de Montaigne, Bordeaux; Dominique Lobstein, Musée d'Orsay, Paris; Sylvie Patry, Musée d'Orsay, Paris; Charlotte Poivre; Rodolphe Rapetti, Service des Musées de France, Paris; Isabelle Roché, La Maison du Pastel, Paris; Anne Roquebert, Musée d'Orsay, Paris; Marie-Pierre Salé, Musée du Louvre, Paris; Xavier Salmon, Musée du Louvre, Paris; Charlotte Wilkins; and Georges Winter.

Emmanuelle Gaillard thanks: Sabine Arqué, Lucile Audouy, Hervé Cabezas, Florence Cailly, David Coussirat-Coustère, Christophe Gaillard, Agnès de Gorter, Sophie Nguyen, Isabelle Roché, Margaret Zayer, Philippe Rollet, and Jean Walter.